2⁵⁰

KWAKIUTL STRING FIGURES

Kwakiutl String Figures

JULIA AVERKIEVA AND MARK A. SHERMAN

Foreword by Bill Holm

UBC Press *Vancouver*
American Museum of Natural History *New York*

Kwakiutl String Figures is published as number 71 in the
Anthropological Papers of the American Museum of Natural
History.

Published simultaneously in the United States by the University
of Washington Press, PO Box 50096, Seattle, Washington
98145-5096

Canadian Cataloging in Publication Data

Averkieva, Yulia
 Kwakiutl string figures

 Includes bibliographical references and index.
 ISBN 0-7748-0432-7

 1. Kwakiutl Indians—Games. 2. String figures—British
Columbia. 3. Indians of North America—British Columbia—
Games. I. Sherman, Mark A. (Mark Allen), 1960–
II. Title.
E99.K9A94 1992 793.9 C92-091573-6

The paper used in this publication meets the minimum
requirements of American National Standard for Information
Sciences—Permanence of Paper for Printed Library Materials,
ANSI Z39.48–1984.

CONTENTS

STRING FIGURES

ILLUSTRATIONS

FOREWORD

I am not by any stretch of the imagination a "string figure scholar," but thirty years ago my wife and I spent many memorable evenings learning, from our close friends Chief Mungo Martin and his wife Abayah, to make pictures with a loop of string. Most of these sessions stretched far into the night. Mungo called the activity k·ōta, but our nickname for it was "Indian TV" because of the entertaining moving pictures it produced and the way time slipped by as we sat entranced by the changing web. Some of the figures were simple and static, occasionally requiring a vivid imagination to see the subject of the illustration. But more often than not they depicted evolving narratives with interesting and very graphic characters. Rhythmic, poetic narrations in the Kwakiutl language accompanied many of these miniature dramas, sometimes in the form of songs. At least one of the songs, "Two Brothers Going after Moss," we recorded as Mrs. Martin sang and gracefully looped and twisted the string into a lively contest between the big and little brothers.

Even with our expert teachers, learning to make those figures was not easy. Like many string artists, Mungo could seldom stop in the middle of the development of a picture and then start up again from that point. We had to start at the beginning over and over. And after learning each design, I had to practice again and again until the memory of the movements was in the fingers rather than the mind. I don't know how many figures Mungo and Abayah knew, but I learned perhaps a dozen, of which I still remember eight. I learned from Mungo to keep my k·ōtayu, or "Indian TV apparatus," looped twice around my neck for handy access, but today I carry it coiled in my pocket in the interest of propriety!

The Martins and other old people from Fort Rupert and Alert Bay remembered "the Russian girl" who accompanied Franz Boas to the Kwakiutl country in the winter of 1930 and '31, and they recalled that she was amazingly quick to learn k·ōta. She appears fleetingly in Boas's Fort Rupert film, *The Kwakiutl of British Columbia,* slipping in and out of the frame to adjust the wax cylinder recorder. Julia Averkieva's skill with string figures was mentioned by Franz Boas in his letters from Fort Rupert and Alert Bay (Rohner 1969: 289–93, 301), where he also noted that there were "hundreds" of cat's cradles. When I heard that Averkieva's study of Kwakiutl string figures was being edited for publication, I was eager to read it to see if my old favorites were included. More important, I hoped to relearn some of those I had forgotten, or to learn some of Mungo's that I had admired but never learned. I was satisfied on all counts!

String figures can be learned from the printed page. Julia Averkieva's and Mark Sherman's descriptions are clear and precise. The unfamiliar vocabulary of string figure production is not hard to learn, and a few successes make each succeeding figure easier. Fingers will learn to catch and twist and loop the string to make salmon leap, sand fleas hop, sparks fly, and frogs jump. You might even invent an original figure. I did—a realistic image of breaking a copper, of which I am inordinately proud!

Kwakiutl String Figures is a serious scholarly study. It is also a lot of fun!

BILL HOLM
Seattle

PREFACE

Of the games people play, string figures enjoy the reputation of being the most widespread form of amusement in the world: more cultures are familiar with string figures than with any other game. Over 2,000 individual patterns have been recorded worldwide since 1888, when anthropologist Franz Boas first described a pair of Eskimo string figures (Boas 1888a, 1888b; Abraham 1988:12). Few studies, however, have been made of North American Indian string figures. This book describes 102 string figures and 10 string tricks collected among the Kwakiutl* Indians of Vancouver Island in 1930 by Soviet ethnologist Julia Averkieva. It represents the most comprehensive Native American string figure collection ever assembled from a single tribe.†

In *Kwakiutl String Figures*, Averkieva's notes and descriptions are published for the first time, along with working illustrations prepared by the editor from her original photographs and pencil sketches. As editor, I have carefully rewritten Averkieva's construction methods to improve their workability.

Also, I have updated the preliminary distribution analyses and have examined the ethnological value of the collection. If this collection gives any indication of the rich string figure heritage which once characterized all of North America, a lifetime of study awaits anyone successful in tapping the memories of today's tribal elders.

The popularity of string games derives in good measure from the novelty of being able to construct highly complex designs instantaneously in a reproducible fashion using readily available materials such as plant fibers, leather thongs, or even plaited human hair (K. Haddon 1930:138). Many string figures are of great antiquity: Eskimo figures believed to be over a thousand years old are known (Paterson 1949:53; Mary-Rousselière 1965:15), and written records of string figures appear in Greece as early as A.D. 100 (Miller 1945). String figures also are a vehicle for self-expression: cultures lacking graphic art forms often use string figures to illustrate their myths and legends (Jayne 1906:3; Ball 1920:13; K. Haddon 1930:145; Paterson 1949:85). In some cultures string figures have a religious or supernatural significance (Maude & Maude 1958:8–12; Jenness 1924:181B–83B; McCarthy 1960:423).

String figures possess several properties that anthropologists find particularly attractive. First, string figures tend to be rather stable elements of a given culture; in the absence of physical migration, specific patterns do not spread rapidly to adjacent regions (Paterson 1949:50; Mary-Rousselière 1965:15; Mary-Rousselière 1969:123). Second, thousands of individual patterns can be generated from the same loop of string; the chances are very small that two separate cultures will develop identical string figure repertoires in the absence of social contact. Finally, string figures can be perpetuated only via a living

*The term *Kwakiutl* was fabricated years ago by anthropologists as a means of identifying the native inhabitants of northeast Vancouver Island. The term is no longer considered accurate. The correct term, as used by the natives in referring to themselves, is *Kwakwąką'wakw.* The term *Kwakiutl* has been retained in this book solely as a means of maintaining a sense of continuity among the published works of Boas and his students. Use of the outdated term *Kwakiutl* is in no way intended to discourage use of the native term *Kwakwąką'wakw.* A similar argument is offered for use of the term *Eskimo* versus the preferred term *Inuit.*

†For consistency's sake, the designation of "tribe" is used throughout this book to refer to people who share common cultural traits. Averkieva used this term in her text, which predated use of terms such as "group," "nation," or "peoples," when referring to Native Americans.

host, much like a myth or legend. But they differ from the latter in that they are much less susceptible to modification: one cannot substitute different loop maneuvers for a forgotten manipulation and still obtain the same figure. These features led early anthropologists such as Tylor (1879:26) to propose that string figure distribution patterns may prove useful in tracing the diffusion of culture across a given region, or in establishing early migration routes taken by prehistoric societies.

Tylor's hypothesis stimulated a great deal of interest in string figures among anthropologists of the early twentieth century. Several dozen papers and monographs were soon published in prominent journals describing string figures from all parts of the world, including Australia (Roth 1902; K. Haddon 1918; Stanley 1926), the South Pacific (Jayne 1906; A. C. Haddon 1912; Hambruch 1914; Jenness 1920; Handy 1925; Hornell 1927; Dickey 1928), the Arctic (Gordon 1906; Jenness 1924), North America (A. C. Haddon 1903; Jayne 1906), South America (Roth 1908, 1924; Lutz 1912; Farabee 1918, 1924), and Africa (A. C. Haddon 1906; Cunnington 1906; Parkinson 1906; Griffith 1925).

Not all anthropologists accepted Tylor's hypothesis. Opponents argued that identical final patterns collected from separate locations were quite possibly the product of independent invention: some figures could be made by more than one method. Many early papers that failed to include methods of construction for each figure were deemed worthless by such critics (Davidson 1941:770).

Independent invention was not the only obstacle encountered by early investigators attempting to use string figures as markers of population migration or cultural diffusion. Many early collections were not comprehensive; they failed to include all the figures of a given region. Under such circumstances, the distribution patterns of some figures were quite misleading (K. Haddon 1930:5). Field workers also failed to realize that a *number* of informants must be consulted when recording a collection; figures obtained from a single informant were not always representative of the local repertoire. Finally, many early investigators were discouraged by the rapid disappearance of figures from regions heavily influenced by European culture (Ball 1920:13). Missionaries often discouraged the making of string figures because of their frequent association with pagan myths or depiction of sexual acts (Dickey 1928:11).

These early obstacles did not, however, discourage a second generation of string figure enthusiasts who began publishing major studies some fifty years ago. In 1941, Davidson published a remarkably complete collection of Australian aboriginal string figures and proposed many sound theories regarding their derivation and origin (Davidson 1941). Soon after, Paterson completed his exhaustive survey of all known Eskimo figures, and for the first time, used distribution data to propose a theory of cultural diffusion in the Arctic (Paterson 1949). Starting in the late 1950s, Honor Maude of Australia began publishing her now-classic monograph series on Oceanic string figures, a series that soon established her as a world authority on the subject (Maude & Maude 1958; Maude & Wedgewood 1967; Firth & Maude 1970; Maude 1971; Maude 1978; Emory & Maude 1979; Maude 1984; Beaglehole & Maude 1989).

As pride in cultural heritage asserted itself in the 1960s and 1970s, interest in string figures again flourished. No longer were string figures considered mere anthropological baubles. Rather, string figures were now emerging as living relics with names evoking the charm, warmth, and passion of long-lost cultures (Mary-Rousselière 1965:15). Scholars in other disciplines began to take interest. Linguists and musicologists explored the chants that often accompany string figures, many of which contain archaic words (Campbell 1971; Blixen 1979; Johnston 1979). Mathematicians became interested in the knot theory which underlies all string figures (Gardener 1962; Amir-Moéz 1965; Noble 1980; Noguchi 1981; Walker 1985; Storer 1988). Others were intrigued by the psychological significance of the titles attached to many of the more abstract string patterns (McCarthy 1960). Finally, educators

considered the use of string figures to teach children manual dexterity and creativity (Helfman 1965; Elffers 1978; Gryski 1984, 1985, 1988).

Yet despite more than a century of interest in string figures, few scholars have taken the time to collect string figures from North American Indian tribes. In fact, not a single major collection has appeared since Jayne published her small Navaho and Klamath collections in 1906. One cannot, however, interpret the dearth of information as meaning that string figures were uncommon elements of Indian culture. Scattered references throughout the anthropological literature suggest quite the contrary: apparently, string figures were at one time known to nearly all tribes, although the extent of their repertoires may have varied greatly.

The only major effort to document familiarity with string figures among North American Indians was undertaken by A. L. Kroeber and his associates in the early 1930s as part of a comprehensive study examining the distribution of culture elements among all Native American tribes west of the Rocky Mountains (Kroeber 1939). The study suggests that string figure repertoires were extensive, although some tribes insisted that string figures were a recent introduction. The only conclusion one can draw from Kroeber's data is that string figure repertoires were at one time quite extensive along the Pacific Coast and in some areas of the desert Southwest. One of James's Cahuilla informants stated that the southern California Indians at one time knew hundreds of figures (James 1959). Clearly, the western American Indian tribes enjoy a rich string figure heritage.

Unfortunately, the extent of string figure making east of the Rockies in bygone days is unclear. Scattered references suggest that many of the very common figures such as Crow's Feet and Jacob's Ladder were widely known, but few collections have been published. One must keep in mind, however, that many of the eastern tribes were either displaced by or constantly at war with white intruders (and other Native American tribes) long before serious ethno-

graphic work could be done in the area. String figures are a product of leisure time, and it is not unlikely that their practice was abandoned soon after Europeans arrived. String figure repertoires from eastern tribes are probably lost for good. There does, however, appear to be a pocket of surviving string figure activity in the Great Lakes region (Storer, personal communication, 1985).

Clearly, there is much to learn about the extent and nature of the North American Indian string figure repertoire. For instance, do chants accompany these string figures as they do in many other regions? Jayne did not record any among the Navaho or Klamath. What do the titles attached to each individual pattern tell us about the psychology and imagination of the North American Indian? Are there figures known to nearly all Indian tribes, such as one finds among the Arctic Eskimo? Finally, how long has the practice of making string figures existed in North America, and where did it originate? Were string figures carried over the Bering land bridge from Asia with the initial colonization of North America centuries ago? Or did the practice arise spontaneously among established populations? Is there any indication that the practice was introduced at some later date from an outside source?

Before such questions can be answered, comprehensive string figure collections from a large number of North American Indian tribes are needed. With complete collections at hand, one can begin to establish which techniques and which patterns are widespread in North America and which are restricted in their distribution. This type of information may eventually lead to the development of a general theory explaining the origin of string figures in North America. Averkieva's Kwakiutl collection is the first such string figure collection to provide the type of information needed to address these questions.

I would like to thank the following individuals for their generous assistance. First and foremost, thanks go to Philip Yampolsky, grandson of Franz Boas, for granting me permission to prepare and edit Julia

Averkieva's manuscript. Sincere thanks are also in order to Stanley Freed, curator of ethnology, and Belinda Kaye, assistant registrar in the Department of Anthropology at the American Museum of Natural History, for providing free access to the manuscript during the editing process; their enthusiasm and cooperative spirit were greatly appreciated. I also wish to thank Nancy Oestreich Lurie, curator of anthropology, Milwaukee Public Museum, for providing biographic data on Julia Averkieva. Her fond recollections of Averkieva's collaborative spirit afforded me the final impetus for completing the editing task.

Many string figure enthusiasts from around the world contributed significantly to the preparation of Averkieva's manuscript. Thanks go to Yukio Shishido of Kyoto, Japan, for teaching me how to draw string figures accurately, and to Felix R. Paturi of Rodenbach, Germany, for providing string figure literature not readily available in the United States. I also wish to thank Honor Maude of Australia, a leading authority on string figures, for her constant support and inspiration. Largely owing to her efforts, hundreds of string figures from all over the world have been preserved for future generations.

Finally, I wish to express my deepest gratitude to Thomas Storer, professor of mathematics at the University of Michigan and noted authority on North American Indian string figures, for his invaluable assistance in locating Averkieva's lost manuscript. During the editing process, Dr. Storer was kind enough to lend me numerous volumes from his extensive collection of string figure literature gathered over a period of twenty years. Without the assistance of his comprehensive string figure bibliography, much of the comparative work presented in this volume would not have been possible. Dr. Storer was also kind enough to review carefully each string figure description to ensure that all construction methods were accurate and reproducible. This volume is as much his as it is mine.

A portion of the proceeds generated from the sale of this book will be used to fund cultural heritage projects at U'mista Cultural Centre, Alert Bay, British Columbia.

M. A. S.

Introduction by Mark A. Sherman

In the Soviet Union, the name of Julia Pavlovna Petrova-Averkieva (1907–1980) is synonymous with North American Indian ethnography—her studies on the social organization of Northwest Coast tribes are considered classics. Unfortunately, however, the vast majority of her work is not yet available in English translation. As a result, her name remains relatively obscure in the western world. The following biography was compiled from information provided by Averkieva's eldest daughter, Helena Petrova, her grandson, Anthony Nioradze, and from information published by the Institute of Ethnography, Academy of Sciences, USSR, at the time of Averkieva's death (*Sovetskaia Etnografiia* [1980] 6:181–83).

Julia Pavlovna Averkieva was born July 24, 1907, in the small coastal village of Poduzhemyeh, located on the White Sea in Karelia, just east of Finland. Averkieva developed a strong character in childhood, partly because of the responsibilities thrust on her after her mother's death in 1918. Although Averkieva's father, a lumberjack, loved his children dearly, his profession required long hours deep within the Karelian forest. As a result, his visits home were limited to Sundays. Thus, at age eleven, Julia alone raised her two younger sisters, prepared the meals, built the fires, did the laundry, and baked the bread. At the same time, she attended school and managed to excel at her studies. Julia was also athletically inclined. With travel limited by the harsh Arctic climate and rugged terrain, she soon became an excellent ice skater and cross-country skier, sports she would continue to practice, even in old age. Given the wonderfully rich, mixed Karelian-Russian environment of her childhood, it is not surprising that she later developed an intense interest in folk culture and general ethnology.

Averkieva's bold personality and early academic success qualified her highly for advanced education. Thus, in May of 1925, Averkieva was sent to Leningrad State University, where she studied under the world-renowned ethnologist W. G. Bogoras (or Bogoraz). During her undergraduate years she took part in many expeditions to her native Karelia and became an expert on the small nations in the northwestern part of the Soviet Union. In this golden age of Soviet ethnography, the student Averkieva was a star.

At that time, however, few Soviet scholars specialized in the ethnography of North American natives. Realizing Averkieva's tremendous potential as an ethnologist, her advisers encouraged her to take advantage of a recently established foreign student exchange program with Columbia University in New York, where she could obtain specialized training. Thus, in October of 1929, Averkieva came to New York to study Northwest Coast Indians with Franz Boas, chairman of the Department of Anthropology at Columbia University, and the acknowledged father of American ethnography.

Shortly thereafter, Boas invited Averkieva, as his sole companion, to take part in an expedition to Vancouver Island, British Columbia, to study the Kwakiutl tribe. The expedition, which started in October of 1930 and lasted for six months, had a tremendous impact on the twenty-three-year-old Averkieva, defining the circle of her interest for years to follow. It was at Fort Rupert that Averkieva lived among the Kwakiutl, participating in potlatches, studying their social organization, and, of course, collecting string figures. The Kwakiutl developed great respect for her. They honored her by officially admitting her to their tribe and giving her her own colorfully painted totem in the image of an

eagle. Averkieva kept this totem on her desk her entire life.

In May of 1931, Averkieva returned to Leningrad to receive her master's (kandidat) degree. Soon after her return, she began doctoral studies at the Institute of Ethnography, Academy of Sciences USSR (located in Leningrad at that time), which in 1935 awarded her a Ph.D. in history. A condensed version of her thesis, "Slavery among Tribes of the Northwest Coast of North America," was immediately published in the Institute's prestigious journal (*Sovetskaia Etnografiia* [1935] 4–5:40–61) and was later published in full as a book (*Slavery among North American Indians*, Moscow: 1941). This has since been translated into English (Victoria College, B.C.: 1966).

Averkieva's return to Leningrad also coincided with great changes in her personal life. On August 4, 1931, three months after her return, Averkieva married an American by the name of "Peter" (surname unknown). Peter Averkiev (he took her name) was a recently graduated electrical engineer who apparently emigrated to the Soviet Union after completing his studies. In July of 1934, the couple bore a child by the name of Helena. Unfortunately, details concerning Peter Averkiev are sketchy after this date. It is rumored that he was accused of antigovernment activities. His ultimate fate is unknown.

Despite her loss, Averkieva soon remarried. Her second husband was a highly intelligent Sinologist by the name of Apollon A. Petrov, whom she met during her studies at the Academy of Sciences. A second daughter soon followed, so that by the end of the decade the family numbered four.

When the Soviets entered World War II on June 22, 1941, the government recruited Petrov to work in the prestigious Ministry of Foreign Affairs. The entire family was immediately evacuated from Leningrad and relocated in the city of Kuybyshev on the river Volga, where Petrov assumed his new position. Ironically, their stay in Kuybyshev was short. In 1942, the entire family left for the Far East; Petrov was now an official Soviet delegate to China.

Petrov, Averkieva, and their two children spent five years in China, living first in Chongquing, and later in Nanjing. In April 1945, A. A. Petrov became chief Soviet delegate to China, thus marking the high point of his career. During her years in China, Averkieva attended to her duties at the Institute of Ethnography through frequent correspondence.

By the time the family returned to Moscow in the summer of 1947, Averkieva was more than eager to resume her studies. Within weeks she was able to contribute two papers on Native Americans to leading Soviet journals, despite her long absence. Her third child, a boy, was also born during this time. Within months, however, Averkieva and her career would fall victim to the treacherous politics of the Stalin era.

In the fall of 1947, Averkieva was falsely accused of crimes against the state. She was immediately arrested and swiftly deported to a detention camp in the republic of Mordovia. She was later transferred to an isolated village in Siberia. Such villages were officially referred to as "secluded resting places, for living." Here Averkieva would remain in exile, separated from her family, until 1954.

Averkieva's husband was devastated. Petrov had always been considered a very loyal and important diplomat in the Soviet Union; his diplomatic and scientific work was highly respected by his colleagues. It was inconceivable to him that someone would accuse a member of his family of antigovernment activities.

Petrov sought refuge from grief in devoting himself to his children and his academic studies. During his wife's exile, Petrov worked diligently on his doctoral thesis, a study of the old Chinese philosopher Wan Chung (published in Moscow, 1954). He also taught courses on the history of Chinese philosophy at the Soviet Academy of Sciences. All the while, he continued to maintain his post at the Ministry of Foreign Affairs. But Petrov and Averkieva would never again be together; Petrov died tragically in early 1949 of a massive heart attack.

In 1954, after seven years in exile, Averkieva was reunited with her children. Ironically, two years later she was pronounced "not guilty" by the Supreme Court of the Soviet Union. She was fully pardoned. The basis of her arrest was never recorded in the papers of the Court, although Averkieva knew who had accused her and why. The suspect incident had occurred in China: upon learning that the Soviet Embassy's doctor was away, Averkieva had indiscreetly contacted the American Embassy's doctor in seeking emergency medical care for her younger daughter.

Upon her return from exile, she began to live again: Averkieva was a strong-willed woman, full of heart and dignity. In the summer of 1954 she joined the staff at the Institute of Ethnography, Soviet Academy of Sciences in Moscow, as a scientific associate. Thus, her career as an ethnologist did not begin in earnest until her forty-seventh year. During her next twenty-six years at the institute, Averkieva would publish over sixty papers, monographs, and books on various aspects of North American ethnology. A complete bibliography of her work has been published (*Sovetskaia Etnografiia* [1977] 6:137–38 and *Sovetskaia Etnografiia* [1980] 6:182 [footnote]).

Scientifically speaking, Averkieva introduced many bold and novel concepts into a field dominated by westerners. Throughout her research career she was fascinated with the various mechanisms by which primitive tribal societies, made up of simple fishers and hunters, developed rigid class systems, systems in which certain members were considered inherently superior to others. It was, of course, the complex social system of the American Northwest Coast Indian that provided the basis for nearly all her future studies.

Averkieva was especially interested in how materialism, totemism, and belief in personal property eventually gave rise to the institution of slavery. Such studies were considered avant-garde at the time. The bulk of her work on these aspects of Northwest Coast society were pulled together in her monograph entitled *Materialism of Tribal Societies and Formation of Early Class Relations in Societies of Indi-*ans of the Northwest Coast of North America (1961, in Russian).

She later authored a second, related study entitled *Nomadic Indian Societies of the 18th and 19th Century* (1970, in Russian). Here, Averkieva critically examined how the early capitalistic exploitation of several Native American tribes forced them into a nomadic existence on the American Great Plains. She also investigated the source of the social inequality that developed among various American Indian prairie tribes of the eighteenth and nineteenth centuries. This study provided a basis for understanding the evolution of other nomadic societies around the world.

In 1974, Averkieva once again attacked the problem of understanding how primitive cultures develop complex social systems. In her monograph *Indians of North America, from Tribe to Class Society*, she analyzed the influence of capitalistic nations on the social and cultural development of mid-nineteenth-century tribes. Here she was able to define four different processes by which class-based societies develop. This work contributed significantly to our understanding of how capitalism influences the making and breaking of tribal relations in modern-day underdeveloped countries.

Although she was a strong Marxist and a firm believer in the teachings of American ethnographer Lewis Henry Morgan (1818–81), Averkieva always considered it important to work closely with American ethnographers, even during the height of the Cold War. Her collaborative spirit is manifested in the now-classic volume, *North American Indians in Historical Perspective* (1971, in English), which Averkieva instigated in collaboration with American ethnologists Nancy Oestreich Lurie and Eleanor Leacock. The book was later translated into Russian under Averkieva's supervision (*Progressive Ethnography in the U.S.*, 1978).

Averkieva always paid close attention to modern Indian movements in the U.S. and Canada. She was deeply concerned about the poor social treatment of Native Americans, whose fate she took to her heart. Throughout her life she kept in contact with Indian

activists in the U.S., and contributed to their cause by writing supportive articles (e.g., "Native Americans: New Opposition Movements among the Indians," in *William Meyers, Angry Bear* (1974, in Russian)).

Averkieva eventually became director of North American Studies at the Institute of Ethnography in Moscow. During the height of her career, Averkieva enjoyed a world-wide reputation. She was a member of the International Union of Anthropologists and Ethnologists and participated in many of their congresses (Moscow, 1964; Tokyo, 1968; Chicago, 1973; and despite her illness at the time, in Delhi, 1978). In 1964, she helped organize a special international symposium dedicated to the works of Lewis Henry Morgan. From 1966 until the time of her death in 1980, Averkieva was editor-in-chief of *Sovetskaia Etnografiia,* the official journal of the Institute of Ethnography, Soviet Academy of Sciences. Under her supervision, the journal underwent significant improvements. Most noteworthy was the development of a section in which group discussions with western colleagues were presented. Certainly, however, the establishment of a North American division at the Museum of Anthropology and Ethnology in Leningrad was her greatest achievement. Over half of the artifacts in the museum's permanent collection were contributed by Averkieva. Today, the Institute of Ethnography in Moscow houses an *Archive Averkieva,* where information on her life, work, and achievements can be found.

Julia Pavlovna Petrova-Averkieva was a spirited and courageous woman, proud of her humble beginnings. She endured many hard and bitter experiences during the postwar years and survived many personal tragedies, but throughout she remained a beautiful, optimistic woman with a brilliant sense of humor. Averkieva died of cancer on October 9, 1980. Today her three children live in Moscow; Helena is a Sinologist and her other daughter and son are government workers.

History of the Manuscript

Julia Averkieva's Kwakiutl string figure collection was assembled between October 21, 1930, and January 12, 1931, just off the coast of British Columbia at Fort Rupert, Vancouver Island.

Director of the expedition Franz Boas had repeatedly visited the Northwest Coast over a period of forty-five years in order to conduct ethnographic research. This was his last visit (Rohner 1969:313). Fort Rupert was chosen because of the large number of Kwakiutl subtribes or bands which had taken up residence there. Representatives from many bands had moved to Fort Rupert soon after its establishment as a major fur-trading post in 1849 by the ubiquitous Hudson's Bay Company. The Europeans were anxious to exploit the bartering skills developed by many Northwest Coast tribes as a result of their extensive participation in the trade networks that had linked all inhabitants of the coast for centuries prior to the arrival of Europeans in the late 1700s (Kirk 1986:141). The concentration of so many subtribes in a single location greatly simplified ethnographic work (Woodcock 1977:102).

Rohner has chronicled many of Boas and Averkieva's adventures at Fort Rupert during their winter visit (Rohner 1969:288–93). Although Averkieva managed to gather a great deal of information on Kwakiutl dancing, weaving, and box making, among other things, her primary efforts were focused on the collecting of local string games or "cat's cradles," as Boas called them. Despite her young age, Averkieva was able to assemble an exhaustive collection of string figures, complete with methods of construction. The collection rivals those published by more experienced ethnologists in terms of its accuracy, thoroughness, and completeness. Upon returning to New York, Averkieva tackled the arduous task of writing up her descriptions and preparing photographs of the final figures as well as many of the intermediate stages. A preliminary attempt was made at analyzing the North American distribution pattern of the figures, but resources were

very limited at the time, consisting primarily of Jayne's Navaho and Klamath collections (1906), Jenness's Eskimo collection (1924), and Dickey's Hawaiian collection (1928). Four months later (May 1931) Averkieva departed for Leningrad to join Waldemar Bogoras, her mentor at the Soviet Academy of Sciences. Northwest Coast American Indians would fascinate her for the rest of her life.

Although Averkieva and Boas corresponded regularly over the next several years, little mention was made of the string figure manuscript she had left with Boas in New York (Scholarly Resources, Inc., 1972). Unfortunately, Franz Boas died in 1942 without having published Averkieva's work. Paula Jacobs, Boas's secretary at the time the manuscript was being edited, provided the following information concerning the status of the manuscript in response to an inquiry from the Boas family:

> The string figures were finished by me with what I thought were very good illustrations (photographs) many years ago. When the elder von Hornbostel came to the States Professor Boas gave him the manuscript to go over, together with the string figure illustrations. Dr. von Hornbostel went over the ms., put in some corrections and returned it to Professor Boas as a finished job but did not return the pictures. In the meantime he died. Professor Boas wrote to Mrs. von Hornbostel, and also inquired of the younger von Hornbostel (the son), but no trace of the illustrations could be found. To the best of my knowledge the illustrations were not in Professor Boas's office. I was not in the office at the time the manuscript was returned to Professor Boas and I don't know whether von Hornbostel actually gave him the manuscript personally or mailed it.
>
> I think the manuscript is almost ready for publication with the exception of a few queries which von Hornbostel made and which neither I nor Professor Boas could figure out. The thing that has held it up has been the illustrations. Van Veen tried drawing a few but it took a terrific amount of time and he couldn't bother to figure out the complicated knots and things. Also he charged a ridiculous sum of money for the few preliminary studies he made. That's where the matter has stood for many years. (Letter from Paula Jacobs, February 1943)

Erich von Hornbostel, an ethnomusicologist, was a long-time colleague and friend of Boas. He apparently became interested in string figures after meeting Kathleen Haddon. Haddon and von Hornbostel co-authored a paper on Chama string games of Peru (1939) based on an unpublished manuscript by Tessmann. The paper cites several figures from Averkieva's manuscript.

Before returning Averkieva's manuscript to Boas, von Hornbostel expanded the meager distribution analysis supplied by Averkieva and prepared a brief introductory chapter describing the significance of the collection and the role of string figures in primitive societies. The entire 391–page manuscript remained in the Boas family's private collection until 1960, when it was turned over to the Department of Anthropology at the American Museum of Natural History in New York. There the manuscript lay undisturbed until the summer of 1982, at which time I located it after several years of searching.

The text of the manuscript itself was in fairly good order. Descriptions were present for all 102 figures and 10 tricks listed in the table of contents, as were several pages of chants transcribed from cylinder recordings and written in Kwakwala by Boas. The missing illustrations referred to by Jacobs apparently resurfaced sometime after 1943. Hundreds of photographs and negatives, largely unlabeled, accompanied the document, including the "plates" referred to by Boas in personal correspondence with Averkieva. Two dozen crude pencil sketches by Averkieva supplemented those photographs that were either missing or of poor quality. Several of the large, half-finished artist sketches referred to by Jacobs in her status report were also present. All in all the manuscript appeared ready for publication, except for the tremendous problem of identifying illustrations referred to by Boas in his letters to Averkieva.

Upon closer examination, however, several other problems surfaced. The "plates," composed of miniature photographs ($1'' \times \frac{1}{2}''$), were totally unsatisfactory for publication, depicting nothing more than a silhouette of each string figure's final pattern. Therefore, my first step in preparing the manuscript for

publication was to draw detailed illustrations of each string figure, showing exact string crossings. But in working through Averkieva's directions for constructing the figures, it soon became apparent that only the most experienced string figure maker could ever hope to reproduce the figures from the instructions provided. Averkieva had decided to abandon the scientific nomenclature (devised by Rivers and Haddon in 1902 for recording string figure methods) in favor of the "simplified" terminology popularized by Jayne in 1906. Unfortunately, Averkieva's command of the English language was not precise enough to effect such a substitution. Many of her instructions could be interpreted in ways that reduced figures to a mass of tangles. It was therefore mandatory that the methods of construction be rewritten in Rivers and Haddon's terminology. This I proceeded to do, and the rewritten directions constitute the bulk of this present edition of Averkieva's book. The nomenclature devised by Rivers and Haddon is reviewed at the close of my Introduction, immediately preceding Averkieva's text.

All instructions, when properly followed, will produce a figure that matches precisely the photographs and pencil sketches provided by Averkieva, although it must be noted that the numbers assigned to each figure do not correspond to those cited in Tessmann's "Chama String Games" (1939), which was written before completion of the numbering system. Close attention was paid to the exact way the figures were woven: no substitutions or simplifications were introduced into the string manipulations originally recorded by Averkieva. Authentic Kwakiutl string figures are now available to all.

In addition, I have entirely replaced von Hornbostel's preliminary distribution study with an updated version: many of the collections instrumental in establishing the origin of figures in the Kwakiutl repertoire were unpublished at the time von Hornbostel completed his analysis (see von Hornbostel and Sherman 1989, for his original study). These distribution data I have appended under the heading of "Analysis."

Also, to enhance the experience of making the Kwakiutl figures, I have included three Appendixes. Appendix A examines the cultural significance of the titles attached to each figure: many of these titles also appear in Kwakiutl myths and legends. Appendix B proposes archaeological, anthropological, and linguistic data which attempt to explain the distribution pattern common to many of the Kwakiutl figures. Appendix C provides an illustrated cross index of analogous figures. The string figure Bibliography that closes this volume should assist anyone interested in pursuing string figure research, regardless of cultural area.

The Distribution Data

As previously described, early attempts at using string figures to trace cultural diffusion were sharply criticized once it became apparent that numerous patterns could be independently invented by unrelated cultures. Subsequent attempts relied heavily on analysis of construction methods (Paterson 1949).

But recently, perceptions of how string figures are transmitted have begun to change. In 1969, Mary-Rousselière challenged the theory that identical patterns must be formed by identical methods of construction before one can establish previous contact between cultures. Based on his long-term residency among the Netsilik Eskimos as a Catholic missionary, Mary-Rousselière pointed out that there are many examples in the Arctic of identical figures being made by unrelated methods of construction at different locations, yet the figures in question do not occur anywhere else outside Eskimo territory (Mary-Rousselière 1969:135). This is not what one would expect to find if these were indeed examples of "independent invention." Thus, the notion was introduced that, at least in Eskimo society, more emphasis is placed on preservation of the final pattern than on conservation of the construction method (Mary-Rousselière 1969:126).

In support of his hypothesis, Mary-Rousselière

provided several examples of identical patterns made by unrelated methods *at a single location*. Among the Arviligjuarmiut, a Netsilik Eskimo tribe, he recorded ten entirely different methods for constructing the ever popular Fox figure (Mary-Rousselière 1969:51–55). Thus, for the first time, proof existed that the expert string figuremaker has a far greater understanding of how certain manipulations of the string give rise to specific loops and twists in the final pattern than was previously thought. The creation of a string figure was not necessarily a random process. Kathleen Haddon had suggested such a phenomenon as early as 1930 in her string figure monograph, *Artists in String*. This observation implies that upon being shown the final pattern of a given string figure, the true expert can eventually succeed in developing a similar or identical figure of his own. One must realize, however, that this sort of expertise requires years of accumulated knowledge and a profound understanding of the potentials and limitations of the string (Dawkins 1931:43). But this depth of understanding was certainly no problem for the average Eskimo, who was confined indoors for weeks at a time by the long, dark Arctic winters. Lacking the modern conveniences of television, radio, or even books, the Eskimo was forced to devise engaging forms of entertainment with the available materials of his surroundings.

Hence, in recent years, the rules governing the use of string figures as indicators of previous cultural contact have relaxed a bit. Identical patterns made by unrelated methods of construction are not necessarily examples of independent invention. If the patterns in question are of sufficient complexity, one must consider transmission through previous contact as a real possibility. There are still, however, many examples of simple patterns arising through independent invention. Some degree of expertise in knowing the likelihood of producing a given pattern through random fiddling is indeed necessary in making these sorts of judgments.

The relaxation in standards does not, however, imply that recording the method of construction is no longer necessary when making a collection of string figures. On the contrary, the method of construction reveals whether a figure is produced by a limited set of manipulations or a long series of complex maneuvers. This in turn helps determine the likelihood of the figure's being independently invented in widely separated areas. Methods of construction are also vital for documenting the general types of manipulations which characterize the practice in any given region. It is quite feasible that cultures can transmit string figure techniques to one another without transmitting any actual figures. The occurrence of shared techniques may therefore be just as useful in establishing previous social interaction between cultures as the actual figures themselves. Most scholars now agree that theories of cultural diffusion or migration should never be based solely on the distribution of string figures in a given region (Mary-Rousselière 1969:161). But when combined with relevant archaeological, ethnological, and linguistic data, string figure distribution patterns can indeed provide useful evidence *in support* of such theories.

With these concepts in mind, I proceeded to update Averkieva's preliminary distribution analysis by searching the string figure literature for figures that resemble or are identical to those collected at Fort Rupert. A list of source documents consulted in preparing the analysis, regardless of whether matches were found, is included in the Bibliography. The analysis sought primarily to determine possible sources for figures in the Kwakiutl repertoire. Implications of the distribution data with respect to theories of migration and cultural diffusion are presented in Appendix B, but only for cases where sufficient anthropological, archaeological, or linguistic data exist in support of such interactions.

In order to evaluate the degree of similarity between a given Kwakiutl string figure and a similar figure recorded elsewhere, I have devised the following categories: (1) identical or nearly identical patterns made by identical or nearly identical methods of construction [ID-ID figures]; (2) identical or nearly identical patterns made by totally unrelated methods of construction [ID-UN figures]; and (3)

similar patterns made by similar methods of construction [SIM-SIM figures].

The headings "identical pattern," "nearly identical pattern," or "similar pattern" used in the Analysis sections describe the degree of similarity between the Kwakiutl figure in question and the related patterns recorded elsewhere. In cases where the Kwakiutl pattern is related to an Eskimo pattern, the number assigned to that pattern by Paterson in his tabulation of Eskimo figures is indicated by the notation "P" followed by the number. In cases where the figure was recorded after Paterson compiled his tabulation, the number assigned by Mary-Rousselière (as prefixed by "MR") is used. Throughout the work, the numbers assigned to individual Kwakiutl string figures (by Averkieva) are always enclosed in square brackets [].

Following each heading is a listing of the cultural units or "tribes" from which related patterns have been collected. Table 1 provides a listing of native North American tribes from which major string figure collections have been made. The Eskimo classification scheme adopted herein does not necessarily match that used by Paterson or Mary-Rousselière, but it greatly simplifies presentation and analysis of the distribution data. The locations of the various tribes are illustrated in maps 1 and 2. A map of Vancouver Island is also provided (map 2) to illustrate the locations of the various Kwakiutl villages referred to by Averkieva in her descriptions.

Mathematical symbols are used to indicate the degree of similarity between the Kwakiutl method of construction and the construction method recorded elsewhere. These symbols are defined as follows:

+	Identical or nearly identical in method of construction
−	Unrelated methods of construction
"+"	Similar methods of construction
(+)	Probably identical or nearly identical methods of construction
(−)	Probably unrelated methods of construction
("+")	Probably similar methods of construction

Symbols in parentheses indicate reports in which no method of construction was recorded by the author; most of these describe Eskimo figures. Based on the extensive observations of Paterson and Mary-Rousselière regarding modes of Eskimo string figure transmission, one can safely assume that methods of construction at the site in question are likely to be identical to those recorded in surrounding sites. But in cases where no valid assumption can be made (i.e., the figure does not occur in any nearby territories), a question mark indicates an unknown method of construction.

The mathematical notation precedes the name attached to the pattern in the region from which it was collected. This is followed by the author who published a drawing or description of the pattern, as well as the number assigned to the pattern in that author's work. A complete citation of each work can be found in the Bibliography (entries marked with an asterisk contain string figure collections). Every effort has been made to illustrate figures classified as being nearly identical or similar to a Kwakiutl figure, since many of the original publications describing the figure are now difficult to obtain. These illustrations can be found in Appendix C and all are adapted from illustrations provided by the original authors.

Finally, I have listed figures which, although unrelated in final pattern to the Kwakiutl figure in question, nonetheless share small blocks of construction technique which thereby relate them. The listings in this category are by no means comprehensive. Such similarities can be discovered only after memorizing construction methods for hundreds of figures—no small task for any enthusiast.

Following presentation of the distribution data, I have included comments relevant to the observed distribution, related chants, and any other auxiliary material that further illustrates the diversity of string figure interpretation among different cultures. Theories based on the distribution analysis which describe possible origins and modes of transmission for many of the Kwakiutl figures can be found in Appendix B of this work.

Table 1. Major North American String Figure Collections

Author*	Tribal Designation	Sites	Figures in Collection
Jayne (1906)/Culin (1907)	Navaho	Gallup (New Mexico) St. Michael's Mission (Arizona)	26
Jayne (1906)	Klamath/Modoc	Oregon/California	15
Jenness (1924) (from Bernard)	Chukchi Indians	Cape Nuniamo to Cape Unikin (U.S.S.R.)	26
Jenness (1924)	Siberian Eskimo	Indian Point (U.S.S.R.)	21
Gordon (1906)	Bering Eskimo	Cape Prince of Wales, King Island, Diomede Island (Alaska)	6
Jenness (1924)	Bering Eskimo	Kobuk River, Nome, Port Clarence, Cape Prince of Wales (Alaska)	34
Jochelson (1933)	Aleut	Attu, Unalaska (Aleutian Islands)	7
Gordon (1906)	Nunivak Eskimo	Nunivak Island, Anvik (Alaska)	8
Lantis (1946)	Nunivak Eskimo	Nunivak Island (Alaska)	26
Jenness (1924)	North Alaskan Eskimo	Point Barrow, Point Hope, Colville River, Endicott, Cape Thompson (Alaska)	89
Jenness (1924)	Mackenzie Eskimo	Mackenzie Delta (Yukon)	72
Jenness (1924)	West Copper Eskimo	Bernard Harbor (Canada)	84
Rasmussen (1932)	East Copper Eskimo	Coronation Gulf, (Northwest Territory)	57
Mary-Rousselière (1969)	Netsilik Eskimo (Arviligjuarmiut)	Pelly Bay (N.W.T.)	112
Mathiassen (1928)	Iglulik Eskimo (Aiviligmiut)	Repulse Bay (N.W.T.)	18
Mary-Rousselière (1969)	Iglulik Eskimo (Aiviligmiut)	Repulse Bay (N.W.T.)	57
Mathiassen (1928)	Iglulik Eskimo (Tununermiut)	Pond Inlet (Baffin Island)	34
Mary-Rousselière (1969)	Iglulik Eskimo (Tununermiut)	Pond Inlet (Baffin Island)	101
Paterson (1949)	Iglulik Eskimo (Tununermiut)	Craig Harbor (Ellesmere Island)	80
Mary-Rousselière (1969)	Iglulik Eskimo	Iglulik	97
Jenness (1924) (from Boas)	Baffinland Eskimo	Cumberland Sound (Baffin Island)	35
Jenness (1924) (from Boas)	Caribou Eskimo	West Coast of Hudson Bay	24
Birket-Smith (1929)	Caribou Eskimo (Qaernermiut, Padlimiut)	West Coast of Hudson Bay	29
Paterson (1949)	Polar Eskimo	Cape York (Greenland)	67
Holtved (1967)	Polar Eskimo	Thule district (Greenland)	50
Paterson (1949)	West Greenland Eskimo	Upernavik, Ubekendt Island (Greenland)	55
Hansen (1974–75)	West Greenland Eskimo	Kraulshavn (Greenland)	25
Victor (1940)	East Greenland Eskimo (Angmagssalik)	Angmagssalik (Greenland)	23

*Complete citations can be found in the Bibliography.

Map 1: Location of Eskimo (Inuit) groups and also of North American Indian groups cited in text. North American Indian groups are in italics.

Map 2: Location of major Northwest Coast Indian groups. Inset shows Kwakiutl villages cited by Averkieva.

Selecting and Preparing String

The type of string used in forming the Kwakiutl figures is largely a matter of personal preference. Most Kwakiutl figures require a cord capable of generating some friction. Strings or cords made of nylon, although ideal for many of the intricate South Pacific figures, are far too slippery for the Kwakiutl figures. Heavy cotton or polyester string, such as cable cord (1/16″ diameter) or even drapery cord (1/8″ diameter), is therefore recommended. Solid braids, as opposed to fibrous cores surrounded by a woven sheath, are much preferred for their greater flexibility. It is not clear what material the Kwakiutl routinely used in forming their figures. Averkieva used a shoe lace in her photographs.

Cords measuring 4, 6, and 8 feet in length should produce loops in a range of sizes (short, medium, long) suitable for making nearly all of the Kwakiutl figures (increase length by one foot if using heavy 1/8″ diameter string). Unsightly knots can be avoided by "cementing" the free ends together. This is readily accomplished by melting a bit of nylon string in a flame, quickly applying the molten material to the free ends of the cotton string to be used, reflaming briefly, and joining the ends. The bond forms in seconds and is quite durable. If polyester cord is being used, the ends can be melted and joined directly. The flexibility of a given loop often improves with age. Many string figure experts retain their well-worn loops for years.

String Figure Methodology

Standard string figure nomenclature was first proposed in 1902 by Rivers and Haddon. For the first time in history, the complex manipulations required in forming a string figure could be precisely recorded in written form. The Rivers and Haddon nomenclature uses anatomical terms to name the strings that pass between the hands. Regions of space surrounding the strings can also be specified. Although this language is a bit cumbersome at times, the terms are rigorously defined and leave little room for misinterpretation.

Simplified versions of the Rivers and Haddon nomenclature have been adopted by some authors. Such anatomical terms as "radial" and "ulnar" are replaced with more familiar terms, such as "near" and "far." But these terms are relative and are oftentimes misinterpreted if the hands or fingers are in positions other than vertical. The simplified versions work well only in situations where many of the intermediate steps used in forming a figure have been illustrated (cf. Jayne 1906). As mentioned above, I rewrote Averkieva's descriptions using Rivers and Haddon nomenclature so that all manipulations could be precisely defined. The nomenclature, as defined below, is easily mastered with a bit of practice. Several new terms have been introduced to clarify key manipulations.

The five digits are named as follows: *thumb, index finger* or *indices* (pl.), *middle finger, ring finger,* and *little finger.* Occasionally, two or more fingers need to be held together and treated as a single finger. In writing this, the names of the fingers in question are linked by a hyphen: the phrase *middle-ring-little finger* suggests that these fingers should act as one while carrying out the specified manipulation.

Any segment of string encircling a finger is called a *loop.* A loop on any given finger can be thought of as being composed of two strings that join at the back of the finger. The string nearest the thumb is called the *radial* string, in reference to the radius arm bone running from the wrist (near the base of the thumb) to the elbow. The string nearest the little finger is called the *ulnar* string, in reference to the ulna arm bone running from the wrist (near the base of the little finger) to the elbow. Although the terms *radial* and *ulnar* can oftentimes be replaced with the terms *near* and *far,* respectively, the substitution fails when the fingers or hands are not held vertically. By adding the designations *right* and *left,* one can precisely identify any one of the twenty possible strings which exist when a loop encircles each finger, i.e., *left radial little finger string, right ulnar thumb string.*

When two loops occur on the same finger, the loop nearest the base of the finger is called the *proximal* loop, whereas the loop nearest the tip of the finger is called the *distal* loop. These terms can also be applied to the individual strings of such loops, i.e., the distal radial index strings or the proximal ulnar thumb strings. Although the terms *proximal* and *distal* can oftentimes be replaced with *lower* and *upper,* respectively, the substitution fails when the fingers or hands are not being held vertically. The terms *radial, ulnar, proximal,* and *distal,* can also be used to specify regions of space which surround a given loop or string. In all cases, the terms are defined relative to the finger bearing the loop or string in question.

The terms *proximal* and *distal* can also be used to specify the direction in which a finger is inserted into a loop. Thus, a finger inserted proximally enters the loop from the side nearest the base of the finger. A finger inserted distally enters from the side nearest the tip of the finger. Although the terms *proximally* and *distally* can oftentimes be substituted with the phrases *from below* and *from above,* respectively, the substitution fails when the fingers or hands are oriented in positions other than vertical. This is especially true of loops maintained on bent fingers so that the fingertip is nestled in the palm: entering such a loop distally means that the loop is entered from the fingertip side, as defined by the finger carrying the loop is question, and not from above, relative to all the strings.

Occasionally a string will pass horizontally across the entire palm, or across the fingerprint side of a given finger. Such a string is referred to as a *palmar* string. A string passing horizontally across the back of the hand, parallel to the knuckles, is called a *dorsal* string.

A string passing from the finger of one hand directly to the same finger on the opposite hand is called a *transverse* string. Transverse strings often constitute the framework of a final pattern. Occasionally, a string running horizontally across the center of an unfinished pattern is also called a transverse string.

String Figure Commands

Release: This command indicates that all loops held on a given finger should be allowed to slip off. Thus, the command to release indices specifies that all loops encircling the index fingers should be dropped.

Pick up and hook back: String figures are formed by drawing designated strings through designated loops until the desired pattern emerges. In the process of drawing a string through a given loop, the string is first retrieved by a specified finger. This can be done in one of two ways. The command to pick up indicates that the finger is passed proximal to the specified string, which is then taken up on the backside (fingernail side) of the finger, thus creating a loop. The straightened finger is then returned to its position, carrying the string on its back.

The command to hook back means that the finger is passed distal to the specified string, which is then taken up on the palmar side (fingerprint side) of the finger. The bent finger is then returned to its original location, carrying the string in the crook of the finger, thus creating a loop. Both the pick up command and hook back command are oftentimes replaced by a phrase which includes the terms *insert* and *return with.* Instructions reading, "insert indices proximally into little finger loops and return with radial little finger strings" are equivalent to "pick up radial little finger strings with indices."

Frequently, two fingers of the same hand are required to retrieve a given string. In such instances, the string is pinched firmly between the tips of the specified fingers and drawn through any intervening loops as the fingers are returned to their original position. The string is placed on the back of one of the two fingers by straightening the fingers with a pivot about the knuckle, so that the fingertip traces out a 180-degree arc. Such a pivoting action is referred to as a half turn rotation. Half turn rotations can be carried out in the radial direction (towards you) or in the ulnar direction (away from you).

Navaho: This command indicates a rather mechanical way of drawing one loop through another loop on the same finger. The proximal loop is lifted

over the distal loop with the aid of the opposite hand and allowed to slip off the finger entirely. The action is then performed on the opposite hand. This technique is common among the Navaho Indians of Arizona, hence the name.

Transfer: Occasionally certain fingers bearing loops must be freed in order to perform subsequent movements. The loops are therefore transferred to other fingers. In all cases, it is important that the fingers to which the loops are being transferred are inserted from the proper side, either proximally or distally. Loops transferred to fingers already bearing loops should be kept distal to and well separated from the original loops after the transfer is complete.

Exchange: This command indicates that right- and left-hand loops of a given finger are traded, so that one loop passes through the other. This is most readily accomplished by transferring one loop to the same finger of the opposite hand, and then using the free finger to retrieve the proximal loop of the opposite finger. The direction from which the loop is entered is important, as specified in the text.

Extend: This command indicates that the hands are separated as far as possible, so that the strings are drawn taut. This is oftentimes the last step in the construction of a figure.

Twisting loops: A twist is created in a loop by pivoting the finger from the knuckle, so that the fingertip traces out a 360-degree arc. To twist a loop in the radial direction, the finger is first passed towards you, then towards the elbow, then away from you, then finally away from the elbow. To twist a loop in the ulnar direction, the process is performed in the reverse order. Care must be taken not to catch any intervening strings in the process.

Closing a loop to the palm: Oftentimes it is necessary to secure a loop to prevent its slipping off a finger while other movements are being performed. This is best accomplished by bending the loop-bearing finger at the second joint, nestling its fingertip in the palm of the hand. This position is frequently assumed when strings have been retrieved by hooking back.

Katilluik: The *katilluik* maneuver is a series of movements in which thumb loops are combined prior to drawing strings through them. The term itself is an Eskimo word meaning "put two things together," and was first described by Jenness (1924:12B). The katilluik maneuver requires thumb loops and index loops and is performed as follows:

The thumb loop of one hand is transferred to the thumb of the second hand by inserting the second thumb proximally and withdrawing the first thumb. The identity of the "first" and "second" thumb, i.e., right or left, depends on the individual figure and is specified in the text. The first thumb is then inserted proximally into both loops of the second thumb, so that two loops now encircle each thumb. The radial index strings are then drawn through both sets of thumb loops by inserting the thumbs proximally (or occasionally distally, as specified in the text), and returning through the thumb loops with the radial index string, so that the original thumb loops slip off entirely. Releasing the indices completes the katilluik maneuver.

Dissolving a figure: Undoing a complex string figure can create a mass of tangles if done improperly. Most string figures are best dissolved by laying the figure on a flat surface and pulling in opposite directions on the upper and lower transverse strings which make up the framework of the figure.

Commonly Used Openings

POSITION I

1. Place loop on thumbs.
2. Insert little fingers proximally into thumb loop and return with ulnar thumb string.

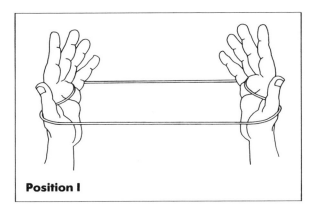

Position I

OPENING A

1. Position I.
2. Pick up left palmar string with right index.
3. Insert left index finger distally into right index loop. Pick up right palmar string and return through right index loop.

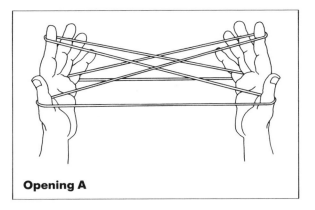

Opening A

OPENING B

1. Place loop on thumbs.
2. Insert left index proximally into thumb loop and return with left ulnar thumb string. You now have a short string passing between the left thumb and index.
3. Bring hands together and pass right index distal to the short string described above. Hook back this string with the right index. Rotate the right index half a turn in the ulnar direction in order to place the string on the back of the finger.

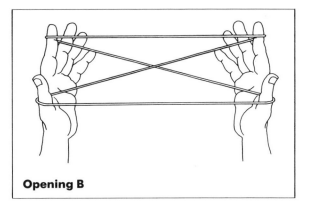

Opening B

Those readers who desire detailed illustrations of the movements described above are referred to Jayne's classic volume, *String Figures and How to Make Them* (Jayne 1906; reprint, New York: Dover, 1962).

KWAKIUTL STRING FIGURES

Soviet ethnologist Julia Averkieva at age 23, soon after her return from Vancouver Island. Averkieva would eventually become Director of North American Studies at the Moscow Institute of Ethnography, Academy of Sciences, USSR, and editor-in-chief of the internationally known journal *Sovetskaia Etnografiia*.

Introduction by Julia Averkieva

The following collection of string figures was made at the suggestion and with the constant help of Professor Boas during a four-months' field trip among the Kwakiutl Indians of Fort Rupert in the winter of 1930. The game is not played extensively at the present time, but the variety of string figures still known indicates how important these were at one time. According to the statements made by various natives, string figure making was a favorite pastime among the younger people about twenty years ago [c. 1910]. In the winter, young men were wont to gather in groups and spend entire evenings going from house to house, strings in hand, competing with each other and with their hosts in the facility with which they executed and varied the designs of their figures. The winner usually blew his string in the face of the defeated. The girls likewise spent their evenings making figures, as well as learning and inventing new ones. String figure making ability was even used as a test of intelligence and good memory; the ease with which one learned a new figure and the greater number one remembered, the more intelligent one was judged to be. Possibly, these figures were even used by some as a method for memory training.

Perhaps at still earlier times the figures possessed more significance. Names such as "Paddling under Coppermaker," "Sisiutl," "Two Ghosts," and "Daylight Receptacle" strongly suggest a relationship between these figures and the mythology and beliefs of the people. The fact that most of the figures are accompanied by a chant or a short story often related to myths may prove that the figures were at one time more than a mere pastime for the people who made them.

As far as I could see, there were no superstitious beliefs connected with their making. This does not, however, exclude the possibility of their existence at a much earlier time. As the string figures themselves are gradually disappearing, so might the beliefs connected with them have disappeared at a much earlier time. At the present time, string figures are known only to the older people. I know of only two young people, little girls from ten to twelve years of age, who knew some of the more simple figures. The games are not restricted to either sex; both men and women are equally dexterous with the string.

In general, the figures represent both natural and artificial objects in a state of rest or motion. Each figure is named after an object which it seems to resemble. The figures can be classified into four groups, according to the subject they depict. The first and largest of these groups is that of animal forms. Almost every animal familiar to the native is depicted in a string figure: the bear, deer, porcupine, mink, elk, and salmon are the most commonly represented. It is striking that no figure suggests a wolf, considering the significance the wolf has in the mythology and beliefs of the people. There is a figure which corresponds exactly to the Eskimo "wolf" but bears the name "porcupine," the figure resembling the porcupine figure made by the Klamath Indians. The second group of figures represents people in everyday activities, such as pulling a line in halibut fishing, getting bait, digging clams, and men fighting. The third group represents objects of everyday use and also natural phenomena such as kelp, mountains, canoes, fire-drills, walking sticks, and ships, the latter being a representation of the white man's ship. The fourth and final group contains three figures which are related to the mythology of the Kwakiutl Indians. These are "sisiutl,"

"two ghosts," and "daylight receptacle." The last figure is accompanied by a story which connects it with the myth "Stealing the Sun."

An extensive collection of general literature on string figures exists at the present time. They have been recorded from all parts of the world. Good collections have been made in the South Sea Islands, Africa, and among the Eskimos of Arctic America. Data from Australia, Asia, and Europe is rather scarce, however. Several figures have been recorded from various Indian tribes of [North] America, but they are accidental and cannot be very characteristic. The first mention of Kwakiutl string figures was made by Dr. Boas in 1888 after his first visit among these Indians (Boas 1888c). One of them is described in Mrs. Jayne's book as "Threading a closed loop" (Jayne 1906:354). I have also included this figure in my collection.

Besides general literature on the technique of string figure making in various areas, Miss Haddon has made an attempt at generalization and analysis of existent material (K. Haddon 1930). Her conclusions are quite interesting, and more sufficient material from all parts of the world may bear them out. Miss Haddon considers string figure making as a form of art, and approaches its analysis from the standpoint of the general development of art.

At the present time, most investigators believe in the accidental and spontaneous origin of string figures in the various areas where they are found. According to Miss Haddon, "string figures have a very early origin and are based on chance resemblance" (K. Haddon 1930:139). The proof of this assertion may lie in the world-wide association figures have with mythology and magic. Thus, Jenness states concerning Papuan figures, "Some of the figures appear to be connected with magic. . . . Whenever a vegetable was stolen, people would employ a string figure to discover the thief. . . . Another figure, *buibui*, was performed only when clouds seemed to prophesy fine weather" (Jenness 1920:301). According to Jenness and other investigators of Eskimo culture, the Eskimos believe in the spirit of string figures (Jenness 1924:182B). They are

only played at a particular time of the year when the sun is not out. John White tells us concerning the Maori string figures, "Some of the figures made in this game are said to have represented occurrences in the mythology of the race, such as, the making of *tiki-ahua*, the birth of the gods, the descent of *hine-titama* to the underworld, *Maui* procuring fire, and many other exploits of Maui." As to the origin of the Maori figures, Andersen makes the following statement: "Their origin is in a myth accredited to Maui, one of the old heroes, demigods, or personifications so loved by primitive man" (1927:2). The few instances given here may indicate the importance string figures have had in the culture of many peoples. Chanting and story-telling as an accompaniment to string figures is almost universal. At the present time, however, string figures are merely described as a form of play by the natives.

Dr. Haddon has classified all figures into two groups—Asiatic and Oceanic (Jayne 1906:xii). Holding to this classification, the Kwakiutl figures can be placed in the Oceanic group, to which belong the figures of America and the South Sea Islands. The majority of them are made by one player, except for two figures and two tricks in which a partner is required. In one case, the toe is used as supplementary to the fingers, and in three other cases, the teeth are employed.

The majority of figures recorded from other parts of the world bear animal names; the rest are named after objects of everyday use and the various activities of the natives. A comparison of the Kwakiutl figures with figures from other parts of the world reveals a close relationship to those of the Eskimo (Jenness 1924); and as far as can be judged from the few figures recorded, they also bear relationship to the figures of the Klamath Indians (Jayne 1906). On account of the lack of data, it is difficult to trace relationships with other parts of America. Frachtenberg in his "Alsea Texts and Myths" (1920:211) gives the names of several figures played by the natives, but he gives no description or plates. The names are very much like those used by the Kwakiutl, but it is impossible to trace any further

relation until more sufficient data are presented.

It is evident that string figures are a common phenomenon among all American Indian tribes, but only one more or less complete collection has been made—that of the Eskimo by Jenness (1924). On comparison, as we have said before, we find a number of similarities between these figures and the Kwakiutl. Many of the figures are common to both regions, as for instance, the "fire-drill," "meeting of two brothers-in-law," "killerwhales," etc. Some figures have different names, but are produced by the same movements, such as the Eskimo "Siberian House" (LX, p. 73B), and the Kwakiutl two dogs [73], or the Eskimo "Kayaker" (CXXXVI, p. 155B) and the Kwakiutl Paddling Coppermaker [21], or the Eskimo "Arms" (XXXI, p. 41B) and the Kwakiutl Sisiutl [48], etc. The most popular figure in both regions is the one depicting a bear. The pattern representing it is common, but the movements required to produce the pattern are entirely different. There are also several tricks common to both areas. Evidently, a close relationship existing between the two regions has influenced their string patterns.

The Kwakiutl string figures also bear resemblance to those of Hawaii. This is the only region which has an opening corresponding to the Kwakiutl Opening B. There are three figures common to these areas: The Kwakiutl Killerwhale [82] and the Hawaiian "Hermaphrodites" (Dickey 1928:133) as well as "The Ghost of Ngivae" (Raymund 1911:52) from the Caroline Islands; the Kwakiutl Digging Clams [91] and the Hawaiian "Hermaphrodites" (Dickey 1928:135), and the Kwakiutl Pulling the Line in Fishing Halibut [95] and the Hawaiian "Two birds flying" (Dickey 1928:165). But the latter figure is recorded from almost every part of the world. Two other figures which are considered universal are also met with among the Kwakiutl; The Devil Fish [80], and Two Devil Fish [37].

In this paper, the figures are classified by the opening employed and subclassified based on similarities in subsequent manipulations of the string. The simplest and most common are given first.

[The remainder of Averkieva's Introduction consists of nomenclature for construction of the string figures. Rather than selecting the precise anatomical terminology developed by Rivers and Haddon for the purpose of recording string figures (Rivers and Haddon 1902), Averkieva preferred the simplified, non-technical terminology used by Jayne (1906). Unfortunately, Averkieva's descriptions lack the detail necessary to permit accurate reconstruction of the figures by the average string figure enthusiast. Since I have taken the liberty of transcribing all of Averkieva's descriptions into the more precise anatomical nomenclature devised by Rivers and Haddon, Averkieva's rendition of Jayne's simplified nomenclature has been omitted. The text continues with Averkieva's concluding remarks on the methods most frequently used by the Kwakiutl in making their figures—M.A.S.]

The Most Frequently Used Movements

1. Holding the hands with palms facing each other, fingers upward or away from the player.
2. Bringing the hands together for the taking of loops or strings by one hand from another, or exchanging loops and strings.
3. Separating the hands in order to extend the patterns.
4. Passing the thumbs away from you, bending the thumbs toward each other and restoring them to their original position.
5. Bending the thumbs downward, away from the player, and returning them back.
6. Pointing the indices toward the center, so as to catch a certain string from a finger of the other hand, and returning them.
7. Pointing the indices toward the player, in order to take a string from the thumbs, [and] returning them.
8. Passing the indices away from the player, and returning them to their original position.

9. Bending the middle fingers toward the player, toward the middle of the figure, i.e., toward each other, and away from the player, downward, and restoring them with the new loops or strings on them.

10. Almost all manipulations in producing a figure are produced by these movements of the thumbs, indices, and middle fingers.

11. The ring and little fingers are used only for closing some strings against the palms; for that purpose they are hooked over the strings and firmly closed to the palms, and usually remain in this position throughout the process of making the figure; or sometimes they are straightened, so as to release the strings held under them and to hook them over new ones.

12. Sometimes the indices and middle fingers are moved together, so as to take between their tips some particular string.

[Averkieva then proceeds directly to the string figure descriptions—M.A.S.]

String Figure Construction Methods

1. The "Fire Drill" Series

Loop size: small

This is one of the most popular figures among the Kwakiutl Indians of Northern Vancouver Island, and it seems equally popular among the Eskimo. Both groups know many ways of making it. One of the simplest methods, common to both groups, is given below. Other methods are described later according to their various openings [69c, 98].

1. Opening B.

2. Insert middle-ring-little fingers into index loops proximally. Close radial index strings to the palms.

3. Draw radial thumb string through index loops as follows: Insert middle fingers distally into thumb loops. Grasp radial thumb string between the tips of the index and middle fingers, and return through index loops. Place the loop on the backs of the indices by rotating indices half a turn in the ulnar direction. Release thumbs and extend. You have a two-diamond pattern.

4. Transfer index loops to middle fingers, inserting middle fingers distally.

5. Transfer right middle finger loop to the left middle finger, inserting the left finger distally. Straighten the ring and little fingers, and transfer right ring-little finger loop to left ring and little fingers, inserting them distally, thus freeing the right hand.

6. Transfer middle finger loops of left hand to the four fingers of right hand as follows: Pass right hand to the ulnar side of the left middle finger loops, and insert the four fingers of the right hand proximally into both left middle finger loops. Close both ulnar middle finger strings to the right palm, releasing left middle finger.

7. Transfer the two left ring-little finger loops to the left thumb, inserting thumb distally.

8. Close both ulnar left thumb strings to the palm by inserting the four left-hand fingers distally into the left thumb loops.

9. Insert the right thumb distally into the loops encircling the four right-hand fingers. Extend the pattern by pointing fists away from you, widening the double loops with the thumbs. You have a Fire Drill (A$^{\varepsilon}$no) [1a]. Expand and contract the triangle in the center of the figure by alternately twisting the forearms so that wrists face up, then down.

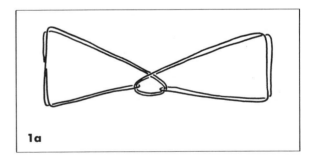

1a

A story is told with this figure. A second person inserts his index into the triangle formed at the center of the figure. He is then asked:

"What do you come for?"
He answers, "I come to get some fire."
"Go and get the stick," he is told.

At this point, the index is taken out of the triangle. The partner licks his index and inserts it again into the triangle. He is asked:

"Why is there grease around your mouth?"
He replies, "Because I ate some salmon with the grease."
"What was the basin you ate from?" he is again asked.
"Oh, it was a wooden dish," he answers.
"Where was the dish standing when you were eating?"
"Oh, it was standing on the floor on a little old mat."
"Where did you get the salmon?"
"I took it from my grandmother. She had it soaking."
"Oh, then it's you who stole the salmon from the old woman!"

With that, the triangle is tightened and the index finger of the partner is caught in it.

The following chant was also recorded:

aᵉno'
ᵉmā'sas q!ă'ldzExstālag·iɫaōs
t!ēɫt!āɫdEnʟax t!ē'ɫas ɫEk!wā'neᵉ
sō ᵂᵉmaëɫ hai'x·ᵉidExEn t!āɫtleɫaxa
g·îlōʟaxEn t!āɫt!ēɫaxda qaᵉs ᵉwŭ'nx·g·iäᵉlsē
"Fire drill"
Why have you grease running down from your mouth?
I ate the the old woman's soaked salmon.
So you are the one who is eating my soaked salmon, stealing it and hiding it on the ground.

10. Use left thumb and index to separate the two right thumb loops. Pass left index between the two right radial thumb strings, and hook up the double ulnar strings emerging from the fist near the right little finger. Release right hand.

11. Transfer left index loops to right thumb, inserting thumb distally. Close both right ulnar thumb strings to the palm, inserting the four right-hand fingers distally. Extend the figure as before. You have another Fire Drill [1b]. The

1b

double vertical string at the center of the figure can be made long and short by twisting the forearms back and forth, so that as one wrist faces up, the other faces down.

ANALYSIS: [1a], [69c], [98]

Identical patterns: (P17)

Bering:	+	Mouth	(Jayne, fig. 652)
	−	Trap	(Gordon, p. 93)
Nunivak:	?	*Tkulu'ŋax Nuŋi'kulu'ŋax* (archaic)	(Lantis, 22)
N. Alaska:	−	Little Finger	(Jenness, XV)
Mackenzie:	−	Anus	(Jenness, XV)
W. Copper:	−	Anus	(Jenness, XV)
E. Copper:	(−)	Anus	(Rasmussen, 26)
Caribou:	(−)	Anus	(Birket-Smith, p. 279)
Netsilik:	−	Mouth	(Mary-Rousselière, 54)
Iglulik:	(−)	Mouth	(Mathiassen, p. 222)
	−	Mouth	(Mary-Rousselière, 54)
	−	Like a Mouth	(Paterson, 17)
Polar:	−	Like a Mouth	(Paterson, 17)
	(−)	Mouth	(Holtved, 45)
Bella Coola:	+	Fire Seeker	(McIlwraith, VIII)
Finland:	+	*Liikkuva Suu*	(Jättiläinen, p. 372)

Both the Eskimos and the Kwakiutl know many ways of producing this pattern and are delighted when they are able to create it while dissolving an unrelated figure. Averkieva recorded three distinct methods for producing this pattern [1a, 69c, 98], none of which matches the four methods recorded by Jenness. Of the three Kwakiutl methods, the method used to produce [1a] is identical to the Topek Eskimo method recorded by Jayne; the other two have not been recorded elsewhere. It is unclear whether the identical method from Finland is a traditional method or one learned from Jayne's book.

As expected, the Bella Coola figure is identical in

method and bears a related title. The story accompanying that figure is basically the same as the Kwakiutl story, except for the notion that the person who inserts his finger in the center triangle is seeking embers for his extinguished fire. After the initial request is made by the second person, he is asked to fetch something for carrying the coals, at which point he temporarily withdraws his finger. He then licks his finger and re-inserts it into the triangle, and explains that during his return journey, he stopped to eat some human grease. The interrogation and subsequent "trapping" then continues along the same lines as the Kwakiutl story.

ANALYSIS: [1b]

This figure, a continuation of [1a], has not been recorded elsewhere.

2. Mā'sLasʟEmēki

Loop size: small

1. Opening B.
2. Insert middle-ring-little fingers into index loops proximally. Close radial index strings to the palms.
3. Draw radial thumb string through index loops as follows: Insert middle fingers distally into thumb loops. Grasp radial thumb string between the tips of the index and middle fingers, and return through index loops. Place loop on the backs of the indices by rotating indices half a turn in the ulnar direction. Release thumbs and extend. You have a two-diamond pattern.
4. Pick up radial index string at its midpoint with teeth. Release ring and little fingers. Separate hands as far as possible.
5. Bring hands together as far as possible from the mouth. Transfer right index loop to right little finger by passing right little finger proximal to

right index loop and returning with radial index string. Release right index.
6. Transfer left index loop to right index, inserting index distally.
7. Transfer mouth loop to four fingers of left hand, inserting left hand proximally. The vertical figure at the center of the pattern slides to the right as the hands are gradually separated. You have Mā'sLasʟEmēki [2].

The last movement is accompanied by a song:

mā'sLasʟEmēʾki
ᵋmā'saᵋmäL!EslEmēgʸi
qǎ'nkwiyōliɬ qaᵋs dā'ɬᵋLyoqwᵋliɬeᵋ
What will you do?
What is in front of the house?
Your forehead wrinkles as you squint to gaze at it.

2

ANALYSIS: [2]

Identical pattern:

 Bella Coola: + An Old Woman (McIlwraith, XII)

The Bella Coola chant is as follows:

"Where are you going, old woman?"
"I am going to seek food at the bottom house."
"Be careful, lest you fall down as you go towards River's Inlet."

At this stage, the Bella Coola release a little finger and the "old woman falls down."

The Bella Coola method of construction is the same as the Kwakiutl method except that the figure is transferred to the left hand rather than the right

prior to releasing the mouth string. The Bella Coola also close a middle finger over the "old woman" to prevent her from sliding across the figure until the appropriate moment.

3. The Bear (Laε)

Loop size: small

This is one of the most popular figures among the natives. It was taught to me by Mrs. George Hunt, an old Indian woman.

1. Opening B.
2. Insert middle-ring-little fingers into index loops proximally. Close radial index strings to the palms.
3. Draw right ulnar index string through left index loop as follows: Insert left index distally into right index loop. Return through left index loop with right ulnar index string, allowing original left index loop to slip off.
4. Draw left radial index string through left thumb loop as follows: Insert left thumb proximally into left index loop. Return through thumb loop with left radial index string.
5. Release left index. Release right thumb and extend. You have The Bear [3]. The bear walks to the left by pulling the right hand loop.

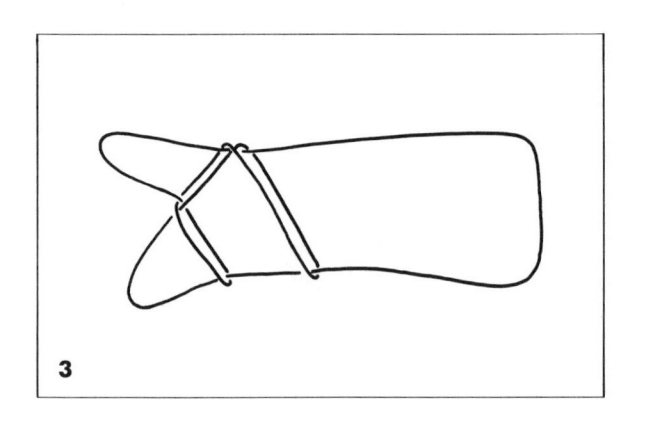

3

ANALYSIS: [3], [6b], [78], [79]

Nearly identical patterns except for minor differences in string crossings: (P9)

N. Alaska:	–	Dog	(Jenness, XCV)
Mackenzie:	–	Fox	(Jenness, XCV)
W. Copper:	–	Fox	(Jenness, XCV)
Caribou:	?	Brown Bear	(Birket-Smith, fig. 104a)
Netsilik	–	Fox	(Mary-Rousselière, 14)
Iglulik:	(–)	Fox	(Mathiassen, p. 222)
	–	Fox	(Paterson, 9)
Polar:	–	Dog	(Paterson, 9)
W. Greenland:	–	Dog	(Paterson, 9)

According to Jenness, this figure is one of the most popular Eskimo patterns. It is often encountered as the first pattern in a series (see Jenness, XCVI through C). As with the Fire Drill [1a, 69c, 98], there are many ways of producing this pattern. The Kwakiutl know four methods [3, 6b, 78, 79], and Mary-Rousselière was able to record five methods among the Netsilik, none of which duplicates the Kwakiutl methods.

The naming of this pattern is very curious. When formed on one side of the figure as the opening pattern in a series, the Eskimos call it a Dog or Fox (the Caribou Eskimo is an exception). However, when formed in duplicate, the title of Brown Bear is adopted (see Kwakiutl [52] and the distribution therein). The same also applies when the pattern appears in a more complex figure or when it is produced as a dissolution figure, but only in Alaska and adjacent territories:

N. Alaska:	A Man Chewing, who dissolves into the Brown Bear	(Jenness, LXXXVI)
	Brown Bear and the Shaman	(Jenness, VII)
	The Brant, which dissolves into the Brown Bear	(Jenness, CII)

Mackenzie:	Brown Bear Issuing from a Cave	(Jenness, III)
N. Alaska:	Brown Bear's Pack	(Jenness, CXVII)
Mackenzie:	Brown Bear's Pack	(Jenness, CXVII)

Other Eskimos retain the names Fox or Dog for their dissolution patterns (see Paterson, 61b; Jenness, XXXV, LXIV, and XCVIIA, B, C). Alaskan and Kwakiutl titles probably share a common origin.

4. The Porcupine

Loop size: small

This figure is a continuation of The Bear [3].

1. Opening B.
2. Insert middle-ring-little fingers into index loops proximally. Close radial index strings to the palms.
3. Draw right ulnar index string through left index loop as follows: Insert left index distally into right index loop, and return through left index loop with right ulnar index string, allowing original left index loop to slip off.
4. Draw left radial index string through left thumb loop as follows: Insert left thumb proximally into left index loop, and return through thumb loop with left radial index string.
5. Release left index. Release right thumb and extend. Return hands to upright position.
6. Draw left thumb loop through the center of the bear as follows: Insert left index-middle fingers distally between the "legs" of the bear pattern. Pass these fingers proximal to the double strings that cross the left thumb loop, then insert them proximally into left thumb loop. Hook back the left radial thumb string. Place the new loop on the backs of the left index-middle fingers by rotating them half a turn in the ulnar direction. Release left thumb. Turn hands away from you and extend loosely.

7. Draw the double strings that cross the left index loop around the lower transverse string as follows: Pass left thumb proximal to lower transverse string and insert proximally into left index-middle finger loop. Rotate thumb a full turn in the ulnar direction, catching the double strings that cross the left index loop. (In order to get a good final extension, the strings must be kept loose in steps 7 through 9.)
8. Transfer left thumb loops to left index as follows: Withdraw left index only from the loop encircling it, and transfer left thumb loops to left index, inserting index proximally.
9. Pass left thumb through left index loops distally; then insert into left middle finger loop proximally. Return with radial middle finger string.
10. Release left index and middle finger and extend. You have The Porcupine [4]. Produce the movements of the porcupine by see-sawing the hands as described in step 11 of the Fire Drill [1].

ANALYSIS: [4]

Identical patterns: (P151)

| Caribou: | (–) | Man Kneeling | (Birket-Smith, fig. 104e) |
| Netsilik: | – | Hunter Approaching a Seal on Ice | (Mary-Rousselière, 77) |

The Kwakiutl form this pattern by continued manipulation of the bear [3], whereas the Central Eskimos form it de novo using an unrelated method. Based on its limited distribution, this figure appears

to be subject to independent invention. The Kwakiutl name of Porcupine is obviously based on this figure's resemblance to [59].

5. The Goose

Loop size: small

This figure is a continuation of The Bear [3] similar to The Porcupine [4].

1. Opening B.
2. Insert middle-ring-little fingers into index loops proximally. Close radial index strings to the palms.
3. Draw right ulnar index string through left index loop as follows: Insert left index distally into right index loop, and return through left index loop with right ulnar index string, allowing original left index loop to slip off.
4. Draw left radial index string through left thumb loop as follows: Insert left thumb proximally into left index loop. Return through thumb loop with left radial index string.
5. Release left index. Release right thumb and extend. Return hands to upright position.
6. Draw left thumb loop through the center of the Bear as follows: Insert left index-middle fingers distally between the "legs" of the bear pattern. Pass these fingers proximal to the double strings that cross the left thumb loop, then insert them proximally into left thumb loop. Hook back the left radial thumb string, and place the new loop on the backs of the left index-middle fingers by rotating them half a turn in the ulnar direction. Release left thumb. Turn hands away from you and extend loosely.
7. Draw the double strings that cross the left index loop around the lower transverse string as follows: Pass left thumb proximal to lower transverse string and insert proximally into left index-

middle finger loop. Rotate thumb a full turn in the ulnar direction, catching the double strings that cross the left index loop. (In order to get a good final extension, the strings must be kept loose in steps 7 through 9.)

8. Withdraw left middle finger only from the loop encircling it. Draw left radial index string through both left thumb loops as follows: Insert left thumb proximally into left index loop and return through both left thumb loops with left index string.
9. Release left index and extend. You have The Goose [5]. Produce the movements of the Goose by see-sawing the hands as in step 11 of the Fire Drill [1]. Release the left thumb, and the figure will disappear.

5

ANALYSIS: [5]

The Kwakiutl Goose [5] is a slight variation of the Kwakiutl Porcupine [4] and differs from the latter in that the half twists in the left thumb loops are retained prior to drawing through the left index loop (step 8). It has not been recorded elsewhere.

6. The "Bear and His Den" Series

Loop size: small

1: Opening B.
2. Insert middle-ring-little fingers into index loops

proximally. Close radial index strings to the palms.

3. Draw right ulnar index string through left index loop as follows: Insert left index distally into right index loop. Return through left index loop with right ulnar index string, allowing original left index loop to slip off.

4. Draw left radial index string through left thumb loop as follows: Insert left thumb proximally into left index loop. Return through thumb loop with left radial index string.

5. Release right index. Insert distally into left index loop. Return with left ulnar index string.

6. Release left index and right thumb. You have The Bear's Den [6a].

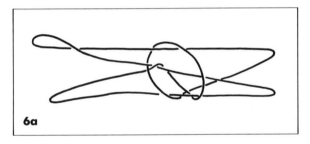

6a

7. The bear can be seen walking from his den as follows: Release right index. Enlarge right hand loop by inserting right thumb distally, returning with the radial string of this loop. Draw strings tight and extend. You have The Bear [6b]. Releasing the left thumb causes the bear to disappear.

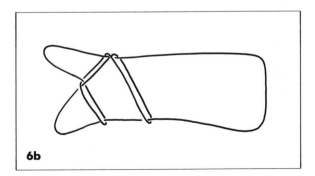

6b

The following chant is recited with the figure:

gîluɬts!âliɬgʹada L!ēkʹ lāʼxgʹas L!Eʼnyats!ēkʹ
Bear walks out of his den.

ANALYSIS: [6a]

The Kwakiutl Bear's Den figure [6a] is actually nothing more than an intermediate pattern which arises by introducing an additional step into the method used in constructing the Kwakiutl Bear [3]. Release of the extra loop created as a result of the added step then gives the Bear [3] as a dissolution figure. This variant has not been recorded elsewhere, although Jenness observed a figure of similar title and action among the Mackenzie Eskimos (Brown Bear Issuing from a Cave, Jenness, III; Paterson, 24; Mary-Rousselière, 9).

ANALYSIS: [6b], see [3]

7. The "Elk" Series

Loop size: medium

Although not many people knew this figure, its shape was not unfamiliar to them.

1. Opening B. Keep the strings loose throughout steps 2–5.

2. Insert middle-ring-little fingers into index loops proximally. Close radial index strings to the palms.

3. Draw right ulnar index string through left index loop as follows: Insert left index distally into right index loop. Return through left index loop with right ulnar index string, allowing original left index loop to slip off.

4. Draw left radial index string through left thumb loop as follows: Insert left thumb proximally into left index loop. Return through thumb loop with left radial index string.

5. Release right index. Insert distally into left index loop. Return with left ulnar index string.

6. Draw right ulnar index string through left thumb loop as follows: Withdraw left middle finger from the loop encircling it, and insert it proximally into left thumb loop. Continue by inserting left middle finger proximally into right index loop and hooking back right ulnar index string. Return through left thumb loop, and close the new loop to the left palm.

7. Release the right thumb and extend. Release right index and left thumb, but do not extend. Enlarge the right hand loop by inserting the right thumb distally into the right ring-little finger loop and returning with the radial string. Extend. You have An Elk [7a].

7a

8. Release right thumb. Transfer left index loop to right thumb, inserting thumb proximally. Extend. You have Two Little Elks Lying [7b].

7b

9. Transfer left middle finger loop to left thumb, inserting thumb distally.

10. Exchange the thumb loops as follows: Transfer right thumb loop to left thumb, inserting left thumb distally. Transfer proximal left thumb loop to right thumb, over distal loop, inserting right thumb distally. Extend. You have The Dog [7c].

7c

11. The dog can be made to walk by releasing right thumb and pulling right-hand loop.

ANALYSIS: [7a]

Nearly identical patterns, but distinctly different: (P2)

Chukchi:	– Hare	(Jenness, XXVI)
Bering:	– Hare	(Jenness, XXVI)
N. Alaska:	– Hare	(Jenness, XXVI)
Mackenzie:	– Hare	(Jenness, XXVI)
W. Copper:	– Hare	(Jenness, XXVI)
E. Copper:	(–) Hare	(Rasmussen, 35)
Caribou:	(–) Hare	(Birket-Smith, p. 279; Jenness, XXVI [Boas])
Netsilik:	– Hare	(Mary-Rousselière, 12)
Iglulik:	– Hare	(Mathiassen, p. 222; Paterson, 2)
Polar:	– Hare	(Paterson, 2)
W. Greenland:	– Hare	(Paterson, 2; Holtved, 1)

Nearly identical patterns, but distinctly different: (P7)

Bering:	—	Caribou	(Gordon, fig. 15)
N. Alaska:	—	Hare	(Jenness, XXIV)
Mackenzie:	—	Caribou	(Jenness, XXIV)
W. Copper:	—	Caribou	(Jenness, XXIV)
E. Copper:	(−)	Caribou	(Rasmussen, 15)
Caribou:	(−)	Caribou	(Birket-Smith, p. 279)
Baffinland:	(−)	Caribou	(Jenness, XXIV [Boas])
Netsilik:	—	Caribou	(Mary-Rousselière, 1)
Iglulik:	—	Caribou	(Mathiassen, p. 222; Paterson, 7)
Polar:	—	Caribou	(Paterson, 7; Holtved, 7)
W. Greenland:	—	Caribou, Reindeer	(Paterson, 7; Hansen, 1)
Naskapi:	(−)	Rabbit	(Speck, 5)

The Kwakiutl Elk [7a] is constructed from intermediate steps used in forming The Bear [3]. It is similar in name and form to the widely distributed Eskimo figure known as The Caribou. Their methods of construction, however, are entirely unrelated. The Eskimo Hare figure is nearly the same as the Eskimo Caribou, except for subtle differences in string crossings. Likewise, its method of construction is entirely unrelated to the Kwakiutl Elk as well as the Eskimo Caribou. The Kwakiutl pattern has not been recorded elsewhere.

ANALYSIS: [7b]

Nearly identical patterns, but distinctly different: (P21a)

N. Alaska:	—	Brown Bear Carried It Away	(Jenness, CXVII)
Mackenzie:	—	Brown Bear Carrying a Pack	(Jenness, CXVII)
W. Copper:	—	Brown Bear Carrying a Pack	(Jenness, CXVII)
E. Copper:	(−)	The Amaut Troll	(Rasmussen, 11)
Caribou:	(−)	A Female Spirit (troll)	(Birket-Smith, 104c)
Baffinland:	(−)	One Carrying a Pack	(Jenness, CXVII [Boas])

Netsilik:	—	One Who Carries in Her Amaut	(Mary-Rousellière, 87)
Iglulik:	—	Animal Carrying a Load on Back	(Paterson, 21a)
Polar:	—	Animal Carrying a Load on Back	(Paterson, 21a)
	(−)	Woman with Child in Her Amaut	(Holtved, 4, 15)
W. Greenland:	—	Animal Carrying a Load on Back; Woman with Child in her Amaut	(Paterson, 21a)

The Kwakiutl Two Little Elks Lying [7b], a dissolution figure of The Elk [7a], also appears to be an imitation of a common Eskimo figure. Their string weavings and methods of construction are, however, entirely different. The Kwakiutl pattern has not been recorded elsewhere.

ANALYSIS: [7c]

The Kwakiutl Dog [7c], a dissolution figure of [7b], bears no resemblance to any known Eskimo figure and has not been recorded elsewhere.

8. The Mink

Loop size: small

This figure was known to all string figure makers. It was shown to me at Fort Rupert, but the natives of Newettee and Alert Bay also indicated a knowledge of it. It depicts the most popular hero in their mythology.

1. Opening B.
2. Insert middle-ring-little fingers into index loops proximally. Close radial index strings to the palms.
3. Draw right ulnar index string through left index loop as follows: Insert left index distally into right index loop. Return through left index loop with

right ulnar index string, allowing original left index loop to slip off.

4. Draw left radial index string through left thumb loop as follows: Insert left thumb proximally into left index loop. Return through thumb loop with left radial index string.

5. Release right index. Insert right index distally into left index loop. Return with left ulnar index string.

6. Release left index and right thumb. You have the Mink's House, which is the same as the Bear's Den [6a].

7. Widen left thumb loop as follows: Insert left index proximally into left thumb loop. Return with left ulnar thumb string.

8. Pass left thumb and index proximal to right radial index string. Grasp the right ulnar index string between tips of left thumb and index. Release right index. With tips of right thumb and index, grasp the left radial thumb string, lifting left thumb loop over loop held by left thumb and index. Allow the loops held by the thumbs and indices to slip onto the thumbs. Extend. You have The Mink [8].

8

ANALYSIS: [8]

The Kwakiutl Mink [8] bears no resemblance to any known Eskimo figure and has not been recorded elsewhere.

9. The Mink's House

Loop size: medium

This figure was learned in Alert Bay from a little girl about ten years old. It had probably been forgotten in Fort Rupert.

1. Opening B.
2. Insert middle-ring-little fingers into index loops proximally. Close radial index strings to the palms.
3. Draw the short radial index strings through the thumb loops as follows: Insert thumbs proximally into index loops. Return through thumb loops with radial index strings.
4. Withdraw middle fingers from their loops. Insert proximally, close to the thumb, into the small thumb loops. Draw middle fingers toward center of figure, carrying the thumbs' palmar strings on their backs, until behind the crossing of the ulnar index strings.
5. Draw each ulnar index string through its opposite middle finger loop as follows: With each middle finger, hook up the ulnar index string of the opposite hand, below the point of their crossing. Close the middle fingers to the palms.
6. Exchange thumb loops, inserting thumbs proximally, passing left loop through right. Extend.
7. Draw the short strings that cross the back of each middle finger through the thumb loops as follows: Insert thumbs distally into middle finger loops. Rotate thumbs a full turn in the ulnar direction, catching the short strings on backs of thumbs and drawing strings through the thumb loops, thus releasing the original thumb loops. Release middle fingers and extend.
8. Transfer new thumb loops to middle fingers, inserting middle fingers proximally. Close middle fingers to palms.
9. Widen middle finger loops with thumbs by inserting them distally and returning with radial

strings. Turn hands away from you to extend. You have The Mink's House [9]. Release index, ring, and little fingers, and the figure will disappear.

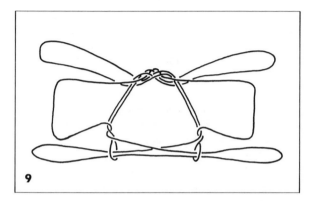

9

ANALYSIS: [9]

The Kwakiutl Mink's House [9] bears no resemblance to any known Eskimo figure and has not been recorded elsewhere.

10. The "Horse Clam" Series

Loop size: medium

This figure was learned in Fort Rupert from an old Indian woman. It was known to every string figure expert.

1. Opening B.
2. Insert middle-ring-little fingers into index loops proximally. Close radial index strings to the palms.
3. Draw the short radial index strings through the thumb loops as follows: Insert thumbs proximally into index loops. Return through thumb loops with radial index strings.
4. Withdraw middle fingers from their loops. Insert middle fingers proximally, close to the thumb, into the small thumb loops. Draw middle fingers

toward center of figure, carrying the thumbs' palmar strings on their backs, until behind the crossing of the ulnar index strings.

5. Exchange middle finger loops, inserting middle fingers proximally and passing right loop through left. Close middle fingers to the palms.
6. Release thumbs and extend tightly.
7. Widen middle finger loops by inserting thumbs distally and returning with the radial middle finger strings. At the same time, release indices and extend slowly. You have Horse Clams [10a]. Continue to extend the figure and observe the Horse Clams in Motion [10b]. Finally, the horse clams disappear.

10a

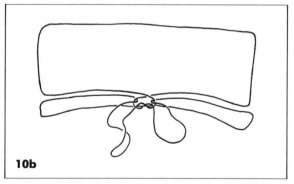

10b

ANALYSIS: [10a, 10b]

Identical patterns: (P68)

Siberia:	+	A Man Chewing; He Dropped It from His Mouth [10b only]	(Jenness, LXXXIV)
N. Alaska:	+	(intermediate stages of a Man Chewing) [10a, 10b]	(Jenness, LXXXVI)
	+	(intermediate stage of a Seal Net) [10b only]	(Jenness, LXXXVII)
Mackenzie:	+	Two Frozen Caribou Tongues [10b only]	(Jenness, LXXXIV)
	+	(intermediate stage of a Small Platter) [10b only]	(Jenness, LXXXV)
Netsilik, Iglulik:	+	She Who Has a Large Hairknot, Which She Undoes and Goes Off Searching for Moss [10a, 10b]	(Mary-Rousselière, 75)
Polar:	+	The Woman Knots Her Hair; Husband Gets a Caribou [10a, 10b]	(Paterson, 68)
	(+)	Hair Knotted in a Chignon, Undone at Night [10a, 10b]	(Malaurie, p. 159)
	(+)	Knotted Hair [10a only ?]	(Holtved, 49)
Bella Coola:	+	The Long Penis of the Raven [10a only]	(McIlwraith, VI)

Considering their widespread and sporadic distribution, figures [10a] and [10b] are either very old or are subject to independent invention. Their methods of construction are identical to the Kwakiutl method throughout. Several western Eskimo groups do not acknowledge these patterns as distinct figures, but rather as intermediate stages in the formation of more complex patterns.

Other groups acknowledge only one of the patterns as being a figure. The Bella Coola Indians moisten the long hanging loops of [10a] to make them stand erect and do not continue on to form [10b]. The Siberian Eskimos release the thumb and index loops simultaneously rather than sequentially (steps 6 and 7). Therefore, their initial figure is different from the Kwakiutl [10a].

Among the eastern Eskimos, the interpretation of knotted hair being undone is consistent throughout the region. Mary-Rousselière remarks that these figures are surely ancient, since the practice of knotting one's hair in a bun has long been out of fashion in this region. The strange title accompanying the Netsilik figure refers to a woman who prefers chores over grooming (moss is gathered for use as a wick in oil lamps).

11. The "Hunter's Bag" Series

Loop size: medium

This figure was shown to me in Fort Rupert. It was known to only one person there, although its shape was familiar to many others.

1. Opening B.
2. Insert middle-ring-little fingers into index loops proximally. Close radial index strings to the palms.
3. Draw the short radial index strings through the thumb loops as follows: Insert thumbs proximally into index loops. Return through thumb loops with radial index strings.
4. Withdraw middle fingers from their loops. Insert middle fingers proximally, close to the thumb, into the small thumb loops. Draw middle fingers toward the center of the figure, carrying the thumbs' palmar strings on their backs, until in front of the crossing of the ulnar index strings.
5. Exchange middle finger loops, inserting middle fingers proximally and passing left loop through

right. Close middle fingers to palms.

6. Draw radial thumb strings through middle finger loops by passing middle finger proximal to the string and straightening middle fingers so that the original middle finger loops are released. Insert straightened middle fingers proximally into index loops.

7. Transfer index loops to middle fingers by withdrawing indices, leaving double loops on the middle finger.

8. Release thumbs. Transfer double middle finger loops to thumbs, inserting thumbs proximally. Extend. You have a Hunter's Bag [11a].

9. Release ring and little fingers. Widen thumb loops by inserting ring and little fingers distally and closing ulnar thumb strings to the palm. Extend. Turn figure upside down by rotating the wrists half a turn in the radial direction, so that thumbs point downward. The triangle at the bottom of the figure represents a Seal in the Hunter's Bag [11b]. The seal can be made to "wiggle" in the bag by see-sawing the hands.

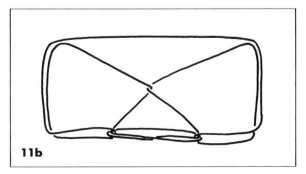

ANALYSIS: [11a, 11b]

The Kwakiutl Hunter's Bag [11a] and Seal in the Hunter's Bag [11b] bear no resemblance to any known Eskimo figures and have not been recorded elsewhere.

12. Le⁣ᵉleta

Loop size: small (a stiff cord is essential)

This figure was known to only one woman in Alert Bay. She was from Newettee by descent.

1. Opening B.

2. Insert middle-ring-little fingers into index loops proximally and close radial index strings to the palms.

3. Draw the short radial index strings through the thumb loops as follows: Insert thumbs proximally into index loops. Return through thumb loops with radial index strings.

4. Withdraw middle fingers from their loops and insert them proximally, close to the thumb, into the small thumb loops. Draw middle fingers toward the center of the figure, carrying the thumbs' palmar string on their backs, until in front of the crossing of the ulnar index strings.

5. Exchange middle finger loops, inserting middle fingers proximally and passing left loop through right. Close middle fingers to palms.

6. Release thumbs and extend figure loosely. Extend

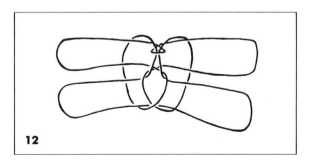

fully by inserting thumbs distally into middle finger loops and returning with radial strings, thus widening the middle finger loops. Release indices. You have *Le^εleta* [12].

ANALYSIS: [12]

Identical patterns: (P84)

Siberia:	+	*Agasoki* (a man's name)	(Jenness, LXXXIII)
Mackenzie:	+	The Old Man	(Jenness, LXXXIII)
W. Copper:	+	Vulva	(Jenness, LXXXIII)
E. Copper:	(+)	Vulva	(Rasmussen, 25)

The method of construction is identical to the Kwakiutl method throughout, except that the Kwakiutl widen the middle finger loops with the thumbs in the final extension. Although no chant was recorded among the Kwakiutl, the following Eskimo chants exist:

Siberian chant:

"Agasoki, the walrus down there, harpoon it, Agasoki."
"I have missed it."
(Figure is dissolved and left index caught in a noose.)

Mackenzie chant:

"Old man, the young ice is going to crush you. The ice-cake over there, stick your spear into it."
(Dissolution is as above.)

The Kwakiutl name for this figure could not be translated by Boas, despite his expertise in Northwest Coast linguistics. Evidently the name is either archaic, suggesting a long history for this figure, or is a personal name, as among the Siberian Eskimos. It is also possible that the name is sexual slang for the female genitalia, as among the Copper Eskimos.

13. A Small Owl (*Gugugu*)

Loop size: small

1. Opening B.
2. Insert middle-ring-little fingers into index loops proximally. Close radial index strings to the palms.
3. Draw radial thumb string through index loops as follows: Pass indices and middle fingers proximal to ulnar thumb string. Grasp between their tips the radial thumb string and return through the index loops, catching the string on the backs of the middle fingers. Transfer the new middle finger loops to the indices, inserting them proximally. Release thumbs and extend loosely.
4. To extend the figure properly, the upper transverse string (ulnar index string) must be shortened as follows: Insert middle fingers into ring-little finger loops proximally. Bring middle fingers to the center of the figure and pass them away from you, proximal to the upper transverse string. Hook this string down, and rotate the middle fingers a full turn in the radial direction so as to draw the string through the ring-little finger loops. After completing the rotation, pinch the transverse string between the index and middle fingers, thus shortening it. Extend.
5. Remove slack from the figure by inserting thumbs into ring-little finger loops distally and pushing down on the lower transverse string. You have A Small Owl [13].

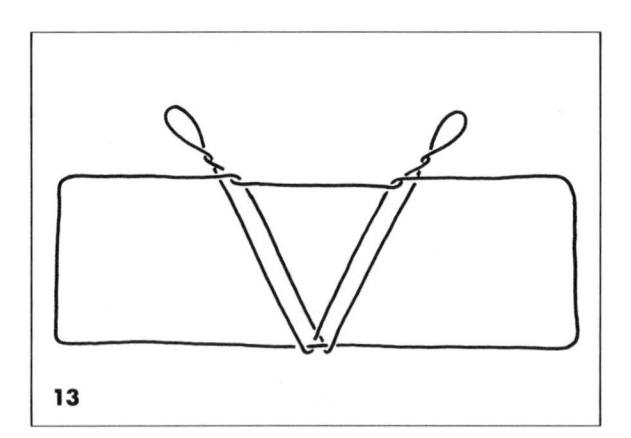

13

ANALYSIS: [13]

Identical patterns: (P35a)

N. Alaska:	+	The Bow	(Jenness, LXXXIX, fig. 130)
	+	(intermediate stage in figures based on the Bow)	(Jenness, LXXXIX, figs. 131 through 136, XC)
W. Copper:	+	(intermediate stage)	(Jenness, XC)
E. Copper:	(+)	(intermediate stage)	(Rasmussen, 57)
Netsilik:	+	(intermediate stage)	(Mary-Rousselière, 23, 34)
Iglulik:	+	(intermediate stage)	(Mary-Rousselière, 23)
	(+)	(intermediate stage)	(Mathiassen, fig. 179)
Polar:	+	(intermediate stage)	(Paterson, 35)
W. Greenland:	+	(intermediate stage)	(Paterson, 79)
E. Greenland:	+	(intermediate stage)	(Victor, 12)
Navaho:	−	The Bow	(Jayne, fig. 486)

Although this pattern is made by nearly all Eskimos east of the Bering Sea, only the northern Alaska Eskimos acknowledge it as a distinct figure. The method of construction is identical to the Kwakiutl method throughout. The Kwakiutl, however, improve the final extension of the pattern by wrapping the upper transverse string around the middle fingers. Although the Navaho method of forming this pattern is different, the final extension is very similar to that of the Kwakiutl.

It should also be noted that V-shaped patterns formed by doubled strings are widespread throughout the world. This is not surprising, considering the simplicity of the figure. Nonetheless, methods of construction and final extension vary widely. In North America, however, the figure is consistently made from Opening B, or a variation of it (Navaho Opening).

14. A Second Owl

Loop size: medium

1. Opening B.
2. Insert middle-ring-little fingers into index loops proximally. Close radial index strings to the palms.
3. Draw radial thumb string through index loops as follows: Insert middle fingers distally into thumb loops. Grasp radial thumb string between the tips of the index and middle fingers. Return through index loops. Place the loop on the backs of the indices by rotating indices half a turn in the ulnar direction. Release thumbs and extend. You have a two-diamond pattern.
4. Pass each thumb away from you through the center of its diamond and return with the strings forming the upper, inner sides of the diamonds. Release indices and extend.
5. Turn hands away from you so that thumbs are pointing upward. Tighten the ulnar little finger string so that an upper transverse string appears. Draw this string through the middle-ring-little finger loops as follows: Insert indices proximally into middle-ring-little finger loops, and pass indices to the radial side of the double strings that loop around the lower transverse string, then to the ulnar side of the upper transverse string. Hook down this string and draw it through the loops by rotating indices a full turn in the radial direction, thus taking up the string on the back

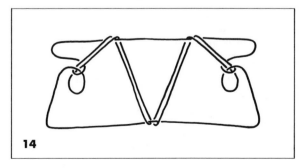

14

of the index. With palms away from you, gently release thumbs, but do not extend the figure tightly. You have A Second Owl [14]. The hanging loops represent the ears of the owl.

ANALYSIS: [14]

Identical patterns:

Bella Coola: + A Rabbit (McIlwraith, V)

The very limited distribution of this figure strongly suggests that it is a local invention. In both cases, the hanging loops of the final pattern represent ears. The Kwakiutl name of Owl is apparently based on this figure's resemblance to A Small Owl [13]. Since [13] is apparently lacking among the Bella Coola, the dangling loops were interpreted as being the ears of a rabbit rather than an owl.

15. Mallard Ducks

Loop size: medium

1. Opening B. Twist thumb loops by rotating thumbs in the ulnar direction a full turn.

2. Draw radial index string through thumb loops by inserting last three fingers of each hand into thumb loops proximally, then into index loops proximally. Hook radial index string down to the palm.

3. Pass left index to the ulnar side of right ulnar index string, then insert proximally into right index loop. Release right index but do not extend. Pass right index to the ulnar side of both ulnar left index strings. Insert into both loops proximally and return with both left ulnar index strings. Do not extend.

4. Draw radial thumb strings through both index loops by inserting indices distally into thumb loops and returning through index loops with the radial thumb strings. Release thumbs.

5. Transfer index loops to thumbs, inserting thumbs

distally. Extend by tightening the radial thumb string. You have two Mallard Ducks [15]. Drop the loops from the last three fingers. The figure will disappear.

The following is sung while moving the figure:

ai ai ai ai ai k!wiyō^εxwe ai
wä'εntsōs dā's^εidōs k!wiyō^εxwe ai ai
Quack, quack, quack, quack, quack, ducks, quack
Go on, ducks, dive! Quack, quack

15

ANALYSIS: [15]

Identical patterns, but upside-down: (P79)

W. Copper:	"+"	Two Thighs	(Jenness, XC)
E. Copper:	("+")	The Forequarters	(Rasmussen, 1)
W. Greenland:	"+"	Walrus Tusks Broken off the Head	(Paterson, 79)

The link between the Eskimo pattern and the Kwakiutl Mallard Ducks figure [15] is tenuous, owing to the difference in final display. On preliminary examination, the Eskimo method of construction appears to be unrelated to that of the Kwakiutl. A closer examination reveals, however, that the methods are mechanistically the same but performed on different fingers; thus, the inverted form of the final pattern. Independent invention should not be ruled out in determining the origin of this figure among the Kwakiutl.

16. A Canoe

Loop size: small

1. Opening B.
2. Insert middle-ring-little fingers into index loops proximally and close radial index strings to the palms.
3. Pass indices away from you through the small triangle at the center of the figure. Return with the strings forming the sides of the triangle, letting the former index loops slip off.
4. Withdraw middle finger from ring and little finger loops. Transfer index loops to middle fingers, inserting middle fingers distally. Insert indices into middle finger loops proximally, so as to widen them.
5. Draw radial thumb string through middle finger loops by grasping radial thumb string between tips of indices and middle fingers. Place this string on the backs of the indices by rotating the two fingers half a turn in the ulnar direction. Release thumbs.
6. The figure now resembles a house, with double diagonal strings forming the roof. Invert the figure as follows: Pass thumbs away from you toward the center of the figure and return with the diagonal strings that pass across the radial surface of the figure. Katilluik, inserting right thumb first. You have A Canoe [16].

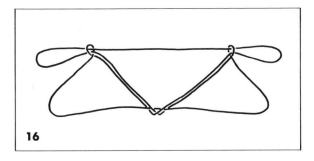

16

ANALYSIS: [16]

Similar patterns, but upside-down: (P60)

N. Alaska:	– The House	(Jenness, XCII)
Polar:	– The House	(Paterson, 60)

The method of constructing the Kwakiutl Canoe [16] is unrelated to the Eskimo method. The similarity in pattern is noted here simply because the Kwakiutl produce a similar figure after step 5, but they invert it using a katilluik maneuver.

Identical patterns, non-Eskimo:

Argentina:	? A Boat	(Ryden, fig. 5.1)
Bolivia:	? Armadillo	(Ryden, fig. 5.1)
Hawaii:	– Two Hills of Wailua	(Dickey, fig. 27b)
Yap:	– The Mythical Gabelfelsen	(Muller, fig. 310)

Except for the similarity in name between the Argentinian and Kwakiutl figures, there is no evidence to suggest that these figures share a common origin with the Kwakiutl Canoe. Unfortunately, no method of construction was recorded in Argentina.

17. The "Ghost" Series

Loop size: small

1. Opening B.
2. Insert middle-ring-little fingers into index loops proximally. Close radial index strings to the palms.
3. Pass indices away from you through the small triangle at the center of the figure. Return with the strings forming the sides of the triangle, letting the former index loops slip off.
4. Draw radial thumb string through index loops as follows: Withdraw middle fingers from ring-little finger loops and insert proximally into index loops. Pass indices and middle fingers distal to radial index strings and catch between their tips the radial thumb string, drawing it through the index loops that slip off the indices. Place the string on the backs of the indices by completing their rotation in the ulnar direction. Release thumbs and extend. You have Two Ghosts [17a], one on each side of the figure. The space be-

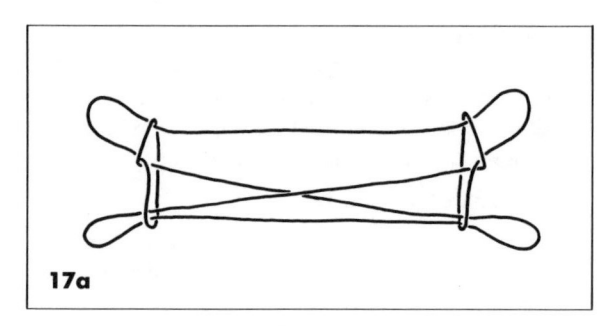

17a

tween them is a river, with each ghost standing on a shore.

5. Insert thumbs away from you into the triangle formed by the lower transverse string with the two diagonal strings that cross in the center of the figure. Release ring-little finger loops and pull thumbs apart so that the released strings form thumb loops. You have Two Skulls [17b] near the index fingers.

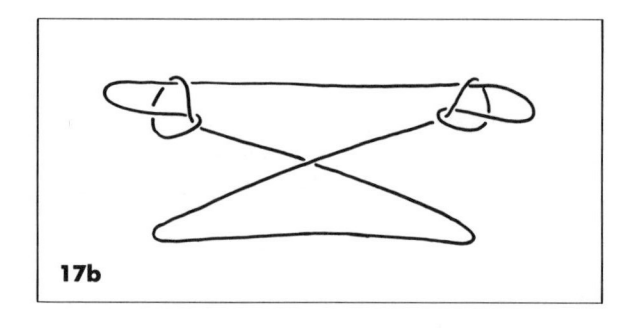

17b

6. Release thumbs. Insert last three fingers toward you into the large hanging loop. Grasp the strings forming the sides of the loop. Release indices and pull hands apart. The figure will disappear.

ANALYSIS: [17a, 17b]

Identical patterns:

Bella Coola:	+ A Corpse [17a]	(McIlwraith, III)
	+ Two Stars [17b]	

The Kwakiutl and Bella Coola titles for [17a] are clearly related, both dealing with death. The Bella

Coola title of Stars for [17b] is interesting because the Kwakiutl interpret loose knots as representing Stars in other figures (Sun, Moon and Star [53], and Moon and Stars [54]). Identical patterns have not been recorded elsewhere.

18. The "*TsƐlatsƐlatso*ᵋ" Series

Loop size: small

This figure, though not very complicated, was known to only a few people in Fort Rupert.

1. Opening B.
2. Insert middle-ring-little fingers into index loops proximally and close radial index strings to the palms.
3. Release indices. Insert indices proximally into thumb loops. Return with ulnar thumb strings.
4. Exchange index loops (which also encircle thumbs), inserting indices distally, passing left loop through right (loops on thumbs are not exchanged).
5. Transfer index loops to thumbs as follows: Pass thumbs proximal to index loops. Return with ulnar index strings. Release indices.
6. Draw proximal thumb loops through distal thumb loops as follows: Insert indices and middle fingers into both thumb loops distally and catch between their tips the proximal radial thumb string. Return through the distal loop and place the new loop on the indices by rotating indices half a turn in the ulnar direction. Release thumbs and gradually extend. You have *TsƐlatsƐlatso*ᵋ[18a].

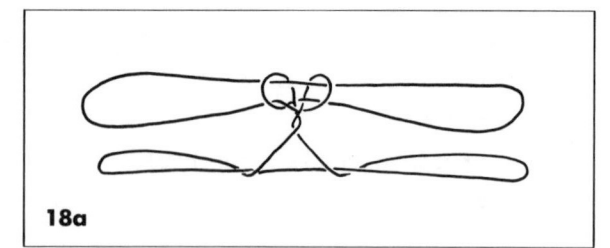

18a

This figure is accompanied by a chant:

nExwag·îltō'sEladzaEms tsElatsElatso^ε
Near go up tsElatsElatso^ε

7. Produce a second figure by inserting thumbs distally into the ring-little finger loops and returning with the radial strings of this loop. Release indices and extend. You have *Ģā'galbala*^ε*Emł* [18b]. The following lines are chanted with it:

ë^ε*sLa*^ε*wī·sEn gā'galbala*^ε*Emł*
Will I not hold on when I fall?

18b

ANALYSIS: [18a, 18b]

Nearly identical patterns: (P156, P110)

Caribou:	("+")	The Sling [18a]	(Birket-Smith, fig. 106d; Paterson, 156)
Netsilik:	"+"	*Tulugaqapserak* (archaic), [18a, 18b]	(Mary-Rousselière, 94)
Polar:	"+"	*Qa'wserge* (archaic) [18b]	(Paterson, 110)
W. Greenland:	"+"	The Testicles [18b]	(Paterson, 110)
E. Greenland:	"+"	The Loops [18b]	(Victor, 10, 11)

(The Greenland Eskimos make [18a] but do not consider it a separate figure.)

Based on similarities in naming and methods of construction, the two Kwakiutl figures [18a] and [18b] are clearly related to the above listed Eskimo figures, even though differences exist in the exact final patterns. To illustrate this point, note that the Caribou Eskimo sling can be produced using the

Kwakiutl method for constructing [18a] if the following modifications are made:

4. Exchange index loops passing *right loop* through *left*.

5. Pass indices proximally through middle-ring-little finger loops prior to inserting index and middle fingers distally into thumb loops.

These simple changes represent either a modification introduced during transmission of the figure, or perhaps by Averkieva's informant. It is also remarkable that the Kwakiutl, Netsilik, Polar, and East Greenland names for [18b] are untranslatable. As with [12], the name is either archaic or sexual. Note that the West Greenland name for [18b] refers to the male genitalia. The chant recorded among the Netsilik is consistent with this interpretation:

Tulugaqapsigaligoq down there,
far away,
it goes toward you.
Your eggs, through them.

Loops dangling from the upper transverse string also occur in the following non-Eskimo figures:

Society Islands:	−	Tuare	(Handy, fig. 41)
New Caledonia:	−	Sugarcane	(Compton, fig. XIV)
North Australia:	−	Cough	(K. Haddon 1918, fig. 10)
Loyalty Islands:	−	Brightly Colored Swamp Birds, followed by Trapped Birds	(Maude 1984, 20c, 20d)

These South Pacific methods are all unrelated to that of the Kwakiutl.

19. The "Two Men Fighting" Series

Loop size: small

1. Opening B.

2. Insert middle-ring-little fingers into index loops

proximally and close radial index strings to the palms.

3. Release indices. Insert indices proximally into thumb loops. Return with ulnar thumb strings.

4. Exchange index loops (which also encircle the thumbs), inserting indices distally, passing right loop through left (loops on thumbs are not exchanged). Draw hands slightly apart, keeping strings loose.

5. Twist index loops by rotating indices a full turn in the ulnar direction.

6. Draw radial thumb string through index loops as follows: Withdraw middle fingers from the middle-ring-little finger loops and insert them proximally into index loops. Pass indices and middle fingers distal to ulnar thumb strings, and take between their tips the radial thumb string. Return through index loops. Place string on backs of indices by rotating indices half a turn in the ulnar direction. Release thumbs and extend loosely. You have Two Men Fighting [19a] in the middle of the figure.

19a

19b

7. Insert thumbs distally into ring-little finger loops and return with radial strings of this loop. Release indices and extend sharply. You have They Pull Each Other by the Hair [19b].

ANALYSIS: [19a, 19b]

The Kwakiutl Two Men Fighting [19a] is essentially the same figure as [18a], except that the index loops are passed right through left in step 4 rather than vice-versa. Note that this is one of the modifications required for producing the Caribou Eskimo Sling from [18a] as previously described, making [19a] more closely related, mechanically speaking, to the Sling than is [18a]. It is also interesting that the Kwakiutl use two different methods to finish off [18a] and [19a], even though the net result is the same (radial thumb string drawn through half-twisted index loops, step 6). This supports the editor's belief that small variations in method introduced by specific performers of a given figure can mislead the analyst into believing that identical patterns are formed by unrelated methods, when in reality this is not the case.

The following non-Eskimo patterns should also be noted:

Hawaii:	"+" Breasts of Hina, Little Lizard [19a, 19b]	(Dickey, 21a, 21b)
E. New Guinea: ?	Dog and Pig [19b]	(Fischer, 49)

The Hawaiian method is somewhat related to the Kwakiutl method and also begins with Opening B.

20. Fighting Men (Pulling Each Other's Hair)

Loop size: large

1. Opening B.

2. Insert middle-ring-little fingers into index loops proximally and close radial index strings to the palms.

3. Exchange index loops, inserting indices distally, passing left loop through right. Withdraw middle fingers from middle-ring-little finger loops. Extend.

4. Draw radial ring-little finger strings through thumb loops as follows: Pass thumbs proximal to index loops and insert proximally into ring-little finger loops. Return through thumb loops with radial string, placing it on the backs of the thumbs by a half turn rotation in the radial direction.

5. Draw radial index strings through ring-little finger loops as follows: Insert middle fingers proximally into ring-little finger loops. Continue by passing them to the radial side of the two strings that form a loop around the palmar strings, and then inserting them proximally into the index loops. Hook down radial index strings through ring-little finger loops and release ring and little fingers. Transfer middle finger loops to ring and little fingers, inserting them proximally and closing them to the palm. Release indices and extend loosely.

6. Insert middle fingers distally into thumb loops, closing the ulnar thumb strings to the palm. Extend the radial thumb string sharply to produce the figure. You have Fighting Men Pulling Each Other's Hair [20].

20

7. Transfer thumb loops to indices and middle fingers, inserting them distally. Exchange index-middle finger loops several times, inserting fingers distally and passing left loop through the right. With each movement one says, "Come in, come in. Look how they fight." Each exchange represents the entrance of a spectator into the house.

8. Release ring-little finger loops and pull hands apart. The figure disappears, and the spectators are kicked out of the house.

ANALYSIS: [20]

The Kwakiutl Fighting Men [20] has not been recorded elsewhere. The technique of hopelessly tangling a figure by repeated exchanges of loops (step 7) is a technique found also among the Bering, North Alaskan, Mackenzie, and Copper Eskimos (see analysis of the Kwakiutl Sparrow [27]). The novelty of watching the tangled mass dissolve in the final step undoubtedly contributes to the popularity of this type of figure.

21. Paddling under Coppermaker
(*Sewābă^εes L!ā'qwag·ila*)

Loop size: medium

This figure, shown to me in Fort Rupert, has reference to a legend and resembles the Eskimo figure, Man Paddling in His Kayak. These figures must have a common origin.

1. Opening B.

2. Insert last three fingers of left hand distally into left thumb loop, closing the ulnar string to the palm. Insert last three fingers of the right hand distally into the right index loop, closing the ulnar string to the palm.

3. Transfer index loops to thumbs, inserting thumbs proximally. It is important that these loops remain distal to the previous thumb loops throughout the next movement. Insert indices proximally into thumb loops. Return with the ulnar thumb strings. This creates an upper transverse string.

4. Draw the proximal radial thumb string through the distal thumb loop as follows: Straighten middle fingers and insert proximally into the loop encircling both the indices and thumbs. Pass indices and middle fingers to the radial side of the distal radial thumb string, grasping the proximal radial thumb string between index and middle fingertips. Return through loop encircling indices and thumbs, placing the new string on the backs of the indices by rotating indices half a turn in the ulnar direction. Release thumbs and extend.

5. Transfer ring-little finger loops to thumbs, inserting thumbs proximally.

6. Insert the last three fingers of each hand toward you through the two triangles whose bases are formed by the central transverse string running parallel to the radial index string. Close this central transverse string to the palm.

7. Share index loops as follows: Insert left index proximally and from the radial side into right index loop. Withdraw right index. Insert right index distally into both left index loops and withdraw left index. Insert left index proximally and from the ulnar side into both right index loops and return, thus sharing the loops.

8. Draw radial thumb string through both index loops as follows: Withdraw middle fingers from middle-ring-little finger loops and insert them proximally into both index loops. Grasp radial thumb string between tips of middle fingers and indices and return through both index loops.

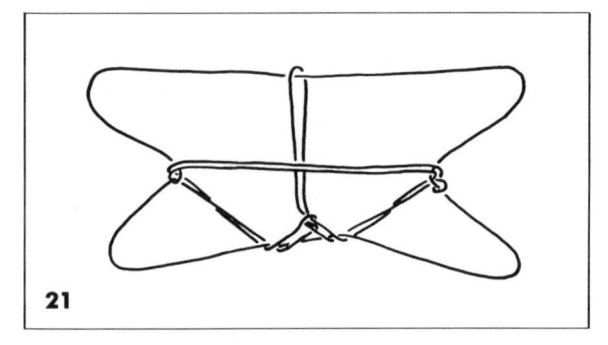

21

Place string on backs of indices by rotating them half a turn in the ulnar direction. Release thumbs and extend. You have Paddling under Coppermaker [21].

ANALYSIS: [21]

Similar patterns: (P70)

| Chukchi: | "+" Man in a Canoe | (Jenness, CXXXVI) |
| Siberia: | "+" Kayaker | (Jenness, CXXXVI) (see also Bogoras, fig. 199d; Paterson, 70) |

Although the final pattern of the Kwakiutl Paddling under Coppermaker [21] clearly differs from that of the Asian Eskimo figures recorded by Bogoras and Jenness, the methods of construction are intimately related. Both share the pattern produced after step 5, except that one is the reverse of the other. As a result of this reversal, the Eskimos must take up the central transverse string with the thumbs rather than the middle-ring-little fingers as in the Kwakiutl method. The differences in the final patterns are a direct result of the loops chosen for the katilluik-type maneuver in steps 6 and 7: the Eskimos select the thumb loops, whereas the Kwakiutl perform the movement on the index loops.

Despite the variation in method of construction, the similarity of names strongly suggests that the Kwakiutl and Siberian figures are somehow related. Note that the Siberians go on to produce a second figure from the Kayaker, which they call The Mountains. The accompanying chant describes a man paddling towards distant mountains. While the Kwakiutl figure lacks a chant, it is remarkable that the tale associated with the title of this figure (Paddling under Coppermaker) describes an ocean journey, via canoe, to the land of a spirit whose house is reached by passing under a distant mountain range. Unfortunately, the final pattern formed by the Kwakiutl does not lend itself to the production of a second figure analogous to the Eskimo Mountains.

The Kwakiutl Paddling under Coppermaker [21] has not been recorded elsewhere. A figure related in name and form has been recorded from the Pacific, but its method of construction is unrelated:

Nauru: − Fishing Canoe (Maude 1971, 46)

22. The "Wrinkled Forehead" Series

Loop size: large

This is a series of figures which was learned in Fort Rupert from an old Kwakiutl woman. It was also known to the natives of Newettee and Alert Bay.

1. Opening B.
2. Insert middle-ring-little fingers into index loops proximally and close radial index strings to the palms.
3. Insert thumbs proximally into index loops. Return with the short radial index strings.
4. Exchange these newly created distal thumb loops, inserting thumbs proximally and passing right loop through left (loops encircling indices are not exchanged).
5. Draw ulnar proximal thumb strings through middle-ring-little finger loops as follows: Keeping the middle fingers within their loops, catch on their backs the ulnar proximal thumb strings near their point of intersection at the ulnar transverse string. Straighten middle fingers so that they are inserted into index loops proximally. Pass index and middle fingers to the radial side of the radial index string. Insert them distally into both thumb loops, closing the ulnar strings to the palms.
6. Allow the distal thumb loops to slip off the thumbs, but catch them on the index tips, leaving a transverse string on the thumbs. Release indices, thus producing three loops on each middle finger, closed to the palm.

7. Draw transverse thumb string through all three middle finger loops as follows: Insert indices proximally into all three middle finger loops, then catch the radial thumb string between the tips of the indices and middle fingers. Return through middle finger loops, placing the string on the backs of the indices with a half-turn in the ulnar direction. Release thumbs and extend. You have Wrinkled Face in the House (Q̆ănkwiyolīɫ) [22a].

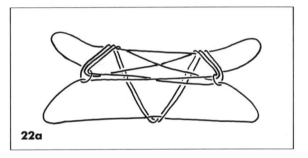

22a

8. The Forehead is unfolded as follows: Rotate indices a full turn in the ulnar direction. In the process, pass the indices through the ring-little finger loops proximally. Transfer distal index loops (original index loops) to thumbs, inserting thumbs proximally. Release indices and extend. You have Unfolded Face in the House [22b] (Dā ɫiyogwalīɫ).

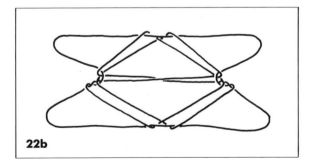

22b

9. Insert indices and middle fingers toward you through the upper triangle of the figure which is formed by three sets of double strings. Rotate

thumbs in the radial direction so that the radial thumb string can be grasped between the index-middle fingertips. Draw this string through the triangle, placing the new string on the backs of the indices with a half-turn rotation in the ulnar direction. Release thumbs and extend. You have Gravel in the House [22c] (*T!ēt!aᵉyᴇmgwalĭƚ*).

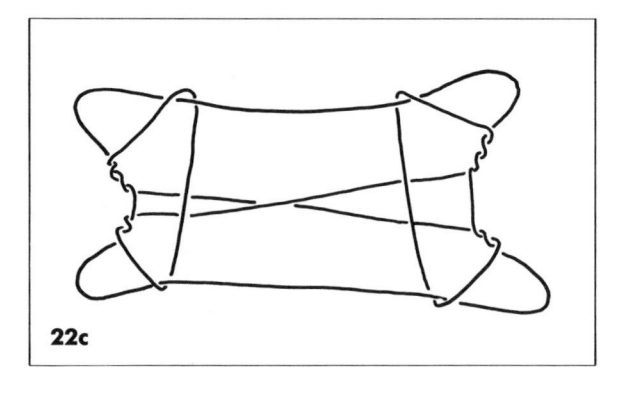

22c

10. A short segment of string forms the sides of the figure, which originates from the ulnar index strings and eventually circles the ring-little finger loop. Pass the middle fingers to the ulnar side of these short strings. Hook back the short strings, and close middle fingers to the palms. Release indices. Transfer middle finger loops to thumbs, inserting thumbs distally. Extend. You have a two diamond pattern called Drying Salmon [22d] (*Q!waxsesnä'ōs*).

11. Hang the figure on the left hand as follows: Transfer right ring-little finger loops to left ring

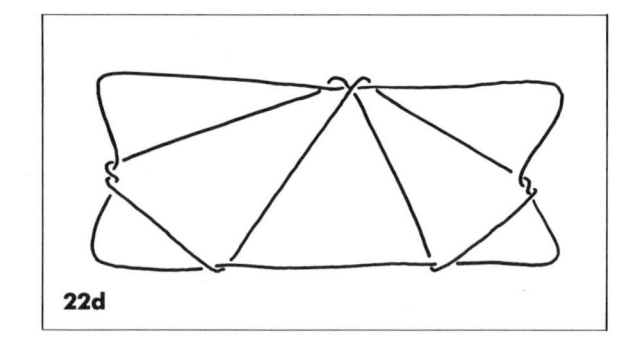

22d

and little fingers, inserting them distally. Transfer left thumb loop to left middle finger, inserting middle finger distally. Transfer right thumb loop to left middle finger, inserting middle finger proximally and from the radial side.

12. Transfer left middle finger loops to the right hand as follows: Insert right thumb distally into both left middle finger loops. Insert the remaining four fingers of the right hand into these same two loops from the proximal side, thus forming a fist around the former ulnar middle finger strings. Release left middle finger. Arrange loops similarly on the left hand, inserting left thumb distally into ring-little finger loops, and inserting the remaining two fingers proximally.

13. Pick up distal radial thumb strings with the backs of the indices, separating thumbs and indices to extend. You have Lying Chest Up [22e] (*Năēnʟ!abōlisk'!aē's*).

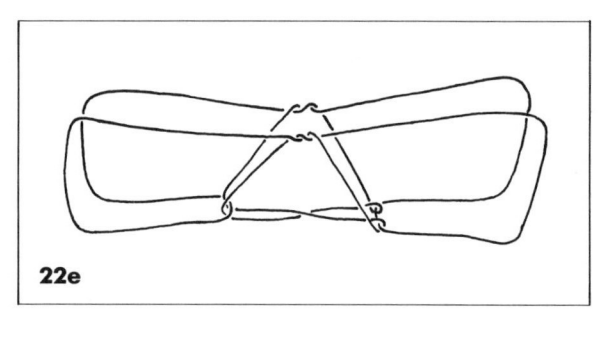

22e

14. There are two small triangles at the center of the figure, joined at their bases. Release left hand. Pass it between you and the strings, then to the right side of the hanging strings. Insert the four fingers of the left hand into the ulnar triangle from the right side, then close the two strings which form the bases of the triangles to the left palm. Pull left hand to tighten the strings.

15. Insert left thumb distally into distal left-hand loop. Return with radial string of this loop. Straighten left index so that the radial string of the proximal left-hand loop is taken up on its

back. Extend. You have Its Musk Bag [22f] (*BōᵋlExstēs*).

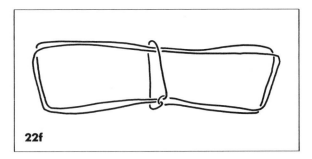

22f

16. Release the last three fingers of each hand. Separate indices and thumbs widely. Turn the figure upside-down as follows: Transfer index loops to the last three fingers, inserting them distally, then closing them to the palm. Transfer thumb loops to indices, inserting indices distally. Transfer middle-ring-little finger loops to thumbs, inserting thumbs proximally.

17. Exchange index loops, inserting indices distally and passing right loop through left. Extend gently. You have What's the Cry of the Geese? [22g], (*ᵋMā'sēs nExā'q!alag·îlitsEmasōᵋ nExā'q*). The figure represents the goose who is asked what he is crying about.

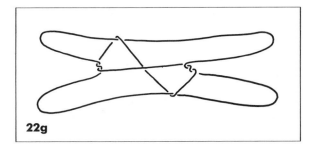

22g

18. Release right index. Pull on right thumb loop slowly. The Walking Goose [22h] will walk to the left. The movement is accompanied by chanting, "*nExā'q, nExā'q, nExā'q.*" Release left index. The figure will disappear.

22h

ANALYSIS: [22]

Identical patterns:

Bella Coola: + *Sniniq* series (McIlwraith, XVIII)

This series of figures, shared by the neighboring Kwakiutl and Bella Coola Indians, has not been recorded outside the Pacific Northwest Coast area. It is quite interesting that the two tribes have chosen entirely different names for each figure in the series, in English as well as in their respective Indian tongues. Also noteworthy is the fact that a large proportion of the titles contain archaic words no longer understood by either tribe. This suggests that the entire series is very old. The following comparison illustrates these points:

[22a] Kwakiutl: Wrinkled Face in the House
 Bella Coola: The *Sniniq* (a monster)

In the Bella Coola version of this pattern, the crossing transverse strings are allowed to hang loosely rather than being pulled taut. The hanging loops represent the eyes of the monster which project death-dealing rays. The Bella Coola chant:

"Reverse your eyeballs! It is too dangerous, O dreaded and powerful one!"

The eyeballs are then "reversed" to give:

[22b] Kwakiutl: Unfolded Face in the House
 Bella Coola: The Hammer of the Raven, Long, Long Ago

This is followed by:

[22c] Kwakiutl: Gravel (?) in the House
 Bella Coola: The *Simqimnikdas* (viscera?) of the Raven, Long, Long Ago

Both of the Indian names for this figure contain archaic words that the authors could not translate. Both series continue to give:

[22d] Kwakiutl: Drying Salmon
 Bella Coola: Whetstone of the Raven,
 Long, Long Ago

This figure is actually an accurate representation of a salmon filet draped over a drying rack. The series continues with a three-dimensional pattern:

[22e] Kwakiutl: Lying Chest Up
 Bella Coola: The Box [archaic] of the
 Raven, Long, Long Ago

The Bella Coola acknowledge the two-dimensional version of [22e] as a separate figure called Firebringer of the Raven, Long, Long Ago. The series continues with another three-dimensional pattern:

[22f] Kwakiutl: Its Musk Bag
 Bella Coola: The Toilet of the Raven,
 Long, Long Ago

As discussed in Appendix A, the "its" in Its Musk Bag likely refers to "the mink." The Bella Coola also acknowledge the two-dimensional form of [22f] as representing The Raven's House Post, Long, Long Ago. At this point, the two series diverge from one another. The Kwakiutl turn the pattern upside-down and exchange the index loops to give:

[22g] Kwakiutl: What's the Cry of the Geese?

The Bella Coola do not invert the pattern. Instead, by exchanging the index loops, they produce a distinctly different pattern called the Heron of the Raven, Long, Long Ago. At this point, both tribes release the right index to give two differing but final figures:

[22h] Kwakiutl: The Walking Goose

The final Bella Coola figure is known as the Dog (archaic) of the Raven, Long, Long Ago.

This is the largest series known to the Kwakiutl, encompassing eight individual patterns. The novelty of being able to produce so many dissolution figures from one initial pattern probably contributed greatly to the survival of the series throughout the ages. The

origin of the first figure in the series is indeed vague. Only one Eskimo figure exists which bears any resemblance to [22a], this being of Siberian origin:

Siberia:	— Man's Boots Hanging Up	(Jenness, LXXX, fig. 115; Paterson, 98)

The method of construction is totally unrelated to that of the Kwakiutl Wrinkled Face in the House [22a].

23. A Toad

Loop size: small

1. Opening B.
2. Insert middle-ring-little fingers into index loops proximally and close radial index strings to the palms.
3. Draw ulnar thumb strings through index loops as follows: Insert indices distally into thumb loops. Grasp ulnar thumb strings between tips of indices and middle fingers. Rotate indices and middle fingers half a turn in the ulnar direction to place this string on the backs of the indices. Release ring and little fingers. Extend.
4. Hook ring and little fingers over the double strings that intersect at the center of the upper transverse string. Close the double strings to the palms.
5. Turn over index loops by withdrawing indices from their loops and re-inserting them from the opposite side, so that loops are not twisted.
6. Draw the radial thumb string through the index loops as follows: Grasp the center of the radial thumb string between the tips of the index and middle fingers and rotate fingers half a turn in the ulnar direction in order to place the new string on the backs of the indices. Do not release thumbs. Release ring and little fingers and extend the figure sharply, palms away from you, separating the thumbs and indices as far as

possible, so that the bulk of the strings come over the top of the radial index string and lie on the radial surface of the figure. An M-shaped pattern should be apparent.

7. Transfer right thumb loop to left thumb, inserting left thumb distally. Close right index loop to the palm by rotating right index half a turn in the ulnar direction.

8. At this point, two sets of double strings (four strings) should be seen looping over the transverse index string (if not, repeat the figure, paying close attention to the sharp extension in step 6). With the right middle finger, hook back the short segment of the transverse index string which is visible between the two sets of doubled strings. Close this segment to the left palm.

9. Transfer the left index loop to the right ring finger, inserting the ring finger proximally, from the radial side. Close the loop to the palm.

10. Insert the four fingers of the left hand into the two left thumb loops proximally. Loosely close both radial strings to the palm. Withdraw the left thumb from both loops and re-insert it from the opposite direction, thus forming a loose fist. You have a Toad [23]. Drop the loops from the right index and ring fingers. Jerk the right middle finger loop to the right. The toad will jump through the "hole" formed by the left fist. (If

your left thumb becomes entangled in string, step 8 was performed incorrectly.)

ANALYSIS: [23]

Identical patterns: (P48b)

North Alaska:	—	A Pair of Knee "Breeks" (breeches)	(Jenness, LXXXVIII, fig. 127)
Mackenzie:	—	He Has Taken off his Fur Coat	(Jenness, LXXXVIII, fig. 127)
W. Copper:	—	(Trousers)	(Jenness, LXXXVIII, fig. 127)
Iglulik:	—	(Trousers)	(Paterson, 48b)
W. Greenland:	—	A Woman's Slim Breeches	(Paterson, 48b)
Bella Coola:	"+"	Toad	(McIlwraith, XIII)

The Eskimo example is actually a dissolution figure in a four-pattern series which describes the disrobing of a man whose "toes are turned out." Those groups unfamiliar with the entire series typically stop after the first figure (see Paterson, 48a–d), which means that occurrence of the primary figure of the series is much greater than the above list suggests. The Kwakiutl, using a related but distinctly different method, by-pass the primary figure. Absent are the mechanical "weaving" steps used by the Eskimo in creating the initial figure. Both groups, however, retain the quarter-turn rotation of the entire figure prior to its extension. The Kwakiutl improve the extension by using the right middle finger to retain one of the transverse strings.

Oddly, the Kwakiutl name for this figure (Toad) matches that given to similar patterns formed by Patomana Indians of South America and the highland natives of Papua New Guinea:

British Guiana:	—	Toad	(Lutz 1912, fig. 2)
	—	Frog	(Roth 1924, fig. 263F)
New Guinea:	—	Frog	(Shishido and Noguchi, 23)

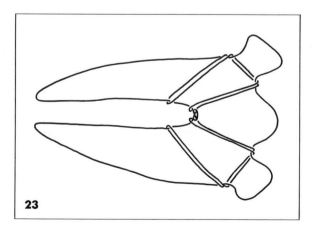

23

As with the Kwakiutl Toad, these figures are displayed vertically. Their methods of construction, however, are unrelated to that of the Kwakiutl figure. Apparently this type of pattern recalls the hind legs of a frog regardless of cultural background.

Finally, the Bella Coola version of this figure provides some interesting insight into mechanisms of string figure transmission. The Bella Coola know two ways of producing [23], both of which differ from the Kwakiutl method. Only the quarter-turn finish in step 6 is retained. Thus we have three methods of constructing this general pattern on the Northwest Coast alone. Of the three methods, the first Bella Coola method is most closely related to that of the Eskimo Trousers figure. In fact, it is possible to make the entire Trousers series from intermediate stages of the Bella Coola Toad (first method), a feat not possible with the Kwakiutl figure. This cluster of figures therefore documents a mechanism by which identical patterns are transmitted over long distances, despite major alterations in their methods of construction (see final chapter).

The following Bella Coola chant is provided as supplemental material:

> "Where are you going?"
> "I am going to get some bunchberries"
> "But how will you be able to reach them?"
> "I can jump!"
> "Go ahead, little fellow."

24. A Kick in the Back (*Qwatsaxsut*)

Loop size: medium

This figure was learned in Fort Rupert from an old Indian woman.

1. Opening B.
2. Insert middle-ring-little fingers into index loops proximally and close radial index strings to the palms.
3. Draw the ulnar thumb strings through the middle-ring-finger loops as follows: Keeping the middle fingers in their loops, insert them distally into the thumb loops. Grasp the ulnar thumb strings between the tips of the middle and ring fingers. Draw them through the middle-ring-little finger loops, while releasing ring and little fingers from their loop. Insert ring and little fingers proximally into the middle finger loops, closing all three fingers to the palm.
4. Release indices and extend. Draw radial thumb string through middle-ring-little finger loops as follows: Insert indices proximally into middle-ring-little finger loops. Pass indices towards you, proximal to the doubled strings that intersect at the center of the ulnar little finger string. Then hook back the radial thumb string through the middle-ring-little finger loops, placing it on the backs of the indices by rotating them half a turn in the ulnar direction. Release thumbs and extend.
5. Release left little finger only from the loop encircling it. Transfer right middle-ring-little finger loop to the left little finger, inserting little finger proximally and closing it to the left palm.
6. Transfer right index loop to the right middle-ring-little fingers, inserting them distally and closing the ulnar right index string to the palm.
7. Transfer left index loop to the right thumb, inserting it proximally. Transfer left middle-ring loop to left thumb, inserting thumb distally. Extend. You have A Kick in the Back [24].

24

ANALYSIS: [24]

Nearly identical patterns: (P48c)

N. Alaska:	— Two Scapulae	(Jenness, LXXXVIII, fig. 128)
Mackenzie:	— He has Stripped Naked	(Jenness, LXXXVIII, fig. 128)
W. Copper:	— (Trousers)	(Jenness, LXXXVIII, fig. 128)
Iglulik:	— Rain Clothes	(Mary-Rousellière, 74 text)
	— Man's Coat with a Windbreak	(Paterson, 48c)
W. Greenland:	— Seal Skin Anarak	(Paterson, 48c)

The above figures represent the third pattern in the Eskimo Trousers series described under [23]. The Kwakiutl Kick in the Back [24] differs from its Eskimo equivalent through subtle distinctions in the string crossings. The Eskimo and Kwakiutl methods of construction, except for the quarter-turn rotation of the finished pattern, are entirely different. It is ironic that the Kwakiutl have their own method of constructing this pattern when an exact duplicate of the Eskimo pattern could be produced easily by performing a dissolution step on the Kwakiutl Toad figure [23].

One other Eskimo pattern is quite similar in form to the Kwakiutl Kick in the Back [24] but is unrelated in method of construction. The name is also similar:

| N. Alaska: | — Snow Shoes (?) | (Jenness, LXXXIX, fig. 134) |

25. Two Kelps (and Two Men Standing at the Ends of Them)

Loop size: medium

This figure was learned at Alert Bay. I did not find it at Fort Rupert.

1. Opening B.

2. Insert middle-ring-little fingers into index loops proximally and close radial index strings to the palms.

3. Draw the ulnar thumb strings through the middle-ring-little finger loops as follows: Keeping the middle fingers in their loops, insert them distally into the thumb loops. Grasp the ulnar thumb strings between the tips of the middle and ring fingers and draw them through the middle-ring-little finger loops, while releasing ring and little fingers from their loop. Insert ring and little fingers proximally into the middle finger loops, closing all three fingers to the palm.

4. Insert thumbs proximally into index loops. Return with the short radial index strings.

5. Exchange these newly created distal thumb loops, inserting thumbs proximally and passing right loop through left (loops encircling indices are not exchanged).

6. Transfer index loops to thumbs as follows: Pass thumbs proximal to radial index strings and return with ulnar index strings. Release indices and extend. You now have three loops on each thumb which should be kept well separated.

7. Draw the proximal radial thumb string through the other two thumb loops as follows: Insert indices and middle fingers distally into distal and center thumb loops, grasping the proximal radial thumb string between their tips. Return through thumb loops, placing the string on the backs of the indices with half a tn in the ulnar direc-

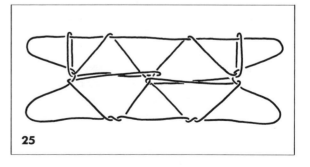

25

tion. Gently withdraw thumbs from all three loops. Re-insert them into the center loops only.

8. Katilluik, inserting left thumb first. Extend. You have Two Kelps and Two Men Standing at the Ends of Them [25]. The strings running across the thumb loops represent the men, and the double strings at the middle, kelps.

ANALYSIS: [25]

The Kwakiutl Two Kelps [25] has not been recorded elsewhere. Mechanistically, it combines techniques used in constructing a Kick in the Back [24] and the "Wrinkled Forehead" series [22]. Its name probably is based on its similarity to another Kwakiutl Kelp figure [70].

26. A Hummingbird

Loop size: medium

1. Opening B.
2. Transfer index loops to thumbs as follows: Pass thumbs proximal to radial index string and return with ulnar index string. Release indices.
3. Draw distal ulnar thumb string through proximal thumb loop as follows: Insert index and middle fingers proximally into proximal thumb loops. Grasp between their tips the ulnar distal thumb string. Return index and middle fingers through proximal loop, closing the string to the palm. Transfer index loops to ring-little fingers, inserting them proximally.
4. Draw proximal radial thumb string through distal thumb loops as follows: Insert index and middle fingers distally into distal thumb loop. Grasp the radial proximal thumb string between their tips. Return through distal loop, placing the new string on the backs of the indices with a half turn in the ulnar direction. Release thumbs to produce a common two-diamond pattern.
5. Transfer ring-little finger loops to thumbs, inserting thumbs proximally.

6. Insert ring and little fingers toward you through the two diamonds, closing to the palm the strings forming the lower outside edges of each diamond. Maintain hands in upright position.
7. Create middle finger loops from the ulnar little finger strings as follows: Pass left middle finger to the ulnar side of the right ulnar little finger string and insert distally into the right ring-little finger loop. Return with right ulnar little finger string. Pass right middle finger through left middle finger loop distally, then to the ulnar side of the left ulnar little finger string. Insert right middle finger distally into the left ring-little finger loop, and return through left middle finger loop with the left ulnar index string. Exchange middle finger loops, inserting middle fingers proximally, from the radial side, passing left loop through right. Extend. As a result, each middle finger loop is twisted half a turn in the radial direction.
8. Draw radial thumb string through middle finger loops as follows: Rotate middle fingers half a turn in the ulnar direction. Insert them proximally into ring-little finger loops, then proximally into thumb loops. With the palms of the middle fingers, hook back the radial thumb string. Return through the middle finger and ring-little finger loops, placing the string on the backs of the middle fingers with a half turn in the ulnar direction. Release thumbs. Extend.
9. Transfer index loops, then middle finger loops to the thumbs, inserting thumbs proximally.
10. Draw radial proximal thumb string through distal thumb loop as follows: Insert index and middle fingers distally into distal thumb loops. Grasp between their tips the radial proximal thumb string. Return through distal loop, placing the new string on the backs of the indices with a half turn in the ulnar direction. Release thumbs and extend.
11. Turn the figure upside-down as follows: Transfer ring-little finger loops to thumbs, inserting thumbs proximally. Close indices to the palms,

rotating them half a turn in the ulnar direction. Transfer index loops to middle-ring-little fingers, inserting them proximally. Extend. You have A Hummingbird [26].

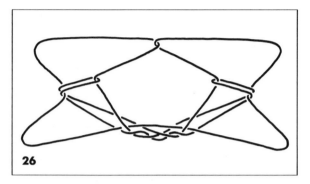

26

ANALYSIS: [26]

The Kwakiutl Hummingbird [26] has not been recorded elsewhere, despite the fact that it arises from a common two-diamond pattern with world-wide distribution. The creation of middle finger loops from the ulnar little finger strings in step 7 is unusual, but the inversion of the final pattern is a common Kwakiutl technique [11,29,43].

No dissolution technique was recorded by Averkieva, but other Indians dissolve the pattern by releasing the middle-ring-little finger loops and then extending. The whirling action of the strings as they unravel represents the hummingbird's disappearance (Storer, personal communication).

27. The "Sparrow" Series

Loop size: small (use a thin string)

1. Opening B.
2. Pass thumbs proximal to radial index string. Return with ulnar index string.
3. Grasping the ulnar index strings firmly between the tips of the indices and middle fingers, rotate

all four fingers half a turn in the ulnar direction, closing the fingers to the palm. The ulnar index string remains gripped between the tips of the index and middle fingers until step 6.

4. Insert index and middle fingers proximally into thumb loops. Straighten fingers, taking up the ulnar thumb strings.
5. Pass ring and little fingers proximal to index and middle finger strings, then distal to the distal radial thumb string. Hook down this string to the palm. Navaho the thumbs.
6. Release the string held between the tips of the index and middle fingers. Turn palms away from you, then release thumbs. Extend gently, pointing indices away from you, palms down. You have A Sparrow (*Tso!ltsEmga*) [27a]. The sparrow's words are said with this figure:

Lē⁺lalEnLōL ts!ō'tsaq

I invite you *ts!ō'tsaq*. The sparrow is inviting a bird named "*ts!ō'tsaq.*"

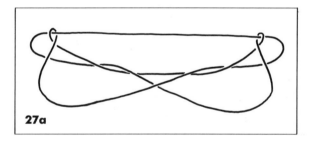

27a

7. Transfer index loops to middle fingers, inserting them distally. Insert indices and thumbs proximally into middle finger loops. Separate all three fingers widely to stretch the loop, then bring tips of thumb, index, and middle fingers back together.
8. Exchange the loops encircling thumb, index, and middle fingers, inserting fingers distally and passing right loop through left. After the exchange is complete, pull hands in opposite directions, with all fingers remaining in a fixed position. Just before strings are taut, briskly separate

thumbs from the index and middle fingers as widely as possible. Extend. Two vertical loops will appear at the center of the figure, representing the Bird Invited by the Sparrow [27b]. She answers the sparrow:

gwaᵋg·aănasʟqEn wŭsē'xᵋidēᵋ

Wait till I put on my belt.

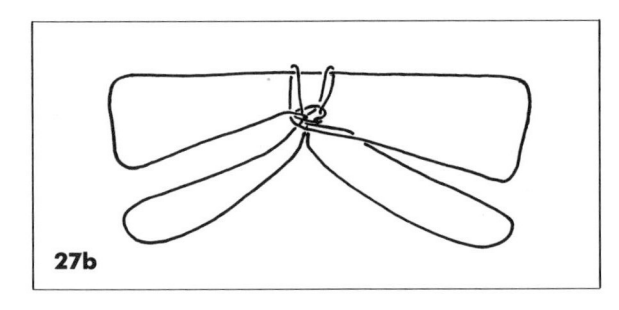

27b

9. Repeat step 8, which indicates Putting on the Belt [27c]. Then, the sparrow says:

ětsēᵋstōl, ts!ō'tsaq
I invite you a second time, *ts!ō'tsaq.*

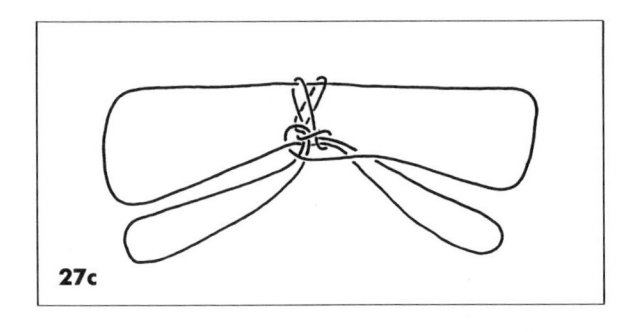

27c

10. Repeat step 8, indicating that *ts!o'tsaq* is being Invited a Second Time [27d]. After that, *ts!ō'tsaq* says:

gwaᵋg·aanasʟ qEn wŭ'sē'xᵋidēᵋ
Wait till I tighten my belt.

11. Repeat step 8, indicating that she is tying her belt.

12. Release ring-little finger loops and draw hands

apart. The figure will disappear. This indicates that the belt is completely untied and *ts!ō'tsaq* cannot go on a visit.

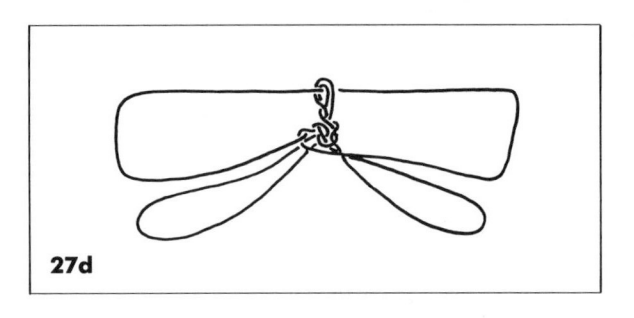

27d

ANALYSIS: [27]

The actual figures of the Kwakiutl Sparrow series [27] have not been recorded elsewhere, although the technique which allows the novel tangling and sudden dissolution of the final pattern has been recorded among the Eskimos: (P87).

N. Alaska:	"+"	Guardian Spirit	(Jenness, CXV)
Mackenzie:	"+"	Guardian Spirit or Shaman Being Bound	(Jenness, CXV)
W. Copper:	"+"	Shaman Who Has Invoked His Guardian Spirits	(Jenness, CXV)
E. Copper:	("+")	Outstretched Arms	(Rasmussen, 44)

See also: (P216)

Bering:	"+"	Two Men Fighting	(Jenness, L, fig. 69)

In all examples an initial figure having two small vertical loops is first produced. The vertical loops are then increasingly twisted about one another, using a repeated loop exchange technique. In the end, the tightly knotted patterns are magically dissolved through a simple loop release.

Evidence for a common origin is further provided by a comparative examination of the chants accompanying these figures. The Kwakiutl narrative describes a small bird adorning a belt prior to visiting her friend the sparrow. The progressive twisting of

the vertical loops is then used to symbolize the tightening of the belt. In the end the belt is untied. Without her belt, the small bird is improperly dressed for a visit and must cancel. The North Alaskan Eskimo chant, which describes a shaman being tied up, likewise mentions a belt:

Tie up your spirits.
Tie up your spirits.
Use up your rope for it.
Use up your old trouser's belt for it.
Tie me up; tie me up.

Once the figure is dissolved, the shaman is said to have extricated himself from the ropes with the help of his guardian spirit.

The opening figure of the "Sparrow" series [27a] resembles an inverted version of a Netsilik Eskimo figure.

Netsilik:	— The Fox, to Which Side Will He Go Running?	(Mary-Rousselière, 15a)

The second figure of the series [27b], resembles a Copper Eskimo figure:

E. Copper:	? *Tunituartershuk* (archaic)	(Rasmussen, 21)

No method of construction was recorded for this figure, but it is said to be representative of ancient Eskimos known as the Tunit.

28. The Log

Loop size: medium

1. Opening B.
2. Pass thumbs proximal to radial index strings and return with ulnar index string.
3. Draw radial index string through proximal thumb loop as follows: Pass middle fingers proximal to radial index string and insert them proximally into thumb loops. Return with ulnar thumb strings to the ulnar side of the radial index string. Hook down this string to the palm with the middle fingers, permitting the former ulnar thumb string to slip off. Insert ring and little fingers proximally into middle finger loops, closing them to the palm. Straighten middle fingers so that the ulnar thumb strings are taken up on their backs.
4. Exchange middle finger loops as follows: Insert left middle finger proximally, from the ulnar side, into right middle finger loop. Return, closing the ulnar right middle finger string to the left palm. Release right middle finger. Insert it proximally, from the ulnar side, into the original left middle finger loop. Return, closing the left ulnar middle finger string to the palm.
5. Straighten the middle fingers so that the distal radial thumb strings (which run vertically across the figure) are drawn through the middle finger loops (which are released).
6. Release thumbs, ring, and little fingers to extend. You have The Log [28].

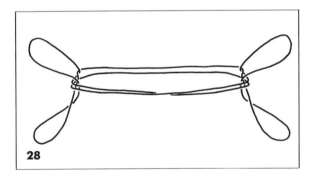

ANALYSIS: [28]

The Kwakiutl Log [28] appears to be a unique variation on one of the most widely distributed figures in the world, commonly known as Crow's Feet (see Kwakiutl [37b, 38b]). It differs from the standard pattern in that there are four transverse strings rather than two. This figure has not been recorded elsewhere.

29. Two Hummingbirds

Loop size: medium

This figure was known to only one native in Fort Rupert.

1. Opening B.
2. Pass thumbs proximal to radial index strings and return with ulnar index string.
3. Draw radial index string through proximal thumb loop as follows: Pass middle fingers proximal to radial index string. Insert them proximally into thumb loops. Return with ulnar thumb strings to the ulnar side of the radial index string. Hook down this string to the palm with the middle fingers, permitting the former ulnar thumb string to slip off. Insert ring and little fingers proximally into middle finger loops, closing them to the palm. Straighten middle fingers so that the ulnar thumb strings are taken up on their backs.
4. Exchange middle finger loops as follows: Insert left middle finger proximally, from the ulnar side, into right middle finger loop. Return, closing the ulnar right middle finger string to the left palm. Release right middle finger and insert it proximally, from the ulnar side, into the original left middle finger loop. Return, closing the left ulnar middle finger string to the palm.
5. Straighten the middle fingers so that the distal radial thumb strings (which run vertically across the figure) are drawn through the middle finger loops (which are released).
6. Transfer middle finger loops to thumbs, inserting thumbs distally.
7. Draw the proximal radial thumb string through the other two thumb loops as follows: Insert index and middle fingers distally into distal and central thumb loops. Grasp proximal radial thumb string between their tips and return, placing the string on the backs of the indices with a half turn in the ulnar direction. Release thumbs and extend.

8. Turn the figure upside-down as follows: Transfer ring-little finger loops to thumbs, inserting thumbs proximally. Rotate indices half a turn in the ulnar direction and point thumbs away from you to extend the figure. You have Two Hummingbirds [29].

29

ANALYSIS: [29]

The Kwakiutl Two Hummingbirds figure [29] has not been recorded elsewhere. Mechanistically, the figure is derived from initial stages of the Kwakiutl Log [28].

30. The "Sitting on the Roof" Series

Loop size: medium

This figure was learned in Fort Rupert.

1. Opening B.
2. Transfer thumb loops to indices so that they become proximal loops as follows: Insert indices distally, deep into thumb loops, so that index loops are proximal to thumb loops. Release thumbs. Return indices to position.
3. Pass thumbs distal to proximal radial index strings. Return with ulnar proximal index strings.
4. Draw distal radial index string through thumb loops as follows: Pass middle fingers through thumb loops from the proximal side and insert into distal index loops proximally. Hook down

distal radial index string, returning through thumb loops. Close the middle fingers to the palm. Insert ring and little fingers proximally into middle finger loops, closing them to the palm.

5. Share the index loops as follows: Transfer right distal index loop to left index, inserting left index proximally, from the ulnar side. Insert right index finger proximally, from the ulnar side, into the left central and distal index loops. Return.

6. Draw radial thumb string through central and distal index loops as follows: Insert indices distally into thumb loops. Pick up radial thumb strings on their backs and return through central and distal index loops. Release thumbs and extend.

7. Navaho the indices. You have Two Sitting on the Roof [30a].

30a

8. Insert thumbs away from you into the center of the figure so that thumbs are resting on lower transverse string. Release ring-little finger loops and pull thumbs apart, catching lower transverse string. You have Two Bears Seen by the Two on the Roof [30b].

30b

The following chant accompanies this figure:

ᵉnēx·dzâᵉs ᵉnēx·dzâᵉs qen wiyaxalēsēᵉ
dExwaxalēsēᵉ L!ēʼbidaᵉwᵉwââ
Little bear, you prevent me from getting off the roof. Shoo! little bear.

ANALYSIS: [30a, 30b]

Identical patterns: (P99)

Siberia:	+ Two Rats [30a]	(Jenness, CXXXI)
	+ Two Rats on a Log [30b]	
Bering:	+ Two Dogs [30a]	(Jenness, CXXXI)
	+ Two Dogs on a Hill [30b]	

Currently, this two-figure series has a very limited distribution, appearing only on the northern Pacific Rim and the Pacific Northwest Coast (Kwakiutl). Except for minor differences in the way the initial index loops are created in step 2, the method of construction is identical throughout. The Kwakiutl also prefer to use the middle fingers rather than the little fingers in performing step 4.

Although the figures have different names in each location, the interpretations are clearly related. The second figure [30b] is always perceived as representing two animals elevated by some means. The Siberian Eskimos recite the follow chant prior to forming [30b]:

Two rats, a stick, on top of it they jump up.

In the Kwakiutl version, it is the spectators who are elevated on the roof. The little bears attempt to jump up in pursuit.

31. A Snake (Snot of a Woman)

Loop size: medium

1. Opening B.

2. Twist the left thumb loop by rotating the thumb a full turn in the radial direction.

3. Pass the left thumb proximal to the left radial index string. Return with left ulnar index string.

4. Draw the left radial index string through the left thumb loop as follows: Pass left middle finger proximal to left radial index string. Insert it proximally into left thumb loop. Return with left ulnar thumb string to the ulnar side of left radial index string. Hook down this string with the left middle finger. Close finger to the palm.

5. Draw left ulnar thumb string through left middle finger loop as follows: Place palm of left thumb on the distal surface of the left ulnar thumb string, which crosses the back of the left middle finger. Hook down this string through the left middle finger loop. Release left middle finger. Extend left hand with the palm away from you.

6. Transfer right index loop to right middle-ring-little fingers as follows: Insert right middle-ring-little fingers proximally into right index loop. Close the radial index string to the palm and release right index. Release right thumb.

7. Straighten right middle-ring-little fingers by rotating them half a turn in the ulnar direction. Insert right thumb proximally into right middle-ring-little finger loop. Press down ulnar string of the loop to extend the figure. You have A Snake [31]. Draw the hands apart to observe the movements of the snake.

According to another's statement, this figure is called The Snot of a Woman from which a boy grew. With this, the following text is recited:

lE'ntaqlE'ntaqg⁻ōs ălk'ä
Your nose is running, *ălk'ä*.
[*Ălk'ä* is a large mask representing a woman.]

There might be a relationship between this figure and a myth in which a boy grew from the snot of a woman. The following lines from the Bella Bella texts of Franz Boas, describing cat's cradles, may be similar to A Snake:

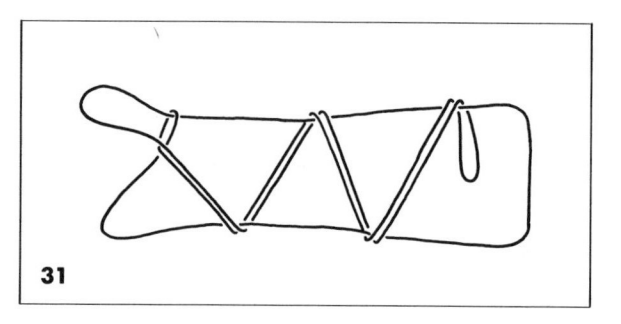

31

It goes down mucus—it goes up mucus.
It goes down mucus—it comes up.

ANALYSIS: [31]

The Kwakiutl Snake [31] is actually a simple variation of Another Deer [33], a figure also known in Alaska (see [33]). Although the exact pattern has not been recorded elsewhere, the general form and action of this figure is widespread throughout the Pacific:

Torres Straits:	– A Sea Snake	(Jayne, fig. 77; Rivers and Haddon, fig. 9)
New Guinea:	– Snake	(Noble 1979, 22) (Jenness, 35)
Gilbert Islands	– Jumping Off	(Maude and Maude, 115)
New Caledonia	– Dance of the New Caledonians	(Maude 1984, 50)

Probably the similarity in name world wide is a direct result of the figure's realistic motion.

32. A Deer

Loop size: medium

1. Opening B.

2. Twist the left thumb loop by rotating the thumb a full turn in the ulnar direction.

3. Pass the left thumb proximal to the left radial index string. Return with left ulnar index string.

4. Draw the left radial index string through the left thumb loop as follows: Pass left middle finger proximal to left radial index string and insert it proximally into left thumb loop. Return with left ulnar thumb string to the ulnar side of left radial index string. Hook down this string with the left middle finger. Close finger to the palm.

5. Draw left ulnar thumb string through left middle finger loop as follows: Place palm of left thumb on the distal surface of the left ulnar thumb string, which crosses the back of the left middle finger. Hook down this string through the left middle finger loop. Release left middle finger and extend left hand with the palm away from you.

6. Transfer right index loop to right middle-ring-little fingers as follows: Insert right middle-ring-little fingers proximally into right index loop. Close the radial index string to the palm. Release right index. Release right thumb.

7. Straighten right middle-ring-little fingers by rotating them half a turn in the ulnar direction. Insert right thumb proximally into right middle-ring-little finger loop. Press down ulnar string of the loop to extend the figure. You have A Deer [32].

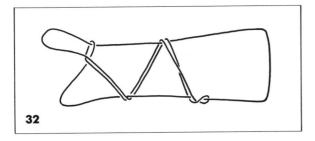

32

ANALYSIS: [32]

The Kwakiutl Deer [32] is a simple variation of Another Deer [33]. It differs from the Kwakiutl Snake [31] solely in the direction the left thumb loop is twisted immediately after the opening movement. This figure shows that strikingly different patterns can arise from very subtle changes in technique. This figure has not been recorded elsewhere.

33. Another Deer

Loop size: medium

1. Opening B.

2. Pass the left thumb proximal to the left radial index string. Return with left ulnar index string.

3. Draw the left radial index string through the left thumb loop as follows: Pass left middle finger proximal to left radial index string and insert it proximally into left thumb loop. Return with left ulnar thumb string to the ulnar side of left radial index string. Hook down this string with the left middle finger. Close finger to the palm.

4. Draw left ulnar thumb string through left middle finger loop as follows: Place palm of left thumb on the distal surface of the left ulnar thumb string, which crosses the back of the left middle finger. Hook down this string through the left middle finger loop. Release left middle finger. Extend left hand with the palm away from you.

5. Transfer right index loop to right middle-ring-little fingers as follows: Insert right middle-ring-little fingers proximally into right index loop. Close the radial index string to the palm. Release right index. Release right thumb.

6. Straighten right middle-ring-little fingers by rotating them half a turn in the ulnar direction. Insert right thumb proximally into right middle-ring-little finger loop. Press down ulnar string of the loop to extend the figure. You have Another Deer [33].

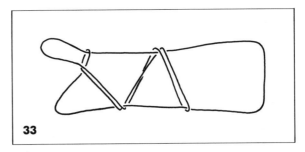

33

ANALYSIS: [33]

Identical patterns: (P101)

Bering:	+	Rabbit	(Jenness, XCI)
Nunivak:	(+)	String Figure Spirit	(Lantis, 6)
North Alaska:	+	Turnstone	(Jenness, XCI)

The Kwakiutl Another Deer [33] figure is identical in pattern and method of construction to Eskimo figures from northern and western Alaska. As previously described, this figure is most likely the original pattern from which the Kwakiutl Snake [31] and Deer [32] were derived. The only other group known to create variations of [33] is the Cape Prince of Wales Eskimo (Bering Group). Their pattern, although identical to the Kwakiutl Lying on the Back in a Canoe [92], is made from [33] (see analysis of [92]).

A similar but nonidentical pattern was found among Athabaskan-speaking Indians of Alaska:

Alaska:	? New Mittens (Tanana tribe)	(Jayne, fig. 826)

Unfortunately, the method of construction was not recorded.

34. Flying Spark

Loop size: large

This figure was known to one elderly man in Alert Bay. No mention of it was made in any other place.

1. Opening B.
2. Insert middle-ring-little fingers into index loops proximally and close radial index strings to the palms.
3. Create middle finger loops as follows: Withdraw middle fingers from the middle-ring-little finger loops and pass them proximal to the short radial index strings, so that these strings rest on the backs of the middle fingers. Bring middle fingers to the center of the figure, to the radial side of the ulnar index string, carrying the radial index strings on their backs. Exchange middle finger loops, inserting middle fingers proximally, passing right loop through left. Close middle fingers to the palms.
4. Draw the ulnar thumb strings through the middle finger loops as follows: Insert middle fingers proximally into thumb loops, and return through middle finger loops with ulnar thumb string. Continue by inserting middle fingers proximally into index loops, and then distally into thumb loops. Close middle fingers to the palm over radial index and ulnar thumb strings.
5. Draw radial thumb string through index loops as follows: Pass indices distal to radial thumb string and to the radial side. Hook back this string through index loops, placing the string on the backs of the indices by rotating indices half a turn in the ulnar direction. Release thumbs.
6. Transfer distal middle finger loops (derived from ulnar thumb strings in step 4) to thumbs, inserting thumbs distally. Release middle fingers.
7. A partner inserts his thumb proximally into the right ring-little finger loop and distally into the left ring-little finger loop, thus allowing the first person to withdraw these fingers. The partner pulls down with his thumb, while the first person points indices away from himself and points thumbs upward to extend the figure. The partner then places a small stick on the strings that pass between the hands, quickly releasing the thumb. The stick will fly off. You have a Flying Spark [34].

34

ANALYSIS: [34]

The Kwakiutl Flying Spark [34] has not been recorded elsewhere. The incorporation of a stick to help demonstrate the action of this figure is unusual but not entirely unknown. The following North American figures also employ a stick:

| Klamath: | "+" | Two Boys Fighting Over an Arrow | (Jayne, fig. 732) |
| Bella Coola: | "+" | Tug of War Over a Stick | (McIlwraith, IX) |

Although the Kwakiutl know the Bella Coola figure (see [73b]), they do not employ a stick to demonstrate its action.

A figure known by name only was recorded among the Tlingit Indians of the Alaskan panhandle. It may be identical to the Kwakiutl Flying Spark [34]:

| Tlingit Indians: | ? | String Basket | (de Laguna, 4) |

The following description of the figure was provided: "A piece of charcoal or other small object was put in the bottom of the 'basket,' and when the two correct strings were jerked, the pellet flew into the air."

The Kwakiutl Flying Spark [34] could easily be interpreted as representing a basket.

35. A Canoe Maker Looks at His Road from the Hill (O'ᵉxalso)

Loop size: small

This figure was learned from an Indian of Turnour Island who said that no one else besides himself knew it. He had learned it as a boy from an old man and kept it as his own figure, and beat other men with it at contests.

1. Opening B.
2. Transfer left thumb loop to left index as follows: Rotate left index a full turn in the ulnar direction, inserting it proximally into the left thumb loop. Release left thumb. The original thumb loop should remain distal to the original index loop.
3. Transfer left index loops to left thumb, inserting thumb distally.
4. Transfer right index loop to right thumb, inserting right thumb proximally.
5. Insert four fingers of each hand distally into both thumb loops. Close the proximal and distal ulnar strings to the palm to extend. The two left radial thumb strings pass between the two right radial thumb strings. You have A Canoe Maker Looks at His Road from the Hill [35a]. To produce the canoe [35b], point elbows in opposite directions and rotate the entire left forearm half a turn in the radial direction, so that the left thumb is pointing downward. To produce the hill [35c], return left hand to normal position. Rotate entire right forearm in the radial direction, so that the right thumb is pointing downward.

35a

35b

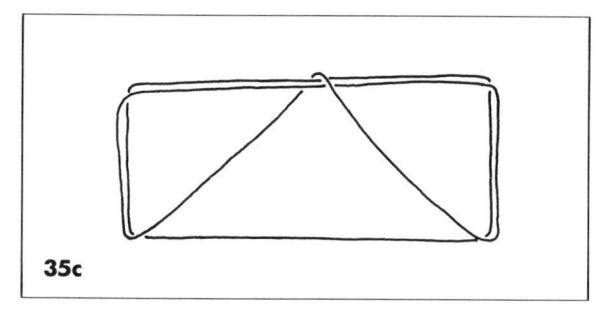

35c

ANALYSIS: [35]

Despite this figure's simplicity, it has not been recorded elsewhere. Comments made by Averkieva's informant would suggest that it is a local invention. String figure contests were likely a rich source of new figures among the Kwakiutl.

36. Ła'sʈanala

Loop size: small

 This figure is a kind of trick. The important element is the speed with which it is produced. No one must notice the way it is made.

1. Opening B.
2. Transfer index loops to thumbs as follows: Pass thumbs proximal to radial index string. Return with ulnar index strings. Release indices.
3. Transfer proximal and distal thumb loops to the four fingers as follows: Insert four fingers of each hand distally into both thumb loops. Close proximal and distal ulnar thumb strings to the palms, permitting the proximal and distal radial thumb strings to slip off the thumbs and onto the backs of the four fingers, but in such a way that the proximal radial thumb string slips over the distal radial thumb string. Straighten the fingers with palms facing you. The loops encircling the four fingers are referred to as hand loops. The distal radial hand string and the proximal ulnar hand string are the transverse strings.

4. Insert left thumb proximally into distal left hand loop. Insert right thumb proximally into proximal right hand loop only. Return, thus creating wrist loops. Close the remaining radial hand strings to the palm with the four fingers of each hand.
5. Exchange wrist loops, inserting hands distally, passing right loop through left. Straighten the four fingers of each hand. Withdraw thumbs from wrist loops, thus allowing them to become hand loops. Extend the figure, pointing the four fingers away from you. Rotate both wrists to the right, then to the left, and repeat. The pattern will expand and contract. You have Ła'sʈanala [36].

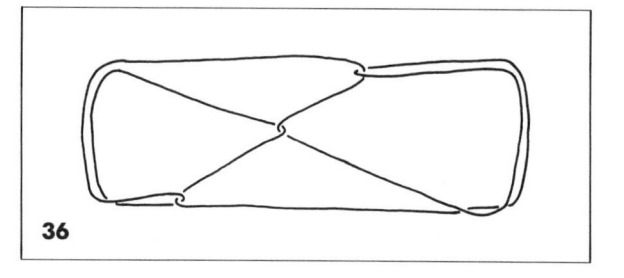

36

ANALYSIS: [36]

Boas was unable to translate the title given to this simple action figure. It has not been recorded elsewhere. No data concerning its occurrence among the Kwakiutl themselves were provided, so one cannot determine if the figure is merely a private invention, as is [35].

37. Two Devil Fish (Series 1)

Loop size: medium

 This figure is one of the most widely distributed figures in the world. Although it is not made the same way everywhere, the pattern is the same. It is surprising not to find it among the Eskimos.

1. Opening A.
2. Draw ulnar thumb strings through little finger

loops as follows: Pass middle fingers distally through little finger loops and then insert them distally into thumb loops, passing them proximal to index loops. Return through little finger loops with ulnar thumb string, placing it on the backs of the middle fingers with half a turn in the ulnar direction.

3. Draw radial little finger string through thumb loops as follows: Pass thumbs proximal to index loops, and insert them distally into little finger loops. Rotate thumbs a full turn in the ulnar direction, catching the radial little finger strings on their backs and allowing the original thumb loops to slip off. Release little fingers. Point fingers away from you, palms facing each other. You have the House of the Devil Fish [37a].

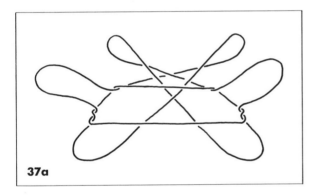

37a

4. Release indices. Point fingers upward and extend. You have Two Devil Fish [37b].

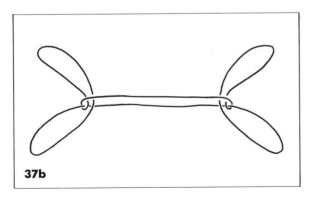

37b

38. Two Devil Fish (Series 2)

Loop size: medium

This figure is the same as the foregoing one, only made differently. It was obtained from a Newettee Indian.

1. Opening A.

2. Draw ulnar little finger string through thumb loop as follows: Pass ring fingers to the ulnar side of ulnar little finger string, then proximal to all other strings. Insert them into thumb loops proximally.

3. With the teeth, grasp the center of the ulnar ring finger string. Release ring fingers.

4. With palms facing you, close the four fingers of each hand over all strings except those forming the teeth loop.

5. Release teeth. Use teeth to grasp all other strings in the center of the figure, letting former teeth-loop hang downward. Release thumbs. Straighten fingers. Extend. Two loops now encircle the ulnar little finger string, passing vertically across the figure. Each loop is composed of a proximal string, below the figure, and a distal string, running across the surface of the figure.

6. Insert middle fingers into little finger loops distally, between the two vertical loops. Then insert them into their respective vertical loops from the inner side. Return with proximal vertical loop strings on their backs. Release teeth. Extend figure. Display the House of the Devil Fish [38a]

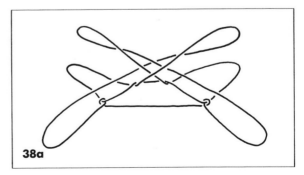

38a

(method 2) by pointing fingers away from you, palms facing each other.

7. Release indices and extend. You have Two Devil Fish [38b].

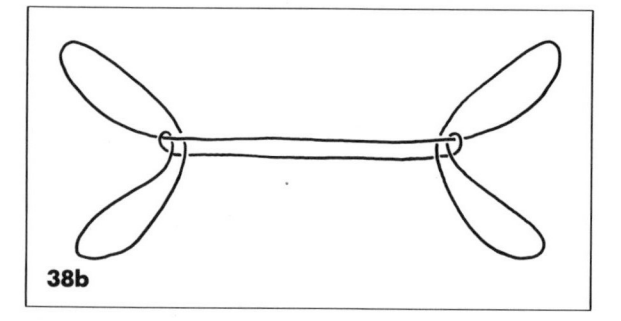

38b

ANALYSIS: [37a, 37b] [38a, 38b]

Although the Kwakiutl Devil Fish Houses [37a, 38a] have not been recorded elsewhere, their dissolution figures are examples of the most widespread string figure in the world, recorded on every inhabited continent. The most common interpretation is that of birds' feet, although many titles exist for this figure.

A representative North American distribution is provided below. A world-wide distribution is beyond the scope of this work, but may be found in Storer (1988).

Cherokee:	— Crow's Feet	(A. Haddon 1903, p. 317)
Virginia:	— Crow's Feet	(Davidson, fig. 143)
Naskapi:	? Birch Trees (Two Branches)	(Speck, 37)
Chipewyan:	? Two Bags with Caribou Blood	(Birket-Smith 1930, fig. 36a)
Navaho:	— Two Hogans	(Jayne, fig. 272)
Iroquois:	? Crow's Feet	(Jayne, p. 121)

This simple figure is remarkable for the number of ways it can be made; nearly all groups have a unique method of construction, some of which require the use of the mouth or toes. The Kwakiutl methods of construction via [37a] or [38a] have not been recorded elsewhere. Either this figure is very ancient or is quite easy to invent. As pointed out by Storer (1988), the novelty of the figure lies in the surprise catching of the strings in the final step; loop releases usually cause a pattern to dissolve.

39. A Butterfly (*Halolo*)

Loop size: large

This figure was known to only two persons in Fort Rupert.

1. Opening A.
2. Pass thumbs distal to index loops and insert proximally into little finger loops. Return with radial little finger strings.
3. Pass middle fingers distal to index loops and insert proximally into proximal thumb loops. Return with proximal ulnar thumb strings. Release thumbs.
4. Draw ulnar little finger string through index loops as follows: Pass thumbs through index loops from the distal side and proximal to ulnar little finger strings. Return through index loops with ulnar little finger string on thumbs' backs. Release little fingers.
5. Enlarge middle finger loops as follows: Rotate middle fingers half a turn in the ulnar direction, closing them to the palm. Insert ring and little fingers proximally into middle finger loops, closing them to the palm.
6. Draw ulnar thumb string through middle-ring-little finger loops as follows: Keeping middle fingers within their loops, pass middle fingers proximal to index loops and insert them distally into thumb loops. Grasp the ulnar thumb strings between tips of middle and ring fingers, and return through middle-ring-little finger loops, releasing ring and little fingers. Close middle fingers to the

palms. Insert ring and little fingers proximally and close them to the palm.

7. A loop encircles each palmar string, having a proximal and distal string, and a radial and ulnar side. Draw proximal string through middle-ring-little finger loops as follows: Withdraw middle fingers from their loops and insert them from the ulnar side into the loops encircling the palmar strings. Grasp the proximal string between the tips of the middle and ring fingers. Return through ring-little finger loops, releasing ring and little fingers. Close middle fingers to the palms. Insert ring and little fingers proximally into middle finger loops and close them to the palm.

8. Draw radial thumb string through index loops as follows: Withdraw middle fingers from their loops and insert them proximally into index loops. Grasp radial thumb string between index and middle fingertips and return through index loops, placing the string on the backs of the indices with a half turn in the ulnar direction. Release thumbs and extend. You have A Butterfly [39].

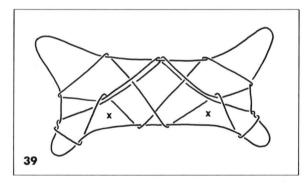

39

Pass thumbs away from you into the triangles marked by an X in the illustration. Release ring and little fingers. Draw the hands apart, and the butterfly will disappear.

40. A Toad

Loop size: large

1. Opening A.

2. Pass thumbs distal to index loops and insert proximally into little finger loops. Return with radial little finger strings.

3. Pass middle fingers distal to index loops and insert proximally into radial thumb loops. Return with radial ulnar thumb strings. Release thumbs.

4. Draw ulnar little finger string through index loops as follows: Pass thumbs through index loops from the distal side and proximal to ulnar little finger strings. Return through index loops with ulnar little finger string on thumbs' backs. Release little fingers.

5. Enlarge middle finger loops as follows: Rotate middle fingers half a turn in the ulnar direction, closing them to the palm. Insert ring and little fingers proximally into middle finger loops, closing them to the palm.

6. Draw ulnar thumb string through middle-ring-little finger loops as follows: Keeping middle fingers within their loops, pass middle fingers proximal to index loops. Insert them distally into thumb loops. Grasp the ulnar thumb strings between tips of middle and ring fingers. Return through middle-ring-little finger loops, releasing ring and little fingers. Close middle fingers to the palms. Insert ring and little fingers proximally and close them to the palm.

7. The loop encircling each palmar string has a proximal and distal string, and a radial and ulnar side. Draw proximal string through middle-ring-little finger loops as follows: Withdraw middle fingers from their loops and insert them from the ulnar side into the loops encircling the palmar strings. Grasp the proximal string between the tips of the middle and ring fingers. Return through ring-little finger loops, releasing ring and little fingers. Close middle fingers to the palms. Insert ring and little fingers proximally into middle finger loops. Close them to the palm.

8. Draw radial thumb string through index loops as follows: Withdraw middle fingers from their loops

and insert them proximally into index loops. Grasp radial thumb string between index and middle fingertips and return through index loops, placing the string on the backs of the indices with a half turn in the ulnar direction. Release thumbs and extend.

9. Rotate entire figure a quarter-turn to the right as follows: Withdraw left little finger from ring–little finger loop. Transfer right ring-little finger loop to left little finger, inserting it proximally and closing the ulnar string to the left palm. Transfer the right index loop to the right ring and little fingers, inserting them distally and closing the ulnar index string to the right palm. Transfer the left index loop to the right thumb, inserting thumb proximally, from the radial side. Transfer left ring finger loop to the left thumb, inserting thumb distally. Extend. You have A Toad [40].

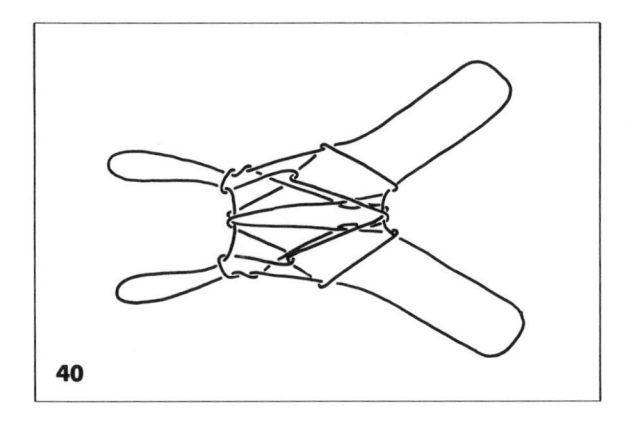

40

41. Laughing in the House (DEsdaᵉleLa)

Loop size: large

1. Opening A.
2. Insert thumbs distally into index loops. Return with ulnar index strings.
3. Pass middle fingers distal to index loops and insert proximally into radial thumb loops. Return

with radial ulnar thumb strings. Release thumbs.

4. Draw ulnar little finger string through index loops as follows: Pass thumbs through index loops from the distal side and proximal to ulnar little finger strings. Return through index loops with ulnar little finger string on thumbs' backs. Release little fingers.

5. Enlarge middle finger loops as follows: Rotate middle fingers half a turn in the ulnar direction, closing them to the palm. Insert ring and little fingers proximally into middle finger loops, closing them to the palm.

6. Draw ulnar thumb string through middle-ring-little finger loops as follows: Keeping middle fingers within their loops, pass middle fingers proximal to index loops. Insert them distally into thumb loops. Grasp the ulnar thumb strings between tips of middle and ring fingers. Return through middle-ring-little finger loops, releasing ring and little fingers. Close middle fingers to the palms. Insert ring and little fingers proximally and close them to the palm.

7. The loop encircling each palmar string has a proximal and a distal string, and a radial and ulnar side. Draw proximal string through middle-ring-little finger loops as follows: Withdraw middle fingers from their loops and insert them from the ulnar side into the loops encircling the palmar strings. Grasp the proximal string between the tips of the middle and ring fingers. Return through ring-little finger loops, releasing ring and little fingers. Close middle fingers to the palms. Insert ring and little fingers proximally into middle finger loops and close them to the palm.

8. Draw radial thumb string through index loops as follows: Withdraw middle fingers from their loops and insert them proximally into index loops. Grasp radial thumb string between index and middle fingertips and return through index loops, placing the string on the backs of the indices with a half turn in the ulnar direction. Release thumbs and extend. You have Laughing in the

House [41]. The exact final configuration will depend on the degree of tension on the strings during the final extension.

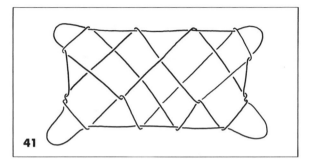

41

42. The Spider's Web

Loop size: large

1. Opening A.
2. Pass thumbs distal to index loops and insert proximally into little finger loops. Return with radial little finger strings.
3. Pass middle fingers distal to index loops and insert proximally into radial thumb loops. Return with radial ulnar thumb strings. Release thumbs.
4. Draw ulnar little finger string through index loops as follows: Pass thumbs through index loops from the distal side and proximal to ulnar little finger strings. Return through index loops with ulnar little finger string on thumbs' backs. Release little fingers.
5. Transfer thumb loops to ring and little fingers as follows: Pass ring and little fingers proximal to middle finger and index finger loops, and insert them proximally into thumb loops. Close radial thumb string to the palm, releasing thumbs.
6. Transfer middle finger loops to thumbs, inserting thumbs proximally. Then insert middle fingers into ring-little finger loop, inserting them proximally. Close them to the palm.

7. Draw ulnar thumb string through middle-ring-little finger loops as follows: Keeping middle fingers within their loops, pass middle fingers proximal to index loops and insert them distally into thumb loops. Grasp the ulnar thumb strings between tips of middle and ring fingers. Return through middle-ring-little finger loops, releasing ring and little fingers. Close middle fingers to the palms. Insert ring and little fingers proximally and close them to the palm.
8. The loop encircling each palmar string has a proximal and distal string, and a radial and ulnar side. Draw proximal string through middle-ring-little finger loops as follows: Withdraw middle fingers from their loops and insert them from the ulnar side into the loops encircling the palmar strings. Grasp the proximal string between the tips of the middle and ring fingers. Return through ring-little finger loops, releasing ring and little fingers. Close middle fingers to the palms. Insert ring and little fingers proximally into middle finger loops and close them to the palm.
9. Draw radial thumb string through index loops as follows: Withdraw middle fingers from their loops and insert them proximally into index loops. Grasp radial thumb string between index and middle fingertips and return through index loops, placing the string on the backs of the indices with a half-turn in the ulnar direction. Release thumbs and extend. You have The Spider's Web [42].

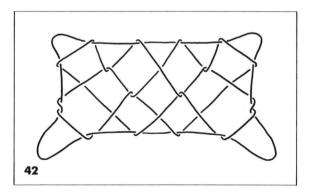

42

43. Two Seals

Loop size: large

1. Opening A.
2. Pass thumbs distal to index loops and insert proximally into little finger loops. Return with radial little finger strings.
3. Pass middle fingers distal to index loops and insert proximally into radial thumb loops. Return with radial ulnar thumb strings. Release thumbs.
4. Draw ulnar little finger string through index loops as follows: Pass thumbs through index loops from the distal side and proximal to ulnar little finger strings. Return through index loops with ulnar little finger string on thumbs' backs. Release little fingers.
5. Transfer thumb loops to ring–little fingers as follows: Pass ring and little fingers proximal to middle finger and index finger loops and insert them proximally into thumb loops. Close radial thumb string to the palm, releasing thumbs.
6. Transfer middle finger loops to thumbs, inserting thumbs proximally. Then insert middle fingers into ring-little finger loop, inserting them proximally, and close them to the palm.
7. Draw ulnar thumb string through middle-ring-little finger loops as follows: Keeping middle fingers within their loops, pass middle fingers proximal to index loops and insert them distally into thumb loops. Grasp the ulnar thumb strings between tips of middle and ring fingers, and return through middle-ring-little finger loops, releasing ring and little fingers. Close middle fingers to the palms. Insert ring and little fingers proximally and close them to the palm.
8. The loop encircling each palmar string has a proximal and distal string, and a radial and ulnar side. Draw proximal string through middle-ring-little finger loops as follows: With-

draw middle fingers from their loops and insert them from the ulnar side into the loops encircling the palmar strings. Grasp the proximal string between the tips of the middle and ring fingers, and return through ring-little finger loops, releasing ring and little fingers. Close middle fingers to the palms. Insert ring and little fingers proximally into middle finger loops and close them to the palm.

9. Draw radial thumb string through index loops as follows: Withdraw middle fingers from their loops and insert them proximally into index loops. Grasp radial thumb string between index and middle fingertips and return through index loops, placing the string on the backs of the indices with a half turn in the ulnar direction. Release thumbs and extend.
10. Turn the figure upside-down as follows: Transfer ring-little finger loops to thumbs, inserting thumbs proximally. Rotate indices half a turn in the ulnar direction, closing them to the palm. Transfer index loops to ring and little fingers, inserting them proximally. Transfer thumb loops to indices, inserting them distally.
11. There is a diamond near each ring-little finger loop. Insert thumbs away from you into its respective diamond. Return with the string forming the outer, upper side of each diamond. (This string wraps around the palmar string and travels to the upper transverse string.)
12. Katilluik, inserting right thumb first. You have Two Seals [43].

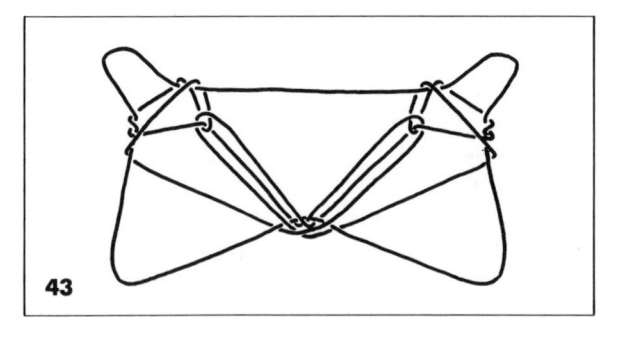

43

ANALYSIS: [39], [41], [42]

Similar patterns (Eskimo): (P106a)

Nunivak:	("+")	Seal Net	(Lantis, 19)
N. Alaska:	"+"	A Fish Net	(Jenness, XLVII)
Mackenzie:	"+"	A Fish Net	(Jenness, XLVII)

Similar or identical patterns:

Klamath:	"+"	Owl's Net	(Jayne, fig. 153)
Navaho:	"+"	Many Stars	(Jayne, figs. 104, 105)
Apache:	("+")	*i-ki-nas-thla'-ni*	(Culin, fig. 1034)
Tigua:	("+")	unnamed	(Culin, fig. 1063)
Bella Coola:	"+"	Butterfly	(McIlwraith, VII)
Br. Guiana:	–	Little Fishes	(Roth 1924, fig. 279)

The Eskimo and British Guiana patterns are identical. The American Southwest patterns (Navaho, Apache, Tigua) are identical to the Kwakiutl Spider's Web [42]. The Bella Coola figure, although similar to the Kwakiutl Butterfly [39], is distinctly different.

With the exception of the Patomana Indian figure from British Guiana, all of the above patterns are formed by closely related methods, methods which the Kwakiutl employ in forming A Butterfly [39], Laughing in the House [41], The Spider's Web [42], and their derivatives [40,43]. The basic unit of weaving which gives rise to this related family of figures consists of steps 1 through 4 of the Kwakiutl Butterfly [39]. This frequently used technique block is therefore given its own name: the *Butterfly Opening*. Small variations of this initial set-up are used to create variant patterns, such as Laughing in the House [41].

Other variants arise from changes made in the way the Butterfly Opening is finished off, (steps 6 and 7 of [39]). This distinct finishing maneuver intertwines the thumb and little finger loops; a manipulation that makes possible the beautiful final extension. Since this technique was also recorded by Jayne (1906:70–73) among the Klamath Indians of the California-Oregon border, the title of *Northwest Coast intertwine* seems appropriate.

Thus, we find that all figures of this family arise from a rendition of the Butterfly Opening followed by the Northwest Coast intertwine, or some variation thereof. The Alaskan Eskimos, after forming a modified Butterfly Opening (thumbs under ulnar index strings in step 2, and little finger loops retained in step 4) finish off their Fish Net with a very crude and awkward manipulation. Northwest Coast intertwine accomplishes the same weaving in a much more efficient manner. It is unclear whether the awkward Eskimo maneuver is the original technique or an approximation of the more elegant Northwest Coast intertwine.

The Northwest Coast intertwine represents a significant breakthrough in the development of string figure technique. In addition to the five Kwakiutl figures cited above, the technique also forms the basis of the entire Tree family of figures [44–47]. The Klamath use it to form the following patterns:

Klamath:	"+"	Owl's Net	(Jayne, fig. 153)
	"+"	Rattlesnake and a Boy	(Jayne, fig. 241)
	"+"	Two Skunks	(Jayne, fig. 252)
	"+"	Two Foxes	(Jayne, fig. 253)
	"+"	Two Squirrels	(Jayne, fig. 256)

The Indians of the American Southwest developed a third way of carrying out the required weaving. The maneuver is not as elegant as the Northwest Coast intertwine, but it is certainly an improvement over the Eskimo method. Their technique involves a Navaho manipulation followed by recovery of the dropped loops with the middle fingers (see Jayne, steps 6 through 7 of Many Stars). Since most believe that the Navaho Indians are descendants of recent immigrants who migrated to the Southwest from the Western regions of subarctic Canada late in the first millennium A.D., it is tempting to speculate that the following relatives of the Many Stars figure are actually variations on an initial Eskimo pattern similar or identical to the Fish Net:

Navaho:	"+"	An Owl	(Jayne, fig. 110)
	"+"	A Second Owl	(Jayne, fig. 112)
	"+"	A Third Owl	(Jayne, fig. 113)
	"+"	Seven Stars	(Jayne, fig. 117)

"+" Two Horned Stars	(Jayne, fig. 122)
"+" Two Coyotes	(Jayne, fig. 131)
"+" Big Star	(Jayne, fig. 133)
"+" North Star	(Jayne, fig. 135)
"+" An Arrow	(Jayne, fig. 301)

It is interesting that the Bella Coola Butterfly pattern is not identical to the Kwakiutl pattern of the same name, despite the close association of their repertoires. The construction method for the Bella Coola Butterfly is quite unusual, employing a rare opening found only in the Kwakiutl Grave of a Child [50] and its Eskimo relatives. The Bella Coola pattern does, however, contain a very crude rendition of the Northwest Coast intertwine. This figure therefore represents either a poorly transmitted version of the Kwakiutl Butterfly [39], or perhaps even a transitional figure intermediate in technique between the Eskimo Fish Net and the Kwakiutl Butterfly family [39–43].

ANALYSIS: [40]

The Kwakiutl Toad [40] is simply the Butterfly [39] rotated a quarter-turn about its center. This rotation technique is quite popular among the Kwakiutl. It is used in the extension of many final patterns [23, 53, 54, 55, 56, 57]. This figure was probably named Toad because of its resemblance to another Kwakiutl pattern of the same name [23]. The Kwakiutl Toad [40] has not been recorded elsewhere.

ANALYSIS: [43]

The Kwakiutl Two Seals [43] is a continuation of the Spider's Web [42]. It is formed by simply inverting the pattern and performing a katilluik maneuver. The figure has not been recorded elsewhere.

44. Two Trees

Loop size: large

1. Opening A.

2. Pass thumbs proximal to index loops and little finger loops and return with ulnar little finger strings.

3. Pass middle fingers away from you, to the ulnar side of the radial little finger strings, then toward you, proximal to the index loops, carrying the radial little finger strings on the middle fingers. Insert middle fingers distally into thumb loops and return to the upright position, placing the ulnar thumb strings on their backs with half a turn in the ulnar direction. You have a large triangle; its base is formed by the proximal radial thumb string, and its sides are formed with the distal radial thumb string.

4. Draw the radial little finger strings through the distal thumb loops as follows: Pass thumbs proximal to index strings, then insert them proximally into middle finger loops. Rotate thumbs one full turn in the ulnar direction, carrying the radial little finger strings on their backs; pass thumbs through the large triangle from its proximal side as the thumbs complete their rotation. This ensures that the radial thumb string remains on the thumbs. You now have two loops on each thumb, the distal loops being quite small. Release middle fingers and extend.

5. Draw proximal ulnar thumb strings through the small distal thumb loops as follows: Pass middle fingers distal to index loops. Insert them distally into the small distal thumb loops only. Pass middle fingers to the ulnar side of the proximal ulnar thumb strings; then insert middle fingers proximally into the proximal thumb loops, very close to the thumbs. Return through distal loops with proximal ulnar thumb strings on the backs of the middle fingers. Release thumbs and extend.

6. Transfer middle finger loops to thumbs, passing thumbs distal to index loops and inserting them into middle finger loops proximally.

7. Transfer little finger loops to ring and middle fingers, inserting ring and middle fingers distally

and closing them to the palm. After the little fingers have been withdrawn, insert them proximally into ring-middle finger loops and close them to the palm.

8. Draw ulnar thumb string through middle-ring-little finger loops as follows: Keeping middle fingers within their loops, pass middle fingers proximal to index loops and insert them distally into thumb loops. Grasp the ulnar thumb strings between tips of middle and ring fingers. Return through middle-ring-little finger loops, releasing ring and little fingers. Close middle fingers to the palms. Insert ring and little fingers proximally and close them to the palm.

9. The loop encircling each palmar string has a proximal and distal string, and a radial and ulnar side. Draw proximal string through middle-ring-little finger loops as follows: Withdraw middle fingers from their loops and insert them from the ulnar side into the loops encircling the palmar strings. Grasp the proximal string between the tips of the middle and ring fingers, and return through the ring-little finger loops, releasing ring and little fingers. Close middle fingers to the palms. Insert ring and little fingers proximally into middle finger loops and close them to the palm.

10. Release indices and extend. You have Two Trees [44].

44

45. Three Trees

Loop size: large

This figure was known to only one woman in Fort Rupert.

1. Opening A.

2. Pass thumbs proximal to index loops and little finger loops and return with ulnar little finger strings.

3. Pass middle fingers away from you, to the ulnar side of the radial little finger strings, then toward you, proximal to the index loops, carrying the radial little finger strings on the middle fingers. Insert middle fingers distally into thumb loops and return to the upright position, placing the ulnar thumb strings on their backs with half a turn in the ulnar direction. You have a large triangle; its base is formed by the proximal radial thumb string, and its sides are formed with the distal radial thumb string.

4. Draw the radial little finger strings through the distal thumb loops as follows: Pass thumbs proximal to index strings, then insert them proximally into middle finger loops. Rotate thumbs one full turn in the ulnar direction, carrying the radial little finger strings on their backs; pass thumbs through the large triangle from its proximal side as the thumbs complete their rotation. This ensures that the radial thumb string remains on the thumbs. You now have two loops on each thumb, the distal loops being quite small. Release middle fingers and extend.

5. Draw proximal ulnar thumb strings through the small distal thumb loops as follows: Pass middle fingers distal to index loops. Insert them distally into the small distal thumb loops only. Pass middle fingers to the ulnar side of the proximal ulnar thumb strings; then insert middle fingers proximally into the proximal thumb loops, very close to the thumbs. Return through distal loops with proximal ulnar thumb

strings on the backs of the middle fingers. Release thumbs and extend.

6. Transfer middle finger loops to thumbs, passing thumbs distal to index loops and inserting them into middle finger loops proximally.

7. Transfer little finger loops to ring and middle fingers, inserting ring and middle fingers distally, and closing them to the palm. After the little fingers have been withdrawn, insert them proximally into ring-middle finger loops and close them to the palm.

8. Draw ulnar thumb string through middle-ring-little finger loops as follows: Keeping middle fingers within their loops, pass middle fingers proximal to index loops and insert them distally into thumb loops. Grasp the ulnar thumb strings between tips of middle and ring fingers. Return through middle-ring-little finger loops, releasing ring and little fingers. Close middle fingers to the palms. Insert ring and little fingers proximally and close them to the palm.

9. The loop encircling each palmar string has a proximal and distal string, and a radial and ulnar side. Draw proximal string through middle-ring-little finger loops as follows: Withdraw middle fingers from their loops and insert them from the ulnar side into the loops encircling the palmer strings. Grasp the proximal string between the tips of the middle and ring fingers, and return through ring-little finger loops, releasing ring and little fingers. Close middle fingers to the palms. Insert ring and little fingers proximally into middle finger loops and close them to the palm.

10. Release right index. Do not extend the figure.

11. Insert right index distally into right thumb loop and close it to the palm. Press the right index against the right middle finger, thus pinching the right ulnar thumb string and right radial little finger string between them.

12. Withdraw left middle finger from left middle-ring-little finger loop and insert it proximally

into left index loop. Bring hands together, grasping between the tips of the left index and middle fingers the two strings held between the tips of the right index and middle fingers. Withdraw right hand from all its loops and allow left index loop to slip off over the strings held between the tips of the left index and middle fingers. Insert right thumb, ring, and little fingers back into their original loops, in the same position they were prior to withdrawing the right hand. Extend the figure. You have Three Trees [45].

45

46. Four Trees

Loop size: large

1. Opening A.

2. Pass thumbs proximal to index loops and little finger loops and return with ulnar little finger strings.

3. Pass middle fingers away from you, to the ulnar side of the radial little finger strings, then toward you, proximal to the index loops, carrying the radial little finger strings on the middle fingers. Insert middle fingers distally into thumb loops and return to the upright position, placing the ulnar thumb strings on their backs with half a turn in the ulnar direction. You have a large triangle; its base is formed by the proximal radial thumb string, and its sides are formed with the distal radial thumb string.

4. Draw the radial little finger strings through the distal thumb loops as follows: Pass thumbs proximal to index strings, then insert them proximally into middle finger loops. Rotate thumbs one full turn in the ulnar direction, carrying the radial little finger strings on their backs; pass thumbs through the large triangle from its proximal side as the thumbs complete their rotation. This ensures that the radial thumb string remains on the thumbs. You now have two loops on each thumb, the distal loops being quite small. Release middle fingers and extend.

5. Draw proximal ulnar thumb strings through the small distal thumb loops as follows: Pass middle fingers distal to index loops. Insert them distally into the small distal thumb loops only. Pass middle fingers to the ulnar side of the proximal ulnar thumb strings, then insert middle fingers proximally into the proximal thumb loops, very close to the thumbs. Return through distal loops with proximal ulnar thumb strings on the backs of the middle fingers. Release thumbs and extend.

6. Transfer middle finger loops to thumbs, passing thumbs distal to index loops and inserting them into middle finger loops proximally.

7. Transfer little finger loops to ring and middle fingers, inserting ring and middle fingers distally and closing them to the palm. After the little fingers have been withdrawn, insert them proximally into ring-middle finger loops and close them to the palm.

8. Draw ulnar thumb string through middle-ring-little finger loops as follows: Keeping middle fingers within their loops, pass middle fingers proximal to index loops and insert them distally into thumb loops. Grasp the ulnar thumb strings between tips of middle and ring fingers. Return through middle-ring-little finger loops, releasing ring and little fingers. Close middle fingers to the palms. Insert ring and little fingers proximally and close them to the palm.

9. The loop encircling each palmar string has a proximal and distal string, and a radial and ulnar side. Draw proximal string through middle-ring-little finger loops as follows: Withdraw middle fingers from their loops and insert them from the ulnar side into the loops encircling the palmar strings. Grasp the proximal string between the tips of the middle and ring fingers, and return through ring-little finger loops, releasing ring and little fingers. Close middle fingers to the palms. Insert ring and little fingers proximally into middle finger loops and close them to the palm.

10. Exchange index loops, inserting indices distally, passing left loop through right.

11. Draw radial thumb string through index loops as follows: Withdraw middle fingers from middle-ring-little finger loops and insert them proximally into index loops. Grasp the portion of the radial thumb string which is close to the thumbs, pinching it between the tips of the indices and middle fingers, and return through the index loops, placing the string on the backs of the indices with half a turn in the ulnar direction. Release thumbs and extend.

12. The former index loops now form a triangle near the base of each index. Insert thumbs away from you into these triangles and return with the short segment of string which passes from radial to ulnar index string near the palmar surface of each index finger.

13. Draw ring-little finger loops through thumb loops as follows: Keeping ring and little fingers within their loops, insert them proximally into thumb loops. Withdraw thumbs from their loops and re-insert them from the opposite side. Insert thumbs proximally into ring-little finger loops. Release ring and little fingers, drawing the loop through the original thumb loop.

14. Transfer thumb loops to ring–little fingers, inserting them proximally. Extend. You have Four Trees [46].

46

47. Two Forked Trees

Loop size: large

1. Opening A.

2. Pass thumbs proximal to index loops and little finger loops and return with ulnar little finger strings.

3. Pass middle fingers away from you, to the ulnar side of the radial little finger strings, then toward you, proximal to the index loops, carrying the radial little finger strings on the middle fingers. Insert middle fingers distally into thumb loops and return to the upright position, placing the ulnar thumb strings on their backs with half a turn in the ulnar direction. You have a large triangle, its base is formed by the proximal radial thumb string, and its sides are formed with the distal radial thumb string.

4. Draw the radial little finger strings through the distal thumb loops as follows: Pass thumbs proximal to index strings, then insert them proximally into middle finger loops. Rotate thumbs one full turn in the ulnar direction, carrying the radial little finger strings on their backs; pass thumbs through the large triangle from its proximal side as the thumbs complete their rotation. This ensures that the radial thumb string remains on the thumbs. You now have two loops on each thumb, the distal loops being quite small. Release middle fingers and extend.

5. Draw proximal ulnar thumb strings through the small distal thumb loops as follows: Pass middle fingers distal to index loops. Insert them distally into the small distal thumb loops only. Pass middle fingers to the ulnar side of the proximal ulnar thumb strings; then insert middle fingers proximally into the proximal thumb loops, very close to the thumbs. Return through distal loops with proximal ulnar thumb strings on the backs of the middle fingers. Release thumbs and extend.

6. Transfer middle finger loops to thumbs, passing thumbs distal to index loops and inserting them into middle finger loops proximally.

7. Transfer little finger loops to ring and middle fingers, inserting ring and middle fingers distally and closing them to the palm. After the little fingers have been withdrawn, insert them proximally into ring-middle finger loops and close them to the palm.

8. Draw ulnar thumb string through middle-ring-little finger loops as follows: Keeping middle fingers within their loops, pass middle fingers proximal to index loops and insert them distally into thumb loops. Grasp the ulnar thumb strings between tips of middle and ring fingers, and return through middle-ring-little finger loops, releasing ring and little fingers. Close middle fingers to the palms. Insert ring and little fingers proximally and close them to the palm.

9. The loop encircling each palmar string has a proximal and distal string, and a radial and ulnar side. Draw proximal string through middle-ring-little finger loops as follows: Withdraw middle fingers from their loops and insert them from the ulnar side into the loops encircling the palmar strings. Grasp the proximal string between the tips of the middle and ring fingers. Return through ring-little finger loops, releasing ring and little fingers. Close middle fingers to the palms. Insert ring and little fingers proximally into middle finger loops and close them to the palm.

10. Draw ring, little finger, and thumb loops through index loops as follows: Pass left index and thumb through right index loop from the distal side. With tips of left index and thumb, grasp the "knot" where the right ulnar thumb string meets the right radial little finger string. Withdraw the entire right hand and draw the "knot" through the former right index loop. Reinsert the right thumb, ring, and little fingers into their own loops as they were prior to withdrawing the hand. Repeat the movement on the left hand, and extend. You have Two Forked Trees [47].

47

ANALYSIS: [44] [45] [46] [47]

The figures comprising the Kwakiutl Tree family [44–47] provide excellent examples of how figures can be created by simply varying the movements used in finishing off the figure. Prior to carrying out the variable final maneuvers, an initial arrangement of strings is first produced by a 9-step procedure which concludes with a Northwest Coast intertwine. Two Trees [44] are then produced by simply releasing the index loops. Three Trees [45] arise if the entire pattern is first drawn through the left index loop prior to releasing the indices. Four Trees [46] are formed if the index loops are uncrossed prior to drawing other strings through them. Finally, Two Forked Trees [47] can be produced if the entire pattern is drawn through both index loops. Dozens of additional variations are possible, as described elsewhere by me (Sherman 1991).

The Kwakiutl Tree family figures have not been recorded elsewhere. The origin of the 9-step procedure common to all four figures is obscure and may represent a local invention which exploits the powerful Northwest Coast intertwine maneuver. A closer examination of the intermediate stages of other Eskimo and Pacific island figures may provide a prototype for this unit.

48. The Double-Headed Serpent (Sisiutl)

Loop size: large

1. Opening A.
2. Pass thumbs distal to index loops and insert them proximally into little finger loops. Return with radial little finger strings.
3. Insert indices proximally into proximal thumb loops. Return with proximal ulnar thumb strings. Release thumbs and extend.
4. Transfer both sets of index loops to thumbs, inserting thumbs proximally so that the proximal index loop becomes the proximal thumb loop, and the distal loop becomes the distal thumb loop.
5. Transfer little finger loops to indices, inserting indices distally.
6. Draw radial index string through both sets of thumb loops as follows: Pass middle fingers proximal to index loops. Insert them proximally into proximal and distal thumb loops, then proximally into index loops. Hook down the radial index string through the thumb loops and close middle fingers to the palms. Insert ring and little fingers proximally into middle finger loops and close them to the palm.
7. Draw distal radial thumb string through index loops as follows: Withdraw middle fingers from middle-ring-little finger loops and insert them

proximally into index loops. Grasp distal radial thumb string between the tips of the indices and middle fingers. Return through index loops, placing the string on the backs of the indices with half a turn in the ulnar direction. Release thumbs from distal loops only.

8. Katilluik, inserting right thumb first. Extend. You have the Double-Headed Serpent [48].

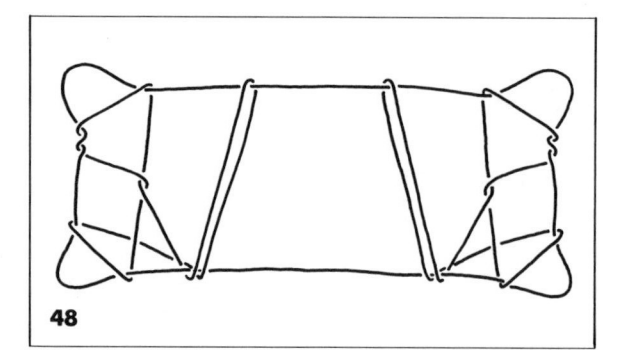

48

ANALYSIS: [48]

Identical patterns: (P1)

Chukchi:	+	Arms	(Jenness, p. 185B)
Nunivak:	+	Arms	(Gordon, fig. 9; Jayne, fig. 809)
Bering:	+	Arms	(Jenness, XXXI)
N. Alaska:	+	Arms	(Jenness, XXXI)
Mackenzie:	+	Arms	(Jenness, XXXI)
W. Copper:	+	Arms	(Jenness, XXXI)
E. Copper:	(+)	Arms	(Rasmussen, 10)
Caribou:	(+)	Arms	(Birket-Smith, fig. 106e; Jenness, XXXI [Boas])
Baffinland:	(+)	Arms	(Jenness, XXXI [Boas])
Netsilik:	+	Arms	(Mary-Rousselière, 57)
Iglulik:	+	Arms	(Mary-Rousselière, 57)
	?	Lemming (upside-down)	(Mathiassen, fig. 196)
	+	Like Walrus Flippers	(Paterson, 1)
Polar:	+	Like Arms	(Paterson, 1)
W. Greenland:	+	Big Arms, Flippers of a Ring Seal	(Paterson, 1)
	(+)	Strong Arms	(Hansen, 6)

The above distribution shows that [48] is one of the most widespread Eskimo figures known. With the exception of Mathiassen's report, the figure is known by the same name and method throughout. The Kwakiutl method of construction is also identical except for slight differences in the exact fingers used to carry out the manipulations (the Eskimos use the middle fingers rather than the index fingers in step 3, and the little fingers rather than the middle fingers in step 6). As discussed in Appendix B below, this distribution suggests a very early date of origin for this figure.

After forming the "arms," the Nunivak Eskimos continue the figure by making the "legs" (Gordon, fig. 10; Jayne, fig. 810). Since Gordon's description is difficult to follow, the method is presented here. After forming the Kwakiutl Sisiutl [48], continue as follows:

9. Transfer thumb loops to indices, inserting them distally.

10. Insert thumbs distally into middle-ring-little finger loops and return with the short strings that cross these loops.

11. Insert thumbs into index loops proximally. Navaho thumbs. Release indices. Extend. You have the Eskimo Legs.

This continuation figure has not been recorded outside Nunivak.

Despite the popularity of this figure, no chant has been recorded. The figures of the Butterfly family [39–43] are somewhat related to [48] in that the first three steps are the same. After step 3 the figures diverge: in the Butterfly family, the ulnar little finger string is drawn through one set of index loops to complete the Butterfly Opening, whereas in Sisiutl [48] the same string is drawn through two sets of

index loops (after transferring them to the thumbs). Therefore, one concludes that the entire Butterfly family of figures may have arisen through variation of the opening movements used to create the widely distributed Arms pattern.

49. Nā⁺nakoma

Loop size: medium

1. Opening A.
2. Transfer little finger loops to thumbs, passing thumbs distal to index loops and inserting them proximally.
3. Draw distal ulnar thumb strings through proximal thumb loops as follows: Pass middle fingers proximal to index loops and insert them proximally into proximal thumb loops. Pass them to the ulnar side of the distal ulnar thumb string and insert them distally into distal thumb loops. Hook down the distal ulnar thumb string through the proximal thumb loop and close middle fingers to the palm. Insert ring and little fingers proximally into middle finger loops and close them to the palm.
4. Transfer proximal thumb loops to indices as follows: Withdraw middle fingers from middle-ring-little finger loops and insert them proximally into index loops. Pass indices and middle fingers distal to distal radial thumb strings. Grasp between their tips the proximal radial thumb string. Lift the string over the distal thumb strings and off the thumb entirely, and return through index loops, placing the loop on the indices by rotating indices half a turn in the ulnar direction.
5. Katilluik, inserting left thumb first. Extend. You have Nā⁺nakoma [49]. The last movement is accompanied by the following chant:

> nā⁺nakoma nā⁺nakoma g·i⁺mpē
> ge·ila⁺ nakola ek·atsesa k·a·tses
> awig·a·lis awi·g·adze
> [No translation is provided by Boas.]

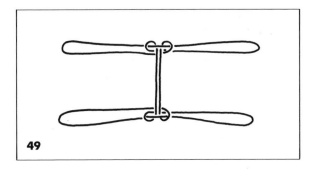

49

ANALYSIS: [49]

Identical patterns: (P52b)

W. Copper:	—	Two Sticks that Support the Lamp	(Jenness, LXXVI, not illustrated)
Iglulik:	—	*Equidlunuk Paluk* (archaic)	(Mary-Rousselière, XVIII)
	(−)	It (loon) Flies Away	(Paterson, 52b)
Polar:	—	It (loon) Flies Away	(Paterson, 52b)
W. Greenland:	—	The Loon	(Paterson, 52b)

Nearly identical patterns (Eskimo):

| N. Alaska: | — | Two Men | (Jenness, LXXVI, fig. 105) |

Nearly identical patterns (Indians and others):

Cahuilla:	—	no name	(James)
Wailaki:	—	*Nisianei* (boy), *Teskiei* (girl)	(Foster)
Navaho:	—	A Worm	(Jayne, fig. 515)
E. New Guinea:	(−)	Echo, or a Man	(Fischer, 32)
New Guinea:	—	Echo, or Imitation	(Noble 1979, 43)

Although the eastern Eskimo figures are identical to Nā⁺nakoma [49], all are made by a method unrelated to that of the Kwakiutl. In addition, all are preceded by another figure variously known as Loon Sitting (W. Greenland), or Two Hips (W. Copper). This suggests that the similarities arose through independent invention. The pattern recorded by Jenness

from North Alaska is nearly identical to the Kwakiutl figure [49], but is actually produced from the Eskimo equivalent of [50a], a figure the Eskimos once again call Two Hips. Clearly, some confusion exists among the North Alaskan and West Copper Eskimos as to which figure represents Two Hips.

The Indians of the American Southwest also produce a figure nearly identical to [49], but by a method unrelated to that of the Kwakiutl. The same applies for the New Guinea examples. It is interesting, however, that on both sides of the Pacific Ocean, supernatural powers are attributed to this figure. The California Indians (Cahuilla, Wailaki) use this figure to predict the sex of an unborn child. Subtle differences in the exact string arrangement during the construction of this figure randomly generate one of two possible patterns, representing either a "boy" or a "girl." Since the performer is unable to predict which pattern will arise, the figure is used for purposes of divination. In New Guinea, this figure is a source of great amusement. After successfully producing this figure, the maker lays the figure on top of his head, which gives him the "power" to imitate his onlookers (see Noble, 1980:2–5 for details).

Unfortunately, Averkieva's informants were not aware of any supernatural powers that may have been associated with this figure at one time. Perhaps a translation of the title and also the chant accompanying this figure would provide insight into the matter (Boas failed to provide a translation in the manuscript). "Grandparent" has been suggested as a possible translation for the title of this figure (Storer, personal communication).

50. A Grave of a Child

Loop size: large

This figure was known to only one woman in Fort Rupert. As the figure is woven, several patterns are generated that closely resemble various finished Eskimo figures.

1. Place loop of string on little fingers only, so that no twists are present.

2. Insert each thumb proximally into its little finger loop. Rotate thumbs a full turn in the ulnar direction, taking up the ulnar little finger string in the process. This creates a ring around each thumb and little finger, as well as a palmar string. Pick up the palmar strings, as in Opening A.

3. Transfer index loops followed by little finger loops to thumbs, inserting thumbs proximally. Make sure that all loops remain well separated on the thumbs.

4. Draw the central and distal ulnar thumb strings through the proximal thumb loop as follows: Insert middle fingers proximally into proximal thumb loops. Pass middle fingers to the ulnar side of the central and distal ulnar thumb strings, and insert distally into the distal and central thumb loops. Hook down the central and distal ulnar strings, closing the middle fingers to the palm. Transfer middle finger loops to ring and little fingers, inserting them proximally and closing them to the palm.

5. Draw the distal radial thumb string through the central thumb loop as follows: Insert index and middle fingers distally into the distal and central thumb loops only. Pass these fingers to the radial side of the central radial thumb string, then grasp between their tips the distal radial thumb string. Return through central loop, placing the string on the backs of the indices with a half turn in the ulnar direction. Release thumbs from the distal and central loops only.

6. Katilluik, inserting right thumb first. Extend.

7. Transfer thumb loops to indices, inserting them distally. Extend. (You have the Eskimo Two Hips [50a].)

8. Pass thumbs proximal to the central string that runs parallel to the upper transverse string, and return with it on their backs.

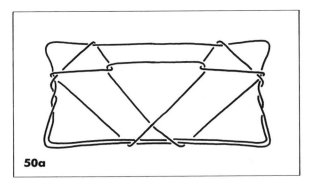

50a

9. Draw radial index strings through thumb loops as follows: Insert thumbs proximally into index loops and return through thumb loops with radial index string. Release indices and extend. Transfer thumb loops to indices, inserting indices proximally.

10. Two diagonal strings lie on the backs of the ring and little fingers on each hand. One set runs across the radial side of the pattern; the other set runs across the ulnar side. Pass thumbs proximal to the radial diagonal strings and return with them on the thumb backs.

11. Katilluik, inserting right thumb first. Extend.

12. At the center of the figure, two strings cross to form an X. Pass middle fingers toward you, proximal to the upper legs of the X, and return with these strings on their backs. Insert indices proximally into middle finger loops.

13. Draw the ulnar thumb strings through the index and middle finger loops as follows: Insert middle fingers proximally into the small thumb loops, close to the thumbs, and grasp the ulnar thumb strings between the tips of the indices and middle fingers. Return through index-middle finger loops, placing the strings on the backs of the indices by rotating indices half a turn in the ulnar direction. Release thumbs and extend.

14. In the center of the figure is a perfect triangle with its apex pointing upward. Pass thumbs proximal to the single string forming the base of this triangle. Return with this string on the backs of the thumbs.

15. Draw the radial index strings through thumb loops as follows: Insert thumbs proximally into index loops. Return through thumb loops with radial index strings. Release indices and extend.

16. You have a transverse string that runs across the middle of the figure along the ulnar side of the pattern, parallel to the upper and lower transverse strings. Draw this string through the ring-little finger loops as follows: Withdraw little fingers from the ring-little finger loops and insert them distally into ring finger loops. Pass little fingers to the ulnar side of the middle transverse string, and hook it down to the palms, passing through the ring finger loops. Release ring fingers and insert them proximally into little finger loops. Extend. The hole in the middle of the figure is the Grave of a Child [50b]. The double strings running across the thumb loops are the parents crying on their child's grave.

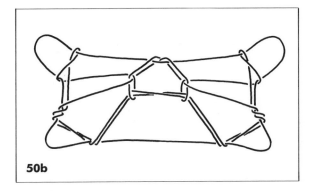

50b

ANALYSIS: [50]

Identical pattern after step 15: (P20a)

Nunivak:	+	*Tu'vax* (name of a man)	(Lantis, 12)
Bering:	+	*Tegvaq* (archaic)	(Jenness, LXXVIII, fig. 107)

N. Alaska:	+	Sealer's Two Snowshoes	(Jenness, LXXVIII, fig. 107)
Mackenzie:	+	(intermediate stage)	(Jenness, LXXVIII, fig. 107)
W. Copper:	+	Two Men Sealing	(Jenness, LXXVIII, fig. 107)
E. Copper:	(+)	Little Piece of Firm Ice	(Rasmussen, 39)
Caribou:	(+)	Ice	(Birket-Smith, fig. 105b)
Baffinland:	(+)	*Gowatcheak* (archaic)	(Jenness, LXXVIII, [Boas])
Netsilik:	+	The Hunter	(Mary-Rousselière, 76)
Iglulik:	+	Like a Man Sealing on Ice	(Paterson, 20a)
	(+)	Piece of Cut Ice, Dog	(Mathiassen, p.223)
Polar:	+	Like a Man Sealing on Ice	(Paterson, 20a; Holtved, 31)
W. Greenland:	+	Two Men Sealing on Ice	(Paterson, 20a)

The pattern produced after step 7 [50a], though not recognized as an individual string figure by the Kwakiutl and many Eskimos, is acknowledged by some: (P52c)

N. Alaska:	+	Two Hips	(Jenness, LXXVI, fig. 104)
W. Copper:	+	Two Hips (slightly modified)	(Jenness, LXXVI)

The Two Hips / Sealer series is known to virtually all Eskimos, with all groups constructing it identically. The Eskimos differ, however, in the number of dissolution figures they acknowledge after the initial Sealer is made (see Paterson 1949:22). The gradual change in name as one proceeds from west to east across the Arctic is fascinating. Mary-Rousselière attributes this change to cumulative mistranslations of the Alaskan word for "hunter." The figure is clearly very old.

The Kwakiutl method of construction differs only slightly from the Eskimo method. The Kwakiutl perform a full katilluik maneuver in step 11, which is only partially carried out in the Eskimo method (the Eskimos omit the thumb loop exchange). Unfortunately, this creates some extra work for the Kwakiutl, who must perform two additional steps (12 and 13) before resuming the simpler Eskimo method.

As described above, the figure produced after step 15 is identical to the first figure in the Eskimo Sealer series. But the Kwakiutl do not acknowledge this as a distinct figure. Rather, they "finish" the figure with one additional step, which involves drawing the central transverse string through the middle-ring-little finger loops. This produces A Grave of a Child [50b], a figure unrecorded elsewhere.

51. The "Eagle" Series

Loop size: large

This figure was known to only a few people in Fort Rupert.

1. Opening A.
2. Transfer index loops followed by little finger loops to the thumbs, inserting thumbs proximally each time. Keep loops well separated.
3. Draw distal ulnar thumb string through proximal and central thumb loops as follows: Insert index and middle fingers into proximal and central thumb loops proximally. Grasp between index and middle fingertips the distal ulnar thumb string, and return through proximal and central loops, closing middle fingers to the palm. Transfer middle finger loops to the ring and little fingers, inserting them proximally and closing them to the palm.
4. Draw proximal radial thumb string through central and distal thumb loops as follows: Insert index and middle fingers distally into distal and central thumb loops. Grasp between index and

middle fingertips the proximal radial thumb string. Return through central and distal loops, placing the string on the backs of the indices with a half turn in the ulnar direction. Release thumbs and extend. (You have a figure known to the Eskimos as the Burbot [51a].)

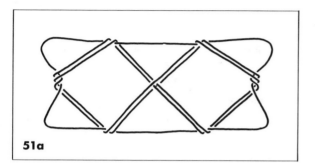

51a

5. A set of double strings runs on each side of the figure, from the upper transverse string to the palmar strings. One of these pairs passes around the palmar string once, while the other pair twists around the palmar string. Pass thumbs proximal to these double strings, and return with the former pair of strings described above.

6. Katilluik, inserting right thumb first. Extend.

7. There are triangular patterns on each end of the figure which the Eskimos call "eyes." Draw the radial thumb strings through the "eyes" as follows: Insert indices from the ulnar side into the eyes, then proximally into the thumb loops. Rotate indices a full turn in the radial direction, drawing the radial thumb strings through the eyes. Release thumbs and extend. The eyes are now slightly modified.

8. Insert thumbs from the radial side into the eyes, and return with the double vertical strings on their backs. Exchange double thumb loops, inserting thumbs proximally passing right loops through left. Extend.

9. Draw radial index string through double thumb loops as follows: Insert thumbs proximally into

index loops and return through thumb loops with radial index strings on thumbs' backs. Release indices and extend. You have Two Eagles Sitting in a Nest [51b].

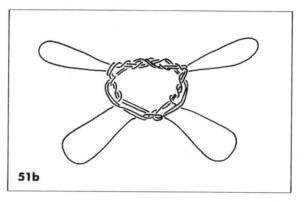

51b

10. Transfer thumb loops to indices, inserting indices distally.

11. Near the center of the figure, double strings run across the ring-little finger loops on the radial surface of the pattern, and a similar set of double strings runs on the ulnar surface. Insert thumbs distally into ring-little finger loops, and return with the double strings that run across the radial surface of the pattern.

12. Katilluik, inserting right thumb first. Release indices and extend. You have An Eagle on Each End of the Figure. They Are Eating [51c].

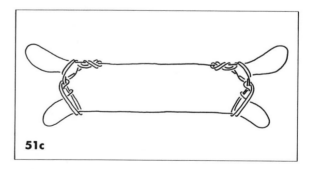

51c

13. Transfer thumb loops to indices, inserting indices proximally.

14. Insert thumbs from the radial side into the center of the figure, between the upper and lower transverse strings. Release ring and little fingers. Draw hands apart, catching the lower transverse string on the thumbs. You have The Eagles Fly and Sit Down on the Tree [51d].

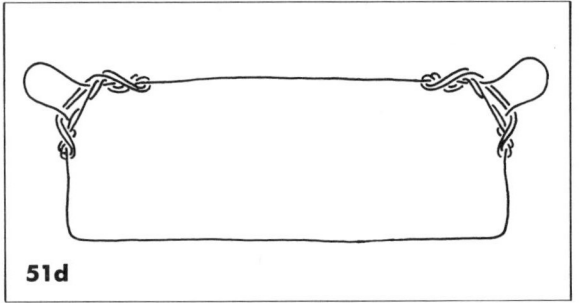

51d

ANALYSIS: [51]

[51a], identical patterns: (P105)

N. Alaska:	+	Burbot (a fish)	(Jenness, XXXIX)
Navaho:	+	Twin Stars	(Jayne, fig. 289)
New Hebrides:	+	*Kombe*	(Dickey, fig. 106)

After step 6, identical pattern:

Bering:	+	Eyes	(K. Haddon 1930, 8a)

[51b], identical patterns:

Bering:	+	Mouth	(K. Haddon 1930, 8b)
Bella Coola:	+	Eagle's Nest	(McIlwraith, XVI)

[51c], identical patterns: (P15)

Chukchi:	(+)	*Marark*	(Jenness, XLI)
Nunivak:	(+)	Two Ptarmigans	(Lantis, 14)
N. Alaska:	+	Hair puller	(Jenness, XLI)
Mackenzie:	+	Hair puller	(Jenness, XLI)
Caribou:	(+)	A Man Pulling Another by the Hair	(Birket-Smith, p. 279)

Baffinland:	(+)	Hair Puller	(Jenness, XLI [Boas])
Netsilik:	+	The Two Who Pull Hair	(Mary-Rousselière, 80)
Iglulik:	+	Like Two Women Pulling Hair	(Paterson, 15; Mary-Rousselière, 80)
Polar:	+	Like Two Women Pulling Hair	(Paterson, 15)
W. Greenland:	+	Two Women Pulling Hair; Two Fat Men	(Paterson, 15; Holtved, 25)

[51d], identical pattern:

Nunivak:	(+)	Two Ptarmigans Flying	(Lantis, 14a)

Various patterns in the Kwakiutl Eagle series [51a–d] are known to nearly all Eskimos. The Kwakiutl method is used throughout. As with the Sealer series, however, not all groups acknowledge each pattern in the series as a distinct figure. The Bering Eskimos even acknowledge a fifth pattern, which the Kwakiutl do not (Eyes, after step 6). In addition, they stop after forming [51b], which they call the Mouth. As shown above, most Eskimos do not acknowledge any of the patterns formed prior to [51c], a figure consistently interpreted as Hair Pulling. Jenness was able to record the following chant from North Alaska:

Hair pulling, hair pulling,
The other wife's hair, she pulled it.
Because she would not bring water,
Because she would not bring wood,
She pulled her hair.

The Kwakiutl acknowledge more separate figures than do any other group. Even the neighboring Bella Coola stop after forming [51b], a figure they also call Eagle's Nest. Remarkably, only on Nunivak Island and Vancouver Island does one encounter [51d]. The similarity in names, both of which describe birds that fly away, suggests intimate contact between the Kwakiutl and Yupik-speaking Eskimos of Southwest Alaska at some point in time.

Finally, one should note that [51a] is acknowledged as a separate figure only by the Eskimos of North Alaska and the Navaho Indians. This may indicate that this figure accompanied the ancestors of the Navaho on their migration from the subarctic regions of western Canada to the American Southwest. However, one must never rule out the possibility of independent invention, since the exact figure and method have also been reported from the South Pacific.

52. Two Bears

Loop size: large

This figure was learned in Fort Rupert from a young Indian woman.

1. Opening A.
2. Transfer index loops followed by little finger loops to the thumbs, inserting thumbs proximally each time. Keep loops well separated.
3. Draw distal ulnar thumb string through proximal and central thumb loops as follows: Insert index and middle fingers into proximal and central thumb loops proximally. Grasp between index and middle fingertips the distal ulnar thumb string, and return through proximal and central loops, closing middle fingers to the palm. Transfer middle finger loops to the ring and little fingers, inserting ring and little fingers proximally and closing them to the palm.
4. Draw proximal radial thumb string through central and distal thumb loops as follows: Insert index and middle fingers distally into distal and central thumb loops. Grasp between index and middle fingertips the proximal radial thumb string, and return through central and distal loops, placing the string on the backs of the indices with a half turn in the ulnar direction. Release thumbs and extend.
5. Four strings cross at the center of the figure,

forming a very small diamond that is hardly visible unless the strings are mechanically separated. Draw the radial index strings through this diamond as follows: Pass thumbs from the radial side through the diamond and insert them distally into index loops. Rotate thumbs a full turn in the ulnar direction, catching the radial index strings on their palms and drawing them through the small diamond at the center of the figure. Release indices and extend.

6. At each end of the figure, two loops encircle the lower transverse string. The loop nearest the center of the figure encircles both upper and lower transverse strings, while the loop nearest the hand encircles the lower transverse string only. Pass indices from the ulnar side between the two loops described above, distal to the lower transverse string, then pass them through the center of the figure from the radial side, between the upper and lower transverse strings, and finally to the ulnar side of the upper transverse string. Rotate indices a full turn in the radial direction, catching the upper transverse string on their palms and drawing it through the other loops encircling the indices. Release thumbs and extend. You have Two Bears [52].

52

ANALYSIS [52]

After step 5, identical pattern: (P118)

E. Greenland: + *Katizi*[t] (archaic) (Victor, 14)

Identical final pattern, but facing the opposite direction: (P192b)

| N. Alaska: | – | Two Brown Bears that Came Out of a Cave | (Jenness, LXI) |

Nearly identical patterns: (P8)

Bering:	–	Two Caribou without Their Horns	(Jenness, I)
N. Alaska:	–	Two Brown Bears	(Jenness, I)
Mackenzie:	–	Two Brown Bears	(Jenness, I)
W. Copper:	–	Two Brown Bears	(Jenness, I)
E. Copper:	(–)	Little Black Bears	(Rasmussen, 14)
Caribou:	(–)	Two Brown Bears	(Birket-Smith, p. 279)
Baffinland:	(–)	*Aktakjew* (archaic)	(Jenness, I [Boas])
Netsilik:	–	Two Brown Bears	(Mary-Rousselière, 7)
Iglulik:	(–)	Brown Bear without Head	(Mathiassen, p. 222)
	–	Big Black Bear	(Paterson, 8)
Polar:	–	Two Brown Bears	(Paterson, 8)
		Axtarsung (archaic)	(Holtved, 22)
Klamath:	–	Two Foxes	(Jayne, fig. 253)

At first glance, the Kwakiutl Two Bears [52] appears to be identical to the common Eskimo pattern of the same name. But a close examination of the strings reveals that it is significantly different. This becomes more apparent when one examines the methods of construction: the Kwakiutl figure is actually a continuation of the Burbot pattern [51a], whereas the Eskimo figures arise from a totally independent technique. What is remarkable is that other members of Northwest Coast society (i.e., the Klamath) employ the Eskimo method to construct this type of pattern, rather than the Kwakiutl method. Also intriguing is the observation that the isolated Eskimos of East Greenland know steps 1 through 5 of the Kwakiutl Two Bears figure [52], but not step 6. They have long since forgotten the meaning of the title attached to this remnant.

Another interesting aspect of this figure is the variability inherent in the final pattern; the figure produced during any given attempt does not always match the drawing provided herein. For a complete discussion of this problem, see the analytical comments following The Dog Salmon [84].

53. Sun, Moon, and Star

Loop size: medium

1. Opening A.

2. Pass thumbs proximal to index loops and insert them proximally into little finger loops. Return with radial little fingers strings. Insert little fingers distally into index loops and close ulnar index strings to the palm, allowing ulnar little finger string to slip off.

3. Draw proximal ulnar thumb strings through little finger loops as follows: Insert middle fingers proximally into little finger loops, then distally into proximal thumb loops, carrying on their backs the transverse string (former ulnar little finger string). Rotate middle fingers half a turn in the ulnar direction, drawing proximal ulnar thumb string through little finger loops. Release little fingers, extend, and close middle fingers to the palm. Insert ring and little fingers proximally into middle finger loops and close them to the palm.

4. Release indices.

5. Draw proximal radial thumb string through distal thumb loop as follows: Withdraw middle fingers from middle-ring-little finger loops. Insert the index and middle fingers distally into the distal thumb loops. Grasp the proximal radial thumb string between index and middle fingertips, and return through distal thumb loop, placing the string on the backs of the indices with a half turn in the ulnar direction. Release thumbs and extend.

6. Two loops encircle each palmar string; a distal loop, whose ulnar string runs straight across the figure, and a proximal loop, whose ulnar strings originate from the ulnar little finger strings. Insert thumbs proximally into the proximal loops

that encircle the palmar strings, and return with the radial strings.

7. Katilluik, inserting left thumb first. Extend the figure slightly.

8. Rotate the entire figure a quarter-turn to the right as follows: Withdraw left little finger from left ring-little finger loop. Transfer right ring-little finger loop to left little finger, inserting it proximally. Transfer right thumb loop to right ring and little fingers, inserting them distally. Transfer left thumb loop to right thumb, inserting right thumb proximally. Transfer left ring finger loop to left thumb, inserting thumb distally. Extend loosely. You have Sun (the triangle at the right end of the figure), Moon (a knot on the left little finger strings), and Star (a knot on the middle of the thumb strings)[53].

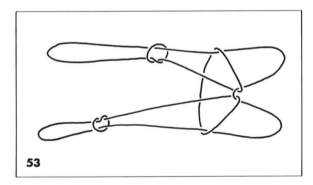

53

The following chant was collected. It appears to refer to this figure:

p!ămxsâliłEla
ē'xEnt!ēnoxᵘ maᵉlō'χᵘ ts!ē'daq
L!ē'sElabalis ᵉmEkŭ'labilis t!ō't!obalis
Putting arms through
Two women always menstruating
Never ending, like the sun, moon, and stars

54. Moon and Stars

Loop size: medium

This figure was known to only two women, one from Quatsino, and the other from Blunden Harbor.

1. Opening A.

2. Pass thumbs proximal to index loops and insert them proximally into little finger loops. Return with radial little finger strings. Insert little fingers distally into index loops and close ulnar index strings to the palm, allowing ulnar little finger string to slip off.

3. Draw proximal ulnar thumb strings through little finger loops as follows: Insert middle fingers proximally into little finger loops, then distally into proximal thumb loops, carrying on their backs the transverse string (former ulnar little finger string). Rotate middle fingers half a turn in the ulnar direction, drawing proximal ulnar thumb string through little finger loops. Release little fingers, extend, and close middle fingers to the palm. Insert ring and little fingers proximally into middle finger loops and close them to the palm.

4. Release indices.

5. Draw proximal radial thumb string through distal thumb loop as follows: Withdraw middle fingers from middle-ring-little finger loops. Insert the index and middle fingers distally into the distal thumb loops. Grasp the proximal radial thumb string between index and middle fingertips, and return through distal thumb loop, placing the string on the backs of the indices with a half turn in the ulnar direction. Release thumbs and extend.

6. Rotate entire figure a quarter-turn to the right as follows: Withdraw left little finger from left ring-little finger loop. Transfer right ring-little finger loop to left little finger, inserting it proximally. Transfer right index loop to right ring and little fingers, inserting them distally. Transfer left index loop to right thumb, inserting thumb proximally. Transfer left ring finger loop to left thumb, inserting thumb distally. Extend. You have the Moon on the right side of the figure, and Stars on the left [54].

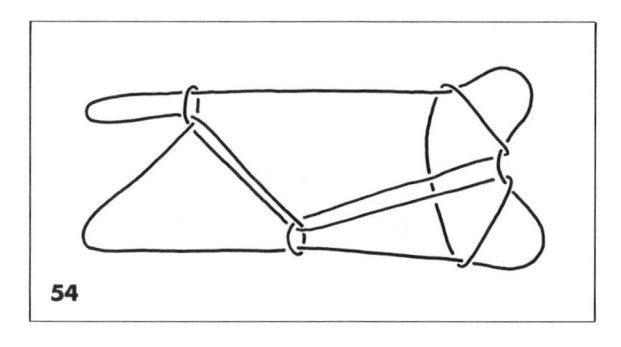

54

55. A Swollen Stomach (Qoqwi)

Loop size: medium

1. Opening A.
2. Pass thumbs proximal to index loops and insert them proximally into little finger loops. Return with radial little finger strings. Insert little fingers distally into index loops and close ulnar index strings to the palm, allowing ulnar little finger string to slip off.
3. Draw proximal ulnar thumb strings through little finger loops as follows: Insert middle fingers proximally into little finger loops, then distally into proximal thumb loops, carrying on their backs the transverse string (former ulnar little finger string). Rotate middle fingers half a turn in the ulnar direction, drawing proximal ulnar thumb string through little finger loops. Release little fingers, extend, and close middle fingers to the palm. Insert ring and little fingers proximally into middle finger loops and close them to the palm.
4. Release indices.
5. Draw proximal radial thumb string through distal thumb loop as follows: Withdraw middle fingers from middle-ring-little finger loops. Insert index and middle fingers distally into the distal thumb loops. Grasp the proximal radial thumb string between index and middle fingertips, and return through distal thumb loop, placing the string on the backs of the indices with a half turn in the

ulnar direction. Release thumbs and extend.
6. Near each index finger is a triangle. Its apex crosses the upper transverse string, and its base is formed by a single straight string running along the ulnar surface of the figure, parallel to the upper transverse string. Pass thumbs proximal to the bases of each triangle, then insert thumbs into triangles from the ulnar side. Return each thumb with the string that forms the base of each triangle.
7. Draw radial index strings through thumb loops as follows: Insert thumbs proximally into index loops and return through thumb loops with radial index string. Release indices.
8. Rotate the entire figure a quarter-turn to the right as follows: Withdraw left little finger from left ring-little finger loop. Transfer right ring-little finger loop to left little finger, inserting it proximally. Transfer right thumb loop to right ring and little fingers, inserting them distally. Transfer left thumb loop to right thumb, inserting right thumb proximally. Transfer left ring finger loop to left thumb, inserting thumb distally. Extend. You have A Swollen Stomach [55].

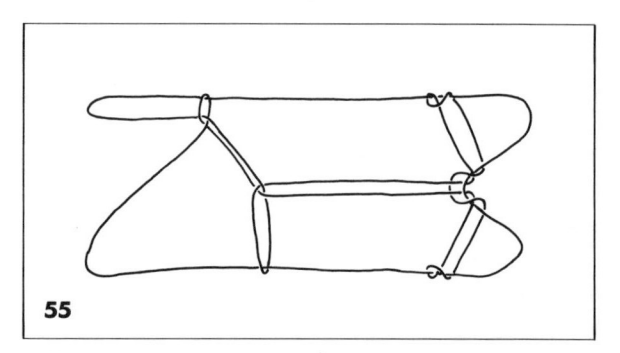

55

56. A Toad and a Man Ahead of It

Loop size: medium

1. Opening A.
2. Pass thumbs proximal to index loops and insert

them proximally into little finger loops. Return with radial little finger strings. Insert little fingers distally into index loops and close ulnar index strings to the palm, allowing ulnar little finger string to slip off.

3. Draw proximal ulnar thumb strings through little finger loops as follows: Insert middle fingers proximally into little finger loops, then distally into proximal thumb loops, carrying on their backs the transverse string (former ulnar little finger string). Rotate middle fingers half a turn in the ulnar direction, drawing proximal ulnar thumb string through little finger loops. Release little fingers, extend, and close middle fingers to the palm. Insert ring and little fingers proximally into middle finger loops and close them to the palm.

4. Release indices.

5. Draw proximal radial thumb string through distal thumb loop as follows: Withdraw middle fingers from middle-ring-little finger loops. Insert the index and middle fingers distally into the distal thumb loops. Grasp the proximal radial thumb string between index and middle fingertips and return through distal thumb loop, placing the string on the backs of the indices with half a turn in the ulnar direction. Release thumbs and extend.

6. Near each index finger is a triangle. Its apex crosses the upper transverse string, and its base is formed by a single straight string running along the ulnar surface of the pattern, parallel to the upper transverse string. Pass thumbs proximal to the short segment of the middle transverse string that lies between the two triangles. Return with it on the thumbs' backs.

7. Draw radial index strings through thumb loops as follows: Insert thumbs proximally into index loops and return through thumb loops with radial index string. Release indices.

8. Rotate the entire figure a quarter-turn to the right as follows: Withdraw left little finger from left ring-little finger loop. Transfer right ring-

little finger loop to left little finger, inserting it proximally. Transfer right thumb loop to right ring–little fingers, inserting them distally. Transfer left thumb loop to right thumb, inserting right thumb proximally. Transfer left ring finger loop to left thumb, inserting thumb distally. Extend. You have a Toad and a Man Ahead of It [56] (man on the left; toad on the right).

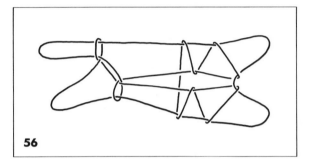

56

57. A Toad (Wak!es)

Loop size: large (use a thin string)

This figure was known by only one woman from Newettee. She was living lately in Alert Bay.

1. Opening A.

2. Pass thumbs proximal to index loops and insert them proximally into little finger loops. Return with radial little finger strings. Insert little fingers distally into index loops and close ulnar index strings to the palm, allowing ulnar little finger string to slip off.

3. Draw proximal ulnar thumb strings through little finger loops as follows: Insert middle fingers proximally into little finger loops, then distally into proximal thumb loops, carrying on their backs the transverse string (former ulnar little finger string). Rotate middle fingers half a turn in the ulnar direction, drawing proximal ulnar thumb string through little finger loops. Release little fingers, extend, and close middle fingers to

the palm. Insert ring and little fingers proximally into middle finger loops and close them to the palm.

4. Release indices.

5. Draw proximal radial thumb string through distal thumb loop as follows: Withdraw middle fingers from middle-ring-little finger loops. Insert the index and middle fingers distally into the distal thumb loops. Grasp the proximal radial thumb string between index and middle fingertips, and return through distal thumb loop, placing the string on the backs of the indices with a half turn in the ulnar direction. Release thumbs and extend.

6. Near each index finger is a triangle. Its apex crosses the upper transverse string, and its base is formed by a single straight string running along the ulnar surface of the pattern, parallel to the upper transverse string. Pass thumbs proximal to the short segment of the middle transverse string that lies between the two triangles, and return with it on the thumbs' backs.

7. Draw radial index strings through thumb loops as follows: Insert thumbs proximally into index loops and return through thumb loops with radial index string. Release indices.

8. Rotate the entire figure a quarter-turn to the right as follows: Withdraw left little finger from left ring-little finger loop. Transfer right ring-little finger loop to left little finger, inserting it proximally. Transfer right thumb loop to right ring and little fingers, inserting them distally. Transfer left thumb loop to right thumb, inserting right thumb proximally. Transfer left ring finger loop to left thumb, inserting thumb distally. Extend.

9. Two loops encircle the right palmar string; a proximal and a distal loop. Pass right middle finger, from the ulnar side, between these two loops. Close the right palmar string (the short segment between the loops) to the palm.

10. Keeping the hands pointed away from you, pass left middle finger to the right, behind the figure, and insert left middle finger proximally into right ring-little finger loop. Pass middle finger to the radial side of the proximal right palmar loop, and to the ulnar side of the distal right palmar loop. Rotate left middle finger one full turn in the radial direction, thus drawing both strings of the distal loop through the right ring-little finger loop. Do not extend. Return hands to their upright position.

11. Draw right middle finger loop through both left middle finger loops as follows: Insert left thumb proximally through both loops of the left middle finger. Note that the right middle finger is still closed to the palm at this point. Transfer the small right middle finger loop to left thumb by passing the left thumb to the ulnar side of the right middle finger loop, and inserting the thumb into the loop distally. Return through both loops of the left middle finger. Release left middle finger.

12. Transfer left thumb loop to right thumb, inserting thumb proximally. Navaho right thumb. Release right ring and little fingers, and insert them distally into right thumb loop, closing the ulnar string to the right palm. Extend the pattern at the middle of the figure so that all strings will be distinct and their weaving visible. You have A Toad [57]. Gradually pull the thumb string to the right. The figure will move to the left. The movement is accompanied by a chant:

tsagi tsagi tsagi
Ribbit, ribbit, ribbit

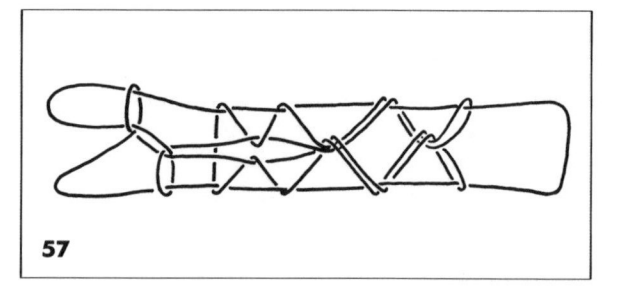

57

ANALYSIS: [53], [54], [55], [56], [57]

Identical pattern: [55]

Bella Coola: + The Cripple (McIlwraith, XVII)

Similar pattern: [56]

Solomon Is.: – *Toronii'a Pari* (Maude, 62, ill. p. 89)

The Kwakiutl Sun, Moon, and Stars family [53–57] consists of one basic pattern [54] and four variations [53, 55, 56, 57]. Only one member of this family, Swollen Stomach [55], has been recorded elsewhere. The Bella Coola interpretation of this figure is similar to that of the Kwakiutl in that the pattern at the right side of the figure represents a man with an umbilical hernia (Kwakiutl: Swollen Stomach). According to the Bella Coola, the left side represents a cripple. Their chant is as follows:

> Hi! Hi! Hi! Hurry up, you cripple.
> Don't say that, you man with umbilical hernia.
> Hi! Hi! Hi!

The Bella Coola method of construction for the Cripple is identical to that of the Kwakiutl Swollen Stomach [55], except for minor differences in step 7. It is also interesting that all of Averkieva's informants for this family of figures were from north of Fort Rupert. Only one woman knew a Toad [57]. Perhaps the entire family is rather new to the area.

Several novel string configurations can be found in this family of patterns. Loose knots, previously encountered in [17b] as Skulls, here represent celestial bodies, (Sun, Moon, and Star [53]; Moon and Stars [54]). It is worth noting that the Bella Coola interpretation of [17b] is also Stars. As in [23], a symmetrical zig-zag pattern is consistently interpreted by the Kwakiutl as representing the hind legs of a Frog or Toad (A Toad and a Man Ahead of It [56]). The Kwakiutl Toad [57] is probably the most elaborate figure of their repertoire. The name may derive from its resemblance to the Kwakiutl Frog figures [71, 72] since all three share a peculiar fish-shaped pattern. In [57], this feature is even added

mechanically to the completed pattern of [56], thus creating a new figure.

This entire family of figures exploits the technique of rotating the final pattern a quarter of a turn about its center in order to finish the figure. This technique is very popular among the Kwakiutl, being used in no less than seven figures. The technique is also known to the Eskimos, and is the key movement in forming figures in the "Sealer, Trousers, and Bow" series (represented in the Kwakiutl repertoire by Grave of a Child [50], A Toad [23], and A Small Owl [13], respectively). But there does not appear to be a pattern in the Eskimo repertoire analogous to that formed after step 5 of Sun, Moon, and Star [53] which could subsequently be rotated. Until such a pattern is uncovered, perhaps as an intermediate step in some unrelated figure, one must assume that this entire family of figures is of Northwest Coast origin.

58. The "Hanging Oneself by the Neck" Series

Loop size: medium

1. Opening A.
2. Transfer index loops to middle fingers, inserting middle fingers proximally. Transfer thumb loops to indices, inserting indices proximally.
3. Draw the string passing from right middle finger to left little finger through index loop as follows: Insert thumbs into index loops distally and pass thumbs proximal to middle finger loops. With right thumb, catch right ulnar middle finger string on its back. Return through index loop. Insert left thumb proximally into left little finger loop. Return through index loop with the left radial little finger string.
4. Release indices and draw strings tight. Release middle fingers and draw strings tight again. Point fingers away from you. You have Man Tying the Rope around His Neck in the Woods [58a].

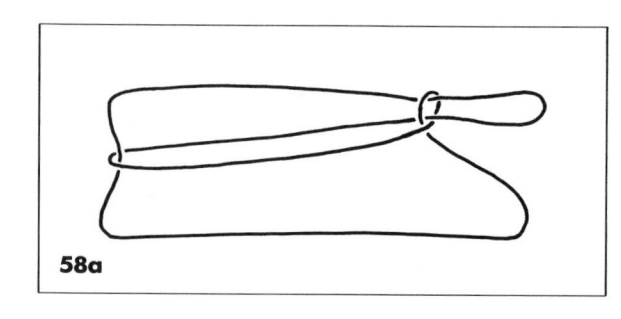

58a

5. Release right thumb gently and insert it proximally into right little finger loop. Return with right radial little finger string to extend the figure. You have Man Hanging by His Neck [58b].

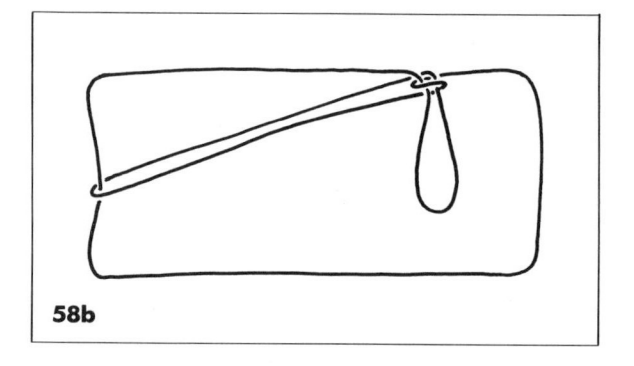

58b

ANALYSIS: [58]

Similar in overall form: (P56)

Chukchi:	— A Dead Raven	(Jenness, CXXXVIII)
Siberia:	— A Man Hanging by the Neck	(Jenness, CXXXVIII)
N. Alaska:	— A Man Hanging by the Neck	(Jenness, CXXXVIII)
Iglulik:	— A Dog Hung Up by the Neck	(Paterson, 56)

Although the patterns are not the same, the Kwakiutl series Hanging Oneself by the Neck [58] is clearly related in concept and name to figures collected by Jenness in the Bering Strait region. The Eskimo method of construction is entirely unrelated to that of the Kwakiutl.

59. A Porcupine

Loop size: medium

This figure is one of the most popular among the Kwakiutl. It was known to many persons who otherwise had no knowledge of string figure making.

1. Opening A.
2. Exchange index loops, inserting indices distally, passing right loop through left.
3. Transfer left index loop to left thumb, inserting thumb proximally. Transfer left little finger loop to left thumb, inserting thumb proximally. Make sure the three left thumb loops are well separated.
4. Draw left distal ulnar thumb string through central and proximal left thumb loops as follows: Insert left index and middle fingers proximally into left proximal and central thumb loops. Pass left index to the ulnar side of the left distal ulnar thumb string, then catch this string between the tips of the left index and middle finger. Return through left central and proximal thumb loops, closing left index to the palm. Transfer left index loop to left ring and little fingers, inserting them proximally.
5. Draw left radial proximal thumb string through left central and distal thumb loops as follows: Insert left index and middle fingers distally into left distal and central thumb loops. Pass left index to the radial side of the left proximal radial thumb string. Grasp this string between the tips of the left index and middle fingers. Return through left central and distal thumb loops, placing the new string on the back of the left index by rotating the index half a turn in the ulnar direction. Release left thumb and extend. Near the left hand, you now have a diamond-shaped lozenge formed by double strings.
6. Insert left thumb proximally into right little finger loop, then into the diamond from the ulnar side. Return with the double strings that form the right lower side of the diamond.

7. Draw left radial index string through both left thumb loops as follows: Insert left thumb proximally into left index loop, and return through left thumb loop with left radial index string. Release left index and extend.

8. Release right thumb and little finger. Transfer right index loop to right thumb and little fingers, inserting these fingers proximally. Extend. You have A Porcupine [59].

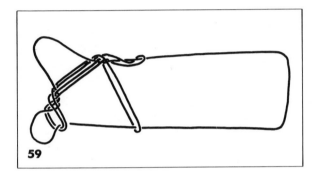

59

By see-sawing the hands, you produce the movements of the animal. The movements are accompanied by a chant:

xŭ'mLEs xŭ'mLEs mē'x·dalaġa xŭ'młts!ōts
Back, back, Porcupine woman! She retreated.

ANALYSIS: [59]

Identical patterns: (P5)

Siberia:	+	The Dog	(Jenness, XXVIII)
Nunivak:	+	Wolverine	(Gordon, fig. 11)
Bering:	+	Wolf	(Jenness, XXVIII)
N. Alaska:	+	Wolf	(Jenness, XXVIII)
Mackenzie:	+	Wolf	(Jenness, XXVIII)
W. Copper:	+	Wolf	(Jenness, XXVIII)
E. Copper:	(+)	Wolf	(Rasmussen, 23)
Caribou:	(+)	Wolf	(Birket-Smith, p. 279)

Baffinland:	(+)	Wolf	(Jenness, XXVIII, [Boas])
Iglulik:	(+)	Wolf	(Mathiassen, p. 222)
	?	Tamanuakataq	(Mathiassen, fig. 185)
Netsilik:	+	Wolf	(Mary-Rousselière, 19a)
Polar:	+	Fox	(Paterson, 5; Holtved, 8)
	(+)	Fox on the Trail	(Malaurie, p. 42)
	(+)	Fox	(Kroeber, p. 298)
W. Greenland:	+	Fox	(Paterson, 5; Hansen, 26)
E. Greenland:	+	Fox	(Victor, 1)
Klamath:	+	Porcupine	(Jayne, fig. 313)
Bella Coola:	+	Porcupine	(McIlwraith, XV)

Identical patterns, but made differently: (P89)

Chukchi:	−	Fox	(Bogoras, fig. 199b)
Siberia:	−	Dog	(Jenness, XXIX)
Nunivak:	(−)	Red Fox	(Lantis, 4)
N. Alaska:	−	Red Fox	(Jenness, XXIX)
Mackenzie:	−	Red Fox Waving his Tail	(Jenness, XXIX)
W. Copper:	−	Red Fox Waving his Tail	(Jenness, XXIX)

The Kwakiutl Porcupine [59] is one of the most widely distributed figures in North America. It has never been recorded outside North America. No doubt, the popularity of this figure arises from its novel and easily remembered method of construction.

As shown above, this figure undergoes some interesting name changes as one proceeds east and south of Alaska. Among the North American Indians the figure is consistently known as Porcupine. In the Arctic, however, it is known as Wolf in the western and central regions, and Fox in the east. The western Eskimos, using a method of construction that requires wrist loops, make an identical figure, which they call Red Fox. Only on Nunivak are both methods of construction found simultaneously. It is interesting that the chant accompanying Red Fox is

somewhat similar to the Kwakiutl's chant for Porcupine [59]:

> Red fox, red fox,
> To his mother's sister he went.
> There, he went in.

The Bella Coola chant also is similar:

> Don't hurry away. Go easily when you go to your house.

As in the Kwakiutl chant, the Indian grammar suggests that a female creature is being addressed. The contrasting Kwakiutl/Bella Coola interpretations of this figure are somewhat amusing: the Bella Coola fear that the porcupine may injure herself with her own quills if she moves too quickly, whereas the Kwakiutl apparently fear injury to themselves!

It is also worth noting that the Bella Coola form another figure by omitting steps 6 and 7 of Porcupine [59]. This figure (McIlwraith, II) which they call Water Ouzel is unknown to the Kwakiutl.

60. Sneezing

Loop size: small

This figure refers to the story of grizzly bear who swallowed the wren and had to sneeze when wren started a fire in his stomach (Boas, Tsimshian mythology).

1. Opening A.
2. Transfer index loops to middle fingers, inserting middle fingers proximally. Transfer thumb loops to indices, inserting indices proximally.
3. Pick up the string passing from right middle finger to left little finger as follows: Pass thumbs proximal to index and middle finger loops. Insert left thumb into left little finger loop. With the right thumb, catch the right ulnar middle finger string and return. Return left thumb with left radial little finger string on its back.
4. Draw the string passing from left middle finger to right little finger through index loops as follows:

Insert thumbs distally into index loops. Pass thumbs proximal to ulnar index strings and radial middle finger strings. With the left thumb, pick up left ulnar middle finger string, returning through left index loop. Insert right thumb proximally into right little finger loop, and return with right radial little finger string through right index loop. Keeping thumb loops well separated, release all fingers except thumbs. Draw strings tight.

5. Insert last three fingers of each hand distally into distal and proximal thumb loops, and close both proximal and distal ulnar thumb strings to the palms.
6. Transfer distal thumb loops to indices, inserting indices distally. Palms are facing toward you.
7. Increase the tension on the ulnar index string so that it becomes the upper transverse string of the figure. At the same time, decrease the tension on the thumb strings by turning palms away from you. This causes a vertical double string to appear at the center of the figure. This is the sneeze [60]. "Hā'sx·i" is said as the sneeze appears.

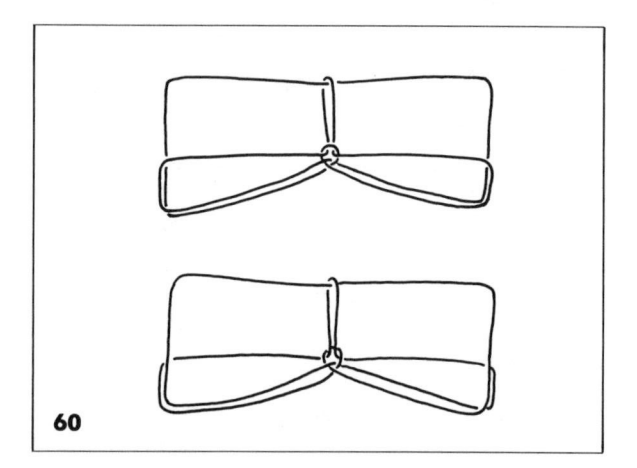

60

8. Release the tension on the ulnar index string by pointing indices toward each other. At the same time, increase tension on the radial thumb string by lifting the thumbs high above the index loops,

so that the radial thumb string becomes the upper transverse string. This causes a different vertical double string to appear at the center of the figure. The sneezing movement is repeated over and over again by repeating steps 7 and 8, alternately. With each repetition, the following is chanted:

hā'sxˑi hā'ts!Exsxˑi
Achoo! Achoo!
[Bear is sneezing to rid himself of the wren he swallowed.]

ANALYSIS: [60]

Identical patterns and motions: (P202)

Bering:	– Copulating Wolverines	(Jenness, CXLIX)
Netsilik:	– Gopher	(Mary-Rousselière, 26)
Iglulik:	– Gopher	(Mary-Rousselière, 26)

The Kwakiutl figure known as Sneezing [60] is constructed using techniques also encountered in the Hanging Series [58]; that is, an asymmetric movement is performed in which a single middle-little finger string is drawn through the index loops. The Eskimos use an unrelated method of construction.

A novel and uncommon motion accompanies this figure. The Bering Eskimos interpret the motion as representing the sexual act, whereas the Netsilik and Iglulik interpret it as representing a small animal poking his head in and out of his burrow.

The distribution of this figure is curious. The methods used by both the Bering and the eastern Eskimo groups are identical, but also very mechanical; the figure is manually woven on the left hand. The Kwakiutl method is much more refined and direct. This may indicate that the Eskimo method is a crude attempt at reconstructing a figure they once encountered and found quite novel. Alternatively, the Kwakiutl method is an improved version of the Eskimo method.

61. A Patch

Loop size: large

This figure was learned in Fort Rupert.

1. Opening A. Turn palms slightly away from you.

2. Pass thumbs proximal to index loops and insert proximally into little finger loops. Return with radial little finger strings as well as ulnar index strings, the little finger strings being the uppermost of the two. Release index and little fingers. Extend.

3. Draw the central portion of the ulnar distal string (the ulnar transverse string) through the proximal and central thumb loops as follows: Insert index and middle fingers proximally into all three thumb loops. Bring these fingers to the center of the figure, then grasp between their tips the center portion of the ulnar transverse string and draw it through the proximal and central thumb loops. Close the middle fingers to the palm to secure the loops. Transfer middle finger loops to ring and little fingers, inserting them proximally.

4. Transfer distal and central thumb loops to indices, inserting indices distally, leaving a transverse string on the thumbs.

5. Create a second set of thumb loops from the radial thumb string as follows: Pass left thumb to the radial side of the right radial thumb string; then insert left thumb proximally into right thumb loop and return. Release right thumb. Insert it proximally into both left thumb loops, and return.

6. Draw both index loops through both thumb loops as follows: Insert thumbs distally into both sets of index loops and return through thumb loops with proximal and distal ulnar index strings, taking care not to disturb their order. Release indices and extend.

7. Arrange thumb loops mechanically so that the proximal and distal radial thumb strings are parallel and do not cross. Separate these two upper

transverse strings as follows: Insert indices distally into thumb loops. Transfer distal thumb loops to indices. Widely separate the thumb and index fingers to extend. You have A Patch [61]. This figure is accompanied by a chant:

[Chant is missing from the manuscript—M.A.S.]

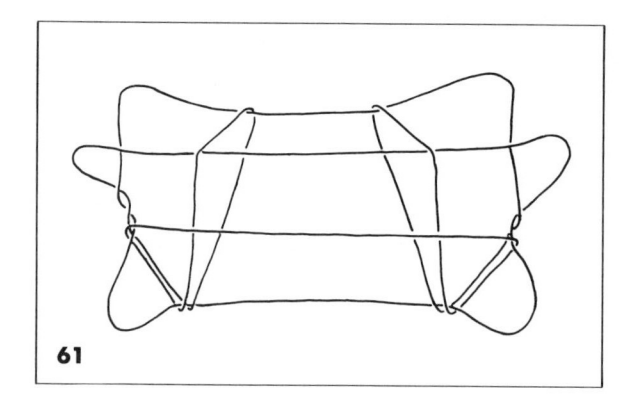

61

62. Two Brothers-In-Law Meeting

Loop size: large

This figure is not so commonly known as others. It was shown to me in Fort Rupert but was also known to string figure experts from Alert Bay, Turnour Island, and Newettee.

1. Opening A.

2. Transfer index loops to thumbs as follows: Pass thumbs proximal to index loops and return with ulnar index strings. Release indices. Transfer little finger loops to thumbs, inserting thumbs proximally.

3. Draw the central portion of the ulnar distal string (the ulnar transverse string) through the proximal and central thumb loops as follows: Insert index and middle fingers proximally into all three thumb loops. Bring these fingers to the center of the figure, then grasp between their tips the center portion of the ulnar transverse string and draw it through the proximal and central thumb

loops. Close the middle fingers to the palm to secure the loops. Transfer middle finger loops to ring and little fingers, inserting them proximally.

4. Transfer distal and central thumb loops to indices, inserting indices distally, leaving a transverse string on the thumbs.

5. Create a second set of thumb loops from the radial thumb string as follows: Pass left thumb to the radial side of the right radial thumb string; then insert left thumb proximally into right thumb loop and return. Release right thumb. Insert it proximally into both left thumb loops, and return.

6. Draw both index loops through both thumb loops as follows: Insert thumbs distally into both sets of index loops; return through thumb loops with proximal and distal ulnar index strings, taking care not to disturb their order. Release indices and extend.

7. Arrange thumb loops mechanically so that the proximal and distal radial thumb strings are parallel and do not cross. The distal radial thumb string will have a loop encircling it near the left thumb, whereas the proximal radial thumb string will have a loop encircling it near the right thumb.

8. Transfer distal thumb loops to indices, inserting indices distally. Extend. You have Two Brothers-In-Law Meeting [62].

62

63. Daylight Receptacle (*ᵋNāl'aats!e*)

Loop size: large

1. Opening A. Left palmar string must be taken up first.

2. Pass thumbs proximal to index loops, inserting left thumb only into left little finger loop. Return left thumb, with left radial little finger string and left ulnar index string on its back. Return right thumb, with right ulnar index string only. Release indices. Release left little finger only. Transfer right little finger loop to right thumb, inserting thumb proximally.

3. Draw the central portion of the ulnar distal string (the ulnar transverse string) through the proximal and central thumb loops as follows: Insert index and middle fingers proximally into all three thumb loops. Bring these fingers to the center of the figure, then grasp between their tips the center portion of the ulnar transverse string and draw it through the proximal and central thumb loops. Close the middle fingers to the palm to secure the loops. Transfer middle finger loops to ring and little fingers, inserting them proximally.

4. Transfer distal and central thumb loops to indices, inserting indices distally, leaving a transverse string on the thumbs.

5. Create a second set of thumb loops from the radial thumb string as follows: Pass left thumb to the radial side of the right radial thumb string, then insert left thumb proximally into right thumb loop and return. Release right thumb. Insert it proximally into both left thumb loops. Return.

6. Draw both index loops through both thumb loops as follows: Insert thumbs distally into both sets of index loops and return through thumb loops with proximal and distal ulnar index strings, taking care not to disturb their order. Release indices and extend.

7. Arrange thumb loops so that the proximal and distal ulnar thumb strings are parallel and do not cross. Then transfer distal thumb loops to indices, inserting indices distally. Separate indices from thumbs, turning palms upward to extend. You have the Daylight Receptacle [63]. The following words are chanted with this figure:

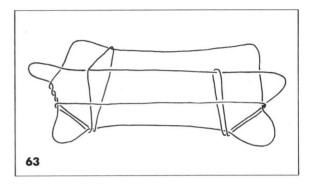

63

t!ēx·g·iwalaxēs ᵋnā'laats!e
qaᵋsdExᵘstE'nde xēs ᵋnā'laats!e
She lies on her back in the bow of the canoe on her daylight receptacle,
and she makes her daylight receptacle jump into the water.
Then it became daylight.

Other words also accompanied this figure:

ōxLā'lalisxēs ᵋnā'laats!e
qaᵋs ōxLeg·îliseᵋ
She carries her daylight receptacle on her back,
and puts it down on the beach.

ANALYSIS: [61], [62], [63]

[61]: Identical patterns: (P47)

N. Alaska:	+	The Scapulae	(Jenness, XXXVII)
Mackenzie:	+	The Scapulae	(Jenness, XXXVII)
W. Copper:	+	The Scapulae	(Jenness, XXXVII)
Netsilik:	+	The Scapulae	(Mary-Rousselière, 56)

Iglulik:	+	The Scapulae	(Mary-Rousselière, 56)
	(+)	The Shoulderblades	(Mathiassen, fig. 191)
Polar:	+	Two Scapulae	(Paterson, 47; Holtved, 44)
W. Greenland:	+	The Scapulae, or Whale Rib	(Paterson, 47; Hansen, 13)

[62]: Identical patterns: (P51)

N. Alaska:	+	The Meeting of Two Brothers-in Law	(Jenness, XXXVIII)
W. Copper:	+	Two Small Ribs	(Jenness, XXXVIII)
Netsilik:	+	Two Men Boxing Eskimo-style	(Mary-Rousselière, 78)
Iglulik:	(+)	Rib	(Mathiassen, fig. 189)
Polar:	+	Like the Ribs	(Paterson, 51; Holtved, 42)
W. Greenland:	+	The Rib	(Paterson, 51)
	(+)	Short Ribs	(Hansen, 11)

[63]: The Kwakiutl Daylight Receptacle [63] has not been recorded elsewhere.

The Kwakiutl Patch [61], Two Brothers-in-Law Meeting [62], and Daylight Receptacle [63] all share the same method of construction, except for small differences in the way the three loops of Opening A are transferred to the thumbs. These subtle differences change the order of the thumb loops and thus create differences in the final pattern. The creation of three thumb loops as an opening movement is a common Kwakiutl technique (see chart 6). Steps 5 and 6 represent a novel way of creating the loops necessary for performing a katilluik maneuver. Here, new thumb loops are created mechanically from a single radial thumb string. The final extension of the figure is also unusual in that two upper transverse strings are created. This represents one of the few ways of creating a three-dimensional figure.

On an individual basis, each member of the Patch family has an interesting distribution. The Kwakiutl Patch [61] represents "shoulderblades" to most Eskimos. Since berry patches are lacking in the Arctic,

it is understandable that the Eskimos would have a different name for this figure. Whale scapulae are commonly used in forming the framework of an Eskimo sod house, a three-dimensional structure by definition. The Eskimo method of construction for this string figure is the same throughout.

The Mackenzie, West Copper, and Polar Eskimos have also attached this name to a second figure that resembles [61] in overall form (see Jenness, XLVI; Paterson, 54). Its limited distribution, however, suggests that it is a recent invention.

Two Brothers-in-Law Meeting [62] is one of the few Kwakiutl figures known by the same name among the Eskimos. The similarity is limited, however, to North Alaska. In the east the figure is consistently interpreted as representing ribs, with the exception of the Netsilik, whose interpretation is closer to the Alaskan interpretation of two men who do not trust each other. Mary-Rousselière has suggested that the change in name from "brother-in-law" to "rib" may stem from similarities in the Eskimo spelling of these terms (Mary-Rousselière 1969:90). Another explanation, however, is that the title of "ribs" was adopted in the east to emphasize the fact that [62] is a simple variant of [61], which also represents a type of bone among the Eskimos.

As examined in Appendix A, below, the Kwakiutl Daylight Receptacle [63] vividly illustrates a myth explaining the arrival of daylight into the world. This figure has not been recorded elsewhere. It may be a local invention.

Finally, it is also worth noting that the only complete Tlingit figure ever recorded is also a member of the Patch family:

| Tlingit: | "+" | Salmon River | (K. Haddon 1930: 2A, 2B) |

64. The "Fish Trap" Series

Loop size: large

1. Opening A.

2. Insert ring fingers proximally into index loops

and return with ulnar index strings.

3. With each middle finger, take up the palmar string of the opposite middle finger. Adjust all loops so that they are near the tips of their fingers. Turn palms toward you slightly.

4. Each of the four fingers then closes its own radial string to the palm, starting with the little fingers, by rotating each finger half a turn in the radial direction. Care must be taken not to close the ulnar string of the neighboring finger to the palm during this movement.

5. With all fingers held firmly against the palms, rotate thumbs one full turn in the ulnar direction. Display The Fish Net [64a] by turning the palms toward you, thumbs pointing upward.

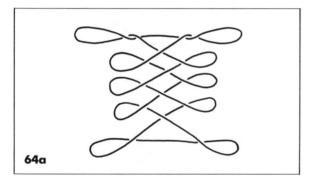

64a

6. A partner grasps the X formed by the crossing of the strings passing from index finger to middle finger, and pulls it away from you. Release index, middle, and ring fingers. Extend. You have The Fish Trap (*Ts!ᵃnus*) [64b].

64b

ANALYSIS: [64a, 64b]

Despite their simplicity, the Kwakiutl Fish Net [64a] and Fish Trap [64b] have not been recorded elsewhere. The creation of loops for all five fingers from Opening A is a common technique among the natives of Nauru Island in the South Pacific (Maude 1971). The practice of twisting each loop is also encountered there. In fact, some of the most elaborate patterns ever recorded begin their construction in this way (see Maude 1971: "Nauru Classics"; and Jayne 1906: figs. 827 to 841). The Nauruans do not, however, acknowledge the Kwakiutl Fish Net [64a] as a string figure.

65. Two Killerwhales (*Maamxeenox*)

Loop size: large

This figure was known to only one woman in Fort Rupert.

1. Opening A.

2. Draw the string passing from left thumb to right index through the little finger loops as follows: Insert middle fingers distally into little finger loops, then pass them proximal to index loops. Insert right middle finger proximally into right index loop, then pass it to the distal side of the right radial index string. With the right middle finger, hook back the right radial index string and draw it through the right little finger loop by rotating the middle finger half a turn in the ulnar direction. Insert left middle finger distally into left thumb loop, and hook back the ulnar left thumb string. Draw it through the left little finger loop by rotating left middle finger half a turn in the ulnar direction. Release little fingers. Close middle fingers to the palms by rotating them half a turn in the ulnar direction.

3. Transfer middle finger loops to ring and little fingers, inserting them proximally.

4. The ulnar left index string runs to the right

hand, turns around the right radial index string, then passes proximal to the right ulnar thumb string, and finally to the left palmar string. Pick up, with the left index, the short segment of this string running from the right radial index string to the right ulnar thumb string. This is best done by inserting left index into the space that is radial to both ulnar index strings, but ulnar to short segment. Then pass left index proximal to short segment, lifting it with back of left index and returning to position.

5. Draw both left radial index strings through the right thumb loop as follows: Pass right middle finger proximal to right index loop (and distal to right radial ring finger string), then insert it proximally into right thumb loop. Bring the right middle finger to the left hand and insert it distally into both left index loops. Hook back both left radial index strings and draw them through the thumb loop, closing the right middle finger to the right palm.

6. Draw the right ulnar thumb string through both left index loops as follows: Insert left middle finger proximally into both left index loops. Pass the left middle finger to the ulnar side of the right ulnar thumb string; then insert it proximally into the right thumb loop. Hook back, with the palm of the left middle finger, the right ulnar thumb string, drawing it through both left index loops. Close the left middle finger to the palm, making sure that the loop it is carrying passes distal to the left ulnar thumb string.

7. The right ulnar index string travels to the left hand, passing ulnar to the right radial ring finger string, then ulnar to the left ulnar middle finger string, then turning finally around the left ulnar thumb string. Insert the left thumb distally into the left middle finger loop, then with the back of the left thumb, catch the segment of the right ulnar index string between the right radial ring finger string and the left ulnar middle finger string. Draw it through the left middle finger loop and left thumb loop.

8. Draw right radial ring finger string through right middle finger loops as follows: Release right thumb; then insert it distally into both right middle finger loops, then proximally into the right ring-little finger loop. Return through middle finger loops with right radial ring finger string. Release indices and middle fingers of both hands. Extend. (This produces the Eskimo figure Beluga [65a], the white whale.)

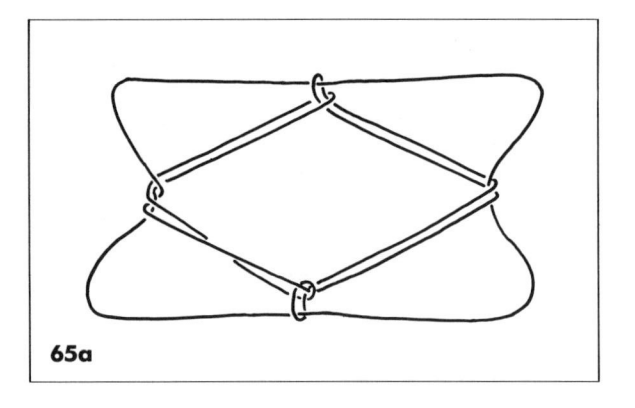

65a

9. A very small loop encircles the upper transverse string (ulnar thumb string) near the center of the figure. Insert right middle finger proximally, and from the ulnar side, into the left thumb loop. Draw right middle finger to the right, catching on its palm the two strings forming the very small loop described above. Release right thumb. Transfer both right middle finger loops to right thumb, inserting thumb proximally.

10. Draw left ulnar thumb string through right ring-little finger loop as follows: Insert right index and middle finger proximally into right ring-little finger loop, then pass them proximal to the four strings forming the central figure, but distal to the left radial thumb string. Grasp between their tips the left ulnar thumb string. Return through right ring-little finger loop, placing the new string on the back of the right index by rotating the right index half a turn in the ulnar direction. Release right thumb.

11. Turn the figure upside-down as follows: Transfer right ring-little finger loop to right thumb, inserting thumb proximally. Transfer right index loop to right ring and little fingers, inserting them distally. Close right ring and little fingers to the palm by rotating them half a turn in the ulnar direction. Transfer left thumb loop to left index, inserting index distally. Do not straighten left index, but keep it closed to the palm. Transfer left ring-little finger loop to left thumb, inserting thumb proximally. Transfer left index loop to left ring and little fingers, inserting them proximally.

12. Encircling the right palmar string are two loops, one formed by doubled strings and one formed by a single string. With the left index and middle fingers, lift the double loop over the single loop. Arrange loops on the right palmar string so that the single loop is nearest to the right thumb and the double loop is nearest the right ring finger. Now, with the right middle finger, hook back the short segment of the right palmar string between the single and double loop, and close the middle finger to the palm. Release right thumb. Transfer right middle finger loop to the right thumb, inserting thumb distally. Extend the pattern. You have Two Killerwhales [65b], with their heads towards the ends of the figure.

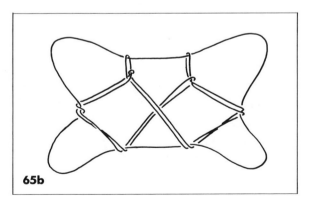

65b

ANALYSIS: [65a, 65b]
[65a]: Identical patterns: (P4a)

Chukchi:	(+)	A Poke (harpoon float)	(Jenness, XLIII)
Nunivak:	(+)	Beluga (white whale)	(Lantis, 2)
N. Alaska:	+	Beluga	(Jenness, XLIII)
Mackenzie:	+	Beluga	(Jenness, XLIII)
W. Copper:	+	Beluga	(Jenness, XLIII)
E. Copper:	(+)	Beluga	(Rasmussen, 20)
Caribou:	(+)	Beluga	(Birket-Smith, p. 279; Jenness, XLIII, [Boas])
Baffinland:	(+)	Beluga	(Jenness, XLIII, [Boas])
Netsilik:	+	Beluga	(Mary-Rousselière, 39)
Iglulik:	+	Beluga	(Mary-Rousselière, 39)
	(+)	Narwhal	(Mathiassen, p. 223)
Polar:	+	Like a Narwhal	(Paterson, 4a; Holtved, 46; Kroeber)

[65b]: Nearly identical patterns: (P59)

Mackenzie:	−	Two Small Seagulls	(Jenness, LVIII)
W. Copper:	−	Two Small Seagulls	(Jenness, LVIII)
Polar:	−	Two Seagulls	(Paterson, 59)

The pattern formed after step 8 [65a] of the Kwakiutl Two Killerwhales [65] is known to nearly all Eskimos as Beluga or Narwhal, a white whale. The Kwakiutl, however, do not acknowledge [65a] as being a distinct figure, even though the methods of construction are nearly identical (minor differences occur after step 6). It is interesting that [65a], regardless of whether it is named, is used by both groups as an initial pattern for subsequent manipulation. The Nunivak Eskimos and those east of Pelly Bay (Netsilik region) go on to form a second figure which they call a Gull. The eastern groups then continue on by making a third figure called White Fox or Polar Bear. Members of the Iglulik even know a fourth figure, (see Mary-Rousselière, 1969:47). In North Alaska, a dissolution figure follows Beluga directly and is known as Beluga Hung up to Dry (see

Jenness, 1924:46B). But in no instance is a figure formed equivalent to the Kwakiutl Two Killerwhales [65b], even though the manipulations performed on the Beluga pattern are very similar (catching the small vertical loop in step 9).

Figures very similar to [65b] in final pattern have been recorded by Jenness and Paterson among the Mackenzie, West Copper, and Polar Eskimos, but the string arrangements differ where the small vertical loops join with the double diamonds. Also, the Eskimo figure is formed using a method of construction totally unrelated to that of the Eskimo Beluga or Kwakiutl [65a]. The Kwakiutl Two Killerwhales [65b] is certainly one of the most difficult figures to construct, which may explain its limited distribution.

66. Another Fire Drill

Loop size: medium

This fire drill was known to one woman in Fort Rupert who came from Blunden Harbor.

1. Opening A.
2. Draw radial little finger strings through thumb loops as follows: Pass thumbs distal to index loops and insert them proximally into little finger loops. Return through thumb loops with radial little finger strings.
3. Exchange index loops, passing left loop through right. Extend. The central oval represents Another Fire Drill [66], which can be made to

expand and contract by alternately turning palms toward you and back to initial position, thus imitating the friction needed to start a fire.

ANALYSIS: [66]

The Kwakiutl Another Fire Drill [66] is a rather simple figure that has not been recorded elsewhere. Although unrelated in pattern and method to the other Kwakiutl figures of the same name [1, 69c, 98], it is capable of the same friction-generating action. The fact that it was known to only one woman suggests that it was a local invention.

67. Walking Sticks of an Old Woman

Loop size: medium

1. Opening A.
2. Pass thumbs proximal to all strings and catch the ulnar little finger string on their backs. Draw the string toward you, proximal to the radial little finger strings, then insert thumbs into the region between the ulnar index strings and the radial little finger strings. Rotate thumbs one full turn in the ulnar direction, catching the radial little finger strings with the thumbs. Release indices and extend. You have Walking Sticks of an Old Woman [67].

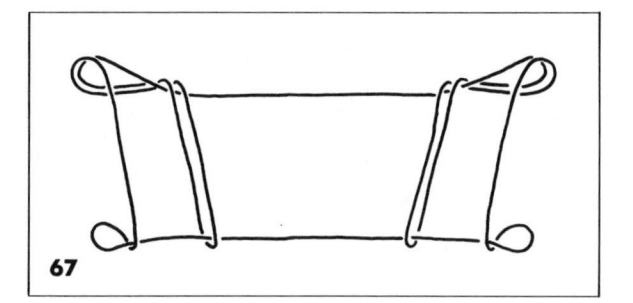

ANALYSIS: [67]

Identical patterns: (P42a)

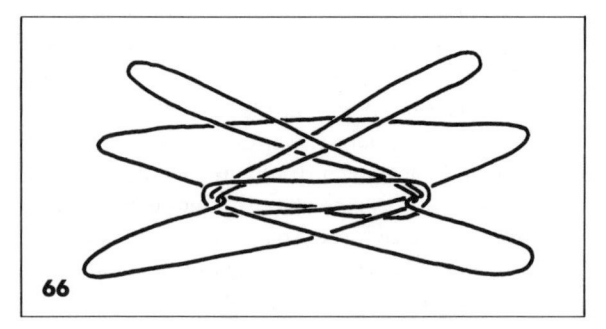

66

Bering:	+ Two Toy Labrets	(Jenness, XXIII)
N. Alaska:	+ Two Toy Labrets	(Jenness, XXIII)
Mackenzie:	+ Two Big Labrets	(Jenness, XXIII)
W. Copper:	+ Two Small Stones	(Jenness, XXIII)
Netsilik:	+ Two Labrets	(Mary-Rousselière, 85)
Iglulik:	+ Spirit Go Quickly	(Paterson, 42)
Polar:	+ *Tugtershkuk* (archaic)	(Paterson, 42)
W. Greenland:	+ *Umiak*	(Paterson, 42; Birket-Smith, fig. 293e)
E. Greenland:	+ *Atoqat* (archaic)	(Victor, 7)

As explained in great detail by Hansen, this figure has a fascinating history. It is a key figure in establishing the antiquity of Eskimo string figures. Labrets, a type of ivory lip ornament, were common in Alaska (and also along the Pacific Northwest Coast) as far back as the beginning of the Christian era. Labrets, however, were unknown in the east. Yet despite lack of familiarity, the western name remained attached to this figure as it spread to the east. Even in Greenland, where the title could not even be translated, the name persisted. This figure affords an intriguing example of Eskimo conservatism in naming string figures.

This figure is intimately associated with a widespread Eskimo belief in the "spirit of string figures." The spirit of string figures, a spirit whose presence is detected by the sound of crackling skins outside the hut, visits youngsters who overindulge in string figure making at night. He then challenges a child to a race, using his own intestines as a string. The child must make the Two Labrets figure over and over, as rapidly as possible, in order to drive away the spirit. If the child fails, the entire household will be paralyzed (Jenness, 1924:181B–83B). Although such beliefs are well known in Alaska, the Kwakiutl apparently do not share them, despite a keen interest in pacifying spirits. It is also remarkable that the Kwakiutl did not adopt the Labret title for this figure, since such ornaments were once quite popular among them.

68. The "Ship" Series

Loop size: large

This figure represents a type of European ship which the Indians saw in the olden days, when the white people first came.

1. Opening A.

2. Transfer index loops to thumbs as follows: Pass thumbs proximal to index loops and return with ulnar index strings. Release indices.

3. Transfer little finger loops to indices, inserting them distally.

4. Pass ring and little fingers proximal to index loops. Insert them distally into distal thumb loops. Close the ulnar distal thumb strings to the palms.

5. Draw the radial index string through the proximal thumb loops as follows: Insert middle fingers proximally into ring-little finger loops, then proximally into thumb loops, and then proximally into index loops. Hook down radial index string through thumb loops. Release ring and little fingers. Transfer middle finger loops to ring and little fingers, inserting them proximally and closing them to the palm.

6. Share the index loops as follows: Transfer left index loop to right index, inserting right index proximally from the ulnar side. Insert left index proximally and from the ulnar side into both right index loops. Return to position.

7. Encircling each thumb are two loops, an inner loop and an outer loop. The inner loop is the distal loop and the outer loop is proximal. The proximal loop has a single straight radial thumb string, and ulnar strings that pass through the distal (inner) loop. Draw both strings of the inner thumb loop through both index loops as follows: Insert indices into the space between the ulnar strings of the inner and outer thumb loops. Pass indices proximal to both strings of the inner thumb loops and return through both sets of

index loops with inner loop strings on index backs. Release thumbs and extend.

8. The upper transverse string travels to the index tips, passes through a loop formed by the double strings on each index back, then continues on to form the sides of the pattern. With the thumb backs, pick up the strings that form the sides. Release indices and extend. You have A Ship with Two Masts [68a].

.5.5.5.5

68a

9. The central portion of the upper transverse string is then drawn through the thumb loops as follows: Insert indices proximally into thumb loops; then pass them toward the center of the figure and away from you between the two vertical loops that encircle the upper transverse string. With the palms of the indices, hook down the central segment of the upper transverse string; then rotate indices a full turn in the radial direction in order to draw upper transverse string through the thumb loops. Release thumbs and extend. You have A Ship with Opened Sails [68b].

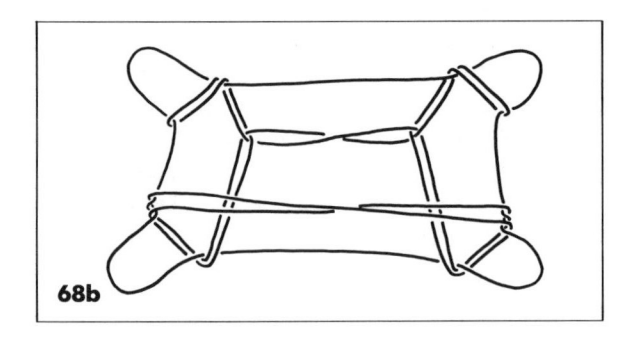

68b

ANALYSIS: [68a, 68b]

The Kwakiutl Ship with Two Masts [68a] and Ship with Opened Sails [68b] have no Eskimo equivalent and have not been recorded elsewhere. The techniques used in forming this series of figures resemble Klamath Indian techniques (see Jayne 1906:101, "a rattlesnake and a boy"). The information provided by Averkieva's informant would lead one to believe that these figures were invented recently, after the arrival of Europeans in the late eighteenth century. But one can never rule out the possibility that new names were merely attached to preexisting figures.

69. The "Mountains with Clouds between Them" Series

Loop size: medium

This figure was obtained in Alert Bay. It was known to only one woman there, although others had heard about it.

1. Place the loop on the thumb backs so that a short segment of string passes from thumb to thumb and a long segment hangs down. Close the last three fingers of each hand over those portions of the hanging loop which cross the palms. Rotate thumbs a full turn in the radial direction in order to wind the short string around the thumbs.

2. Use the thumbs to pick up the "thumb rings" as follows: With the right thumb and index, enlarge the ring on the left thumb and insert right thumb into it proximally. Repeat with ring on right thumb, so that the new left thumb loop passes through the right thumb loop. Rotate thumbs one full turn in the ulnar direction, passing thumbs through the large hanging loop. Pull hands apart so that strings are tight.

3. Transfer middle-ring-little finger loops to indices, inserting indices proximally, then rotating indices half a turn in the ulnar direction.

4. Insert middle-ring-little fingers proximally into index loops and close the radial index string to the palms.

5. Pass indices proximal to both sets of ulnar thumb strings and distal to both sets of radial thumb strings. With the palms of the indices, hook back the transverse radial thumb string, passing indices distal to the remaining radial thumb strings and through the index loops. Place the new string on the backs of the indices by rotating indices half a turn in the ulnar direction.

6. There exists a half twist on both the proximal and distal thumb loops. Remove this twist as follows: With left thumb and index, grasp the right proximal and distal ulnar thumb strings. Withdraw right thumb from both loops. Re-insert right thumb distally, releasing left thumb and index. Repeat on left thumb loops.

7. Draw radial index strings through both sets of thumb loops by inserting thumbs proximally into index loops and returning through thumb loops with the radial index strings. Release indices and extend. You have Mountains with Clouds between Them (Xw'aḵswiq!ēdzɛla Naǎ'ng·'a) [69a].

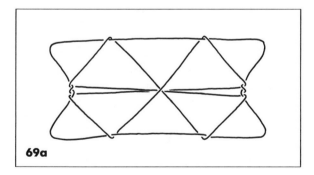

69a

8. Return hands to the upright position. A double transverse string passes horizontally across the upper surface of the figure. Pass indices to the ulnar side of the double transverse strings. Pick up both strings on the backs of the indices.

9. Draw radial thumb strings through double index loops as follows: Insert middle fingers proximally into double index loops, then distally into thumb loops. Return through index loops with radial thumb string on backs of middle fingers, and release indices. Transfer middle finger loops to indices, inserting indices proximally. Release thumbs and extend gently. You have a Mountain Broken in Two [69b].

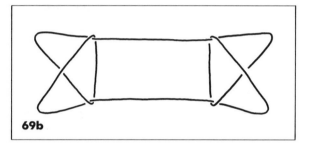

69b

10. Transfer left index loop to left middle finger, inserting it proximally. Transfer right ring-little finger loop to left ring and little fingers, inserting fingers distally. Transfer right index loop to left middle finger, inserting middle finger distally, thus freeing the right hand. Close middle-ring-little fingers of the left hand to the palm.

11. Transfer both left middle finger loops to the four fingers of the right hand, inserting them proximally, from the ulnar side, and closing them to the right palm. Insert left index and middle fingers proximally into left ring-little finger loops, and close them to the left palm. Extend. You have a Fire Drill [69c].

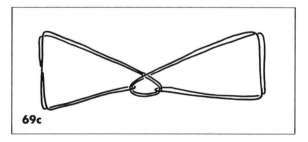

69c

12. Release left hand from its loops and re-insert it away from you into both loops. Pass four fingers of left hand toward you, through the small triangle formed in the center of the figure. Close the double strings forming the left side of the triangle to the palm and extend the figure, allowing left-hand loops to slip off. Two loops encircle the four fingers of each hand. One loop has an upper transverse string running freely from hand to hand, while the second loop has an upper transverse string encircled by a double string from the center of the figure. Insert thumbs distally into the former of the two loops, and return with the radial (free) transverse string. Straighten indices so that the remaining radial string is taken up on their backs. Extend. You have It Sits Down Below [69d].

69d

13. Release middle-ring-little fingers. Transfer thumb loops to middle-ring-little fingers, inserting them proximally. Transfer index loops to thumbs, inserting them distally. Extend. You have It Sits on the Ground and Splits the Sea Egg [69e].

69e

14. Release right thumb and draw hands apart. The figure disappears, and the maker says, And It Is Broken [69f].

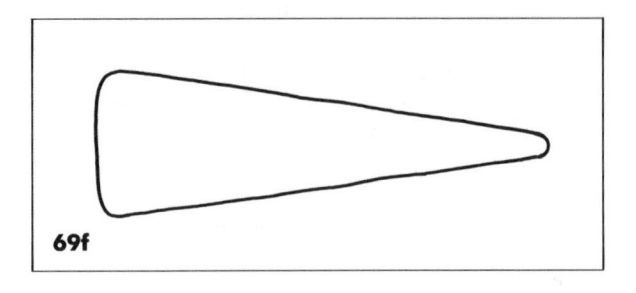

69f

ANALYSIS: [69]

[69a]: Identical patterns, but displayed upside-down:

Navaho:	—	Carrying Woods	(Jayne, fig. 141; Culin, fig. 1047)
Zuni (N. Mex):	(−)	Netted Shield	(Culin, fig. 1068)
Australia:	—	Two Swans	(K. Haddon 1918, 5)
	—	Two Turtles on a Log	(Davidson 1941, XVI)
	(−)	A Fish	(Mountford, fig. 186f)
Africa:	—	Water Tortoise	(Griffith, XV)

[69b]: Identical patterns occur world wide but are formed by unrelated methods of construction.

[69c]: See Kwakiutl Fire Drill [1a] for the distribution of this figure.

[69d]: (P6c) This figure is also a dissolution figure in a common Eskimo series known as the Raven (see Jenness, XXVII; and Paterson, 6), where it is called a Cloud. The Raven series is in no way related to the Kwakiutl Mountain series.

[69e]: This figure is a different extension of [69d].

[69f]: This dissolution figure is rarely considered a figure elsewhere.

The Kwakiutl Mountains with Clouds between Them [69] series is composed of an initial figure followed by five dissolution patterns. Although individual figures in the series are encountered elsewhere in the world, they are undoubtedly products of inde-

pendent invention, since their names and methods of construction bear no resemblance to one another. Mechanistically speaking, the first figure of the series [69a] is actually a variation of the Kwakiutl Kelps [70], a figure also known among the Eskimos. It is, therefore, quite likely that the entire series is a local invention.

70. Kelp (Wa'ɛwadɨ̇)

Loop size: medium

This figure was shown to me in Alert Bay.

1. Place the loop on the thumb backs so that a short segment of string passes from thumb to thumb and a long segment hangs down. Close the last three fingers of each hand over those portions of the hanging loop which cross the palms. Rotate thumbs a full turn in the radial direction in order to wind the short string around the thumbs.

2. Use the thumbs to pick up the "thumb rings" as follows: With the right thumb and index, enlarge the ring on the left thumb and insert right thumb into it proximally. Repeat with ring on right thumb, so that the new left thumb loop passes through the right thumb loop. Rotate thumbs one full turn in the ulnar direction, passing thumbs through the large hanging loop. Pull hands apart so that strings are tight.

3. Transfer middle-ring-little finger loops to indices, inserting indices proximally, then rotating indices half a turn in the ulnar direction.

4. Draw the radial index string through both sets of thumb loops as follows: Insert middle-ring-little fingers proximally into both sets of thumb loops, then insert them proximally into index loops. Hook down the radial index string and close the fingers to the palm.

5. Draw the transverse radial thumb string through the index loops as follows: Withdraw middle fingers from their loops and insert them proximally

into index loops. Grasp transverse radial thumb string between the index and middle finger tips. Lift the entire loop off the thumbs. Place the loop on the back of the indices by rotating indices half a turn in the ulnar direction. Extend.

6. Katilluik, inserting right thumb first, and extend. You have Kelp [70].

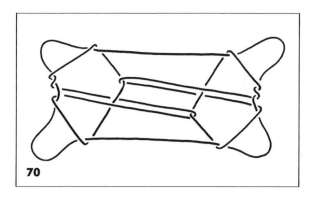

70

ANALYSIS: [70]

Identical patterns: (P171)

W. Copper:	+	Two Men Hauling a Sled, Two Men Have a Tug of War in a Dance House	(Jenness, XII)
E. Copper:	(+)	Those that Can Hold Back, These that Can Be Tightened	(Rasmussen, 53)
Netsilik:	+	Those Who Tug on a Rope	(Mary-Rousselière, 91)
Iglulik:	+	Those Who Tug on a Rope	(Mary-Rousselière, 91)

The Kwakiutl Kelp [70] is formed using a method of construction nearly identical to the Eskimo method. Steps 2 and 3 are dissimilar. The Copper Eskimo method is as follows:

1. Opening A.

2. Transfer thumb loops to indices, inserting indices

distally. Pass thumbs proximal to all index loops and return with both sets of ulnar index strings. Release indices.

3. Transfer little finger loops to indices, inserting indices distally.

4. Steps 4–6 of the Kwakiutl Kelp [70].

Among the Netsilik, the following method is used:

1. Opening A.

2. Transfer index loops to thumbs, inserting thumbs distally. Rotate thumbs a full turn in the ulnar direction.

3. Transfer little finger loops to indices, inserting them distally.

4. Steps 4–6 of the Kwakiutl Kelp [70].

The horizontal loops that "tug" on the diamonds near the center of the figure vary in their arrangement, depending on the order in which the thumb "rings" are taken up in step 2 of the Kwakiutl method. Likewise, the order in which the palmar strings are taken up in step 1 of either Eskimo method determines the exact form of their final pattern.

As previously mentioned, the initial figure of the Kwakiutl Mountains series [69a] is related in method of construction to the Kwakiutl Kelp [70]. The point of divergence occurs in steps 4 and 5 of each figure. In [69a], the index loops are passed through both sets of thumb loops from the *proximal* side prior to drawing the radial transverse thumb string through them. In [70], the index loops are passed through from the *distal* side. It is unclear which figure was originally learned, although the mechanical inversion of the thumb loops in step 6 of [69a] suggests that this figure is not as refined as [70].

71. The Frogs

Loop size: large

This figure was learned in Fort Rupert.

1. Place loop on wrists. Pick up ulnar wrist string

with big toe, inserting big toe proximally. Create a ring around the big toe by grasping the string that passes from the right wrist to the big toe and wrapping it once, in a clockwise direction, around the big toe.

2. Create a twist in the wrist loops by rotating hands a full turn in the ulnar direction.

3. Draw the string encircling the big toe through the wrist loops as follows: With the thumb and index of each hand, grasp the ring encircling the toe and draw it toward you, allowing the wrist loops to slip off the hands entirely. Each index finger is now pointing downward with a loop held under it. A transverse string passes between the indices, and a pair of vertical loops can be seen encircling it.

After Step 3

4. Insert the left little finger proximally into the center of the figure, to the ulnar side of the transverse string that passes from index to index, and close this string to the left palm. Transfer index loops to middle and ring fingers, inserting these fingers proximally. The middle and ring fingers remain pointing downward, as did the indices from which they were taken.

5. Cross the vertical loops encircling the transverse string as follows: Insert thumbs proximally into middle–ring finger loops and bring them toward each other, catching both strings of the vertical

loops on their backs. With thumbs still pointing downward, hook back the two strings of the right vertical loop with the left thumb. Withdraw the right thumb, then hook back both strings of the original left vertical loop, thus crossing the vertical loops. Pass the thumbs to the sides of the figure. Catch on thumb backs the string passing from ring finger to the toe. Place this string on the back of the thumbs by rotating the thumbs half a turn up through the center of the figure. Release middle and ring fingers. Extend.

6. Double strings form a rectangle in the center of the figure. Pass right index and thumb distally through this rectangle and grasp the loop held under the left little finger, releasing left little finger. Return the right thumb and index through the rectangle with this loop. Release all other finger loops, and extend the figure by inserting the four fingers of both hands distally into the loop held by the right thumb and index. Extension of the figure is facilitated if the strings encircling the big toe are not permitted to slide as tension is created in the string. You have The Frogs [71]. The frogs can be made to jump away from you by pulling the hand loops and allowing the toe loops to slide.

71

72. The Frog

Loop size: large

This figure is very much like the preceding one, except for steps 5 and 6.

1. Place loop on wrists. A partner picks up the ulnar wrist string with his thumb, inserting the thumb proximally. Create a ring around the partner's thumb by grasping the string that passes from the right wrist to the thumb and wrapping it once, in a clockwise direction, around the thumb.

2. Create a twist in the wrist loops by rotating hands a full turn in the ulnar direction.

3. Draw the string encircling the partner's thumb through the wrist loops as follows: With the thumb and index of each hand, grasp the ring encircling the thumb and draw it toward you, allowing the wrist loops to slip off the hands entirely. Each index finger is now pointing downward with a loop held under it. A transverse string passes between the indices, and a pair of vertical loops can be seen encircling it.

4. Insert the left little finger proximally into the center of the figure, to the ulnar side of the transverse string that passes from index to index, and close this string to the left palm. Transfer index loops to middle and ring fingers, inserting these fingers proximally. The middle and ring fingers remain pointing downward, as did the indices from which they were taken.

5. Cross the vertical double loops twice as follows: Insert indices proximally into middle-ring finger loops and bring them together in the center of the figure, catching both strings of the vertical loops on their backs. The indices remain pointing downward throughout the subsequent crossing. Twist them around each other as in step 5 of The Frogs [71], except this time perform the movement twice, so that the vertical loops cross twice, and so each index has hooked on its palm the vertical loop it originally carried on its back.

Withdraw middle fingers from middle-ring finger loops. Insert them proximally into the doubled index loops. Grasp between the index and middle finger tips the strings running from the ring fingers to the partner's thumb which form the sides of the figure. Draw these strings through the doubled index loops. The new loop is placed on the back of the middle fingers. Release ring fingers and extend.

6. Double strings form a rectangle in the center of the figure. With the right thumb and index, grasp the loop held under the left little finger, releasing the little finger. Thread this loop through the rectangle from the distal side and place it on the left index. Release middle fingers. Extend the figure by inserting the four fingers of each hand into the left index loop, closing them to the palm. You have The Frog [72], a variation of The Frogs [71], which can be made to move in a similar fashion.

72

ANALYSIS: [71], [72]

Similar patterns: (P214)

Siberia: "+" A Flounder (Jenness, CLV)

The Kwakiutl Frog figures [71, 72] are obviously related to a figure recorded by Jenness at Indian Point in Siberia. They differ slightly in their method of extension and central string crossings. In the Siberian Flounder the loops held by the partner are placed on separate fingers rather than one. Also, the strings forming the central diamond of the Flounder are interlaced rather than merely being crossed. These differences arise from slight variations in the method of construction. In step 5 of the Frogs [71], both strings of each vertical loop are crossed simultaneously prior to drawing through the side strings of the figure, whereas the Siberians perform the maneuver twice; first using the upper strings of the vertical loops and again using the lower strings. When the Kwakiutl do perform the maneuver twice, as in [72], they once again cross both strings of the vertical loops simultaneously rather than sequentially. This does not produce the Flounder, but a second figure, which they also call Frog [72]. Finally, the methods differ in that the Siberians fail to hook the transverse string to the left palm in step 4, preferring to "fish" for it after the figure is completely woven.

Unlike the Kwakiutl, the Siberians know a chant and a dissolution figure:

A flounder went down into the water.
Through the base of its tail,
he [the fisherman] passed a line.

At this point, the single loop held by the first person is drawn through the central diamond, and the figure dissolves.

Although these figures have a very limited distribution, it is worth noting that the pattern produced after step 3 of the Kwakiutl method has world-wide distribution and is often considered a final figure: Nigeria (Haddon and Treleaven 1936); Hawaii (Dickey 1928); Angola (Leakey 1949); Congo (Starr 1909); Australia (Roth 1902); West Africa (Griaule 1938), (Parkinson 1906); Tuamotus (Emory and Maude 1979). In many cases, the toe is used rather than a partner's finger.

73. The "Dogs" Series

Loop size: medium

This figure is a very popular one. It was obtained in Fort Rupert.

1. Place loop on the four fingers of each hand. Pick up the radial transverse string on the backs of the little fingers.
2. Pick up palmar strings with indices, as in Opening A.
3. Pass thumbs distal to the proximal radial index string and proximal to all other strings. Return with the proximal ulnar little finger string.
4. With the thumb and index of each hand, remove loops encircling the four fingers of each hand, and extend the figure, fingers pointing away from you. You have Two Dogs [73a].
5. Release indices and separate hands. You have Two Dogs Running Away from Each Other [73b].

73a

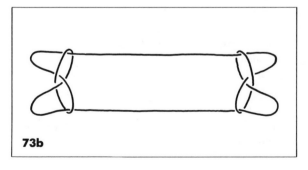

73b

ANALYSIS: [73a, 73b]

Identical patterns: (P100)

Siberia:	+ A Siberian House [73a]	(Gordon, figs. 22, 23)
	+ Two Eskimos Running Away [73b]	
Bering:	+ A Small Boat [73a]	(Jenness, LX)
	+ Two Men [73b]	
N. Alaska:	+ A Small Boat [73a]	(Jenness, LX)
	+ Two Men [73b]	

With the exception of steps 1 and 2, the Kwakiutl Dogs series [73] is identical in method of construction to series recorded from the westernmost Eskimos.

The Eskimo opening is as follows:

1. Opening A.
2. Transfer thumb loops to the four fingers of each hand, inserting fingers distally.

In all cases, the dissolution figure [73b] represents fleeing animals or people. The Inland Eskimos of North Alaska sing:

> Little boat down there, are you stopping to camp?
> We don't intend to camp.
> (Being afraid, it is said, in opposite directions they went away.)

The Siberians also know a nearly identical figure called the Tangarot People, which dissolves in a similar fashion:

[73a, 73b]: Similar patterns: (P203)

Siberia:	"+" Tangarot People	(Jenness, LXII)

The figure is made exactly as the Siberian House, except that a five-finger version of Opening A is used, which is identical to the arrangement found after step 3 of the Kwakiutl Fish Net [64a]. Their chant is as follows:

> We Tangarot People, (release indices)
> we ran away to hide.

We made a tent. (release middle fingers to produce [73a])

They ran away. (release ring fingers to produce [73b])

The only non-Eskimo series that resembles the Kwakiutl Dogs series [73] comes from Hawaii:

Hawaii: — Three Houses (Dickey, figs. 20a, 20b, 16)

The method of construction is entirely different, developing from Opening B. It is interesting, however, that the dissolution figures and methods are nearly identical to those found in the Siberian Tangarot series.

74. Squirrel (*Tamī'nas*)

Loop size: medium

This figure was obtained at Fort Rupert. It was known to only one man.

1. Place loop on thumbs. Insert indices proximally and return with ulnar thumb string.

2. Pass middle fingers proximal to all strings and return with radial thumb string on their backs.

3. Close all strings to the palm under the ring and little fingers.

4. The ulnar index strings consist of very short segments of string which pass under the ring and little fingers. Bring the hands together, and with the right middle finger, hook back the short left ulnar index string and draw it out slightly. Do not close finger to the palm. Pass the left index finger distal to both right thumb strings, and hook back the right ulnar thumb/radial index string. Draw the string out several inches and allow the string on the back of the left finger to slip off. Maintain index finger in a hooked position. Release right thumb, and separate hands a bit to take up the slack. Pass right thumb distal to both left thumb

strings. Hook back left ulnar thumb string. Draw it to the right palm. Catch on the back of the right thumb the short right ulnar index string which passes under the ring finger, and draw it through the right thumb loop just created. Release left thumb. Separate hands slightly to take up the slack in the strings. Pass left thumb proximal to left radial middle finger string. Insert left thumb proximally into left ring-little finger loop. Return with left radial ring-little finger string by rotating thumb half a turn in the radial direction. Release all middle, ring, and little fingers. Straighten left index by rotating it half a turn in the ulnar direction. Draw strings tight. You have [74a], an intermediate stage.

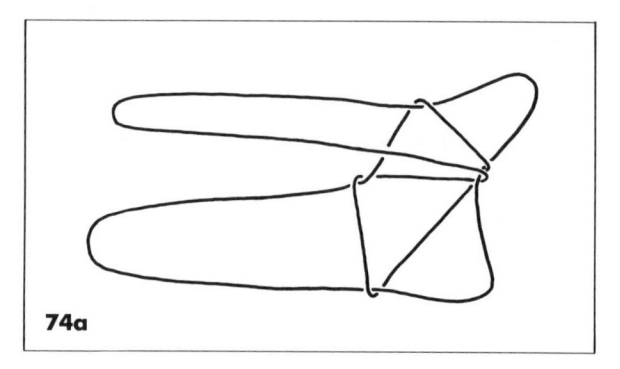

74a

5. Transfer thumb loops to middle-ring-little fingers, inserting them proximally. Insert right thumb proximally into left index loop, and hook back the short string on the right side of the figure which crosses this loop (the left upper side of the diamond-shaped pattern). Draw this short string to the right palm, and catch on the back of the right thumb the string held under the right middle-ring-little fingers. Draw this string through the thumb loop just created, releasing right middle-ring-little fingers. Transfer right thumb loop to right middle-ring-little fingers, inserting them proximally.

6. You now have a triangle on the lower transverse string, near the right side of the figure, formed by

doubled strings. Its apex points downward. Pass right thumb away from you into this triangle. Return with the double strings forming the top side of the triangle. Insert right thumb proximally into right index loop. Draw the right radial index string through the double thumb loops, releasing right index.

7. Upon examining the upper transverse string near the right hand, you will find a double and a single loop which encircle it. Pass the left thumb away from you proximal to the upper transverse string, between the double and single loops, and catch the transverse string on its back. Release left index and extend.

8. Release right middle-ring-little fingers. Insert four fingers of the right hand distally into the right thumb loop and close them to the palm. Extend. You have The Squirrel [74b]. The squirrel moves to the left by pulling on the right hand loop. The figure is accompanied by the following chant:

tamī'nas dzElxwaⱡᶠEnēxa k'at!Es
q!EgᶜExstālaxwa k'ats!Es
Squirrel runs along a log lying on the ground, carrying spruce canes in his mouth.

74b

ANALYSIS: [74a, 74b]

[74a]: This is nowhere considered a distinct figure.

[74b]: Identical patterns: (P13c)

Chukchi:	(+)	Fox-skin	(Jenness, CI, fig. 160)
Siberian:	+	Squirrel	(Jenness, CI, fig. 160)

Bering:	+	Fox (and Whale)	(Gordon, fig. 19)
	(+)	Wolverine	(Klutschak, p. 139)
N. Alaska:	+	Ermine	(Jenness, CI, fig. 160)
Mackenzie:	+	Ermine	(Jenness, CI, fig. 160)
W. Copper:	+	Ermine	(Jenness, CI, fig. 160)
Caribou:	(+)	Ermine	(Jenness, CI, fig. 160, [Boas])

The method used to produce the Eskimo version of [74b] is identical to the method used in making the Kwakiutl Squirrel [74b], with the exception of how the intermediate stage [74a] is formed. The Kwakiutl method is extremely complex and mechanical. By contrast, the Eskimo method is simple and direct:

1. Place loop on thumbs and indices. Pass little fingers proximal to all strings and return with radial thumb string. Pass little fingers distal to ulnar index strings and close the ulnar index strings to the palms.

2. Exchange the thumb loops as follows: Pass left thumb distal to right thumb-index string and close it to the left palm. Release right thumb. Pass right thumb distal to left thumb-index string and close it to the right palm, allowing the string to slip off the left thumb. Draw strings tight.

3. Pass right thumb proximal to right ulnar little finger string and draw it through the right thumb loop. Release right little finger and left index. Extend. Transfer right thumb loop to right little finger, inserting it proximally and closing it to the palm.

4. Transfer left thumb loop to left index, inserting it distally.

5–8. Proceed with steps 5 through 8 of the Kwakiutl method, starting with the *second* instruction of step 5, "Insert right thumb proximally into left index loop . . ."

The method given by Jenness has the left hand performing most of the manipulations, which results in a right-handed version of this figure. The Kwakiutl method uses the right hand and has the Squirrel on the left.

It is interesting that the Siberian Eskimos use the Kwakiutl name for [74b]. In addition, they are the only Eskimos who produce a series of four individual figures by inserting an extra movement between steps 6 and 7 of the Kwakiutl method. This makes the Squirrel the third figure of their series, being preceded by figures called the Shag and the Beaver, and followed by a figure called the Man. Their chant is as follows:

> The shag was feeding its young, the shag was feeding
> its young.
> The beaver came up out of the ground to me.
> Whence that squirrel?
> Coming up it ran away. This man intercepted it.

It is interesting to compare this chant with the Kwakiutl version, which also describes a fleeing squirrel.

The Kwakiutl Squirrel figure [74b] is also produced by many Eskimos using a totally unrelated method. Once again, the figure is the third in a series of four. However, in this context, the name changes.

Identical patterns: (P71b)

Bering:	— Young Beaver	(Jenness, XLIX)
N. Alaska:	— Young Beaver	(Jenness, XLIX)
Mackenzie:	— Young Beaver	(Jenness, XLIX)
Netsilik:	— Wolverine	(Mary-Rousselière, 48)
Iglulik:	— Wolverine	(Mary-Rousselière, 48)

The Kwakiutl do not know this series.

Finally, one method for producing the Squirrel [74b] is unique to the West Copper Eskimos. Here, the pattern is mechanically woven, using the foot as an anchor point:

| W. Copper: | — Ermine | (Jenness, CIII) |

The Kwakiutl Squirrel [74b] is a very popular pattern among all the Arctic inhabitants. In many locations, two or more methods of construction are known.

75. The "Goose" Series

Loop size: medium

The following is the most realistic figure of this collection. It was obtained from a Kwakiutl Indian of Turnour Island, but it was unknown to the people of Fort Rupert. A man from Newettee, however, said that he knew it.

1. Hang the loop on the backs of the left thumb and index.

2. Pass right thumb proximal to the left radial thumb string and the short string passing between the left thumb and index. Return with both of these strings on the right thumb. You now have two loops on the right thumb and single loops on the left thumb and index fingers.

3. Transfer left index loop to left thumb, inserting thumb proximally.

4. Insert index and middle fingers proximally into both thumb loops. Bring these fingers to the center of the figure, and catch between their tips the ulnar transverse thumb string. Draw it through the remaining thumb loop, closing the middle fingers to the palm. Transfer middle finger loops to the ring and little fingers, inserting them proximally.

5. Each thumb has two radial thumb strings. One passes to the center of the figure, and the other is a transverse string. Insert indices distally into both thumb loops. Pass them proximal to the radial thumb strings, which pass to the center of the figure, and distal to the transverse string. Place the transverse string on the backs of the indices by rotating them half a turn in the ulnar direction, thus drawing the string through the remaining thumb loop. Release thumbs and extend to give a two-diamond pattern.

6. Insert left thumb proximally into left index loop. Pass the thumb behind the left diamond. Insert thumb towards you into the triangle (formed between the two diamonds) whose base is the lower transverse string. Return thumb to give two left thumb loops.

7. Insert right thumb proximally into both left thumb loops. Return, thus enlarging the loops. Draw radial index strings through both sets of thumb loops by inserting thumbs proximally into index loops, and returning through thumb loops with radial index string. Release indices and extend. This step resembles the katilluik maneuver.

8. Insert left index distally into left thumb loop, but to the right side of the double strings that cross this loop. Pass left index away from you, proximal to all other strings, then distal to the left ulnar ring-little finger string. Hook back this string with the left index and draw it to-ward you, distal to the double strings that cross the thumb loop, and insert the index finger distally into the left thumb loop. Close the index finger to the palm.

9. Withdraw right little finger only from its loop and pass it to the left, proximal to all other strings. Transfer loop held under the left index to the right little finger, inserting right little finger distally and closing the loop to the right palm. Release right ring finger and extend. You have The Goose [75a]. The following chant is recited:

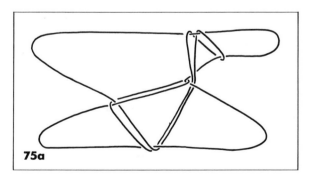

75a

mas^εLae nExā'q!ālag·ilidzEqa nExā'q g·î'lgame'sElaL!a'ē
What sound do geese make when a bear approaches?

10. Release right little finger and insert the right four fingers distally into the right thumb loop, closing them to the palm. Extend. The Bear [75b] now appears.

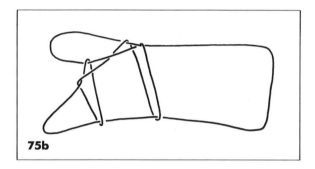

75b

ANALYSIS: [75a, 75b]

Similar patterns:

Mackenzie:	"+"	Old Squaw Duck [75a]	(Jenness, XCVII B)
	"+"	Fox [75b]	
W. Copper:	"+"	Crane [75a]	(Jenness, XCVII B)
	"+"	Fox	

The Old Squaw Duck pattern, although nearly identical to the Kwakiutl Goose [75a], has different string crossings in the "head" and "tail" regions. The Fox / Bear patterns [75b] are also slightly different.

The following chant was recorded among the Mackenzie Eskimos:

> O squaw duck down there, on the river, on its surface, floats along,
> thus (?) down there, thinking, its mother scolding it all the time,
> leaving it behind all the time, while it was still little,
> when I remembered it . . . slow (?)
> It became a fox and ran away.

The Eskimo method for constructing the figures, although seemingly different, is actually related to the Kwakiutl method. Both methods share steps 8 and 9, very odd movements in which the lower

transverse string of the figure is drawn through a thumb loop, and then placed on a little finger. But the Kwakiutl and Eskimo patterns on which this maneuver is carried out are very different and are produced by totally unrelated methods. Therefore, this figure constitutes an example of similar techniques giving rise to similar patterns.

To further complicate matters, the following two-figure series also contains figures nearly identical to the Kwakiutl Goose / Bear figures [75]:

Nearly identical patterns: (P45, P45a)

N. Alaska:	—	The Brant [75a]	(Jenness, CII)
	—	The Brown Bear [75b]	
Mackenzie:	—	The Brant [75a]	(Jenness, CII)
	—	The Fox [75b]	
Iglulik:	—	*Tugdlit* (?) [75a] only]	(Paterson, 45)
Polar:	—	Brant [75a only]	(Paterson, 45)
W. Greenland:	—	Raven [75a only]	(Paterson, 45)
	(−)	The Stomach Eater [75a]	(Hansen 9, 10)
	(−)	It Has Turned into a Dog [75b]	

As before, differences occur in the head and tail weavings, but unlike the previous example, the method is totally unrelated to the Kwakiutl method. In actuality, the method used here is a variation on methods used by the Kwakiutl to construct their Squirrel [74]. The Mackenzie Brant / Fox can be formed from the Kwakiutl Squirrel [74] as follows:

After step 5 of [74]:

6. Transfer right index loop to right thumb, inserting thumb proximally.

7. Pass right index distally through right thumb loop, and insert proximally into left index loops. Hook back left radial index string through right thumb loop, and place the string on the back of the right index by rotating the index half a turn in the ulnar direction. Extend. You have the Mackenzie Brant.

8. Release right middle-ring-little fingers. Widen

the right index loop by inserting the three fingers distally and closing the right ulnar index string to the palm. Extend. You have the Mackenzie Fox.

Finally, one other comparison regarding the opening movements of the Kwakiutl Goose [75] is worth noting: Steps 1–5 produce a two-diamond pattern, which serves as a loom upon which the final figure is constructed. This same technique is exploited by the Eskimos in forming no less than five different figures:

1. Polar Bear (Jenness, CXXXVII; Paterson, 16; and Mary-Rousselière, 6) Known to the Chukchi and most Eskimos. Absent, however, among the Siberian, Nunivak, Bering, and East Greenland Eskimos.

2. Man Hanging by his Neck (Jenness, CXXXVIII; Paterson, 56) Known only to the Chukchi, Siberian, Nunivak, and North Alaskan Eskimos.

3. The Swan (Jenness, CXXXIX; Paterson, 46; Mary-Rousselière, 28) Known to all Eskimos except the Siberian, Bering, and East Greenland Eskimos and the Chukchi. This figure is similar to the Kwakiutl Heron [76].

4. Swan variant (Jenness, CXL) Known to West Copper Eskimos only.

5. A Man Throwing a Duck Noose (Jenness, CXLI) Known to the Chukchi and Siberian Eskimos only.

Although this versatile two-diamond opening appears to be widely used by all Eskimos, it must be noted that the method of constructing it differs from the Kwakiutl. Although steps 4 and 5 are retained, steps 1 through 3 are replaced with a modified version of Position 1. Therefore, the two-diamond patterns differ a bit in the number of twists which occur around the palmar strings.

In summary, it is apparent that the Eskimos are fond of borrowing portions of one figure and applying the methods of construction to another. It is unclear which techniques were developed first and

where they were obtained. This issue is further discussed in Appendix B, below.

76. A Heron

Loop size: medium

This figure comes from the same Indian of Turnour Island from whom I obtained the Goose [75]. It is not known to string figure experts of Fort Rupert. The method of producing it is almost the same as that of the Goose [75], with the only difference being in the opening movement.

1. Hang the loop on the backs of the left thumb and index.

2. Pass the right thumb distal to the short string passing between the left thumb and index, then hook it back so that the right thumb remains within the hanging loop during the movement. When the strings are tight, you will have two loops hooked under the right thumb. Straighten right thumb by rotating it half a turn in the ulnar direction.

3. Transfer left index loop to left thumb, inserting thumb proximally.

4. Insert index and middle fingers proximally into both thumb loops. Bring these fingers to the center of the figure, and catch between their tips the ulnar transverse thumb string. Draw it through the remaining thumb loop, closing the middle fingers to the palm. Transfer middle finger loops to the ring and little fingers, inserting them proximally.

5. Each thumb has two radial thumb strings. One passes to the center of the figure, and the other is a transverse string. Insert indices distally into both thumb loops. Pass them proximal to the radial thumb strings, which pass to the center of the figure, and distal to the transverse string. Place the transverse string on the backs of the indices by rotating them half a turn in the ulnar direction, thus drawing the string through the

remaining thumb loop. Release thumbs and extend to give a two-diamond pattern.

6. Insert left thumb proximally into left index loop. Pass the thumb behind the left diamond. Insert thumb towards you into the triangle (formed between the two diamonds) whose base is the lower transverse string. Return thumb to give two left thumb loops.

7. Insert right thumb proximally into both left thumb loops. Return, thus enlarging the loops. Draw radial index strings through both sets of thumb loops by inserting thumbs proximally into index loops, and returning through thumb loops with radial index string. Release indices and extend. This step resembles the katilluik maneuver.

8. Insert left index distally into left thumb loop, but to the right side of the double strings that cross this loop. Pass left index away from you, proximal to all other strings, then distal to the left ulnar ring-little finger string. Hook back this string with the left index and draw it toward you, distal to the double strings that cross the thumb loop, and insert the index finger distally into the left thumb loop. Close the index finger to the palm.

9. Withdraw right little finger only from its loop and pass it to the left, proximal to all other strings. Transfer loop held under the left index to the right little finger, inserting right little finger distally, and closing the loop to the right palm. Release right ring finger and extend. You have A Heron [76]. The following is said when the figure is ready:

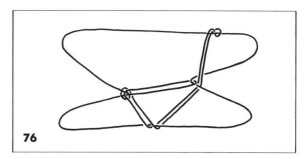

76

qwā^εq!wāniē qas sē'x^εwalēse^ε
The heron paddles ashore.

ANALYSIS: [76]

The Kwakiutl heron is merely a variant of the Kwakiutl Goose [75a] and is formed by creating an extra twist in the left distal thumb loop during the opening movement. As a result, the bird's head in the final figure has a different weaving. Because of this difference, however, no Bear [75b] can be formed as a second figure. The Kwakiutl Heron [76] has not been recorded elsewhere.

77. The Bluejay (*KŭdzE'mts!âlaga*)

Loop size: small

This figure was learned in Alert Bay.

1. Hang the loop on the backs of the left thumb and index. Grasp the hanging strings under the middle-ring-little fingers of the right hand, approximately twelve inches from the left hand. Close the fingers to the palm.

2. Pass right index distal to the short string passing between the left thumb and index and hook it back. Place the string on the back of the right index by rotating the finger half a turn in the ulnar direction. The radial index string should be a single transverse string.

3. Transfer left thumb loop to left middle-ring-little fingers, inserting them proximally. Rotate right index half a turn in the ulnar direction, so that its tip passes to the ulnar side of the most ulnar transverse string. The right index is now bent and points downward. Both strings of the right index loop should now appear to cross the left middle-ring-little finger loop when viewed from below.

4. Insert left thumb distally into left middle-ring-little finger loop. Return with the string which passes directly from index to index. Release

right index and left middle-ring-little finger loop. Extend.

5. You now have a left thumb loop and left index loop. Hanging strings remain grasped by the last three fingers of the right hand. Insert right thumb distally into left thumb loop, and hook back the left radial thumb string to the right palm. With the back of the right thumb, pick up the two strings held under the fingers of the right hand. Draw the strings through the thumb loop. Now pass right thumb distal to the left ulnar thumb string, and hook back this string through the double loop on the right thumb. Close the right thumb to the palm. Release left thumb. Transfer right thumb loop to right index, inserting it distally, and straighten the index by rotating it half a turn in the radial direction.

6. Rotate both indices half a turn in the ulnar direction. Insert left middle-ring-little fingers proximally into left index loop and close the fingers to the palm. With the right thumb, pick up the double strings as they emerge from under the right middle finger, and lift them upward to extend the figure. You have The Bluejay [77]. The hanging loop represents the bird's long tail. The following is sung with The Bluejay [77]:

^εmā·se^εlāē ha mā^ε yasōxda kŭdzEmts!âlaga
hë^ε laēda qabElōxtâ^ε yēse g·a'loła
bEgwanEm qa^εs p!ăł ^εē'de^ε
What does Bluejay woman eat?
She eats first the pupils of a man's eyes.
Then, she flies away.

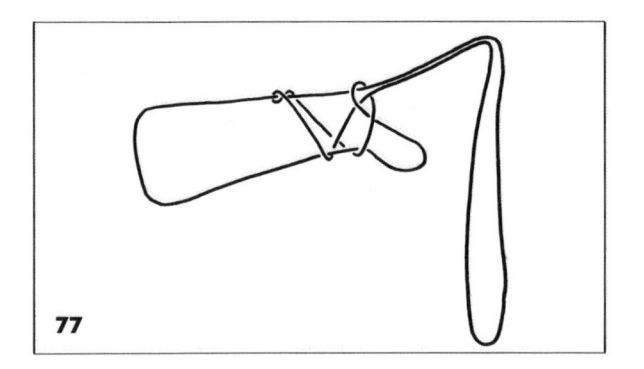

77

78. A Small Grizzly Bear

Loop size: small

1. Hang the loop on the backs of the left thumb and index. Grasp the hanging strings under the middle-ring-little fingers of the right hand, approximately twelve inches from the left hand. Close the fingers to the palm.

2. Pass right index distal to the short string passing between the left thumb and index and hook it back. Place the string on the back of the right index by rotating the finger half a turn in the ulnar direction. The radial index string should be a single transverse string.

3. Transfer left thumb loop to left middle-ring-little fingers, inserting them proximally. Rotate right index half a turn in the ulnar direction, so that its tip passes to the ulnar side of the most ulnar transverse string. The right index is now bent and points downward. Both strings of the right index loop should now appear to cross the left middle-ring-little finger loop when viewed from below.

4. Pass left thumb proximal to both strings of the left middle-ring-little finger loop. Catch on the back of the left thumb the string which passes directly from index to index. Return. Release right index.

5. Draw the left ulnar index string through the left thumb loop as follows: Pass left thumb proximal to left index loop and return with left ulnar index string on its back, drawing the string through the thumb loop. Release left index and extend. You have A Small Grizzly Bear [78].

78

ANALYSIS: [77, 78]

The Kwakiutl Bluejay [77] and Grizzly Bear [78] are produced from an unusual variation of Opening B, in which no right thumb loop is created. Their methods of construction diverge in step 4 where, in the case of the Bluejay [77], the transverse index string is drawn *through* the left middle-ring-little finger loop, whereas in the Grizzly Bear [78], the string is drawn *around* it.

The Kwakiutl Bluejay [77] has not been recorded elsewhere. The Kwakiutl Grizzly Bear [78] is a widely distributed Eskimo figure (see Kwakiutl Bear [3] for analysis). But, as previously described, this method of construction has not been recorded elsewhere.

79. A Bear

Loop size: medium

The opening is atypical for America. It resembles West African openings.

1. Hold left hand horizontally, palm down, with fingers pointing toward the right. With the right hand, grasp a loop of string in the center. Lay the loop across the left hand so that one of the strings lies across the left wrist and the other string lies across the backs of the four fingers. You now have two loops suspended from the left hand: a radial and an ulnar loop.

2. Pass the right hand between you and the strings. With the last four fingers of the right hand, grasp the left string of the radial loop, closing the fingers to the right palm. Do not return right hand. Pick up ulnar loop with right thumb as follows: Pass the entire right hand behind the right string of the radial loop, and then to the right side of the ulnar loop. Insert right thumb from behind into the ulnar loop. Draw the strings tight.

3. You now have a loop on the left wrist, a loop on the four fingers of the left hand, a right thumb

loop, and a loop closed to the right palm under the four fingers. Close the four fingers of the left hand to the palm over the radial string of the left hand. Withdraw right index from the loop encircling it. Insert right index proximally into right thumb loop to enlarge it.

4. Draw left hand loop through right thumb-index loop as follows: Bring hands together. With the right index, hook back the string that passes across the back of the four fingers of the left hand. Draw this string to the right, allowing the right thumb-index loop to slip off. Close the right index to the palm.

5. Draw the loop held under the four fingers of the left hand through the left wrist loop, allowing the left wrist loop to slip off. Extend. You have a Bear [79] near the right hand. By rolling the string on the right ring and little fingers, you can produce the movements of the bear.

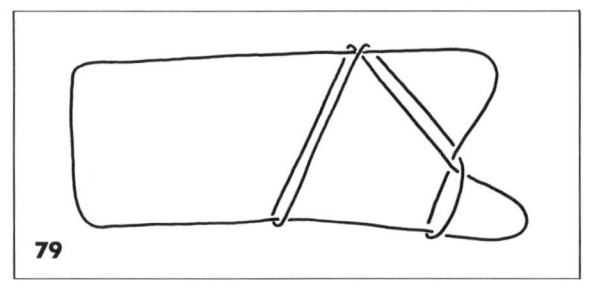

79

ANALYSIS: [79]

The Kwakiutl Bear [79] pattern is widely known among the Eskimos (see Kwakiutl Bear [3] for analysis). But, as previously described, this method of construction has not been recorded elsewhere.

80. The "Devil Fish" Series

Loop size: medium

This is one of the simplest and most widely distributed figures in the world. The method of producing it is practically the same everywhere.

1. Position 1. Pick up left palmar string with right index. Create a twist in the loop by rotating index a full turn in the ulnar direction.

2. Insert left index distally into right index loop. Pick up right palmar string on its back.

3. Release right thumb and right little finger and extend. You have The Devil Fish [80a].

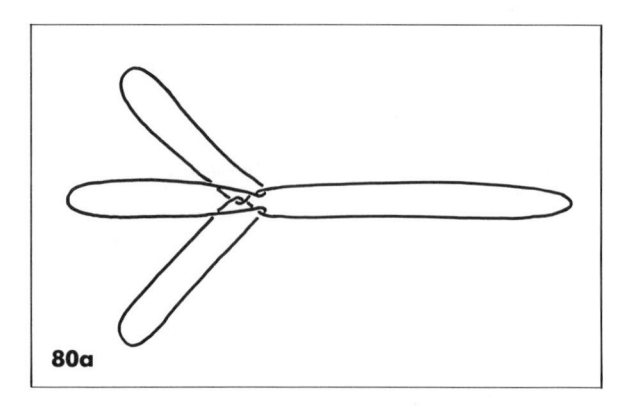

80a

4. Twist right index loop by rotating right index a full turn in the ulnar direction. Transfer right index loop to right thumb and middle fingers, inserting them proximally.

5. Bring hands together. With the right thumb and middle fingertips, lift left index loop off its finger and draw it through the loop encircling the right thumb and middle fingers, allowing the loop to slip off. Insert the four fingers of the right hand into the loop held by the thumb and middle finger, in order to enlarge the loop and extend the figure. You have A Halibut [80b].

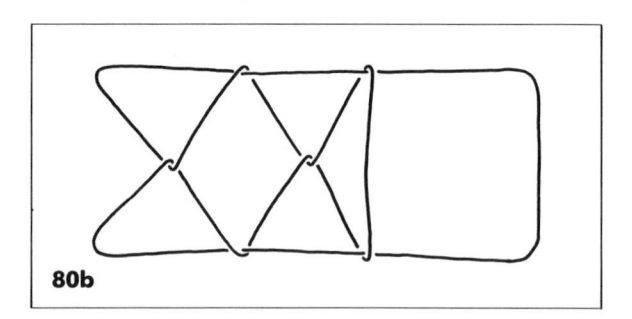

80b

ANALYSIS: [80a, 80b]

The Kwakiutl Devil Fish [80a] is one of the most widely distributed figures in the world. In all cases, its method of construction is the same, except for minor variations in the number of twists created in step 1. The name attached to this pattern varies from one location to the other, but certain tendencies are immediately apparent. In the South Pacific, the figure is commonly known as a Fish Spear: Torres Straits (A. C. Haddon 1912); Loyalty Islands (Maude 1984); Solomon Islands (Maude 1978), to name a few. In South America, the figure most often represents the Roots of a plant: Brazil, Venezuela (Ryden 1934); Peru (Tessmann 1939); Bolivia (Nimuendaju 1952). African names vary considerably, e.g., in Sudan, a Balance (Hornell 1940), and in Zanzibar, a Coconut Palm (Hornell 1930). The North American distribution is as follows:

Identical patterns: (P19a)

Maya:	(+)	Chicken Foot	(Tozzer, fig. 21)
Zuni:	(+)	Brush House	(Culin, fig. 1071)
Thompson:	+	Pitching a Tent	(A. C. Haddon 1903, p. 217; Teit, fig. 270b)
Clayoquaht:	+	Sea-Egg Spear	(Jayne, p. 32)
Makah:	(+)	Devil Fish	(Culin, p. 774)
Tlingit:	(+)	Devil Fish, Crow's Foot	(de Laguna, p. 560)
Nunivak:	(+)	Bird Spear	(Lantis, 8)
N. Alaska:	+	Duck Spear	(Jenness, CXLII)
W. Copper:	+	A Tent	(Jenness, CXLII)
E. Copper:	(+)	A Tent	(Rasmussen, 37)
Caribou:	(+)	The Tent	(Birket-Smith, p. 279)
Netsilik:	+	The Tent	(Mary-Rousselière, 66)
Iglulik:	+	The Tent	(Mary-Rousselière, 66)
Polar:	+	The Tent	(Paterson, 19a)
W. Greenland:	+	Bird Dart	(Paterson, 19a; Birket-Smith, fig. 293b; Hansen, 17)
E. Greenland:	+	Bird Dart	(Victor, 2)

The change in name from Bird Dart to Tent among the central Eskimos is indeed interesting. Mary-Rousselière suggests that the Caribou Eskimos instigated the change (the only tent dwellers of the group). This name better suited the figure, since the bird dart, whose use is confined to open sea, is not used by the central Eskimos. Vancouver Island is also the site of frequent name-changing. The coastal tribe's name of Sea-Egg Spear suggests an affinity with the standard Pacific interpretation of Fish Spear. Those tribes occupying bays and rivers know the figure as Devil Fish (octopus), a sea creature common in sheltered waters. The inland tribes (Thompson), adopt the central Eskimo name of Tent. This figure shows how material culture influences the name attached to an abstract string pattern. But regardless of title, this figure appears to be the most popular figure in the Pacific Northwest. It is often the only figure known to many individuals.

The overall popularity of this figure no doubt arises from the novelty of being able to produce such a realistic figure from such a small number of movements. There is also an element of surprise built into the figure; one fully expects the figure to dissolve when the loops are released in the final step. Instead, a remarkably stable configuration results.

Some tribes, including the Kwakiutl, produce a dissolution figure. Its distribution is primarily confined to North America:

[80b]: Nearly identical patterns: (P19b)

Tlingit:	(+)	Devil Fish under a Rock, Fish Tail	(de Laguna, p. 560)
N. Alaska:	+	He has launched his Duck Spear	(Jenness, CXLII)
W. Copper:	+	Snow Shovel	(Jenness, CXLII)
Iglulik:	+	Snow Shovel	(Mary-Rousselière, 66)
W. Greenland:	+	Snow Shovel	(Paterson, 19b)
	(+)	Throwing Stick	(Birket-Smith 1924, fig. 293a)
Loyalty Is.	+	Fish's Eye	(Maude 1984, 31)

As with [80a], one finds that titles referring to propulsion of the bird dart are confined to those

people who still use the weapon (eastern and western Eskimos only). The differences in final pattern between the Kwakiutl Halibut [80b] and the equivalent Eskimo pattern (P19b) arise from the fact that the Eskimos omit the right index loop twist in step 4.

81. A Sand Flea (*Qat! Yatse*)

Loop size: small

This figure was learned from a twelve-year-old girl of Blunden Harbor.

1. Hang the loop on the left middle finger, allowing the free end to lie on the ground. You have a radial and an ulnar string hanging downward. With the right thumb and index, grasp the ulnar string at its midpoint, and lay the string at a 90° angle across the radial string of the hanging loop.

2. With the thumb and index of each hand, grasp the radial string on either side of the string just laid across it. Slide the thumb and index fingers along the radial string, so that the hands are six inches apart. Release loop from left middle finger. You have A Sand Flea [81]. The sand flea is made to "jump" by rapidly snapping the string held between the thumbs and indices.

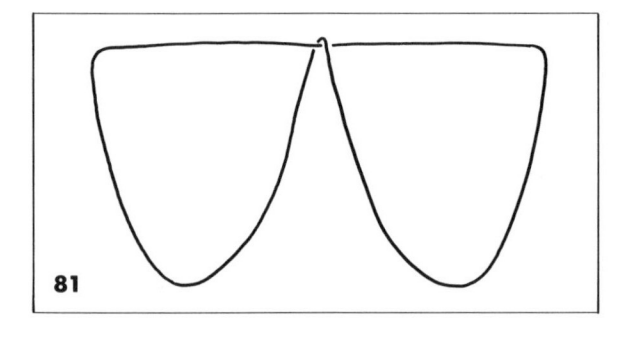

81

ANALYSIS: [81]

This simple figure is characterized by the novel

movement which so vividly recalls the jumping of a flea. Although this figure has not been recorded elsewhere, related figures exist which utilize the same snapping movement to create action:

Peru:	– Bark Floor Inside	(Tessman, VI)
New Guinea:	– Fish Jumping from Stone to Stone	(Jenness 1920, 46)
Fiji:	– A Fish out of Water	(Hornell 1927, fig. 3)

The Peruvian and New Guinea figures, which are identical in final pattern, are displayed exactly like the Kwakiutl Sand Flea [81]. They exploit the same snapping technique to portray the subject of the figure.

82. The Killerwhale

Loop size: large

1. Hang the loop on the left middle finger, allowing the free end to lie on the ground. You have a radial and an ulnar string hanging downward. With the right thumb and index, grasp the ulnar string at its midpoint and lay the string at a 90° angle across the radial string of the hanging loop. With the thumb and index of each hand, grasp the radial string on either side of the string just laid across it. Slide the thumb and index fingers along the radial string, so that the hands are six inches apart. Release loop from left middle finger.

2. You have two hanging loops: a left loop and a right loop. Insert left index away from you into left loop, and insert left thumb away from you into the right loop, releasing the right hand. Arrange the strings so that you have a short string passing between the left thumb and index, and you have two long hanging loops on the left palm. The loop directly beneath the index is loop "a," and the loop beneath the left thumb is loop "b."

3. With the right thumb and index, create a small

ring in the ulnar string of loop "b" by twisting a small segment of the string half a turn counterclockwise (viewing the left palm as the face of a clock). Place the ring on the left index. Insert right thumb and index distally into this ring. Grasp the ulnar string of loop "a" between right thumb and index tips. Thread this string through the ring, allowing the ring to remain on the left index, and continue drawing on the string until the entire loop "a" has passed through the ring. You have two loops on the left index.

4. With the right thumb and index, create a small ring in the radial string of loop "a" by twisting a small segment of the string half a turn clockwise. Place the ring on the left thumb. Insert the right thumb and index distally into this ring. Grasp the radial string of loop "b" between right thumb and index tips. Thread this string through the ring, allowing the ring to remain on the left thumb, and continue drawing on the string until the entire loop "b" has passed through the ring. You now have two left thumb loops.

5. Repeat steps 3 and 4 until the hanging loops "a" and "b" have been consumed and are small. During each repetition, the string derived from loop "a" or "b" is drawn through the most distal of the rings placed on the left thumb or index.

6. Insert right thumb distally into loop "a." Insert the right ring and little fingers proximally into loop "b." Close them to the palm. Transfer all left index loops to the right index, inserting the index distally. Transfer all left thumb loops to the right thumb, inserting the thumb distally. Now examine the right thumb and index fingers, locating the original loop that encircled both the left thumb and index and gave rise to the hanging loops. It will be the only string passing directly from the right thumb to the right index. Transfer this loop to fingers on the left hand as follows: Insert left middle-ring-little fingers distally into the portion of the loop encircling the right thumb. Close the fingers to the palm, and insert left thumb proximally into the portion of the

loop encircling the right index. Release the rings from the right thumb and the right index, but retain the actual right thumb loop. Extend. Mechanically separate the rings in order to spread them out across the entire figure. You have the Killerwhale [82].

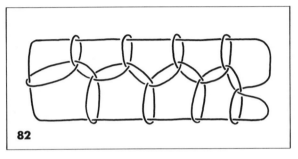

82

[This figure is difficult to dissolve unless done sequentially: Release right ring and little fingers and use them to draw out the section of the lower transverse string, which lies to the immediate left of the ringlet nearest the right hand. Release right thumb. Use right thumb to draw out the section of the upper transverse string which lies to the immediate left of the ringlet now nearest the right hand. Repeat this procedure until the entire figure is dissolved. No dissolution method was recorded by Averkieva—M.A.S.]

ANALYSIS: [82]

Identical patterns:

Hawaii	—	Hermaphrodites	(Dickey, fig. 93)
Marquesas:	—	Pig with Eight Legs	(Handy, fig. 9)
Nauru:	—	Holding up the Sky	(Maude 1971, 120)
N. New Guinea:	—	A Constellation	(Maude & Wedgewood, 10)
E. New Guinea:	(−)	Creeping Plant Species	(Fischer, 15)
Solomon:	—	A Pack of Dogs	(Maude 1978, 64)
Trobriand:	(−)	Little Afternoon Clouds	(Senft & Senft, 59)

| New Guinea: | – Fighting Men | (Noble 1979, 34) |
| | – Hunters and Sorcerers | (Rosser, 20) |

Similar patterns: (P30a, MR 83)

Mackenzie:	"+" The Dancers and the Drum	(Jenness, CXIV)
W. Copper:	"+" They Are Dancing in the Dance House	(Jenness, CXIV)
Netsilik:	"+" Killerwhales and Their Little Ones	(Mary-Rousselière, 83)
Iglulik:	"+" Killerwhale	(Mathiassen, fig. 182; Paterson, 30a)
Polar:	"+" They Are Dancing Because Some Killerwhales Have Been Caught	(Paterson, 30a; Holtved, 38)
W. Greenland:	"+" The Drum Attracts 3 Killerwhales to Shore	(Paterson, 30a)
Hawaii:	"+" Hermaphrodites	(Dickey, fig. 94)

Similar patterns, but different from the above Eskimo figure: (P30b, P30c)

| Bering: | "+" Children, Followed by a Dog Dragging a Sled | (Jenness, CXII) |
| N. Alaska: | "+" Polar Bear Chasing Children | (Jenness, CXIII) |

Probably similar patterns (not illustrated by author):

| Chukchi: | ? Dancing | (Jenness, p. 130B) |
| Caribou: | ? Eskimos and Drum | (Jenness, p. 130B) |

The distribution of this figure is restricted to North America and the Pacific islands. Although the North American and Hawaiian methods of construction all appear to be related, the methods used in the South Pacific are all distinctly different in each location.

There also seems to be some confusion in the Eskimo string figure literature over the exact final pattern of this figure. The pattern given by Jenness and reproduced by Paterson is distinctly different from that illustrated by Mary-Rousselière, Mathiassen, and Averkieva. In the figure supplied by Jenness, the upper and lower loops are joined in pairs at their bases. In the remaining examples, the upper and lower loops alternate. It is not clear whether two distinct figures actually exist. Jenness's description is vague and already contains one error, (p. 131B, fifth line under the heading "subsequent movements in all three figures"; the corrected line should read, "pendent loop, give it a half turn counterclockwise and drop it over the left ring finger"). The figure presented by Jenness may actually be a faulty reconstruction resulting from the inaccuracy of his own field notes. This is supported by the observation that a small modification of his construction method gives rise to the pattern illustrated by others (see revised version of Jenness's description below). It is also worth noting that when Jenness examined the Chukchi and Caribou figures sent to him by Captain Bernard and Boas, respectively, he found figures which "show the children, but as a whole are different . . . The opening movements must be dissimilar" (Jenness 1924:130B). These figures were probably of the alternating loop variety.

Regardless of exact final pattern, the figure itself has an interesting interpretation. As noted by Mary-Rousselière, the Eskimos have two distinct names for this figure; People Dancing, and Killerwhale. The former name is common in the west, whereas the latter occurs primarily in the east. In Greenland, however, the names have converged, producing People Dancing Because Killerwhales Have Been Caught. Among the Netsilik, the figure is called Killerwhale, but is said to represent people dancing, with the upper loops representing men and the lower loops, women. Among the Iglulik, however, the loops actually represent the fins of the many killerwhales that travel in small schools in search of prey (normally a larger whale).

The dissolution of the figure is also interesting. In many locations, the figure is dissolved sequentially, one upper and one lower loop at a time, in order to

represent the dancers or children leaving (Netsilik, North Alaska, Bering). The last set of loops, which consist of two attached loops and one free loop, represents the drummer and his drum, or in Alaska, the last child who is caught by the polar bear. No dissolution figures were recorded among the Kwakiutl.

The popularity of this figure, as judged by its extensive distribution, undoubtedly arises from the easily recalled repetitive weaving movements used in the method of construction (steps 3 and 4 of [82]). Even if forgotten, the movements are readily rediscovered, since the final pattern arises logically from this maneuver. Therefore, only the opening string arrangement must be committed to memory. The method of producing this arrangement is apparently unimportant; most methods recorded so far are unrelated, especially in the Pacific. The Bering Eskimos actually use an intermediate stage of the Kwakiutl Squirrel [74a] as their opening pattern (see Jenness CXII). In fact, Jenness noted that a common method of inventing new figures is to graft the weaving sequence onto different openings (see Jenness CXII, CXIII). Although virtually identical in general pattern, the Eskimo version of this figure is distinct from other examples because the initial loop or "dancer" remains unattached to the palmar string, thus allowing the loops to slide along the transverse strings at will. In contrast, the Kwakiutl and Pacific island examples are static, with the initial loop firmly tethered to the palmar string. These differences are, of course, a direct result of differences in the opening arrangement of strings produced prior to the repetitive weaving maneuver. Although the Kwakiutl Sand Flea opening is found only on Vancouver Island, the final figure is clearly more related to the Pacific island versions than to those produced by the Eskimos.

Clarified method of construction for the Dancers and the Drum, Jenness, CXIV:

1. Position 1, left hand only. Pick up left palmar string with left middle finger.

2. Insert right hand proximally into hanging loop. Draw out palmar strings, which cross left index and ring fingers, as follows: From the distal side, pass right index and right ring fingers behind palmar strings of the corresponding left-hand fingers. Hook back these strings, drawing them out as far as possible to the right through the right wrist loop, allowing this loop to slip off the hand entirely. Maintain right-hand fingers in hooked position.

3. Insert left index and ring fingers proximally (from above) into the corresponding loops of the right hand. Swing the entire right hand over the top of the left hand. Release all right-hand loops, allowing them to hang down against the back of the left hand, with the left palm facing you.

4. Pass the right hand to the backside of the left hand. Using the right thumb and index, create a half twist in the hanging left ring finger loop, so that the radial string is distal to the ulnar string (clockwise, when viewed from the left palm). Place the loop on the left index. Allow it to hang down the back of the left hand. Likewise, create a half twist in the proximal index loop, so that the ulnar string is distal to the radial string, (counterclockwise, if the left palm faces you). Place the loop on the left ring finger, and allow the loop to hang down the back of the left hand.

5. Bring the right hand to the back of the left hand so that the right-hand fingers are pointing downward. Insert right index, from the distal side, underneath the string that crosses the backs of the left index and middle fingers. Likewise, insert the right ring finger underneath the string that crosses the back of the left ring and middle fingers. Return right hand to normal position, lifting these loops off the left hand. Release left middle finger and extend gently. You have one child.

6. Repeat steps 3 through 5 until the hanging string is used up. This creates many children. The figure is dissolved sequentially by releasing the right hand and drawing out the portions of the upper and lower transverse string which pass be-

tween the two children nearest the right side of the figure. This is repeated until no more children are left.

This write-up contains a correction so that the figure corresponds to the drawing provided by Jenness (1924:133B, fig. 174); in step 4, "counterclockwise" has been substituted for the original "clockwise." The figure can be made to match Mary-Rousselière's and Averkieva's figure (alternating loops) if, in step 4, the hanging proximal index loop is drawn *through* the hanging distal index loop prior to creating the twist, then placing the proximal loop on the left ring finger. It is unclear whether this was a mistake made by Jenness, or whether the Eskimos actually prefer the final pattern as illustrated by Jenness.

83. A Salmon

Loop size: large

1. Hang the loop on the left middle finger, allowing the free end to lie on the ground. You have a radial and an ulnar string hanging downward. With the right thumb and index, grasp the ulnar string at its midpoint and lay the string at a 90° angle across the radial string of the hanging loop. With the thumb and index of each hand, grasp the radial string on either side of the string just laid across it. Slide the thumb and index fingers along the radial string so that the hands are six inches apart. Release loop from left middle finger.

2. You have two hanging loops. Transfer the figure to the hands as follows: Close the middle-ring-little fingers of each hand over the outer string of each of these loops. Pass thumbs away from you into the hanging loops, and return with the straight transverse string on thumbs' backs. Release indices and extend. Pick up radial transverse thumb string on backs of indices. You now have short strings passing between each thumb and index, and a transverse ulnar index string.

3. Create a second set of thumb loops as follows: Bring hands together and, with the left thumb, pick up the short string passing between the right thumb and index. Draw the string out a short distance. Pass the right thumb proximal to the newly created right radial index string. Pick up the short string passing between the left thumb and index. Draw it out a short distance.

4. Draw ulnar index string through thumb loops as follows: Insert thumbs distally into index loops. Pick up the ulnar index string on backs of thumbs, making sure that the vertical loop encircling the ulnar index string remains in the middle of the string. Draw ulnar index string through both loops on the thumbs. Release indices. Extend the figure loosely.

5. Withdraw middle fingers from their loops. Insert middle fingers distally into thumb loops. Close middle fingers to the palms. Hold firmly the strings beneath the middle, ring, and little fingers.

6. Insert indices distally into thumb loops. Return with radial transverse thumb string on backs of indices. Do not release thumbs.

7–8. Repeat steps 3 and 4.

9. Remove ring fingers from their loops. Transfer middle finger loops to ring fingers, inserting them proximally and closing them to the palm. Insert middle fingers distally into thumb loops. Close the middle fingers to the palm.

10–12. Repeat steps 6, 3, and 4, and extend the figure fully between the hands. You have A Salmon. The figure is accompanied by the following questions and answers:

wēxtō'las ă'k·ŭlē
qwē͡ᵉxtō'lɛn lax gwā'dzē
Where are you jumping?
I am heading for *gwā'dzē*
[name of a village].

Release the right thumb, extend, and recite:

wēxtō'las ă'k·ŭlē
qwē͡ᵉxto'lEn lax g·Eyō'xᵘ
Where are you jumping?
I am heading for *g·Eyō'xᵘ*.

Release the left thumb, extend, and recite:

wēxtō'las ă'k·ŭlē
qwē͡ᵉxtōlen lax hă'nwadē
Where are you jumping?
I am heading for *hă'nwadē*.

Release the right middle finger, extend, and recite:

wēxtō'las ă'k·ŭlē
qwē͡ᵉxtōlen lax dzā'wadē
Where are you jumping?
I am heading for *dzā'wadē*.

Release the left middle finger, extend, and the figure disappears.

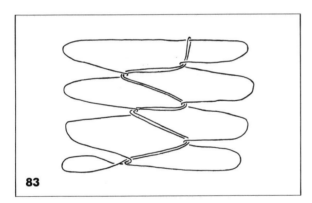

83

ANALYSIS: [83]

As with the Kwakiutl Killerwhale [82], this figure is formed by carrying out a repeating sequence of movements on the initial pattern independently known as the Sand Flea [81]. The figure itself does not depict a salmon. Rather, it depicts Knight Inlet, a winding waterway frequented by spawning salmon (Bill Holm, personal communication). The villages referred to in the chant are located at various salmon streams along the inlet. This novel figure has not been recorded elsewhere. Its title and concept uniquely express the single natural resource most responsible for the prosperity of Northwest Coast culture—the spawning salmon.

84. The Dog Salmon

Loop size: medium

This figure was learned in Alert Bay from a woman of Newettee origin.

1. Place loop on thumbs so that the radial string is short, approximately eighteen inches, and the ulnar string is a long hanging loop. Close the middle-ring-little fingers to the palms over the ulnar thumb strings. Pick up radial thumb string with teeth.

2. You have a left and a right mouth string. Pick up left mouth string with right thumb. Pass left thumb proximal to both of the right mouth strings. Return with the proximal right mouth string.

3. Repeat step 2, and release mouth. Release middle-ring-little fingers and extend. You now have three loops on each thumb.

4. Insert index and middle fingers proximally into all three thumb loops. Bring the fingertips of these fingers together in the center of the figure, and grasp between their tips the ulnar transverse string, which passes directly from thumb to thumb. Draw this string down through the other two thumb loops. Close the loop to the palm under the middle fingers. Transfer middle finger loops to ring and little fingers, inserting them proximally. Insert indices and middle fingers distally into all three thumb loops. Bring these fingertips together at the center of the figure. Grasp with them the radial transverse string, which passes directly from thumb to thumb, and draw it up through the other two thumb loops.

Catch the string on the backs of the indices by rotating the indices half a turn in the ulnar direction. Release thumbs and extend.

5. Four strings cross at the center of the figure, forming a very small diamond, which is hardly visible unless the strings are mechanically separated. Draw the radial index strings through this diamond as follows: Pass thumbs from the radial side through the diamond. Insert them distally into index loops. Rotate thumbs a full turn in the ulnar direction, catching the radial index strings on their palms and drawing them through the small diamond at the center of the figure. Release indices and extend. You have Dog Salmon [84].

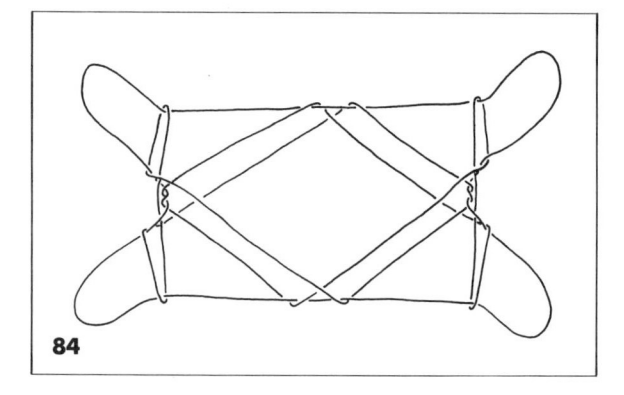

84

ANALYSIS: [84]

The techniques used in producing the Kwakiutl Dog Salmon [84] are derived from those employed in forming the Kwakiutl Two Bears [52]; that is, after producing a Burbot-type pattern [51a], the thumbs are passed through the small central diamond. In creating the Dog Salmon [84], however, the three thumb loops needed for setting up the burbot pattern are created mechanically to ensure that the appropriate half-twists are present: it is difficult to create this arrangement of strings directly from Opening A.

Another interesting aspect of this figure is the variability inherent in the final pattern; the figure produced during any given attempt does not always match the drawing provided herein. The source of this variability can be traced to step 5, in which the thumbs are passed through the small diamond in the center of the figure. The order of the strings that form the diamond will vary with the degree of tension used in extending the pattern. If the order is incorrect at the time step 5 is performed, the final pattern will be malformed. Storer has recently analyzed this problem from a mathematical point of view (Storer 1988:202). Other patterns utilizing this technique also suffer the same handicap, i.e., [52] and [85]. This figure has never been recorded elsewhere.

85. A Big Salmon

Loop size: medium

1. Place the loop on the backs of the thumbs and indices. Pass middle-ring-little fingers distal to all strings and close them to the palm.

2. With right index, pick up the short string passing between left thumb and index. Pass left index distal to right index loop. Return with the short string passing between the right thumb and index. Transfer all index loops to thumbs, inserting thumbs proximally. Release middle-ring-little fingers and extend. You now have three loops on each thumb, which should be kept well separated.

3. Insert index and middle fingers proximally into all three thumb loops. Bring the fingertips of these fingers together in the center of the figure, and grasp between their tips the ulnar transverse string, which passes directly from thumb to thumb. Draw the string down through the other two thumb loops. Close the loop to the palm under the middle fingers. Transfer middle finger loops to ring and little fingers, inserting them proximally. Insert indices and middle fingers distally into all three thumb loops. Bring these fingertips together at the center of the figure. Grasp with them the radial transverse string, which passes directly from thumb to thumb, and draw it up through the other two thumb loops.

Catch the string on the backs of the indices by rotating the indices half a turn in the ulnar direction. Release thumbs and extend. You now have a Two-Diamond figure, each diamond formed from doubled strings.

4. Double strings cross the index loops, forming the upper, outer sides of each diamond. One of these strings becomes the ring-little finger loop after twisting around the palmar string, while the other becomes the outer, lower side of a diamond. Insert thumbs away from you into the diamonds. Return with the latter of these two strings on the thumb backs. Pulling on the thumb loops should cause a small ringlet to form around the ulnar thumb strings at the point where it becomes a lower outer diamond string.

5. Katilluik, inserting left thumb first. Extend. Note that the left thumb must be inserted first to form the pattern successfully. You have A Big Salmon [85].

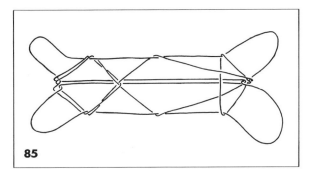

85

ANALYSIS: [85]

Just as the previous figure consists of Kwakiutl Two Bear [52] movements grafted onto a mechanically created set of three thumb loops, the Kwakiutl Big Salmon [85] represents an analogous product created by grafting movements of the Kwakiutl Eagle figure [51] onto a similarly fashioned set of loops: After creating another Burbot-type pattern from a mechanically constructed set of three thumb loops, the side strings of the double diamonds are retrieved.

The side strings are then untangled in a series of movements identical to steps 5 through 7 of the Kwakiutl Eagles [51]. But rather than producing "eyes," as in [51], a "big salmon" is formed as a result of the modified three-thumb-loop opening.

As with the Kwakiutl Two Bears [52] and Dog Salmon [84], this figure also suffers from final-pattern variability. In this case, the variability stems from subtle differences in the arrangement of strings in the Burbot pattern produced after step 3. As before, this variability is derived primarily from the degree of tension used in extending the intermediate pattern. The variability problem encountered here is, in fact, great enough to cast doubt on the authenticity of the final pattern seen in the photograph provided by Averkieva. (Averkieva's photographs were made in New York after her return from Vancouver Island.) There is also some confusion regarding the exact nature of the katilluik maneuver requested in step 6: After step 2, the manuscript refers the reader to the directions for making the Kwakiutl Eagles [51], where a right-handed katilluik is requested. The figure so produced does not, however, resemble a salmon. A more realistic figure is produced if a left-handed katilluik is performed, as described above. But regardless of the exact final pattern, similar figures have not been recorded elsewhere.

86. A Salmon Trap

Loop size: medium

1. Place the loop on the backs of the thumbs and indices. Pass middle-ring-little fingers distal to all strings and close them to the palm.

2. Draw the short string that passes between the left thumb and index through the loop encircling the right thumb and index as follows: Pass the right index distal to the left-hand short string. Hook back this string, allowing the loop encircling the right thumb and index to slip off. Release right middle-ring-little fingers. Draw the hands apart, but do not tighten the strings.

3. Transfer right index loop, still hooked under the right index, to right thumb, inserting thumb distally. Enlarge the new right thumb loop by inserting right index proximally and returning with right ulnar thumb string. The hands remain separated by about six inches.

4. Draw the left radial index string and left ulnar thumb string through the loop encircling the right thumb and index as follows: Pass right index to the ulnar side of left radial index string, and pass right thumb to the radial side of the left ulnar thumb string. Hook back these strings with the right thumb and index. Draw them through the right thumb-index loop, allowing it to slip off. Separate the hands gently and allow both loops to slip onto the right thumb. Insert four fingers of the right hand distally into both right thumb loops and close the ulnar strings to the palm. Extend. You have A Salmon Trap basket [86].

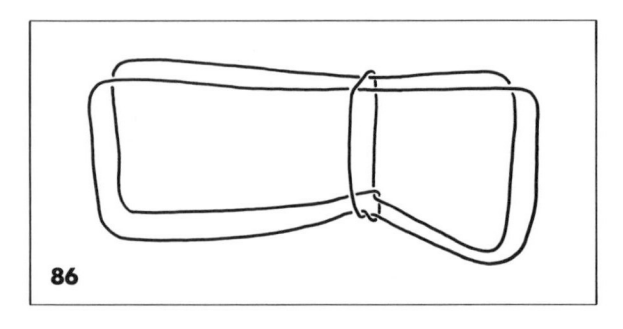

86

87. A Fish Trap

Loop size: medium

This figure was learned in Fort Rupert from a young Indian girl.

1. Place loop on backs of thumbs and indices.

2. Draw the left ulnar index string and the left radial thumb string through the right thumb-index loop as follows: Pass right index to the

ulnar side of the left ulnar index string. Pass the right thumb to the radial side of the left radial thumb string. Hook back these strings. Draw the strings through the right thumb-index loop, allowing this loop to slip off. Grasp the two strings between the tips of the right thumb and index, approximately six inches from the left hand.

3. Grasp the strings held by the right thumb and index between the tips of the left thumb and index, and slide tips to the left along the strings, so that the loop encircling the left thumb and index slips off. You now have two strings held between the thumbs and indices of each hand, which then hang downward across each palm. Close the two hanging strings to the palm under the middle-ring-little fingers of each hand.

4. Transfer the nearer of the two transverse strings onto the backs of the thumbs, and the farther of the two transverse strings onto the backs of the indices. Separate the hands and extend. You have A Fish Trap [87].

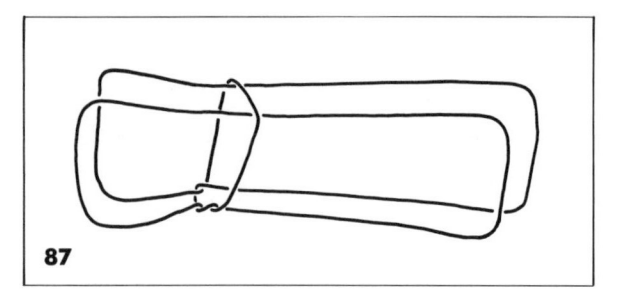

87

ANALYSIS: [86], [87]

The Kwakiutl Salmon Trap [86] and Fish Trap [87] are actually right- and left-handed versions of the same figure, each being constructed differently. This becomes more obvious if the two upper transverse strings are separated and the figure is laid flat. The "unfolded" version of this figure is one of the most popular figures in the world, not only because a method of construction is readily invented if forgotten, but also because of the novel see-sawing motion that accompanies the figure. It is therefore unusual

that both Kwakiutl figures are static. Although a tabulation of the figure's world-wide distribution is beyond the scope of this work, the following summary should provide some insight into its naming:

In Hawaii the figure is known as Leho or Saw (Dickey 1928); in Bora Bora, as Bad Man (Handy 1925); in Fiji, as Butterfly (Hornell 1927); in British New Guinea, as Bird Flies Up (Landtman 1914); and in Australia, as Man and Woman Copulating (McCarthy 1960), to name a few. In Africa, examples include Scissors from Sudan (Hornell 1940); Moving Figure from Nigeria (Parkinson 1906); Skin Bellows from the Gold Coast (Griffith 1925); and Greediness from the Zande (Evans-Pritchard 1972). In India, the figure is called Lock and Key (Hornell 1932). In South America, the figure has been recorded as Horse's Rear End (Métraux 1930). It is one of the few figures known in Europe. In the Netherlands it is called Stool and Chair (Oorschot 1966); in Scotland, Pair of Trousers (Gray 1903); and in England, Scissors (Hingston 1903). The figure is known in Japan (Noguchi 1984) as Blind Man's House, Gate of Shrine, or Oil Light.

The North American distribution is as follows:

[86]: Identical pattern (P34)

Bella Coola:	"+"	Salmon Trap	(McIlwraith, I)
Okanagon:	("+")	Fish Trap	(Jenness, CXLV, footnote)
Alabama:	"+"	Old Man Chewing	(J. Palmer, personal communication)
Navaho:	"+"	Intermediate stage of One Hogan	(Jayne, fig. 552; A. C. Haddon 1903, p. 220)
N. Alaska:	"+"	A Pot Boiling	(Jenness, CXLV)
Mackenzie:	"+"	A Dog's Anus	(Jenness, CXLV)
W. Copper:	"+"	A Dog's Anus	(Jenness, CXLV)
Netsilik:	"+"	Anus	(Mary-Rousselière, 62)
Iglulik:	"+"	Anus	(Mary-Rousselière, 62)
	("+")	Itertjuk	(Mathiassen, fig. 181)
Polar:	"+"	Like an Anus	(Paterson, 34; Holtved, 43)

| W. Greenland: | "+" | Anus, Itinuit, and Fox Trap | (Paterson, 34; Hansen, 27) |
| E. Greenland: | "+" | Anus | (Victor, 3) |

The Siberian Eskimos make the figure using a distinctly different method:

Identical pattern: (P34)

| Siberian: | − | Auyauyangeqaq (woman's name) She is Eating | (Jenness, CXLIV) |

The pattern is also encountered as a dissolution figure among the Siberians:

Identical pattern: (P213b)

| Siberian: | − | Water Seething Up After the Walrus Has Dived | (Jenness, CXXIV) |

Using a slightly different method, the Apache Indians begin to form the figure, but they fail to release the right wrist loop in step 4 of the Kwakiutl Salmon Trap [86]. The result is An Apache Teepee.

| Apache: | "+" | An Apache Teepee | (Jayne, fig. 563) |

Basically, all examples are minor variations on a theme. The Eskimos prefer to use the left little finger rather than the left index in forming the pattern. As mentioned previously, the Northwest Coast Indians have a unique way of displaying their figures, which, unlike most others, are static.

It is also interesting that the Navaho Indians make a related figure called One Hogan (a type of house). The Kwakiutl Salmon Trap [86] is an intermediate stage in the production of this figure. The Mackenzie Eskimos also know this continuation, and likewise call it A Tent: (P185)

| Mackenzie: | "+" | A Tent | (Jenness, CXLVI) |

The Mackenzie and Navaho figures are not identical, however. The Eskimo figure is formed by pulling out two palmar strings in the final step: the Navaho figure requires that only one string is retrieved. The similarities do, however, support the possibility that Athabaskan Indians ancestral to the Navaho people

were in contact with Eskimos prior to their migration to the American Southwest from northwestern Canada sometime around A.D. 1000.

88. The "Two Bear Brothers' Jealousy" Series

Loop size: small

1. Place the loop on the backs of the thumbs and indices. Pass middle-ring-little fingers distal to all strings and close them to the palms.

2. With right index, pick up the short string passing between left thumb and index. Pass left index distal to right index loop. Return with the short string passing between the right thumb and index. Release middle-ring-little fingers and extend.

3. The right ulnar thumb string passes to the left hand, where it becomes the left distal radial index string. Close this string to the palm as follows: Pass right ring and little fingers proximal to index loops. Insert them distally into right thumb loop. Close the right ulnar thumb string to the palm. Pass left ring and little fingers proximal to the index loops, then between left thumb and index loop. Insert them proximally into left distal index loop only. Close the left distal radial index string to the palm.

4. Draw the radial thumb string through both index loops as follows: Insert middle fingers proximally into both index loops. Grasp the radial thumb string between the tips of the indices and middle fingers. Draw this string through the index loops. Place the new loops on the backs of the indices by rotating indices half a turn in the ulnar direction. Release thumbs and extend.

5. Near the right hand you now have a diamond-shaped figure with a transverse string running across the middle of it. The upper sides of the diamond are formed by doubled strings, two of which pass across the radial surface of the figure.

The other two pass across the ulnar surface. Insert thumbs away from you into the diamond, above the central transverse string. Return with the radial surface strings, which form the upper sides of the diamond figure.

6. Katilluik, inserting left thumb first. Extend. You have Two Bear Brothers' Jealousy (*P!ap!alya*) [88a], one small brother at the right side of the figure, and one large brother at the left.

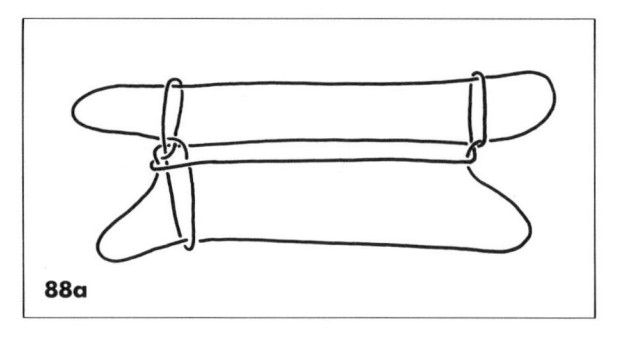

88a

This figure is accompanied by a chant, of which there are three variations:

ᵋNa'k!wax·duᵋxᵘ

> *ᵋmā'ᵋmēlas āda p!ā'p!alyᵋaLEn wīsä.*
> *lā'lax·ōsEn leg·ayōL āda*
> *qwē'sdala ā'Las ōyag·îlxLēᵋlaxwisē*
> *wŭlē wŭlē dā'xwaxāᵋlisē tsē'tsaᵋyatâᵋls*
> *ᵋnōlabidzōᵋs wi's dā'xwaqaᵋlsa tsē'tseᵋyatâᵋls. wā'xa*

Kwakiutl

> *ᵋmā' ᵋmēlahas ā'daya p!ā'p!ElᵋyaLEn wîsaᵋya*
> *lā'lax·ōsEn wî'saᵋya*
> *qwē'dala qwe'dala ā'Las aᵋō'yag·îlxLā'laxōL wīsaᵋya*
> *wŭ'la hai' wŭlahai' dā'xwaqElsayax*
> *ᵋnō'labidzaᵋwas wihīsaya dāxwaqElsa*

L!a'L!asiqwala

> *ᵋmā'ᵋma'Las adē' p!ap!alᵋyaLEn wisä*
> *lalax·osEn lä'g·ayōl adä*
> *g·wā'laā'Las ō'yag·îlxĻēᵋlaxōl wisä*
> *wā'lä wā'la dāxwaqālsaxēs ᵋnō'labits!aos weehesä*

Where are you going, my big brother?
I am going to gather moss, little one.
Please let me follow you, dear brother.
No! You will only slow me down.
The elder brother jumps past the little brother.

7. Release right thumb and extend. You have He Jumps and Passes the Elder Brother [88b]. This movement is performed during the chant at the appropriate time.

88b

ANALYSIS: [88]

The Kwakiutl Two Bear Brothers' Jealousy series [88] has not been recorded elsewhere. Mechanistically, the figure is based on the opening movements of the Kwakiutl Big Salmon [85]. But soon after their common opening, the figures start to diverge. In forming [88a], step 2 does not involve the transfer of all loops to the thumbs, as in [85]. Rather, a more sophisticated, asymmetric maneuver is performed, in which a single, nontransverse string is closed to the palms. The Kwakiutl also use this technique in forming Paddling Under Coppermaker [21], Hanging Oneself by the Neck [58], and Sneezing [60]. Steps 5 and 6 are also popular among the Kwakiutl, and are often performed on Burbot-type patterns (Eagles [51], steps 5 and 6; Big Salmon [85], steps 4 and 5).

89. The "Two Brothers, One Hiding from the Other" Series

Loop size: small

1. Place loop on thumbs so that the radial string is approximately six inches long and the ulnar string forms a long hanging loop. Close the middle-ring-little fingers to the palm over the portion of the hanging loop that crosses the palm.

2. Pass indices proximal to the transverse radial thumb string and return with it on the backs of the indices.

3. You now have a short string passing from each thumb to the index of the same hand. With the right thumb, pick up the left short string, and with the left thumb, pick up the right short string after passing the left thumb proximal to the left radial index string. Release middle-ring-little fingers and extend. You have two thumb loops and a single index loop.

4. Transfer index loops to thumbs as follows: Pass thumbs proximal to index loops and return with ulnar index string. Release indices.

5. Draw the ulnar transverse thumb string through the other two thumb loops as follows: Insert index and middle fingers proximally into all three thumb loops. Bring these fingertips together at the center of the figure. Grasp between them the transverse ulnar thumb string. Draw it through the remaining thumb loops. Close the middle fingers to the palm. Transfer middle finger loops to ring and little fingers, inserting them proximally and closing them to the palm.

6. Release thumbs from the two transverse radial thumb strings only. Extend. You have Two Brothers [89a], one at each end of the figure, represented by a loop encircling the upper transverse string.

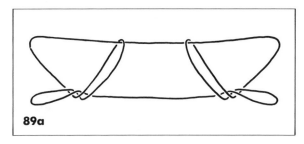

89a

7. The "left" brother hides as follows: Withdraw left ring finger from its loop. Pass left ring and middle fingers toward you into the center of the figure. Close the two vertical strings representing the left brother to the palm. You have One Brother Hides from Another (not illustrated). Transfer right thumb loop to left thumb, inserting thumb proximally. Enlarge right ring-little finger loop as follows: Insert right thumb distally into right ring-little finger loop. Return with the radial string of this loop. Extend. The vertical loop formerly on the right side is now on the left. You have One Brother Looking for Another [89b].

89b

8. Release right thumb and transfer left distal thumb loop back to right thumb, inserting right thumb proximally, thus returning the one brother to the right side of the figure.

Steps 7 and 8 are repeated four times with the accompanying chant. This represents one brother running in search of the other.

> aLex k!wē'sala wī'nī ālēya
> aLex tsE'lxa wīnī ālēya
> aLex yūgwa
> The snow is coming. Where are you brother?
> The hail is coming. Where are you brother?
> The rain is coming.

9. After the chant, release the left middle and ring fingers. You now have the Brother Came from the Hiding Place Because He Was Afraid of the Coming Rain (same as [89a]). The two brothers happily face each other.

ANALYSIS: [89]

Identical pattern:

Bella Coola: + Two Boys (McIlwraith, IV)

The Kwakiutl series, Two Brothers, One Hiding from the Other [89], is a novel action series. Its distribution is currently confined to the Pacific Northwest Coast. The Bella Coola chant is quite brief:

> After step 7: "Where is he?"
> After step 9: "Here he is!"

Mechanistically, the series is closely related in technique to figures of the Patch family [61, 62, 63]. A new technique, however, is used in creating the three thumb loops, thus replacing steps 1 and 2 of the Kwakiutl Patch [61]. Step 3 is also borrowed from the Patch family, but it produces two transverse thumb strings rather than one as a result of the new opening. In step 4, the two figures begin to diverge. In the case of [89], the two transverse thumb strings are dropped; in [61], the transverse thumb string is retained, and the remaining thumb loops are transferred to the indices. As a result, [89] resembles a two-dimensional version of [61]: the two upper transverse strings required for the three-dimensional extension are lacking. This is a wonderful example of how new figures are created from previously known figures through the variation of opening movements.

It is also worth noting that the unusual method of creating index loops from the radial thumb string in step 2 is quite common among the Eskimo. It forms the basis of an entire family of figures known as the Brown Bear's Pack cycle (Jenness, CXVII–CXXVI). The Eskimo method differs only slightly in that the indices are passed *distal* to the transverse ulnar thumb string in step 2.

90. Digging Clams (Version 1)

Loop size: medium

This figure was obtained in Fort Rupert. It was known to a good many people.

1. Hang the loop on the tip of the left thumb, just over the nail. With the left little finger, close the ulnar string of the hanging loop to the left palm. Hook back the radial string of the hanging loop with the left middle finger. Close the finger to the palm above the string that passes under the left little finger.

2. With the right thumb and index, grasp the end of the hanging string emerging from under the left middle finger. Form a ring in the loop by twisting the string a half turn in the clockwise direction (viewing the left palm as a clock face). Insert left thumb away from you into the ring. Place the ring on the base of the left thumb, so that it is proximal to the original thumb loop. Tighten the ring by pulling on the hanging string. Repeat this movement with the radial hanging string until there are six ringlets on the left thumb, all of which are proximal to the original left thumb loop.

3. With the right ring and little fingers, close the string used to make the ringlets to the right palm. Transfer original left thumb loop to the right index, inserting index distally. Rotate right index a half turn in the ulnar direction to straighten the finger. With the tips of right thumb and index, grasp the loops remaining on the left thumb. Withdraw left thumb. Straighten left middle finger by rotating it a half turn in the radial direction. Transfer left middle finger loop to left thumb, inserting left thumb proximally. Release rings from right thumb and index tips. Extend loosely. Mechanically separate the rings, so as to spread them evenly across the figure. The six

rings represent women sitting in a canoe. They are going clam digging [90].

The figure is accompanied by the following saying:

ᵋmāsLas dzē'k·aLEnuᵋxᵘ lā'lax·în lā'xsa
k!! eō'sē k!wāx·ᵋidaōsō ᵋs q! ä'lēg·înuᵋxᵘ
ɫēɫEᵋlō'xwä ᵚnēsLas q̌ăpă'xsdEg·aa'Laᵋē
â ᵋmᵋla q̌ăp!ē'd ᵋwīᵋwuᵋlaxē ts! ē'daqē q! āL!ō'kwe
Where are you going?
We are going clam-digging.
Let me go!
The boat is full. There is no place for you to sit.
I hope the boat capsizes and all of you drown.
The six women fall out of the boat.

[Although no dissolution figure was recorded by Averkieva, the figure is best dissolved by repeatedly releasing the right thumb and re-inserting it back into its own loop, but to the left side of the ringlet nearest the right hand during each repetition—M.A.S.]

91. Digging Clams (Version 2)

Loop size: large

This figure was obtained from a Quatsino Sound Indian. It illustrates the same story as Digging Clams [90] from Fort Rupert. They say that it is the same, only made differently.

1. Place loop on backs of thumbs and indices.

2. You have a short string passing between the thumb and index of each hand. Draw the left short string through the right thumb-index loop as follows: Bring hands together, and hook back the left short string with the right index. Draw string to the right, allowing the loop encircling the right thumb and index to slip off. Remove right index from its loop and re-insert from the opposite side. Insert right thumb proximally into right index loop to enlarge the loop. Extend.

3. Repeat step 2.

4. Transfer left index loop to left thumb, inserting left thumb proximally. You now have two (or

90

more) small loops around the left thumb, and two left thumb strings: the proximal string passes to the back of the right thumb, and the distal string passes to the back of the right index. Pick up the left distal thumb string with the left index (to the right of the small loops that encircle the left thumb).

5. Repeat steps 2, 3, and 4, until the left thumb has seven to eight rings on it.

6. Release left index. Release entire right hand. Extend right arm away from you so that the thumb is pointing to the right. Lay the hanging strings of the loop across the right palm so that the free end of the loop is near the right thumb. Close both strings to the palm under the middle-ring-little fingers of the right hand.

7. With right thumb and index tips, grasp all distal loops of the left thumb. Withdraw the left thumb, so that only the most proximal loop remains on it. Now, grasp the loops with the left thumb and index tips in order to free the right thumb and index. With the tips of the right thumb and index, grasp the single hanging loop that depends from the last three fingers of the right hand. Thread this loop through the rings held by the left thumb and index distally. Place the end of the threaded loop on the left index. Rotate left thumb a full turn in the ulnar direction. Transfer left thumb loop to left ring and little fingers, inserting them proximally and closing them to the palm. Transfer left index loop to left thumb, inserting thumb proximally. Extend. Mechanically separate the rings so as to spread them across the entire figure. You have women going Clam Digging [91]. The

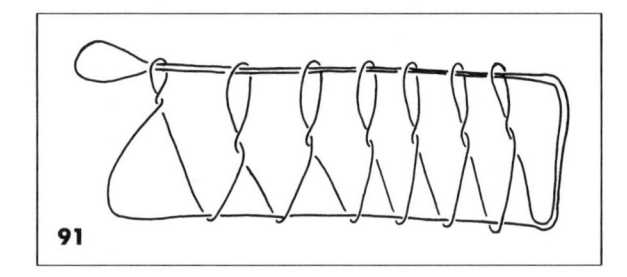

91

same story is recited as for Digging Clams [90] from Fort Rupert.

A similar story accompanies a Bella Bella string figure. Unfortunately, the figure was not recorded.

Where are you going?
We are going to get berries farther down outside.
Why don't you take them to the canoe?
There is nothing that we can use. There is no room in the canoe for the mother of G·i'gināla.
What is the matter with it? There is room in the canoe in the bailing hole.
It is used for bailing by the mother of G·i'gināla.
I wish you would capsize in the mouth of Wā'nuk.
(They upset at the mouth of Wā'nuk.)

[Although no dissolution procedure was recorded by Averkieva, the figure is best dissolved by releasing the left thumb—M.A.S.]

ANALYSIS: [90], [91]

[90]: Similar pattern: (P161)

E. Copper:	? Many People Gathered in the Dance House	(Rasmussen, 2)

[91]: Similar pattern:

Hawaii:	"+" Hermaphrodites, or Calabash Net of Makalii	(Dickey, fig. 95)

The Kwakiutl Digging Clams figures [90, 91] have very limited and interesting distributions. Mechanistically, these figures are related to the Kwakiutl Killerwhale [82] in that a string is drawn through a series of mechanically created ringlets. Realizing this close association, the East Copper Eskimos actually applied the West Copper name for the Killerwhale pattern (They Are Dancing in the Dance House) to their version of [90]. Unfortunately, no method of construction was recorded from the East Copper Eskimos. It is therefore impossible to determine its relatedness to the Kwakiutl figure.

Although the final pattern of the second Kwakiutl Digging Clams figure [91] does not precisely match that of the Hawaiian figure, the figures are closely related in method of construction. Both figures share

the same opening and require that the left index–thumb string be drawn out in forming the ringlets. The methods differ, however, in how the ringlets are created and where they are stored prior to being threaded. As a result of these subtle differences, the Kwakiutl ringlets have a full twist at their base in the final pattern, whereas the Hawaiian ringlets show only a half twist. In dissolving their pattern, the Hawaiians say that the heads of the hermaphrodites are being chopped off sequentially. Although one might think that a similar maneuver would be used by the Kwakiutl to illustrate the women falling from the capsized boat, no dissolution step was observed by Averkieva. If these figures truly are derived from each other, the introduction must have been recent given the limited distribution of [91].

92. Lying on the Back in a Canoe
(*T!ē'g·îxsālalis*)

Loop size: small

1. Place one end of the loop on the backs of the left thumb and index. Place the other end on the right wrist, so that the strings pass from hand to hand uncrossed.

2. Bring the hands together. With the right index, hook back the short string passing between the left thumb and index. Draw it to the right. Place it on the back of the right index by rotating the finger half a turn in the ulnar direction. Extend. You now have a left thumb and left index loop, and a right index and right wrist loop.

3. Pass left thumb proximal to left index loop. Return with ulnar left index string. Draw the left radial index string through the proximal thumb loop as follows: Insert left middle finger proximally into left proximal thumb loop. Pass finger to the ulnar side of the left radial index string. Hook down this string through the left middle finger loop. Close it to the palm.

4. A short segment of string, originating from the left proximal ulnar thumb string, crosses the left middle finger loop. Take up this string on the back of the left thumb as follows: Insert left thumb proximally into left middle finger loop and rotate thumb a full turn in the ulnar direction, allowing the two left thumb loops to slip off the thumb. Release left middle finger. You now have single loops on the left thumb and left index.

5. Insert middle-ring-little fingers of the right hand proximally into the right index loop. Close the radial string of this loop to the palm. Draw this loop through the right wrist loop, allowing it to slip off the hand. Rotate right hand away from you, so that the right thumb is pointing downward. Insert right thumb away from you into the loop encircling the four fingers of the right hand. Press down on the lower string of this loop to enlarge the loop. Turn palm of left hand away from you to extend. You have Lying on the Back in a Canoe [92].

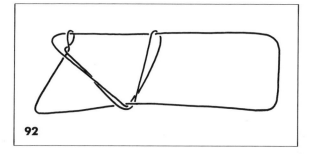

92

The following chant was collected. It appears to apply to this figure:

Lē'la^ɛlānLōL t!ē'g·îxsalālis qa'ēda mō'sgEm tsā'k·us
dEx^ɛwultâ
qa^ɛs lē^ɛ lā'xa mō'sgEm tsā'k·us
hë^ɛmawisEn sē'nadExsālalis t!ē'g·îxsālalis
qaē'da mō'sgEm tsā'k·us
I call this figure "lying down on back in canoe for four fern roots."
He jumps out of his canoe and goes looking for four fern roots.
My reason for lying on my back in a canoe is to look for four fern roots.

One native applied the song for Two Brothers Meet [89b?] to this figure. He applied the name Lying on the Back in a Canoe to [89b].

[Patterns [92] and [89b] are similar but distinct; the confusion is self-evident—M.A.S.]

ANALYSIS: [92]

Identical patterns: (P101a)

| Bering: | + The Ptarmigan | (Jenness, XCI, fig. 139) |

The Kwakiutl Lying on the Back in a Canoe figure [92] is nothing more than Another Deer [33] formed from a modified version of Opening B: the right wrist takes the place of the right thumb. As a result, the right index loop can be drawn through the right wrist loop in the final movement; this is a very awkward maneuver if one starts with the wrist loop on the thumb (Opening B). The Bering Strait Eskimos, however, do not know this modification. In order to form their Ptarmigan, they first form the Kwakiutl Another Deer figure [33]; they finish by drawing out a section of the lower transverse string to partially dissolve the figure. The Kwakiutl method is more refined. It accomplishes the same maneuver prior to weaving the pattern.

93. The "Going to Get Some Bait" Series

Loop size: small

1. Place the loop on the backs of the thumbs and indices. Pass middle-ring-little fingers distal to all strings. Close them to the palms.

2. With right index, pick up the short string passing between left thumb and index. Pass left index distal to right index loop. Return with the short string passing between the right thumb and index. Release middle-ring-little fingers and extend.

3. The right ulnar thumb string passes to the left hand, where it becomes the left distal radial index string. Close this string to the palm as follows: Pass right ring and little fingers proximal to index loops. Insert them distally into right thumb loop. Close the right ulnar thumb string to the palm. Pass left ring and little fingers proximal to the index loops, then between left thumb and index loop. Insert them proximally into left distal index loop only. Close the left distal radial index string to the palm.

4. Draw the radial thumb string through both index loops as follows: Insert middle fingers proximally into both index loops. Grasp the radial thumb string between the tips of the indices and middle fingers. Draw this string through the index loops. Place the new loops on the backs of the indices by rotating them half a turn in the ulnar direction. Release thumbs and extend. A single transverse string runs across the middle of the diamond-shaped pattern at the center of the figure.

5. Pick up the central transverse string with the right thumb as follows: Pass right thumb distal to the central transverse string. Pick string up on the back of the thumb by pointing thumb downward and returning thumb to normal position. This creates a right thumb loop with a half-twist in it.

6. Insert left thumb proximally into right thumb loop. Return so as to enlarge the loop. Insert thumbs proximally into index loops. Return through the thumb loops with the radial index strings on their backs. Release indices and extend.

7. Transfer thumb loops to indices, inserting them proximally.

8–9. The transverse string running across the middle of the diamond-shaped pattern at the center of the figure is now doubled. Repeat steps 5 and 6, treating the doubled transverse string as if it

were a single string. You have a Man Is Going to Get Some Bait [93a].

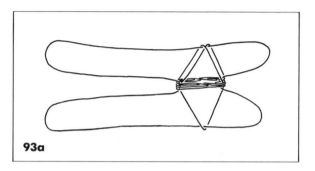

93a

10. Release right thumb and extend. You now have The Man Totes His Clothing on His Head Because It Is Wet [93b]. The following is sung while the figure is being made:

ᵋmā̆ᵋmēdzâLēlaōxda q!ulᵋyakwē
t!aɬt!ēɬt!a'lEya laōxda q!ŭlᵋyakwē
laă'mlōx t!ā'pâ aEmɬaxᵋsEm mōelzEtōl
Where are you going, old man?
He went to get bait, this old man.
Now, my clothes are wet, and I must tote them on my head.

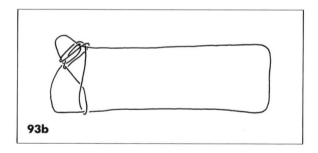

93b

ANALYSIS: [93]

Identical pattern:

Bella Coola: + Crossing a River (McIlwraith, XIV)

It appears that the Kwakiutl "Going to Get Some Bait" series [93] is unique to the Northwest Coast, shared only with the Bella Coola. The Bella Coola

chant describes a woman crossing a river:

After step 9, the woman shouts:

Come to fetch me across the river!

A villager on the other side replies:

Go high up to a place where projecting stones make a causeway.

Upon releasing the right index, it is said that the woman raises her clothing above her knees. By separating the hands, she moves to the left across the river.

Another story recorded by McIlwraith describes a man with an injured leg trying to cross the river. When the villagers make fun of him, he lengthens his injured leg by magic and crosses the river to spite them.

Technically speaking, the figure is a variation of the Kwakiutl Two Bear Brothers' Jealousy figure [88a], another figure confined to the Northwest Coast. Both share identical opening movements, but begin to diverge in step 4: through a series of katilluik-type movements, the central string of the intermediate diamond pattern is wound several times around the diamond's middle. This produces the "man" who is getting bait. Both [88] and [93] creatively portray situations often encountered by the Kwakiutl in the course of performing their daily chores.

94. Pulling the Hair of His Sweetheart

Loop size: small

1. Position 1.

2. Bring the hands together. Insert right index, from the distal side, behind the left palmar string. Hook it back to the right. Place it on the back of the right index by rotating the finger half a turn in the ulnar direction. Bring hands together. Insert left index, from the distal side, behind the segment on the right palmar string which is radial to the right radial index string. Hook back this

short segment. Place it on the back of the left index by rotating the finger half a turn in the radial direction.

3. Transfer index loops to thumbs, inserting thumbs proximally. Transfer little finger loops to thumbs, inserting them proximally.

4. Draw the ulnar transverse thumb string through the other two thumb loops as follows: Insert indices and middle fingers proximally into all three thumb loops. Bring these fingertips together in the center of the figure. Grasp between them the ulnar transverse thumb string. Hook down this string through the thumb loops and close it to the palms under the middle fingers. Insert ring and little fingers proximally into middle finger loop. Close them to the palm.

5. Release thumbs from the two loops that have transverse radial thumb strings. Separate the hands slowly to extend. The movements represent Pulling the Hair of His Sweetheart [94].

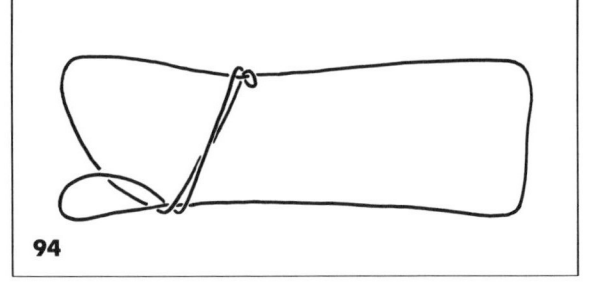

94

ANALYSIS: [94]

The Kwakiutl Hair Pulling figure [94] has not been recorded elsewhere. After creating three thumb loops from a modified version of Opening A, the figure is identical in method of construction to the Kwakiutl Two Brothers, One Hiding from the Other [89] (steps 5 and 6). This figure is, therefore, another member of the popular Patch family of figures [61, 62, 63, 89]. The friction created by the sliding knot vividly portrays hair being pulled.

95. Pulling the Line in Fishing Halibut

Loop size: medium

1. Place one end of the loop on a toe. Take up the remainder of the string in Position 1 by placing the string on the backs of the thumbs and little fingers. Continue by forming Opening A.

2. Pass thumbs distal to index loops. Return with radial little finger strings on their backs.

3. Insert little fingers proximally into index loops. Return with ulnar index strings. Carry these strings on the backs of the little fingers to the outside of the strings running from thumb to toe.

4. Lift the proximal thumb loop over the distal thumb loop using the teeth. Release teeth. Release indices and extend. By alternately pulling thumb loops and little finger loops, you produce a sawing movement, representing Pulling the Line in Fishing Halibut [95].

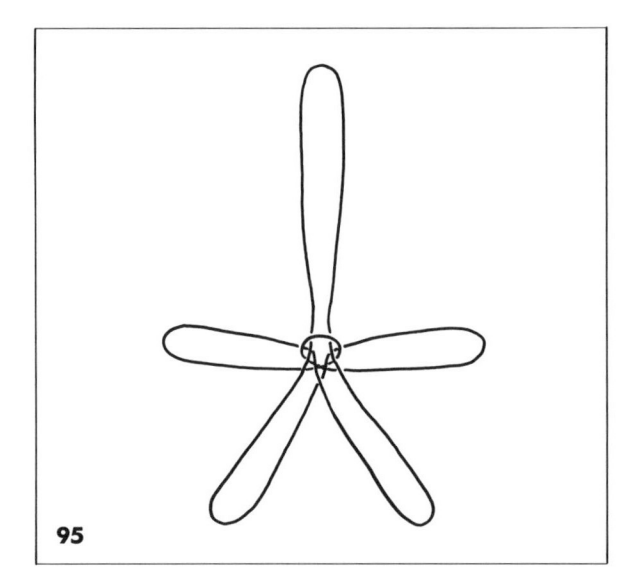

95

ANALYSIS: [95]

The Kwakiutl Fishing Halibut figure [95] is closely

related, if not identical, to a figure known widely throughout the western Pacific: New Hebrides (Dickey 1928); Torres Straits (A. C. Haddon 1912); Goodenough Island (Jenness 1920); Fiji (Hornell 1927); Palau (Raymund 1911); Australia (Davidson 1941); East New Guinea (Fischer 1960), and others. As with most simple figures, the method of construction varies from one location to another, but the end result is basically the same throughout. All examples of this figure are characterized by a long loop held by the toe, and by a central weaving that contracts and expands when the strings are pulled. The name given to this figure is different in each location, suggesting independent invention, or transmittal through brief observation only.

thumb a half turn in the ulnar direction. Release middle-ring-little fingers. Extend loosely. Notice that the string passing from the left index to the right thumb does not pass through the circle. You have Not Passing Through [96].

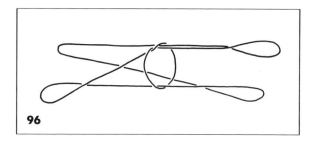

96

96. Not Passing Through (*Wǐ'x·sâ*)

Loop size: small

1. Place loop on backs of thumbs and indices.
2. Create a twist in this loop as follows: Rotate entire right hand half a turn in the ulnar direction. Withdraw right thumb and index from their loop. Re-insert them from the opposite side. The string passing from left thumb to right index now passes distal to the string passing from right thumb to left index. Close all strings to the palm under the middle-ring-little fingers of each hand.
3. Bring the hands together. Pass right index distal to the short string passing from left thumb to left index. Hook it back six inches to the right. Allow the right index loop to slip onto the right index knuckle, thus laying it across the string held in the hook of the right index. Pass left thumb distal to the right ulnar thumb string. Hook it back six inches to the left, allowing the left thumb loop to slip onto the left thumb knuckle, thus laying it across the loop held by the left thumb.
4. Straighten fingers as follows: Rotate right index a half turn in the radial direction. Rotate left

97. Passing Through (*Lā'x·sâ*)

Loop size: small

1. Place loop on backs of thumbs and indices.
2. Create a twist in the loop as follows: Rotate entire right hand half a turn in the radial direction. Withdraw right thumb and index from their loop. Re-insert them from the opposite side. The string passing from left thumb to right index now passes proximal to the string passing from right thumb to left index. Close all strings to the palm under the middle-ring-little fingers of each hand.
3. Bring the hands together. Pass right index distal to the short string passing from left thumb to left index. Hook it back six inches to the right. Allow the right index loop to slip onto the right index knuckle, thus laying it across the string held in the hook of the right index. Pass left thumb distal to the right ulnar thumb string. Hook it back six inches to the left, allowing the left thumb loop to slip onto the left thumb knuckle, thus laying it across the loop held by the left thumb.
4. Straighten fingers as follows: Rotate right index half a turn in the radial direction. Rotate left

thumb half a turn in the ulnar direction. Release middle-ring-little fingers. Extend loosely. Notice that the string passing from the left index to the right thumb passes through the circle in the center of the figure. You have Passing Through [97].

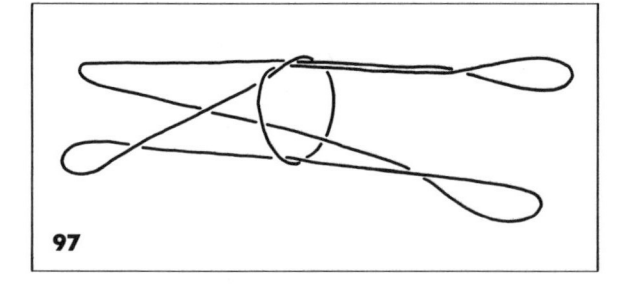

97

ANALYSIS: [96], [97]

The Kwakiutl figures Not Passing Through [96] and Passing Through [97] have not been recorded elsewhere. Steps 3 and 4 are uncommon in the Kwakiutl repertoire, but have also been observed among the North Alaskan, Mackenzie, and Copper Eskimos in their construction of a figure very similar to the Kwakiutl Sparrow [27] (see Jenness, CXV; Paterson, 87). Steps 3 and 4 have also been recorded in Hawaii (Dickey 1928:127). This pair of figures demonstrates how a simple twist in the opening movement can affect the outcome of the final pattern.

98. A Fire Drill

Loop size: medium

1. Lay the loop on the ground so that it is long and oval.
2. Fold the ends of the loop, in book-fashion, to the center to produce a clover-leaf pattern as illustrated.
3. You now have four loops: a near and far left loop, and a near and far right loop. Draw the right

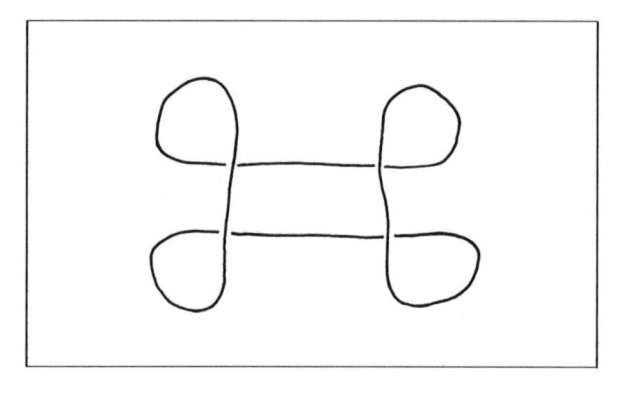

loops through the left loops as follows: Insert left hand from below into far left loop. Grasp the far right loop. Draw it through the left loop and lay it on the ground. Release left hand. Similarly, insert left hand from below into the near left loop and grasp the near right loop. Draw it through the left loop and lay it on the ground.

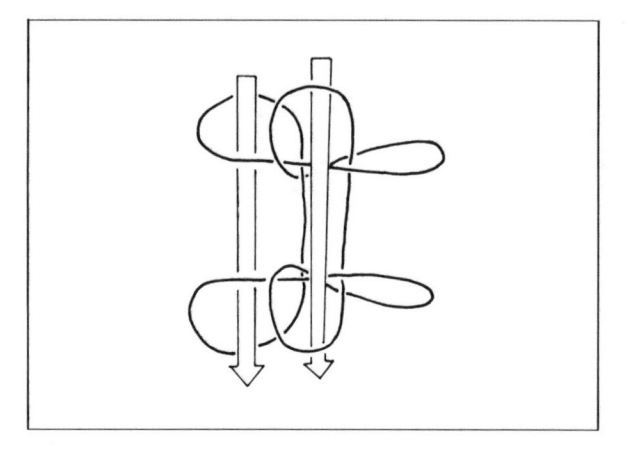

4. Pick up figure as follows: Insert four fingers of right hand into the original far left loop from below, then into the original near left loop from above. Pick up the two strings forming the outer sides of these loops. Close them to the palm. Insert the four fingers of the left hand from above into the original far right loop, and from below into the original near right loop. Pick up the

inner strings of these loops. Close them to the palm. Extend. You have A Fire Drill [98].

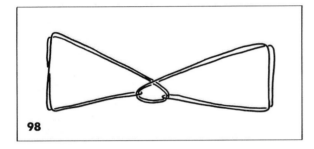

98

ANALYSIS: [98]

See Analysis of [1].

99. Trick on the Speed of Making It

Loop size: small

1. Hang the loop on the backs of the left thumb and index. Allow it to hang downward. The loop has a left surface and a right surface, a radial string and an ulnar string.

2. Pass the right hand between you and the strings, then to the left side of the loop. Finally, pass the right thumb to the ulnar side of both strings. Insert thumb into the loop from the right side, catching the ulnar string on the palmar surface of the thumb. Draw the right hand toward you, then between you and the radial string. Finally, insert the entire right hand proximally into the loop held by the right thumb. Do not draw the hands apart.

3. With the right index, hook back the short segment of string passing between the left thumb and index. Draw it rapidly to the right through the right wrist loop, which is allowed to slip off. The final figure is a triangle near the left hand. The figure must be made as rapidly as possible, so that no one can see how it is made. You have Trick on the Speed of Making It [99].

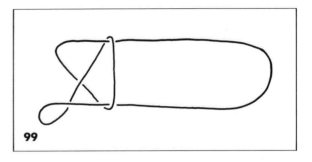

99

100. Cheek of the Halibut (P!alosa)

Loop size: small

1. Place loop around the four fingers of each hand. Insert left thumb proximally into loop. Close radial string to the left palm under four fingers of the left hand. Close ulnar string to the right palm under four fingers of the right hand. The left palm faces toward you, while the right palm faces away from you.

2. Pass right thumb proximal to both transverse strings and return with ulnar transverse string on its back, allowing the string that crosses the back of the right hand to slip off. You have two transverse strings. The radial string emerges from the back of the left hand near the left little finger and becomes the right radial thumb string. The ulnar transverse string emerges from under the left little finger and passes directly to the right little finger, where it is closed to the palm.

3. Bring the hands together. With the left thumb and index, grasp the radial transverse string near the right thumb. Slide the left thumb and index to the left along this string, allowing the string that passes across the back of the left hand to slip off. Place the new loop on the left thumb. Extend. You have Cheek of the Halibut [100].

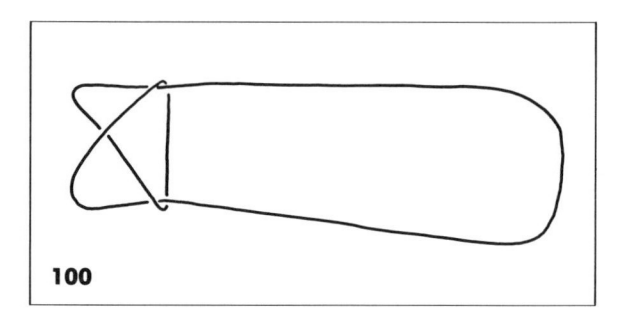

100

101. *Waxwax'asu*

Loop size: small

The purpose of this figure is in the speed with which it is produced.

1. Place loop on the four fingers of each hand. Point fingers away from you. Rotate left wrist so that the palm is facing upward. Rotate right hand so that the palm is facing downward. Close the four fingers of each hand over the string crossing its palm.

2. Rotate left hand a full turn in the radial direction, so that the string crossing the back of the left hand slips off it and onto the left thumb. Rotate right hand a full turn in the ulnar direction, so that the string crossing the back of the right hand slips off, and the palmar string emerging from under the right index now becomes the string crossing the back of the right hand. The right thumb remains free of loops. You now have a left thumb loop, the ulnar string of which is closed to the left palm. You have a loop on the four fingers of the right hand, the radial string of which is closed to the right palm. The strings twist around one another several times in the center of the figure.

3. Bring the hands together. Straighten the left index and middle finger. Pass them distal to the right palmar string at the point where it emerges from under the right little finger. Hook back this

string with the left index and middle fingers. Insert both fingers distally into the left thumb loop. Pass the two fingers toward you, proximal to the left radial thumb string. Grasp between their tips the right palmar string at the point where it emerges from under the right little finger. Draw the string to the left, allowing all other strings encircling these two fingers to slip off. Close the new loop to the left palm, under the left middle finger. Allow the string crossing the back of the right hand to slip off in order to extend the figure. You have *Waxwax'asu* [101].

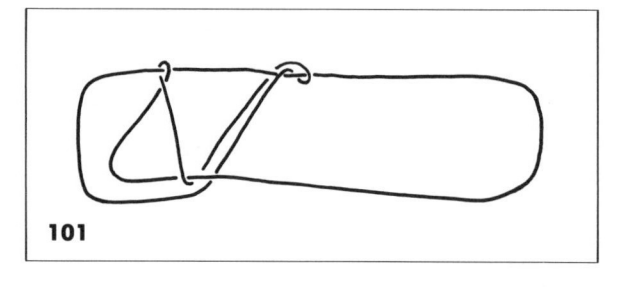

101

ANALYSIS: [99], [100], [101]

The Kwakiutl figures Trick on the Speed of Making It [99], Cheek of the Halibut [100], and *Waxwax'asu* [101], have not been recorded elsewhere. All are made as quickly as possible so that the observer cannot tell how they are made. They may therefore be classified as tricks of a sort. The final pattern of *Waxwax'asu* [101] is an interesting combination of the Kwakiutl figure Lying on the Back in a Canoe [92] and Pulling the Hair of His Sweetheart [94]. The method of construction, however, is totally unrelated to either figure.

102. Moving the Loops (*Kwałk!*)

Loop size: small

1. Opening B.
2. Invert thumb loops as follows: Insert middle-ring-

little fingers proximally into thumb loops. Close radial string to the palm. Release thumbs. Transfer middle-ring-little finger loops to thumbs, inserting thumbs distally. Note the arrangement of the strings (see illustration).

3. The following manipulations are performed as a single movement: Turn palms away from you. Pass thumbs proximal to index loops. Return with ulnar index strings. At the same time, rotate indices half a turn in the ulnar direction, closing them to the palm. Insert middle-ring-little fingers proximally into index loops. Close the ulnar string to the palms, withdrawing indices.

4. Transfer the proximal thumb loops to indices as follows: Insert indices distally into thumb loops. Rotate indices half a turn in the ulnar direction, so that the proximal ulnar thumb string is taken up on the backs of the indices. Allow the proximal thumb loop to slip off the thumbs, up through the distal thumb loops, which remain on the thumbs. Release middle-ring-little fingers.

You now have the same arrangement of strings you had after step 2. Steps 3 and 4 can be repeated indefinitely, and the original pattern will always return. Thus, you have the trick Moving the Loops [102]. The trick lies in the speed with which it is done.

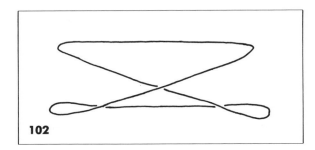

102

ANALYSIS: [102]

Identical trick:

Bella Coola: + *Kwoi-yaix* (McIlwraith, XI)

The Kwakiutl trick Moving the Loops [102] appears to be another Northwest Coast invention. The Bella Coola "move their loops" in the same fashion (steps 3 and 4), but set up the figure in an entirely different manner (steps 1 and 2). From Opening B, the Bella Coola perform step 3 directly. They then insert indices distally into the middle-ring-little finger loops. They pass indices proximal to the ulnar thumb string, and distal to the proximal radial thumb string, which they hook up with the palms by rotating the indices half a turn in the ulnar direction. The thumbs are then released, and the middle-ring-little finger loops are transferred to the thumbs, inserting the thumbs distally. This incredibly complex series of movements produces the same arrangement of strings that one encounters after step 2 of the Kwakiutl method. The Bella Coola then adopt the Kwakiutl method, repeating steps 3 and 4 over and over as the title of the figure is chanted.

McIlwraith also noted that the Bella Coola title of this game is archaic; its meaning is forgotten. It is not clear whether the Kwakiutl Wakashan title for this figure, which is very similar to the Bella Coola *Kwoi-yaix*, translates as "moving the loops," or whether it is merely a Kwakiutl nickname.

103. A Catch (*Ō'xstandy*)

Loop size: medium

1. Place your loop on a partner's finger. Grasp the right portion of your string and wrap it once clockwise around the partner's finger, thus creating a ring. Now place the hanging loop on your hands, and form Opening A, taking up the left palmar string first (see illustration). (If the right palmar string is taken up first, the partner becomes "caught" at the end of the figure.)

2. The partner now inserts the finger bearing the ring (created in step 1) proximally into the index loops. Release all strings from your hands, and with the thumb and index draw out the ring

encircling the partner's finger. The partner will be freed of all loops, as if by magic.

In step 1, if the ring on the partner's finger is made by wrapping the left string counterclockwise around the finger, the right palmar string must be taken up first during the formation of Opening A. Otherwise, the partner will be "caught" in the end. Thus, you have the trick A Catch [103].

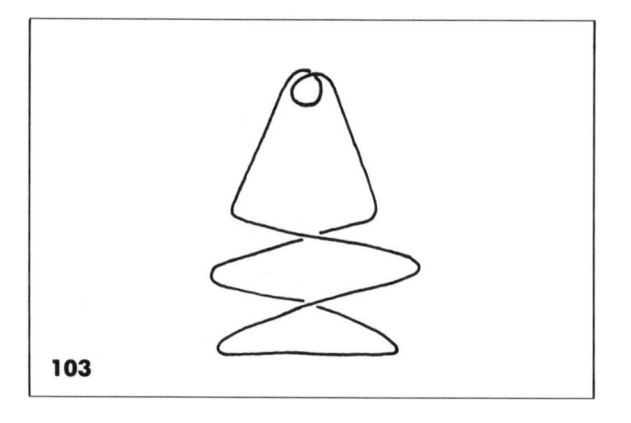

103

ANALYSIS: [103–112]

Most figures in the Kwakiutl string trick repertoire are known world wide. They are therefore of little value in tracing cultural diffusion. Sailors are particularly fond of knot tying and string tricks (Ashley 1944). This may explain the tricks' global distribution. The distribution of the Kwakiutl tricks is included only for purposes of completeness: no analysis will be carried out. The task of compiling the distribution data was greatly simplified by Dr. Tom Storer's recent bibliography on the subject (Storer 1988: 324–44).

[103]: Identical tricks, but performed on one's own neck: (Storer, V.B.7 var. 3)

Arawaks:	+ A Vicious Fly	(Farabee 1918, pp. 128–29)
Caribs:	+ A Fly	(Farabee 1924, 2)
New Guinea:	+ *Ku Katek*	(Fischer, 69)
Philipines:	+ Hanging	(Jayne, p. 339)
Yap:	+ Unnamed	(Muller, 19)

Japan:	+ Hanging	(Noguchi 1984, III, 67)
Br. Guiana:	+ Cutting the Throat	(Robinson, p. 145)
Guiana:	+ Hanging Trick	(Roth 1924, no. 712)
Trobriands:	+ *Boku*	(Senft, no. 26)
Caroline Is.:	+ Hanging	(Jayne, p. 339)

[103]: identical trick, but performed on a partner's wrist: (Storer, V.A.5)

Hawaii:	+ Hand Slip Trick A	(Dickey, p. 150)
Eskimos	+ Cutting the Hand	(Jenness 1924, trick no. 1; Paterson 1949, trick no. 1)
Senegal:	+ Opening-A Trick	(Mindt-Paturi, 3)
New Guinea:	+ Bamboo Cutting the Hand	(Noble 1979, 48)
Japan:	+ Cutting the Wrist	(Saito, 10; Yuasa & Ariki, IV, 3)

The Kwakiutl version of this trick is the only example using the finger of a partner rather than one's own wrist or neck.

104. A Fly on the Nose

Loop size: small

1. Grasp one string of the loop with the thumbs and indices of each hand, so that a short string of approximately six inches separates the hands, and a long hanging loop is formed by the remainder of the string. Create a small hanging loop in the short segment of string by passing the right thumb and index to the left, so that the right portion of the string lies across the radial surface of the left portion.

2. With the teeth, grasp the short segment of string at the point where the strings cross to form the small hanging loop. Release hands. With the left hand, grasp the long hanging loop at its midpoint.

3. Insert right index proximally into the large hanging loop, then distally into the small hanging loop. Keeping the right index within the large hanging loop, twist the small hanging loop by rotating right index half a turn to the right, thus straightening the right index. Place the fingertip of the right index on the tip of the nose (see illustration). Release the teeth, and pull down on the long hanging loop held by the left hand. The string will come free of the right hand. Make sure not to insert the entire right hand into the long hanging loop, or the trick will not work. You have the trick A Fly on the Nose [104].

104

[104]: Identical tricks: (Storer, V.B.6)

Maori:	+ Fly on the Nose	(Andersen, trick no. 3)
Torres Straits:	+ Fly on the Nose	(A. C. Haddon 1912, 31; Jayne, p. 348–9)
Rhodesia:	+ unnamed	(Kraus, 7)
Patagonia:	+ *Koila Kuzen*	(Martinez-Crovetto, fig. 52)
Britain:	+ The Nose Trick	(Pocock 1906, pp. 358–59)
India:	+ Fly on the Nose	(Hornell 1932, p. 149)

105. Cutting off the Fingers (*P!alb!oxtsana*)

1. Hang the loop on the left thumb. Close the right middle-ring-little fingers to the palm over the hanging strings, about three inches from the left hand. Insert right thumb and index distally into left thumb loop. Separate them widely. You have a right index string and a right thumb string, both of which pass to the left thumb.

2. Rotate right hand clockwise (relative to the left palm) half a turn, so that the left thumb strings cross. Close the right thumb string to the left palm, under the left little finger.

3. Rotate right hand half a turn counterclockwise. Pass left index to the ulnar side of right index string. Pick it up on the right index finger's back.

4. Rotate right hand half a turn clockwise. Close the right thumb string to the palm, under the left ring finger.

5. Rotate right hand half a turn counterclockwise, pass left middle finger to the ulnar side of right index string. Pick it up on the middle finger's back.

6. Rotate right hand half a turn clockwise. Straighten left ring finger. Pick up right thumb string on its back.

7. Rotate right hand half a turn counterclockwise. Pass left index to the radial side of the right index string. Pick up the right index string on left index finger's back.

8. Rotate right hand half a turn clockwise. Straighten the left little finger. Pick up the right thumb string on its back.

9. Rotate right hand half a turn counterclockwise. Pass left thumb proximal to right index string. Pick up the right index string on left thumb's back (see illustration). Release right thumb and left middle finger. Pull the two hanging strings with the right hand, and the left hand will come free of all strings. You have the trick Cutting off the Fingers [105].

105

[105]: Identical tricks: (Storer, V.C.2, var. 5)

| Eskimos: | + unnamed | (Jenness 1924, trick no. 4; Paterson 1949, trick no. 3) |
| Bella Coola: | + The Fastening of Raven's Plumage | (McIlwraith, trick no. 2) |

[In reviewing Averkieva's manuscript, Boas replaced all variations of the Kwakiutl term for "cutting off the fingers" with the single spelling *p!aā'ẖp!ōxts!āna*. He lists *t!ā'ẖt!amax·ts!āna* as a synonym. In order to facilitate differentiation of the various Cutting off the Finger tricks, however, Averkieva's original spellings will be retained in tricks 105, 106, 107, and 110, and throughout this book—M.A.S.]

106. Cutting off the Fingers
(*P!alxp!oxtsana*)

Loop size: medium

1. Place the loop on the little fingers.
2. Pass ring fingers distal to radial little finger strings, and return with ulnar little finger string. Similarly, pass the middle fingers distal to radial ring finger string, and return with radial little finger strings. Pass indices distal to radial middle finger strings, and return with radial ring finger string. Turn palms away from you.

3. Pass thumbs proximal to both transverse strings, and return with both strings.

4. Insert indices toward you between proximal and distal radial thumb strings, and return with distal radial thumb string. Pass middle fingers distal to ulnar index string, and return with proximal radial thumb string. Pass ring fingers distal to ulnar middle finger string, and return with ulnar index finger string. Pass little fingers distal to ulnar ring finger string, and return with ulnar middle finger string (see illustration).

5. Release thumbs, and separate hands. The fingers will come free of strings. You have the trick Cutting off the Fingers [106].

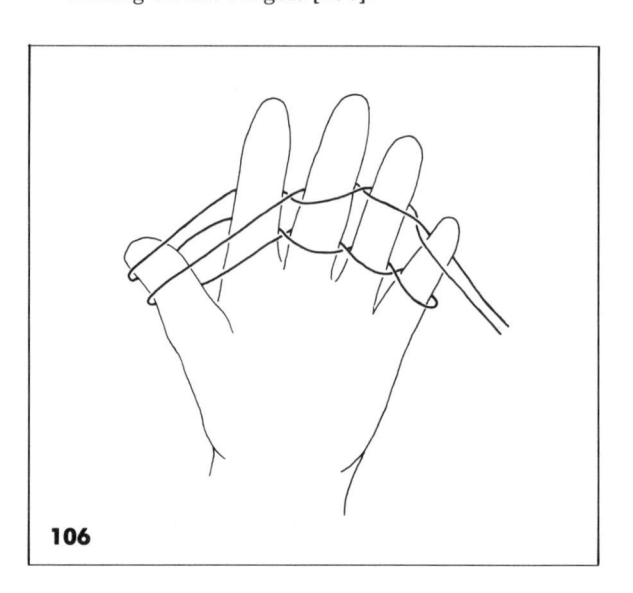

106

[106]: Identical tricks: (Storer, V.C.2, var. 2)

| Maori: | + Mouse Trick | (Andersen, trick no. 7) |

Hawaii	+ Hand Slip Trick C	(Dickey, p. 151)
Eskimos:	+ unnamed	(Jenness 1924, trick no. 2)
Bella Coola:	+ A Cutting	(McIlwraith, trick no. 1)

107. Cutting off the Fingers
(Paā'tboxts!ana)

Loop size: medium

1. Hang a loop on the four fingers of the left hand, palm upward and fingers pointing away from you, so that the hanging loop has a radial index string and an ulnar little finger string.

2. With the right thumb and index, grasp both hanging strings and bring them toward you, so that the radial index string passes between the left index and middle finger, and the ulnar little finger string passes between the left ring and little fingers. Release right hand. Hold left hand so that the palm faces the right, the fingers point upward, and the strings hang vertically across the left palm. There is a ring around the left index, and also a ring around the left little finger.

3. With the right hand, grasp both hanging strings. Bring them toward you, between the left thumb and index, then away from you around the left thumb. Now pass each string to the back of the left hand, passing each string between the fingers from which it originated in step 2. Release right hand.

4. With the right thumb and index, grasp the string that originates from between the left ring and little finger and hangs down the back of the left hand. Wrap it once around the four fingers of the left hand, clockwise (as viewed with left fingertips pointing toward you). Release the string. Allow it to hang down the back of the left hand (see top illustration, right).

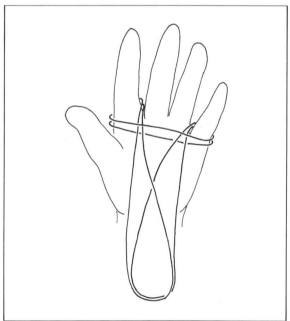

5. Insert right index distally into both left thumb loops. Hook back both thumb strings to the right, thus drawing out the thumb loops as far as possible. Withdraw left thumb from both loops (see lower illustration, above). Pass the four

strings of the two drawn-out loops away from you, between the left middle and ring fingers. Release right index. The two loops now hang down across the back of the left hand (see illustration). With the right index, hook back the left palmar string to the right. The left hand will come free of strings. You have the trick Cutting off the Fingers [107].

107

[107]: Identical tricks: (Storer, V.C.3, var. 1)

Maori:	+ German Trick	(Andersen, trick no. 1)
Sailors:	+ Cutting the Fingers	(Ashley, nos. 2598–9)
Illinois:	+ Cutting off the Fingers	(Brewster, 10b)
Australia	+ Cutting off the Fingers	(Davidson 1941, 72)
Hawaii:	+ Hand slip trick B	(Dickey, p. 150)
Netherlands:	+ The Smith's Secret	(Elffers, p. 43)
Europe:	+ German Trick	(K. Haddon 1912, trick no. 6)
Marquesas:	+ Another Trick	(Handy, pp. 52–5)

Czechoslovakia:	+ *Csavarintas A Kez Tenyere Felol*	(Hathalmi, 7)
New Guinea:	+ The Sago Palm	(Jenness 1920, 45)
N. Alaska:	+ Point Hope Trick	(Jenness 1924, trick no. 6)
Patagonia:	+ *Desenvollar la Tripa*	(Martinez-Crovetto, fig. 50a)
Tonga:	+ Trick	(Maude 1986, 17)
Senegal:	+ Index and Middle-Finger Trick	(Mindt-Paturi, 2)
Japan:	+ *Yubinuki* III	(Noguchi 1984, 73)
	+ *Yubikiri*	(Noguchi 1986, 101)
Netherlands:	+ *Ontsnapping* 5	(Oorschot, pp. 88–91)
Britain:	+ Hand String Trick	(Pocock 1906, p. 367)
Guiana:	+ To Cut the Fingers	(Roth 1924, 710)
Japan:	+ Cutting the Fingers, 2	(Saito III, 8)
Tobriand Is.:	+ *Vayola*	(Senft, 38)
E. Greenland:	+ Cutting the Fingers, II	(Victor, 27)

108. Catching a Leg

Loop size: medium

1. Grasp a loop of string in the middle. Pass the loop beneath your leg. Place the ends of the loop on the hands in position I. The radial thumb string and ulnar little finger string pass underneath your leg.

2. Form Opening A, taking up the left palmar string first (see illustration).

3. Release thumbs, right little finger, and left index. Separate the hands quickly. The leg will come

free of strings. You have the trick Catching a Leg [108].

[108]: The Kwakiutl Catching a Leg [108] has not been recorded elsewhere.

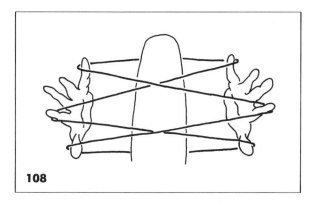

108

109. Threading a Closed Loop

Loop size: medium (or use a piece of string)

This trick is widely distributed in many parts of the world. It was recorded in this locality a long time ago by Professor Boas. There are records of it from the Omahas, Pawnee, Japanese, Caroline Islanders, Hawaiians, and Europeans

1. A single piece of string can be used for this trick. If using a loop, treat it as a doubled string with free ends. Hang the string over the left thumb, so that the ulnar string is short. Close the ulnar string to the left palm, under the left ring and little fingers.

2. With the right thumb and index, grasp the radial string. Wrap it several times around the left thumb, counterclockwise (tip of thumb facing you), until the remaining string is several inches long.

3. Make a small loop in the remaining string. Grasp its base between the left thumb and index, so that the loop remains erect and parallel to your chest.

4. Both hanging strings should now be of equal length. Secretly release the string held under the left ring and little fingers. Close the other hanging string to the left palm. With the right thumb and index, grasp the end of the string just freed from the left ring and little fingers. Hold it level with the erect loop held by the left thumb and index (see illustration).

5. Pass the end of the string held by the right hand away from you as far as possible several times, in order to give the impression that you are trying to thread the erect loop but are having difficulty. On the last pass, pull the string hard enough to cause the base of the string to slip up between the tips of the left thumb and index, and into the erect loop. The right hand will still be holding its string, but the string now passes through the erect loop (see illustration). Thus, it appears as if you have threaded the loop without freeing the right hand in order to pull the string through the loop. You have the trick Threading a Closed Loop [109].

109

[109]: Identical trick: (Storer, VI.1)

Sailors:	+	Threading a Loop	(Ashley, no. 2570)
Virginia Indians:	+	Threading the Needle	(Davidson 1927, fig. 144)
Australia:	+	Threading the Needle	(Davidson 1941, 74)

Omaha, Pawnee:	+ Threading a Closed Loop	(K. Haddon 1912, trick no. 12; A. C. Haddon 1903, 5)
Japan:	+ Threading a Closed Loop	(Jayne, pp. 354–5)
Europe:	+ Threading a Closed Loop	(Jayne, pp. 354–5)
Caroline Is.:	+ Threading a Closed Loop	(Jayne, pp. 354–5)
Finland:	+ *Nuora Neulansilmaan*	(Jättiläinen, p. 371)
Yap:	+ Threading a Closed Loop	(Muller, 20)

110. Cutting off the Fingers
(*P!alxboxtsana*)

1. Hang the loop on the left thumb. Close the rest of the hanging loop to the palm, under the right middle-ring-little fingers, approximately six inches from the left hand.

2. Insert right thumb and index distally into left thumb loop. Pick up left radial thumb string with right thumb, and pick up left ulnar thumb string with right index. Do not separate hands.

3. Rotate right hand half a turn clockwise (relative to the left palm). Pick up right ulnar thumb string with left index. Rotate right hand half a turn counterclockwise. Pass left thumb distal to right ulnar thumb string, then pick up right radial index string. Release right hand, and uncross the hanging loop.

4. Repeat steps 2 and 3 twice more (see illustration).

5. With right thumb and index, remove loops from left index and drop them. Pull the hanging loop to the right and the left thumb will come free of strings. You have the trick Cutting off the Fingers [110].

[110]: Identical trick: (Storer, V.B.2), one cycle only:

W. Copper:	+ Another Copper Eskimo Trick	(Jenness 1924, trick no. 9)

110

111. Making a False Knot

Use a short piece of string.

1. Take a piece of string. Hold an end in each hand. Bring the hands together.

2. Make a knot in the string, passing the right hand behind the left string, around the left string to the front, then through the loop thus created. You have two loops, labeled X and Y in the illustration.

3. Make another knot over the previous one as follows: Pass right string in front of left string, then enter loop X from behind. Draw the right end of the string toward you. This creates loop Z (see illustration). Now pass right end of string away from you, through loop Z, and pull on the ends of the string. The knot will disappear. You have the trick Making a False Knot [111].

[111]: The Kwakiutl False Knot [111] has not been recorded elsewhere.

112

112. Cutting off the Wrist

Loop size: small

1. Hang the loop on the left wrist with palm facing downward and fingers to the right. With the right hand, wrap the radial string once around the left wrist, thus creating a ring.

2. With the right thumb and index, lift the end of the hanging loop up to the level of the left hand, so that the strings are untwisted. Insert left hand into loop held by the right thumb and index. Twist the loop still held by the right thumb and index counterclockwise (relative to the back of the left hand) half a turn. Insert left hand into the loop from the right side (see illustration), and pull the loop to the right. The left wrist will come free of strings. You have the trick Cutting off the Wrist [112].

[112]: The Kwakiutl Cutting off the Wrist [112] has not been recorded elsewhere

Appendix A. Kwakiutl Culture as Reflected in String Figures

Kathleen Haddon, daughter of British anthropologist A. C. Haddon, is the first to suggest that string figures may possess scientific value beyond their potential use as markers of cultural diffusion (K. Haddon 1930:148). From her viewpoint, string figures have the potential to reveal cultural information about a given people in that the names attached to the various patterns can reflect social beliefs of the maker, physical aspects of the maker's environment, and even the maker's religious beliefs. Thus, a collection of string figures can serve as a sort of "picture gallery" capable of preserving the values of a given culture.

This viewpoint derives from Haddon's observation that string figures are subject to natural selection, much like living organisms: Of the hundreds of patterns a native develops during his sessions of fiddling with a loop of string, only those patterns that suggest some object or entity of special significance to the maker will be selected as worthy of duplication and memorization (K. Haddon 1930:143). Likewise, the spread of a particular pattern among an entire cultural unit depends on its universal significance to all who are exposed to it (Jayne 1906:3). Only then does a figure become a permanent fixture in the string figure repertoire of a given people.

Using collections of string figures from five distinct cultural units, Haddon suggests that the names attached to string patterns are highly indicative of a given unit's physical environment. For example, the Navaho Indians, living under the cloudless skies of the American Southwest, have a preponderance of figures representing stars and other celestial objects (K. Haddon 1930:45). In contrast, the Eskimos of fog-enshrouded southern Alaska are much more interested in portraying their animal food sources (K.

Haddon 1930:16). Figures portraying plant life are rare among the Eskimo, whereas portrayals of yams and palm trees can be found among the figures of the Papua New Guinea native (K. Haddon 1930:73).

Cultural notions and beliefs may also be preserved in string. Anthropologists have long noted that string figures are intimately associated with the myths and legends of a given people (Jayne 1906:3; Dickey 1928:11; McCarthy 1960:425–29). Chants and stories are oftentimes recited as a figure is displayed, providing amusement or even a lesson in morality to the observer (Johnston 1979:54–55). In many cases, the language of the actual chant is so archaic that it can no longer be understood by the maker of the figure, the chant being a mere remnant of a once-told story (Mary-Rousselière 1969:130–32). The purpose of associating string figures with the telling of myths and legends is also not clearly understood. String figures have occasionally been referred to as "witches' knots," suggesting that they may once have been perceived as having supernatural power (Day 1967). Haddon, however, suggests that string figures merely served as a ready means of illustration for the objects or beings portrayed in the accompanying legend (K. Haddon 1930:145). The illustration is readily prepared in the absence of drawing materials, and is highly reproducible, independent of the maker's artistic ability. Given that motion is an integral part of many figures, Haddon even suggests that the string figure might be viewed as a primitive form of cinematography (see also Paterson 1939:88; Mary-Rousselière 1965:8). But regardless of their intent, string figures and their associated chants can reveal much about the beliefs of a given culture.

If string figures are indeed a sort of cultural archive, a repository for beliefs and observations

deemed worthy of preserving, a detailed examination of Kwakiutl string figure subject matter should confirm much of what ethnologists have already published. For purposes of discussion, I have organized the figures into six distinct categories based on the type of object, being, or belief that constitutes the subject matter of a given figure. These categories include figures that depict the natural environment of Vancouver Island; figures that reflect Kwakiutl material culture (tools, food and clothing sources, food gathering, and other daily activities); figures that reflect Kwakiutl psychology (emotions, home life, interpersonal relationships); figures that reflect animal spirits of Kwakiutl mythology; and finally, figures that reflect the supernatural (death, spirits, monsters, and religious rituals). It is not my intent to present a Kwakiutl ethnography to the reader: this has already been accomplished by Franz Boas and others. Rather, I wish to utilize previously reported ethnographic data to illustrate just how deeply associated string figures are with every facet of Kwakiutl lifestyle and thought. Literature citations are therefore omitted from this section, except in those instances where a specific Kwakiutl myth is cited. Those desiring greater detail on any aspect of Kwakiutl culture are referred to the general works of Boas (1909, 1966), Woodcock (1977), and Kirk (1986). Relevant Kwakiutl string figures are designated by title and also by Averkieva's number in brackets.

Figures Reflecting the Kwakiutl's Natural Environment

Considering the length of time the Kwakiutl and their predecessors have spent on the Northwest Coast of North America, perhaps 8,000 years, it appears that the Kwakiutl Indian has attained a state of equilibrium with his environment. Vancouver Island is mountainous, heavily wooded, and subject year round to moderate temperature and abundant rainfall. It is not surprising to find aspects of this

environment recorded in string. Two Mountains with Clouds between Them [69a] is an excellent example. The foglike stratus clouds blanketing the valleys are depicted by a horizontal string passing across the face of two large triangles, which, in string figures, typically represent mountains. A triangle is again associated with a mountain in Canoe Maker Looks at His Road from the Hill [35]. In this figure, the hands are rotated in alternating fashion to produce the canoe and then the hill.

Despite the persistent cloud cover of the Pacific Northwest, the Kwakiutl have named two figures after celestial objects, Sun, Moon, and Star [53], and Moon and Stars [54]. It is interesting that the Kwakiutl have chosen to portray all celestial objects in a single figure. This is in sharp contrast to the large percentage of Navaho figures which depict stars alone, and even specific types of stars. This discrepancy undoubtedly reflects the greater visibility of stars in the desert sky of the Navaho.

Trees are portrayed in four Northwest Coast figures; Two Trees [44], Three Trees [45], Four Trees [46], and Two Forked Trees [47]. Yellow and red cedar as well as yew, spruce, and hemlock are particularly plentiful on the island and are utilized extensively by the people in the manufacture of canoes, log houses, and clothing (cedar bark). The Indians of the American Southwest lack any portrayal of trees in their string figure repertoire.

Finally, one finds a figure commemorating the arrival of white men on the island during the late 1700s, Ship with Two Masts [68a], and Ship with Opened Sails [68b]. Such large ships were initially quite frightening to the people of Vancouver Island. When first sighted, they were thought to be large supernatural birds with outstretched wings. The Nootka of West Vancouver Island still refer to white men as Muh-muł-ni or "houses on the water" after their massive ships. During the 1800s, ships were eagerly awaited owing to the extensive fur trade that developed between the Indians and the white man. In return, the Indians received metal objects, such as pots and pans, from which they made jewelry. This figure is therefore one of the few figures that

can be dated with respect to its naming. It is un-likely that it acquired this name prior to the late 1700s.

Figures Reflecting Kwakiutl Material Culture

Although wildlife was abundant in the wooded inte-rior regions of Vancouver Island, the Kwakiutl sub-sisted almost entirely on foods harvested from the sea. The staple of their diet was salmon [22d, 83, 84, 85]. Many different species spawned between early spring and early autumn. Dog salmon [84] was the last species of the year to travel upstream and was especially suited for drying because of its low oil content. Salmon were caught in several ways but primarily by traps [64b, 86, 87]. Salmon or fish traps consisted of loosely woven cedar-root baskets par-tially submerged in streams. Salmon entering the baskets were unable to escape through the cleverly designed basket opening. Other baskets were so nar-row that, once inside, the fish could not readily turn around. Halibut [80b, 100] were also highly prized and were caught with hooks. Kelp stems [25, 70], which had been partially dried, stretched, and oiled, served as fishing lines [95]. Devil fish [37b, 38b, 80a], known to us as octopus, was used as bait.

Nets [64a] were primarily used for catching *oulachon*, a fish valued for its oil. In English transla-tion this oil is often referred to as "grease" (e.g., the tale accompanying the Fire Drill [1]). Dried salmon [22d] dipped in grease was the primary source of food during the long winter months. Clams [10] and other mussels were gathered year round by women who went digging clams [90, 91] on sandy beaches. Clams were eaten fresh, roasted, or were dried for winter use. Various other sea animals, such as ur-chins or sea eggs [69e] were eagerly sought after.

Sea lions and seals [11b, 43] were harpooned at sea, brought home in a Hunter's Bag [11a], and eaten. Various tissues and organs were then used in the manufacture of bow strings, bags, and floats. Whales [65b, 82] were harpooned at sea only by

tribes of the coastal regions of Vancouver Island. Most tribes were content with the dead carcasses of whales which drifted ashore. A single whale repre-sented an enormous supply of food and material.

During the winter months, deer [32, 33], elk [7a, 7b], and bear [3, 6a, 6b, 30b, 52, 75b, 78, 79] were hunted with bow and arrow, large traps, nets, or in the case of deer and elk, by driving them into the water and clubbing them. Dogs assisted in the chase, as is related in the series Elk, Two Little Elks Lying, and a Dog [7a, b, c]. These animals were primarily hunted for their hides, from which blankets, cloth-ing, leather, and ropes were made. Bear meat was eaten only rarely, and eating deer meat was said to affect one's memory. Mink [8, 69d?] and seal [11b, 43] furs were eagerly traded with the white man for metal, particularly copper, which was a symbol of wealth among the Kwakiutl. Ducks [15] and geese [5, 22g, 22h, 75a] were netted on open waters at night. When the fowl poked their heads up through the net in panic, the hunters wrung their necks. Other birds, (owl [13, 14], hummingbird [26, 29], sparrow [27a], heron [76], and bluejay [77]), were shot with arrows if hunted. The down of eagles [51b, c, d] was used in various religious ceremonies. Men at one time wore feathers in their hair.

Plants, roots, and berries were savored by the Kwakiutl and were often dried for winter consump-tion. Viburnum berry patches [61] were individually named and visited frequently by women for gather-ing. Fern roots were dug [92, chant]. An older woman would utilize a walking stick [67] when per-forming her gathering duties. Herring eggs deposited on leaves of the kelp [25, 70] plant were also rel-ished.

Large roofed houses [30a], which could be disas-sembled for moving, were built of cedar planks and had dirt floors [22c]. Fires were built on the ground near the center of the house, and smoke was allowed to escape through a smokehole in the roof. Fires were started by means of a fire drill [1, 66, 69c, 98b]. The "drill" portion consisted of a cylindrical piece of cedar which was twirled in the holes of the hearth, a broad cedarwood plank. Tinder of shred-

ded cedar bark was placed in a notch cut along the side of the hearth, where heat generated from the friction of the drill ignited it. Because of its abundance, cedar wood was often used to fuel the fire. Unfortunately, such logs tended to generate a great number of flying sparks [34].

The Kwakiutl traveled to numerous locations by means of canoe [16, 35] in conducting their daily chores. Canoes were kept on the beach in front of the house and were utilized by both men and women, much like our modern-day automobile. Dugout canoes were manufactured from cedar logs [28] and were propelled by paddling [21]. Fishing tools were stored in a peculiar wedge-shaped box [63], which fit into the bow of the canoe. Women traveled together in canoes, going out to dig clams [90, 91]. People would also go out alone in canoes, sitting in the stern, to perform daily chores (Man Going to Get Some Bait [93a]). Apparently this was quite an active process (Man Totes Clothing on His Head Because It Is Wet [93b]). Canoes, along with salmon traps, coppers, receptacles, and blankets, were among the valuables seized in war.

Figures Reflecting Kwakiutl Emotions, Home Life, and Interpersonal Relationships

Makers of string figures will readily admit that most string figure patterns only vaguely resemble the object or animal for which they are named. But sometimes the degree of abstraction is extreme. In accordance with Haddon's theories regarding the propagation of a given pattern, figures with inappropriate names tend to be forgotten because they lack significance to the cultural unit as a whole. During the course of pattern creation, however, one often encounters patterns that, though lacking realism, are appealing in a physical sense; they possess novel tensions, knots, or motions. In order for such a figure to propagate, the figure is named after a shared situation, event, or feeling suggested by the physical properties of the pattern. The Kwakiutl

developed nearly a dozen such patterns. By examining the titles they attached to these types of patterns, one can speculate about the innermost emotions of the Kwakiutl—their sources of fear and anxiety, as well as their perceptions of others.

Fear is common to all human beings, so it is not surprising to find this emotion expressed in string. *Mā'sLasLEmēki* (What Will You Do?) [2] is a simple but vivid portrayal of a person's decision to run and hide from something unfamiliar encountered in front of his house. This action is conveyed by the sliding of the central tangle to the right as the strings are tightened. The chant that accompanies the figure further conveys the person's uncertainty. "Forehead frowns, forehead unfolds" suggests that the person studies the oddity intently before deciding to flee. Ironically, the "wrinkled forehead, unfolded forehead" gesture is again found in connection with an entire series of string figures named Wrinkled Forehead [22]. Here [22], however, the connection between the individual figures in the series is vague or nonexistent, preventing a definitive interpretation of the significance of the gesture in this context.

Sitting on the Roof [30a], named for four vertical loops (people) atop a horizontal doubled string (the roof), also portrays fear. Several Kwakiutl myths describe situations in which people sit on their roof. People in fear of an attack will sit on the roof (Boas 1935b:137) or even sleep on it (Boas 1910:105), keeping watch or keeping out of harm's way. Unlike *Mā'sLasLEmēki*, however, in which the feared object is not specified, here the source of fear is well documented. By a simple release of loops, Sitting on the Roof [30a] is transformed into Two Bears seen by the Two on the Roof [30b]. Again, the narrative aspect of the series adds much to its appeal.

Anger is also expressed in string. Here, the tension and knots in the final pattern suggest Fighting Men [19a] as they Pull Each Other by the Hair [19b]. One Kwakiutl tale relates how a man, taken by his hair, has his eyes knocked out (Boas 1895:151). The event is again described by Fighting Men Pulling each Other's Hair [20]. Two entangled loops at the center of the figure provide the title.

The fighting intensifies as the degree of tangling is increased by repeatedly exchanging loops. The repeated movement here represents the entrance of spectators into the house. Finally, the figure is dissolved, and it is said that "all the spectators are kicked out of the house."

A different sort of anger is suggested by Lying Chest Up [22e]. Kwakiutl tales abound with references to this position and its association with feeling offended. A man whose wife has been unfaithful lies on his back and covers his face, thinking of revenge (Boas 1902:368). A boy who has lost in gambling and is scolded by his father does the same. After several days, he commits suicide (Boas 1902:105; 1935b:176). In a third tale, a person sulks and lies down with a blanket over his face because he is homesick (Boas 1935b:170). Whether Lying Chest Up [22e] is actually connected with these tales is pure conjecture, since no chant accompanies the figure. The upright triangles may instead represent the breasts of a woman lying on her back. The references in the entire Wrinkled Forehead series are vague. As previously described, the neighboring Bella Coola Indians have a different interpretation of this series.

Shame is portrayed by a Kick in the Back [24]. Being kicked by one's father is the ultimate humiliation a Kwakiutl youth can experience. In mythology, a lazy boy is kicked by his father because he does not purify himself in preparation for an initiation (Boas 1908:60). Likewise, a boy who spends his time dressing up and gambling is scolded by his father (Boas 1910:445), kicked (Boas 1908:60), or struck with fire tongs (Boas 1935b:182). Perhaps the figure's resemblance to a pair of feet suggested the unique title, which then propagated through the strength of associated emotions. One could also view this figure as documenting a specific aspect of an interpersonal relationship (e.g., father-child).

The significance of the title Laughing in the House [41] would be obscure without prior knowledge of Kwakiutl culture. Boas recorded several instances of Kwakiutl laughter. Laughter is a sign of pleasure. A woman laughs when a man wants to

marry her (Boas 1902:65). The Kwakiutl laugh at amusing situations. The woodman laughs because his wife builds a house while she is in a supernatural house that is invisible to her (Boas 1902: 253). But perhaps most relevant to the figure in question is the observation that the Kwakiutl laugh when they know that their enemies have no power (Boas 1902: 338, 339). In one tale, a woman laughs at a man who kills her dog, evidently because she thinks he has no power (Boas 1908:51). Applicable here, however, is the observation that in order to render an enemy powerless, the Kwakiutl will often tie up the house with rope and bar the door (Boas 1910:393). Perhaps the intricate crisscrossing of the strings in this figure reminded its maker of the pattern formed by the ropes used to barricade oneself in the house prior to an attack. Such foresight would, of course, be worthy of laughter. Thus, it is possible that the title Laughing in the House [41] was propagated because it uniquely portrayed the cleverness felt by all Kwakiutl in preventing the destruction of their homes.

Interpersonal relationships are dealt with in three figures and possibly a fourth. In Two Bear Brothers' Jealousy [88], a small loop is made to exchange places with a large loop, a movement which the Kwakiutl interpret as representing a small, jealous brother jumping past an elder brother while hunting. Normally, Kwakiutl brothers are very affectionate with one another. One Kwakiutl tale relates how a man died of grief when he learned of his brother's death (Boas 1910:479). This aspect of sibling affection is well portrayed in Two Brothers [89a] and One Brother Looking for Another [89b], in which a loop representing one brother is made to flip back and forth across the figure in search of the second brother, represented by a loop concealed under the left hand. A strong bond between brothers is expected in Kwakiutl society. But when affection is replaced with jealousy, controversy arises. The existence of three separate chants for Two Bear Brothers' Jealousy [88] emphasizes the significance of this "unnatural relationship." Likewise, in other Kwakiutl tales, "jealousy between brothers, one of whom is a

successful hunter" (Boas 1935b:203), and "jealousy against a brother who makes love to his sister-in-law" (Boas 1902: 114, 365; 1935b:199) are popular themes.

A third figure portraying interpersonal relationships is titled Meeting of Two Brothers-in-Law [62]. Here, the awkwardness and anxiety arising when the sacred relationship of "brotherhood" is forced upon two strangers is graphically expressed by the unusual three-dimensional arrangement of strings. Two vertical loops, each representing a brother-in-law, are suspended on opposite transverse strings separated by a large gap, as if the men are standing in opposite corners of a room, reluctant to interact. Two distinct upper transverse strings are uncommon in string figures. This feature was therefore invoked in naming the figure.

Finally, one might classify Pulling the Hair of His Sweetheart [94] as a figure that expresses intimacy between spouses. It is a wife's duty to cradle the head of her husband in her arms and to pick lice from his scalp during periods of idleness. No doubt this often led to accidental catching of the hair, so well captured by the sliding knot of this figure.

Thus, we find that names of figures are not always based on a resemblance of the pattern to a physical object. Just as emotions and home life are characterized by periods of tension and relaxation, so are string figures, where tension gives rise to an ethereal pattern that ultimately disintegrates into a perfect loop or a mass of tangles. The Kwakiutl apparently appreciated these qualities of "the string" and exploited them in expressing their perspectives on life.

Figures Reflecting Animal Spirits of Kwakiutl Mythology

As noted in the opening remarks of this chapter, string figures are often associated with the mythology of a given culture, as illustrative devices or perhaps even as magical charms or offerings. Averkieva adamantly states, however, that during the time she spent among the Kwakiutl, string figures were prac-ticed for purposes of amusement only. Yet it is remarkable that all of the animals depicted in string also hold prominent positions in the mythology of the Kwakiutl people. While certain figures still appear to be connected with specific myths (Paddling under Coppermaker [21] and Sisiutl, the Double-Headed Serpent [48]), no reference to any past significance of the animal figures was recorded. Beliefs regarding animal spirits do, however, strongly influence the Kwakiutl (i.e., their perception of the world and their place within it) and thus define a way of life that is in harmony with nature.

The Kwakiutl believed that all people are derived from animal spirits living in the sky. Various spirits would descend from heaven on a copper ladder or on a mountain that moved up and down; they would become human by taking off their skins or masks. These myth people, as they were termed, were then free to assume animal forms at their will. Every Kwakiutl family claims to be descended from a particular animal spirit, which they adopt as their family crest. Crests were frequently illustrated as faces on totem poles. A hunter knew specific prayers for each animal he encountered in the woods. He would ask the animal's cooperation and would request that the animal not be offended if he killed it. When an animal was successfully captured or slain, the animal had allowed it to happen as a direct result of the hunter's respect. Supernatural powers could also be obtained from animals. During religious ceremonies, the Kwakiutl wore masks portraying specific animal spirits, each of which had a well-defined role in the rituals.

Each animal spirit had its own personality and a unique relationship with man. Salmon spirit descended to earth for the purpose of providing food for mankind. Other animal spirits, such as toads and frogs, were associated with sickness and disease. In Kwakiutl tales, the animals act as people do in that they marry each other, live in houses and villages, and fight with one another. Oftentimes it is difficult to tell if the subjects are people who have acquired the traits of specific animals, or vice versa.

In light of the overwhelming influence that the

belief in animal spirits has had on the thought patterns of the Kwakiutl, it is interesting to consider how these beliefs may have influenced the naming of the various patterns they developed with string. In doing so, however, I do not wish to suggest that animal string figures were made as offerings to spirits or as a means of illustrating tales, either at the time they were collected or in the distant past. What *is* clear, however, is that the Kwakiutl named a large percentage of their string figures after animals not necessarily utilized as food sources. These animals, therefore, held some other position of significance in the Kwakiutl perception of the world. This section utilizes Kwakiutl myths to illustrate thought patterns which may have influenced the naming of their string figures.

Mammals

The Kwakiutl possess seven figures that represent the bear [3, 6a, 6b, 30b, 52, 75b, 78, 79], making it the most frequently depicted animal in the repertoire. Although each figure is made differently, all result in a similar bracket-shaped pattern recognized by Indians and Eskimos alike as representing a bear. Both Black Bear and Grizzly Bear figure prominently in the mythology of the Kwakiutl. Grizzly-Bear-Woman kills Black-Bear-Woman because she is lazy. In revenge, Black-Bear children kill Grizzly-Bear children and escape. Grizzly-Bear-Woman finds them sitting on a yew tree, which she tries to dig up, but she is hindered when Wren jumps in her mouth and starts a fire in her stomach. In response, Grizzly-Bear-Woman Sneezes [60]. Mosquitos and houseflies originate from her ashes (Boas 1908:15).

The Kwakiutl do not hold Porcupine [4, 59] in high esteem. When Porcupine wants to marry Frog-Woman, she humiliates him by calling him "a ball of the children" and "a sea egg" (Boas 1902:320).

Deer [32, 33], along with Wolf and Mink, are chiefs of the myth people (Boas 1902:295). They are viewed as warriors in many tales, as in the expedition of the myth people to capture Salmon-Woman

(Boas 1902:349). Deer is known as the Fool Dancer of the myth people (Boas 1902:330). When Deer puts his salmon basket in the river, it drifts away because he forgets to make an opening in it (Boas 1910:491). A man was transformed into a deer when mussel shells were driven into his head (Boas 1908:211; 1910:201). Elk [7a, 7b] feels bad because women make fun of his antlers (Boas 1902:320).

People believed that dogs [7c, 73a, 73b] could exchange their skins with their masters; dogs were therefore treated well out of fear of revenge on the dog's part. Dogs were given food by the owner's wife before the family had taken breakfast (Boas 1935b:121). Dogs also acted as guardians and protected their masters from sickness and invisible spirits (Boas 1897:402). Dogs that were ill-treated caused earthquakes to destroy their masters (Boas 1935b:122).

Mink [8, 9] is one of the most important animal spirits of Kwakiutl mythology. The entire Mink legend consumes forty pages of Boas's *Kwakiutl Tales* (1910). Mink is foolish, amorous (Boas 1908:113), and full of curiosity (Boas 1902:392). He is greedy and fond of Sea Eggs [69e] (Boas 1910:131, 133, 135, 141, 157; 1908:130, 140). Frog-Woman dislikes him, however, because he has a long face, small eyes, and smells bad (Boas 1902:319). Several string figures may be connected with specific tales concerning Mink. Passages in the Two Mountains [69] series seem to coincide with a tale in which Mink is thwarted, becomes angry, and so destroys a mountain he is attempting to make (Boas 1908:163). The last few figures of the series, It Sits Down Below [69d], It Sits on the Ground and Splits the Sea Egg [69e], and It Is Broken [69f], strongly suggest that "it" is Mink. Its Musk Bag [22f] also most likely refers to Mink, who, after having his musk bag stolen by children, tries to re-install it by sitting on it (Boas 1910:157).

Young Seal [11a, 43] is referred to in mythology as Sleepy-Eye-Woman. She washes and warms her hands and lets oil drip out of them, which she gives to her guests (Boas 1910:237). Seals traveling in a canoe tell a man that they cannot take him along

because they do not surface very often to blow (Boas 1910:65). In another tale, a hunter cooks seal heads, puts them in a bag [11a], and takes them home to eat (Boas 1910:487,489).

Killerwhale [65b, 82] figures prominently in the mythology and religion of the Kwakiutl. When a person becomes a shaman, he is first visited by a frog, a wolf, or a killerwhale and is told not to be afraid (Boas 1966:133). Killerwhale comes to take away a dead person in a small canoe, which then becomes a killerwhale. The dead one is told to spout, and if he cannot do so properly, he is returned to the grave (Boas 1910:341).

Squirrel [74b], while picking crab apples, advises K!wēxalā'lag·îlis (one of the myth people) how to obtain daylight from Gull-Woman (Boas 1902:394). When Squirrel gives a feast to the myth people, and when Ō'ᵋmäł (one of the myth people) does not appear, he makes him come to a knothole and throws red-hot stones in his mouth (Boas 1910:239).

Birds

Mallard ducks [15] and geese [5, 22g, 22h, 75a] are blind women digging for clover and cinquefoil root. Q!ā'neqeᵋlakᵘ (one of the myth people) gives them eyesight by spitting on their eyes, and then transforms them to birds (Boas 1895:135; 1908:216, 234; 1910:203, 457). The goose Nɛxā'q [22h] cannot take a passenger along in his canoe because he has too much clover aboard (Boas 1910:65; 1935b:164). Laughing geese flap their wings and drive away the sea otters, making the harpooner angry. He curses the geese and accuses them of eating seaweed and sand (Boas 1910:353).

Bluejay-Woman lives in the supernatural house of the son of the Sun and sucks the brains out of visitors (Boas 1902:49). The house of the bluejay [77] has no door, and visitors are treated to dried berries (Boas 1902:361; 1908:55).

Hummingbirds [26, 29] of the water cover the body of a person who purifies himself by bathing; they suck his blood (Boas 1902:126).

Heron [76] sits on the bank of a river and stretches out his leg, over which people may pass (Boas 1908:18). He is the husband of Woodpecker-Woman. Heron's mother lives in their house, but is rooted to the floor (Boas 1908:191). When Heron and his wife starve Q!ā'neqeᵋlakᵘ and his brother, they are shot by the children and transformed into birds (Boas 1908:185; 1910:187).

Eagle [51b, 51c, 51d] and Woodpecker were chiefs of the birds. Eagle down was strewn on the cut-off heads of slain victims (Boas 1902:153, 243).

Owls [13, 14] are mysterious to the Kwakiutl and occupy a special position among birds of mythology. Owls, as well as killerwhales, are able to revive the dead. Owl gives owl masks to the dead which transform them into owls. Owl then teaches them to fly. If they cannot fly, they are returned to the grave (Boas 1910:339). The two string figures depicting owl are both V-shaped, like owl's characteristic brow ridge.

Although the title of Sparrow [27a] is attached to a figure, apparently the title is only symbolic in nature; the initial figure bears no resemblance whatsoever to a bird. The actual subject of the series concerns the adorning of a belt by another bird prior to his visit with the Sparrow. Belts, often made of cedar bark or leather, were used to secure the blanket worn as an outer garment by men and women alike. Belts are frequently mentioned in mythology, where it is said that belts were worn when "going out" (Boas 1910:99). The chant accompanying the Sparrow series also mentions the belt as an accessory required for "going out." The novelty of the figure lies in the formation of two small vertical loops at the center of the figure, one of which represents the bird and the other his belt. During the course of the manipulations, the belt is wrapped around the bird's midsection so tightly that the figure is reduced to a mass of tangles. When the figure is dissolved in the final step, it is said that the bird has removed his belt and therefore cannot go out to visit Sparrow.

Sea Creatures and Fish

It is not surprising that salmon [22d, 83, 84, 85] plays a central role in the mythology of the Kwakiutl, given its prominence as the staple of their diet. The mythic Salmon People turned themselves into salmon so that people could eat. Starvation prevailed before the Salmon People came (Boas 1902:350; 1908:99; 1910:227–29). In appreciation, people returned salmon bones to the river to float back to the Salmon People's house. If any bones were missing, the fish would return deformed the next season. Ō'ᵉmäł's four warriors captured salmon boys. When they approached land, Deer made the canoes of the salmon capsize, and the fish were sent into various rivers (Boas 1902:348). When Salmon asked Mink where he should jump, Mink replied with a series of village names located at various salmon streams on Knight Inlet. The chant accompanying Salmon [83] is a rendition of this tale.

Halibut [80b, 100] is one of the warriors of the myth people. When the myth people make war on South-East Wind and on Sō'dᴇm, Halibut lies down in front of the door, and when the enemy comes out of the house he slips on Halibut's back (Boas 1908:101; 1910:227). Halibut was cut out of cedar bark by Nō'aqaua. Therefore, his meat is white (Boas 1895:174). When a baited halibut-hook is thrown in the water, it falls on the roof of Halibut's house and becomes black from the chimney smoke (Boas 1902:402).

Devil Fish [37, 38, 80a] (octopus) is also a warrior. He sucks South-East Wind out of his house and into the canoe (Boas 1902:351). When Q!ā'neqeᵉlakᵘ goes to marry a daughter of Qa'mxulał, he puts on the mask of Devil Fish and appears as an old man. When the girls try to lift him, he holds on to the ground by means of his suckers until the youngest one makes the attempt. Only then does he let go (Boas 1908:3).

Clam [10, 90, 91] asks olachen how many ways there are to cook a clam properly so that he tastes good (Boas 1935b:115).

Toads [23, 40, 56, 57] are associated with sickness and disease. A man mates with a woman whom he finds in the woods. She is the toad called "Copper-Noise Woman." As a result, he has toads in his stomach (Boas 1910:115). Mink marries Toad-Woman, but cannot endure the noise she makes (Boas 1910:129). (Here Toad-Woman is referred to as Frog-Woman. Apparently the terms toad and frog [71, 72] are interchangeable). On the other hand, Toad-Woman refuses to marry Elk [7a] on account of his loud noises and antlers (Boas, 1902:320). Toad-Woman also refuses to marry Beaver. In retaliation, Beaver causes a flood and washes all the toads away (Boas 1902:318).

Plants

Although not considered to be animals, certain plants do have spirits. Kelp [70, 25] is the wife of Mink. She drags him under water when the tide is running swiftly (Boas 1895:158, no. 5; 1908:117; 1910:127). Trees [44, 45, 46, 47] also have souls. The yew is chief of the trees and calls trees and bushes into his house (Boas 1935b:125). K!wēk!waxā'weᵉ (one of the myth people) asks the trees where their sparks fly [34] when they are thrown into the fire, and Hemlock, Spruce, and Yellow Cedar answer (Boas 1908:174).

In summary, many of the animals mentioned in the mythology of the Kwakiutl are also represented in string. This emphasizes the prominent role of such beings in shaping the Kwakiutl's perception of their world. But not all Kwakiutl animal spirits have string figure equivalents. Raven, the hero of Bella Coola mythology and the animal most represented in their string figures, is absent from Kwakiutl figures. Raven is mentioned only indirectly, as Ō'ᵉmäł, in the chant that accompanies Daylight Receptacle [63]. Thunderbird, a central bird spirit who eats the whales (Boas 1902: 189, 373) and the double-headed serpent [48] (Boas 1902:197), and who creates lightning (Boas 1902:211) is also curiously absent, although Eagle [51] may be synonymous with

Thunderbird. Among mammals, Mountain Goat, Land Otter, Beaver, Marten, Wolverine, Mouse, Ermine, Raccoon, Sea Lion, Sea Otter, and Bat are not represented despite numerous mentions in mythology. Although it is possible that the Kwakiutl never encountered patterns that resembled such animals, it is also possible that Averkieva's collection is simply not comprehensive. But regardless of whether figures representing the missing animals actually exist, it seems evident to me that only a few animal string figures were definitely associated with specific animal myths (Sneeze [60], Sparrow [27], Bluejay [77], and Salmon [83]), as suggested by their associated chants. Most chants accompanying the animal figures simply describe the characteristic motions of the animal (Bear and his Den [6a], Mallard Ducks [15], Porcupine [59], Squirrel [74], Goose/Bear [75], Heron [76]). Therefore, it seems likely that the majority of the Kwakiutl animal figures were probably not formed to illustrate myths or to pacify spirits. Nevertheless, a brief knowledge of how the Kwakiutl perceives himself in relation to the animals of his environment, as revealed in mythology, adds a further dimension of enjoyment to making the animal figures.

Figures Reflecting the Supernatural

Unlike the animal figures discussed above, a subset of string figures in the Kwakiutl repertoire does hold an unquestionable association with the supernatural. An association between string figures and spiritual beliefs can be found in many cultures throughout the world. The Polynesians of the Gilbert Islands claim that a specific series of string figures must be performed at heaven's gate before admittance will be granted (Maude and Maude 1958:10). Many Eskimo tribes believe in "the spirit of string figures," who terrorizes individuals by using his own intestines to form the patterns (Jenness 1924:182B). The following string figures all reflect Kwakiutl perceptions of death and/or the spirit world.

Heaven

As mentioned previously, Kwakiutl myths reveal that the animal spirits who gave rise to mankind lived in "houses" located in heaven, in mythical villages, or beyond the sea. Houses belonging to Mink [9], Bear [6a], and Devil Fish [37a, 38a] are represented in string. Mink lives in *Qā'logwis* (Crooked Beach). *Qā'logwis* was the principal village of the myth people, that is, the animals before they assumed animal forms (Boas 1902: 287; 1908:80, 99, 147). Bear's house [6a] is located on a cliff; a flat stone serves as the door (Boas 1902: 409). The stone takes the form of a large circle in this string figure. Oftentimes the title of "house" is given to the figure that immediately precedes the animal figure, regardless of whether it resembles a house. The movement connecting the two figures evidently suggests the entry of the viewer into the house of the given animal spirit.

Birth and Death

Death is the theme of a string figure known as the Grave of a Child [50]. According to Kwakiutl mythology, a mother is very close to her child. After the death of a child, the mother wails for it (Boas 1908:80; 1910:99). The corpse is then placed in a box, which is sometimes carved. The box is then placed high up in the branches of a spruce tree to prevent wolves from stealing the body (Boas 1902: 278, 286; 1908:90, 141; 1910:137). In this string figure, the elevated coffin is represented by a pentagonal-shaped lozenge located in the upper half of the figure.

Death by suicide is represented in Man Tying the Rope around His Neck is the Woods [58a] and Man Hanging by His Neck [58b]. One Kwakiutl tale states that if a man commits suicide by hanging himself from the rafters of his house, then the body must be burned in the house (Boas 1902:105). Hanging in the woods is not dealt with, however.

Supernatural birth is reflected in a figure called Snot of a Woman [31]. Here, the mucus from the nose of a wailing woman is transformed into a boy who helps her (Boas 1897:373). The slithering motion of the figure symbolizes the mucus, as described in the related Bella Bella chant. It is unclear if the figure Swollen Stomach [55] is a reference to pregnancy, or a reference to the abdominal swelling caused by having "toads" in one's stomach. This figure may be associated with the myth in which an ailing boy cures himself by scratching a scab off his stomach, thus causing a small child to jump out of his stomach. This interpretation of the figure is supported by the presence of the jointed figure to the left of the swollen stomach which is commonly interpreted as representing a person, as seen in a Toad and a Man ahead of It [56]. The Bella Coola, however, specifically state in their chant that the swollen stomach depicted in this figure describes a man with an umbilical hernia (McIlwraith 1948:563). No similar chant accompanies the Kwakiutl figure.

Birth may be the subject of Nā^ε'nakoma [49], a title which Boas was unable to translate. This figure is used by the Indians of the American Southwest, particularly in California, to predict the sex of an unborn child (Foster 1941). Unconscious variation in the method with which the figure is formed leads to differing final patterns, one of which represents a boy, the other a girl. Boas did not translate the chant accompanying this figure, so no straightforward interpretation can be made.

Spirits and Witchcraft

Paddling under Coppermaker [21], a rather unusual name for a figure, actually portrays a very prominent Kwakiutl spirit. Q!ō'mogwa (whose name means "wealthy") is a sea spirit, otherwise known as "Coppermaker" (copper symbolizes extreme wealth among the Kwakiutl). His house is "under" the sea (or beyond it), and is reached by canoe after passing

through the door of the underworld (Boas, 1902:79). In another tale, Q!ō'mogwa is known as "Chief of the North," and his country is reached by passing *under* the mountains (Boas 1902:83, 219). Q!ō'mogwa owns a self-paddling, unfolding canoe, which makes a funny sound because it is made of copper (Boas 1910:279, 468). His house is also made of copper, and his child smells like copper (Boas 1902:67). The vertical loop in the center of this boat-shaped figure evidently represents a man paddling "under" the mountains or sea to the house of Coppermaker.

Sisiutl [48], or the "double-headed serpent," is a spirit much feared by the Kwakiutl. He swims in the water like a fish and causes fainting when sighted (Boas 1935b:126). When shot at, he unfolds to show his true form. If caught in a fishtrap, he will break it (Boas 1902:197; 1908:192). The saliva produced from chewing on hellebore, when spat on the Serpent, will quiet him. Killing the double-headed serpent requires striking him with a weapon covered with the blood drawn by biting one's own tongue (Boas 1910:333). A person who washes his hands in the slime of the double-headed serpent will turn to stone. Clotted blood of the serpent will have the same effect. Even canoes turn to stone at the sight of him (Boas 1902:147, 198; 1895:150). Scales of the serpent, which are found in the ground and shine like mica, will turn birds to stone when used as arrowheads (Boas 1895:143; 1902:138, 149). The symmetry of this pattern evidently suggests the "double-headedness" of the serpent.

The chant accompanying the Daylight Receptacle [63] is a brief rendition of a Kwakiutl myth that describes how people obtained the sun. At the beginning of the world, the sun was kept in a box (receptacle) by Gull-Woman, and all was dark. Ō'^εmäł (a chief of the myth people) succeeded in having himself reborn as a child of Gull-Woman. In order to trick Gull-Woman out of her daylight receptacle, Ō'^εmäł cried and cried until Gull-Woman granted his request for a canoe that bore the daylight receptacle in its bow. After escaping in the canoe, the child opened the box and delivered daylight to

the world (Boas 1910:233, 1895:173). The images of the child and the wedge-shaped box that fits in the bow of the canoe are both captured in an unusual three-dimensional string figure. The child, represented by a vertical loop located in the stern (right end) of the "canoe" can be seen opposite the daylight receptacle located in the bow (left end), represented by a three-dimensional wedge-shaped lozenge. In general, three-dimensional figures such as this are rare and are highly prized.

Ghosts [17a] live in a village underground, their day being our night (Boas 1902:377; 1910:323; 1935b:110). Anyone visiting their house and eating their food must stay forever. Whenever a canoe, food item, or other object burns, a ghost obtains it (Boas 1910:353). The ghosts also have villages near the living people, but a river must be crossed to reach them. This belief is reflected in the explanation accompanying Ghosts [17a] which states that the figure represents two ghosts "standing on the banks of a river that separates them." Living beings are invisible to ghosts, but ghosts can recognize their presence by their bad odor (Boas 1935b:110). Ghosts have no substance, as if they were made of air or foam (Boas 1902:106; 1910:447; 1935b:108). When a living person sees a ghost, his own body becomes contorted. Purification with urine or hemlock branches rubbed on the body is required in order to withstand ghostly influence (Boas 1935b:107; 1910:327). The dead may be revived by ghosts (Boas 1910:347). Owl [13, 14] and Killerwhale [65b, 82] also have this power.

The ghost figure resolves into two loose knots near the top of the figure which represent skulls [17b]. Several tales relate how the cut-off heads of slain war victims are stuck on poles (Boas, 1902:154, 243; 1910:413) or are put on a scaffold erected on the beach (Boas 1935b:228). Another tale describes how a man cuts off the heads of all the monsters he has killed, suspending them on a frame for hanging skulls (Boas 1935b:65). Such a frame is suggested in this figure by the location of the "skulls" on the upper transverse string.

Frogs [71, 72] and toads [23, 40, 56, 57] are associated with sickness and disease. A sickness caused by toads entering the stomach is especially feared. Toads in the stomach make noise and cause the abdomen to swell (Swollen Stomach [55]?). A man with toads in his stomach does not walk fast because the toads will croak (Boas 1902:231). They feel like red-hot stones (Boas 1902:172). A man met a woman in the woods and had intercourse with her. She turned out to be a toad (Copper-Noise-Woman) and as a result, he had toads in his stomach (Boas 1910:115). A Toad and a Man ahead of It [56] may recall the tale in which toads enter the stomach of a man as he passes by the place where they had once been extracted from another man's stomach (Boas 1902:172).

Toads [23, 40, 56, 57], frogs [71, 72], and snakes [31] are also used in the practice of witchcraft, a practice that exploits a person's body parts, body waste, or personal possessions for evil purposes. Inflicting abdominal pain on someone can be accomplished by placing a shred of the victim's clothing in a toad's mouth, then tying the mouth shut (Boas 1966:149). If a woman refuses a man, a love charm is made by placing strands of her hair obtained from her comb into the mouth of a snake. This will give her headaches (Boas 1966:153). To make a refusing woman dizzy, the skin of a dead frog is stuffed with moss, her hair, stones on which she has urinated, and a part of her menstrual napkin. The frog skin is then sewn up and tied to the top of a hemlock tree, where it is left to spin in the wind. The woman's consequent dizziness will cause her to submit (Boas 1966:154).

Religious Rites

Finally, one finds reference to an aspect of the Winter Ceremonial in the figures entitled Not Passing Through [96] and Passing Through [97]. The Kwakiutl believe that winter is the sacred time of year when supernatural beings visit their village. When the sacred season begins, all quarrels, sick-

ness, and causes of unhappiness are forgotten (Boas 1966:172). During the Winter Ceremonial, a ritual lasting several months, the initiates perform skits featuring the animal spirits. Two forms of the Winter Ceremonial are practiced. Performers who have experienced the most important initiations are assigned to the major or "Gone-Through" (lā'x·sâ) ceremony, whereas the less experienced performers are assigned to the minor or "Not-Gone-Through" (wī'x·sâ) ceremony. The "going through" refers to the act of having passed through the house of the Cannibal, the central spirit of the ceremony (Boas 1966:174).

String Tricks and the Supernatural

Considering their world-wide distribution, many of the so-called string tricks might actually be older than most string figures. Although it is probable that these primitive "magic tricks" were associated with witchcraft or the supernatural in ancient times, no mention is made of such a connection by Averkieva concerning the 10 tricks she collected [102 through 112]. Boas does, however, mention that when he first visited the island, Threading a Closed Loop [109] was used as a sort of password by the secret societies of the Kwakiutl shamans or "witch doctors" (Jayne 1906:354).

String Figures as Primitive "Ink Blots"

In summary, the string figures presented here document many aspects of Kwakiutl material culture and belief. String figures supplement the information provided by myths, legends, and ethnographic records regarding a culture's perception of the surrounding world. String figures do not, however, replace such sources; the object or event represented by many of the Kwakiutl figures would remain inaccessible without the accompanying chant or other source of "inside information" to aid in their interpretation. For such information we are greatly indebted to ethnographers' records.

The collection as a whole, however, suggests that an intimate relationship exists between the Kwakiutl and other living things. Representations of animals and plants constitute 54 percent of their entire string figure repertoire. Although representations of material objects are also present, most are items required for the hunting, trapping, or cooking of animal products. Others suggest that home life and the emotions experienced within the confines of a multifamily living unit are also key elements of the Kwakiutl psychology. These figures tend to be more "abstract" in nature and often rely on physical properties of the pattern itself (knots, tension, hanging loops) to provide the name. Finally, some of the remaining figures suggest that the Kwakiutl may resort to beliefs in supernatural forces in order to explain poorly understood aspects of their environment: death, sickness, spirits, and the afterlife are all dealt with in string.

It is also interesting that many important items of Kwakiutl culture lack a string figure equivalent. Representations of objects with great material value to the Kwakiutl (coppers, blankets, weapons, furs, and body ornaments) are totally absent. This observation may suggest that the Kwakiutl figures collected by Averkieva were invented long before the Kwakiutl established their unique monetary system, in which a person's wealth was measured by how much he could give away to his neighbors in ceremonies known as "potlatches." Boas remarks that the truly exorbitant and gaudy displays of wealth characteristic of nineteenth-century potlatches were only recent occurrences instigated by the enormous influx of goods earned as profit in the extensive European fur-trade market, which prospered during the late eighteenth century (Codere 1956:467–73). Representations of geographical features are also few in number. Despite their dependency on the sea, there are no representations of the ocean, waves, or the beach in this collection.

This analysis suggests that the native names attached to various string figure patterns may provide insight into the psychology of a given culture. Perhaps string figures should be viewed as archaic forms

of the modern Rorschach ink-blot test, a psychological test in which a patient's interpretation of a spattered ink pattern provides increased understanding of the individual's perception of reality and those around him. Such tests are even more informative when the individual's responses are contrasted with the responses provided by an entire cross-section of society. This extension of the ink-blot test is readily applied to string figure patterns. Although many of the patterns described here are unique to the Kwakiutl, a fair number are shared with other North American tribes, particularly the Eskimo. Differences in the names attached to these shared patterns, as listed in the analysis section, are indeed novel and provide a greater appreciation of what the Kwakiutl mind deems important.

It is unfortunate that more attention has not been given over the years to the collection and preservation of string figures from North American tribes. Although they are physical objects, string figures are distinctly different from archaeological relics; that is, physical objects still collectible long after the maker has ceased to exist. String figures can be obtained only from living people. The advantage here is that one can obtain the native title of the relic, which, of course, is rarely the case in uncovering a primitive sculpture or work of art. As demonstrated above, the name attached to an individual's creation often reveals more about the artist than does the actual work itself.

Appendix B. Kwakiutl String Figures: Origins and Affinities

Mechanisms of String Figure Transmission

As noted in the Introduction by Mark Sherman, above, anthropologists have long been interested in using string figure distribution data to trace the migration of people across a given geographical region: cultural units with related string figure repertoires may indeed share a common origin. But how closely related must these separately recorded string figures be before one attributes the similarities to common origin? Clearly, figures that are identical in final pattern and method of construction (ID, ID figures) provide the strongest evidence.

Diffusionists argue, however, that such figures only demonstrate prior contact between the populations in question, and not necessarily that the makers share a common origin. Diffusionists also claim that string figures identical in final pattern but unrelated in method of construction (ID, UN figures) are quite likely the products of chance, proving neither common origin nor previous contact. But must such figures always be attributed to independent invention? And what about figures which are similar only in final pattern and method of construction (SIM, SIM figures)? Are such figures inherently related in any way?

Before one can develop theories of cultural diffusion based on similarities in string figure repertoires, one must examine the conditions that give rise to the three types of related figures described above. If these conditions are connected in some way to the mechanisms by which string figures are transmitted between cultures, then one can obtain a great deal of information about the circumstances responsible for the shared figures. This chapter presents theories on how, in the absence of migration, string figures

diffuse from one fixed cultural unit to another, and examines how these mechanisms determine the degree of relatedness between such figures.

It is now clear, based on Paterson's observations of the Polar Eskimos and Mary-Rousselière's experiences among the Netsilik, that the accurate transmission of a newly invented string figure pattern *and* its method of construction from one location to another requires prolonged, intimate social interaction between the cultural units in question (Mary-Rousselière 1969:123, 155). Mary-Rousselière reached this conclusion based on the fact that in Eskimo society, exact duplicates of a given string figure are transmitted primarily within the family unit (Mary-Rousselière 1969:161). Johnston observed the same phenomenon on St. Lawrence Island in the Bering Strait: figures were principally transmitted from grandparent to grandchild (Johnston 1979:54).

Figures then spread to adjacent villages through the intermarriage of village members. Even then, however, the transmission process might take far longer to complete than one would suspect. Mary-Rousselière was able to witness the introduction of several Tunit figures into the local Netsilik repertoire as a result of intermarriage, but he noted that after twenty-five years, only a handful of Netsilik village members had assimilated the foreign figures into their repertoires (Mary-Rousselière 1969:155).

Another crucial observation that emerged from his long-term residency among the Netsilik was that the preservation and perpetuation of a given pattern within the social unit is highly dependent on the unit's size (Mary-Rousselière 1969:123). Of the 128 figures he was able to collect among the Arviligjuarmuit, no single resident could form more than 30 percent of them. In addition, when a given

informant was asked to duplicate a figure he had taught the author a year or two ago, he was often unable to do so. Thus, in the absence of written records, the maintenance of a local repertoire relies heavily on the collective memory of the unit's members, with constant recirculation and re-exposure a must (Mary-Rousselière 1965:14).

Any string figure enthusiast will heartily agree: although one can "learn" a string figure in less than a minute, anyone who has succeeded in committing a string figure to memory will tell you that long-term retention can only be attained through alternating intervals of constant repetition and inactivity, much as one would memorize a poem. One eventually reaches the stage where the movements become mechanical and can be performed with little or no concentration. Others have also observed this phenomenon. McCarthy frequently observed Yirrkalla women making figures while actively engaged in conversation, (McCarthy 1958:280). Haddon referred to this phenomenon as "muscular memory"; that is, the hands "remember" the figure rather than the brain (K. Haddon 1930:142). Commiting a difficult piano piece to memory involves the same sort of muscular memory. Even after years of inactivity, the hands can frequently "remember" the fingering required to reproduce the work in the absence of the written score.

Mary-Rousselière confirmed this phenomenon with respect to string figures by reporting that an old Eskimo man who had been blind for over ten years was still able to make many string figures perfectly, despite his affliction (Mary-Rousselière 1969:123). The author therefore concluded that, in the absence of actual migration, the faithful transmission of both pattern and method of construction for any given figure requires intimate, prolonged social contact, so that constant re-exposure to the figure is guaranteed. This is therefore the most probable mechanism by which identical patterns created by identical methods (ID, ID figures) are transmitted between cultural units.

Although the above mechanism may transmit a figure between adjacent cultural units quite faith-

fully, the transmission of a figure over a great distance via many intermediaries is likely to be unfaithful. With each intermediary, subtle changes in method of construction are likely to be introduced, so that the final pattern is gradually altered as it diffuses from its site of origin. An analogy can be made between this mode of transmission and the children's game of "telephone," in which a phrase is whispered sequentially down a long line of participants. When the final member of the chain is asked to repeat the phrase, the grammatical structure of the original phrase is oftentimes discernible, but the meaning has become nonsensical.

For those more biologically inclined, one can make an analogy between this phenomenon and the passage of a virus through numerous hosts. Gene mutations accumulate upon each passage, so that by the end of its journey, the actual organism may appear physiologically different from the parent strain. String figures are probably subject to the same types of modification, with each intervening performer adding his own touch. The Kwakiutl Spider's Web [42] is a marvelous illustration of this phenomenon. Similar patterns are found up and down the entire West Coast of North America from Alaska to the American Southwest. Subtle changes in the methods of construction appear to be responsible for this continuum of patterns.

Sometimes so many modifications have been introduced into the method of construction that the resulting pattern no longer resembles the original. Thus, it is quite possible for figures to be related in method of construction, but unrelated in final pattern. The analytical comments accompanying the Kwakiutl figures cite many examples of this phenomenon.

Finally, the conditions that give rise to figures identical in final pattern but unrelated in method of construction (ID, UN figures) deserve special examination, since there are many examples of such figures in the Kwakiutl and Eskimo repertoires. Of course, one can never rule out the possibility that such figures are the product of independent invention. But as pointed out by Mary-Rousselière, this

seems unlikely given the fact that the vast majority of Eskimo figures are confined in their distribution to North America (Mary-Rousselière 1969:135). Therefore, one must seek alternative explanations for the occurrence of ID, UN figures. Perhaps figures of this type represent attempts at duplicating figures to which the maker was exposed for only a short period of time.

This theory arises naturally out of the mechanism by which string figures are memorized. As previously described, most authorities agree that the motions required in successfully reproducing a string figure are stored as "muscular" or "kinetic" memories, probably in the primitive regions of the brain stem. The individual manipulations of the string are probably linked together and stored as a unit, much as the experienced typist learns to store entire sequences of keystrokes for typing simple words or common names. This may explain why many natives are unable to reproduce a given string figure in slow motion, so that others may record the manipulations (McCarthy 1960:415; Paterson 1939:88).

The recollection of the final pattern, however, appears to be stored as a visual image in the highly developed regions of the brain. Everyone is familiar with the brain's extraordinary capacity for pattern recognition. Humans and animals alike rely heavily on facial pattern recognition for determining the familiarity of a given community member. When people are asked to draw a familiar face, however, many are unable to do so, since the stored image often lacks detail. String figure patterns are also subject to this sort of memorization. A previously observed string figure is readily identified, but can seldom be drawn in great detail.

Unfortunately, it appears that the visual image of a string figure pattern is oftentimes not connected with the kinetic image (its method of construction). Thus we find that when Mary-Rousselière showed examples of other Eskimo string figures to his Eskimo informants, most immediately recognized the figures but were unable to reproduce them until certain key manipulations were provided (Mary-Rousselière 1969:123). This lack of connection between the

visual and the kinetic memory of a string figure is most likely the source of identical patterns created by unrelated methods, especially at a single location.

Brief exposure to a string figure, even if its method of construction is demonstrated, is much more likely to result in retention of the figure's visual image rather than its kinetic image (the method of construction). When faced with the task of reproducing a figure not encountered on a regular basis, the maker must invent his own method of construction if he wishes to re-experience the figure. Occasionally, the pattern is identical to the pattern known by its visual image only. In other cases, subtle differences in the string weavings are present which are not immediately obvious unless the original pattern is available for comparison, (cf., the Kwakiutl Elk [7a] and the Eskimo Caribou [Paterson, 2]). At any rate, the general pattern is preserved and is therefore successfully transmitted.

String figure contests, quite popular among the Kwakiutl and also known among the Eskimo (Glassford 1976:279), may also have contributed significantly to the production of identical patterns made by unrelated methods of construction. Such contests were of a friendly nature and were engaged in after the evening meal. Participants would take turns forming figures without revealing their method of construction. One of Averkieva's informants stated that the figure he demonstrated for her [35] was "his own figure" with which he beat others in string figure contests. He had acquired it from his father. It is likely that participants were exposed to many new figures during the course of a single session, and that the ability to re-invent unfamiliar patterns was a very desirable skill. Perhaps this is also the mechanism by which the Kwakiutl Toad [23] spread up (or down) the coast to (or from) Alaska. The intervening Bella Coola Indians know two ways of producing the figure, one of which resembles the Eskimo method; and the other, the Kwakiutl method (McIlwraith 1948:556–57). It is unclear just how closely guarded were methods of construction on the Northwest Coast. It is known, however, that certain string tricks were used as

passwords in gaining access to secret societies (e.g., Threading a Closed Loop [109]) and were therefore not widely taught.

In summary, the three classes of string figure homology defined above appear to arise naturally out of the probable mechanisms by which string figures are transmitted from one cultural unit to another via diffusion. Thus, given a newly invented string figure, the faithful transmission of both pattern and method of construction to a foreign population seems to require repeated exposure to the figure through intimate, long-term social intercourse. Briefer exposure is likely to transmit the final pattern only, without method of construction. Finally, transmission over long distances through many intermediaries is likely to give rise to similar or even unrelated patterns created by similar methods or techniques. Such information may prove useful in corroborating theories that postulate various degrees of cultural contact between peoples of the world.

Kwakiutl String Figures and Eskimo Figures

The single most striking feature of the distribution analyses presented above in conjunction with Averkieva's text is that a large proportion of the Kwakiutl figures are related either directly or indirectly to figures collected among the Eskimos. Few, if any, of the Kwakiutl figures are related to figures widely distributed in Oceania. This immediately raises several questions regarding the source of the Kwakiutl-Eskimo relatedness.

First of all, which cultural unit originally developed the shared figures, and when? Both Paterson and Mary-Rousselière agree that Eskimo string figures, many of which are familiar to the Kwakiutl, were present in Alaska prior to A.D. 1000, after which time the figures spread all the way to Greenland with the great Thule expansion (Paterson 1949:62; Mary-Rousselière 1969:165). Were the figures now common to both groups originally developed in Alaska by early Eskimos prior to A.D. 1000,

and subsequently transmitted to the Kwakiutl via diffusion down the Northwest Coast? Or were the shared figures actually developed by early Northwest Coast inhabitants sometime prior to A.D. 1000, and subsequently transmitted to the Alaskan Eskimos? Perhaps the shared figures were not unilaterally developed at all, but rather were developed by a single, homogeneous culture (the Paleo-Arctic people?) that occupied the entire Pacific Northwest coastline from Washington to Southern Alaska, beginning just after the last ice age. One might even speculate that the Kwakiutl-Eskimo figures in question were known to ancient Siberians or Northeast Asians, and were subsequently brought to North America by the original Bering land bridge migrants.

Before one can develop theories of string figure origin along the Northwest Coast, one must first determine which figures of the current repertoire are the original or "core" figures, and which are variants; that is, figures invented later on by altering or splicing together movements borrowed from core figures. Once the core figures and local variants of a repertoire are defined, it becomes far easier to propose theories that explain likely sources of origin and dates of transmission.

When two repertoires share identically constructed core figures, it is likely that the makers share a distant common ancestor. Even if shared figures are entirely lacking, the presence of shared core *techniques* may indicate a very distant common origin, especially when the techniques are highly unusual and limited in their distribution. On the other hand, when two repertoires share not only core figures but also a fair number of local variant figures, a more recent separation is suggested, with little time for the development of individual local variants. Finally, the occurrence of a large number of nearly identical figures, unrelated in method of construction (ID, UN figures), in the repertoires under examination, regardless of whether the imitated figures are core figures or local variant figures in their respective repertoires, suggests that social intercourse has occurred somewhat recently between the two cultural units, so that only the visual image of the

figure was transmitted. Thus, a great deal of information regarding the age and origin of a string figure repertoire can be obtained through careful analysis of its constituents.

How does one distinguish a core figure from a local variant? This task is most readily approached by examining the distribution of a given figure among the many individual local units that constitute a given culture. The most widely distributed figures are most likely the oldest and, therefore, the core figures. Unfortunately, there are only two regions where a sufficient number of collections have been made for this sort of analysis to be carried out properly; the South Pacific and the Arctic. Paterson attempted to define the core Eskimo figures in his monograph on the subject (1949:13–19), but was misled by the paucity of figures collected among the Central Eskimos. Mary-Rousselière provided the necessary data in 1969 with the publication of his Netsilik and Iglulik figures, but he did not attempt to redefine the core figures, commenting that such a task was beyond the scope of his paper (Mary-Rousselière 1969:161). Given the extensive overlap between the Kwakiutl and Eskimo repertoires, I have felt it necessary to redefine and analyze the core Eskimo figures based on the data tabulated by Mary-Rousselière.

Defining the core figures of the Kwakiutl collection is currently rather difficult, since no other major collection has been published from a Northwest Coast source: McIlwraith comments that his own Bella Coola collection is far from comprehensive (McIlwraith 1948:543). Thus, one must settle for a classification of figures into "families" defined by similarities in their methods of construction. Such a classification proceeds with the understanding that one member of the family is a core figure and the remainder are local variants. Figures not related to any member of the repertoire are therefore either entirely new inventions, a rare event according to Mary-Rousselière (1969:150), or recent introductions from an outside source so that no variants have yet arisen. One such analysis is presented in charts 1 through 7. "Family tree" diagrams or "flow

charts" are used to define figures related in their methods of construction. Key manipulations that cause the figures to diverge from one another are indicated along each branch of the tree. The diagrams also reveal "technique blocks" common to more than one figure. The information contained within the diagrams can be summarized as follows:

Thirty-six figures begin with Opening B. These figures can be subdivided into two broad categories; those that arise directly from Opening B, and those that employ the first two steps of the Kwakiutl Fire Drill [1a] as an opening. Considering the large number of figures that begin this way, one should rightly classify it as a distinct opening, analogous to Position I, Opening A, and Opening B. Therefore, the arrangement of strings produced by carrying out the first two steps of the Kwakiutl Fire Drill [1a] will henceforth be referred to as the *Kwakiutl Opening*.

The figures that arise from the Kwakiutl Opening can be further subdivided, based on the nature of the subsequent technique carried out; that is, manipulation of existing strings or the creation of new loops prior to continued manipulation. Figures arising from the simple manipulation of existing strings are presented in chart 1.

Drawing the radial thumb string through the index loops gives rise to the *Mā'sLasLEmēki* family of figures composed of three members [2, 13, 14]. The three members of the Toad family [23, 24, 25] arise from drawing the ulnar index strings through other loops. The remaining two families are created through the exchange of index loops. Maintaining the exchanged loops on their original fingers is a technique common to all members of the Bear family [3, 4, 5, 6, 7, 8]. The Canoe family [16, 17, 20] is defined by the practice of fully transferring the loops during the exchange.

Families arising from the creation of new loops from pre-existing strings of the Kwakiutl Opening are pictured in chart 2. The Mink's House family [9, 10, 11, 12] is generated by creating middle finger loops from thumb strings. The creation of new index loops from thumb strings produces the *TsElatsElatso*[E] family with two members [18, 19]. The two remain-

Chart 1

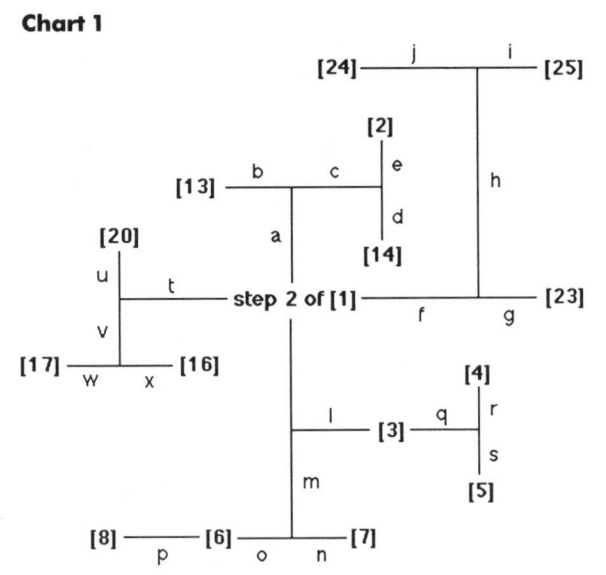

Charts 1–7. Family tree diagrams categorizing Kwakiutl string figures based on similarities in method of construction. Boldfaced numbers enclosed in brackets refer to specific Kwakiutl figures. Perpendicular lines indicate figures that share common opening movements, but later diverge (one-letter codes describe the key manipulation responsible for the divergence). Parallel lines enclosed in dotted boxes indicate figures that share common internal movements or "technique blocks" (one-letter codes describe the sequence common to all members of the family). Kwakiutl figures unrelated in method of construction to any other Kwakiutl figure in the repertoire are listed separately as "independent figures."

Chart 2

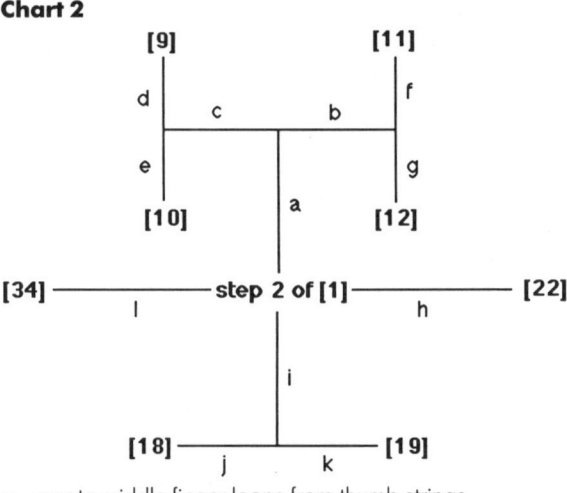

a. radial thumb strings through index loops . . .
b. proximal to ulnar thumb string
c. distal to ulnar thumb string
d. pick up non-transverse strings
e. pick up transverse string
f. ulnar thumb string . . .
g. through index loops
h. through middle-ring-little finger loops
i. retain index loops
j. release index loops
k. right index loop through left index loop
l. retain right index loop
m. release right index loop, re-insert into left
n. retain left index loop
o. release left index loop
p. right index loop through left thumb loop
q. left index loop through left thumb loops . . .
r. from the proximal side
s. from the distal side
t. exchange index loops . . .
u. left through right
v. right through left
w. radial thumb string through index loop distally
x. radial thumb string through index loop proximally

a. create middle finger loops from thumb strings . . .
b. radial to index loops
c. ulnar to index loops
d. draw ulnar index strings through middle finger loops
e. exchange middle finger loops
f. exchange middle finger loops, draw thumb loops through
g. exchange middle finger loops, release thumbs
h. create new thumb loops from index loops
i. create new index loops from thumb loops
j. exchange index loops, left through right
k. exchange index loops, right through left
l. create middle finger loops from index strings

ing figures [22, 34] use loop creations that are encountered only once in the Kwakiutl repertoire. These figures, one of which is an entire series, do

not appear to be related to any other Kwakiutl figures. They may be rare *de novo* inventions, or they may be figures acquired by diffusion from a currently unidentifiable source.

The figures that arise directly from Opening B are classified by technique in chart 3. The four members of the Hummingbird family [26, 36, 30, 35] all arise from the transfer of Opening B loops to different fingers prior to manipulation. The three members of the Sparrow family [27, 28, 29] all begin with thumbs picking up the ulnar index string. The third major family, the Snake family [31, 32, 33, 92], is defined not by similarities in the opening movements, but by a common sequence of left-hand movements which the reader first encounters as steps 3 through 7 of the Kwakiutl Snake [31]. These steps constitute the first example in the Kwakiutl repertoire of a technique block upon which new openings are spliced. Finally, one may loosely define three figures as being members of the Bluejay family [77, 78, 92]. All employ modified versions of Opening B which lack right thumb loops. Two Opening B figures remain unclassified [15, 21]. They are probably either recent *de novo* inventions or recent introductions.

The remaining sixty-four figures of the Kwakiutl repertoire all derive either from Opening A or from an irregular opening which is created mechanically. Unlike the Opening B figures, Opening A and irregular opening figures are better classified by similarities in their internal movements, rather than similarities in their opening movements. Thus we find that most new figures in this category are created by grafting new beginnings or endings onto pre-existing technique blocks derived from core figures (i.e., the *Northwest Coast intertwine,* the *Sun, Moon, and Stars set-up,* the *quarter-turn finish* technique, etc.). In the most sophisticated patterns, several core techniques are combined (e.g. [40], Northwest Coast intertwine and quarter-turn finish). There are also numerous figures with no immediate relatives; figures probably obtained from an outside source. With this introduction, one can classify the remaining Kwakiutl figures as follows:

Chart 4 presents all figures that exploit a very popular technique sequence among the Kwakiutl; the *Northwest Coast intertwine* (steps 6 and 7 of [39]).

Chart 3

a. do not twist thumb loop
b. twist left thumb loop . . .
c. in the radial direction
d. in the ulnar direction
e. steps 3 through 7 of the Snake [31]
f. thumbs pick up ulnar index string
g. index string through thumb loops
h. thumb string through index loops, Log [28], steps 4–5
i. release loops
j. retain loops and finish pattern
k. transfer loop(s) . . .
l. from thumbs to indices
m. from indices to thumbs . . .
n. without inversion of loops
o. with inversion of loops
p. interweave loops
q. exchange loops
r. opening B with modified right thumb loop
s. draw index string . . .
t. through left middle-ring-little finger loop
u. around left middle-ring-little finger loop

Two distinct families employ this manipulation as a late movement in their methods of construction; the Butterfly family [39, 40, 41, 42, 43] and the Tree family [44, 45, 46, 47]. In the Butterfly family, differences in the final pattern are created by varying the movements which occur prior to the Northwest Coast intertwine: in the Tree family, the variation occurs after the intertwine is performed. Two other figures are loosely associated with these families. The construction of *Sisiutl* [48] requires the opening movements of the Butterfly family of figures, but diverges

Chart 4

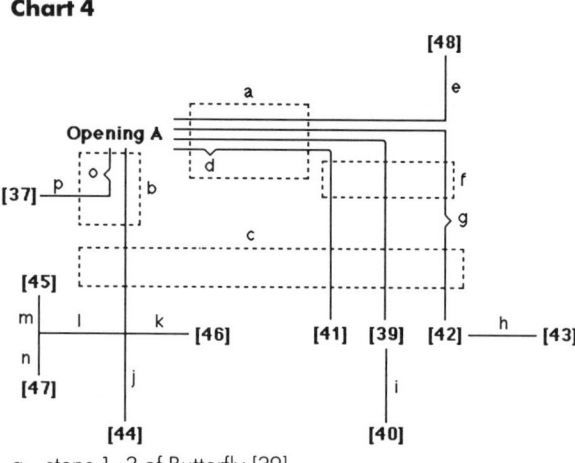

a. steps 1–3 of Butterfly [39]
b. steps 1–7 of Two Trees [44]
c. Northwest Coast intertwine (Butterfly, steps 6–7)
d. thumb loops through index loops
e. ulnar little finger string through 2 sets of index loops
f. ulnar little finger string through 1 set of index loops
g. create half-twist in index loop
h. invert pattern, katilluik
i. quarter-turn rotation of pattern
j. release indices
k. uncross index loops, draw other loops through
l. do not uncross index loops, draw all loops through . . .
m. left index loop only
n. both index loops
o. steps 1–3, 4 of Two Trees [44]
p. release little fingers

Chart 5

a. steps 1–5 of Sun, Moon, and Star [53]
b. manipulate center strings
c. do not manipulate center strings
d. pick up lower palmar strings
e. pick up upper palmar strings . . .
f. near center
g. near ends
h. quarter-turn finish (step 8 of [53])
i. mechanical weaving
j. index loops to thumbs, little finger loops to indices
k. draw index strings through thumb loop(s) . . .
l. from proximal side
m. from distal side
n. exchange index loops
o. katilluik

prior to carrying out the intertwine. The Devil Fish [37] shares opening movements with members of the Tree family, but diverges before the sequence can be completed.

The Sun, Moon, and Star family, with five members [53, 54, 55, 56, 57] is defined on the basis of shared opening movements, and the *quarter-turn finish* [53, step 6]. This family is illustrated in chart 5. Differences in final pattern arise through the insertion of additional steps between the two technique blocks. The Kwakiutl Toad [40] is a compound figure produced by splicing together three technique blocks

(Butterfly Opening, Northwest Coast intertwine, and quarter-turn finish). Two Opening B figures [23, 24] also exploit the quarter-turn finish. The Ship family [68, 69, 70] emerges from a specific arrangement of strings consisting of two thumb loops and one index loop having a transverse radial string. In one case [68], the arrangement is created from Opening A. In the remaining cases, the arrangement is arrived at mechanically.

Chart 6 presents the remaining major families of the Kwakiutl repertoire; the Patch family and the Burbot family. Both arise from an initial maneuver in which all loops are transferred to the thumbs. In some cases, the loops are derived from Opening A. In other cases, the three thumb loops are formed mechanically using a variety of techniques. Once created, the three thumb loops are subject to two different types of manipulation which differentiate the Patch family from the Burbot family. Members of the Patch family [61, 62, 63, 89, 94] arise when one

of the transverse strings is drawn through the thumb loops. If both transverse strings are drawn through the thumb loops in opposite directions, the Burbot family of figures is created [50, 51, 52, 59, 75, 76, 84, 85]. Members of both families then diverge based on subsequently performed manipulations of the basic set-ups.

Other minor families are summarized in chart 7. The Hanging family contains two members [58, 60] and arises when Opening A loops are transferred to other fingers in order to free the thumbs. The Frog family, consisting of two members [71, 72], is composed of figures that share identical opening movements requiring wrist loops and the finger of a second person. Members of the Sand Flea family [81, 82, 83] all share the same opening arrangement of strings (the Sand Flea figure). Mechanical weavings then take place. Members of the Salmon Trap family [86, 87] are right- and left-handed versions of the same figure, formed differently in each case. One can define the Bear Brother family [88, 93] as figures that share a common technique block composed of four steps. Members of the Passing Through family [96, 97] differ only in their opening movements.

All other members of the Kwakiutl repertoire [1, 15, 21, 38, 49, 64, 65, 66, 67, 73, 74, 79, 80, 90, 91, 95, 98, 99, 100, 101, 102] contain technique sequences encountered only once in the Kwakiutl repertoire, suggesting that these figures either derive from a currently unidentifiable source or were invented *de novo*.

Thus, we find that the entire Kwakiutl string figure repertoire can be reduced to twenty-two families of figures and twenty-one independent figures. Within each family, one member is by definition a *core figure*. Therefore, of the one-hundred-two figures collected by Averkieva among the Kwakiutl, it is conceivable that the original Kwakiutl repertoire contained only forty-three figures; the remaining fifty-nine could easily have arisen through the variation of techniques contained within the original forty-three. Having reduced the Kwakiutl repertoire to a manageable number of families, it is now possible to compare these germane figures with core

Chart 6

a. transfer all loops to thumbs
b. draw both transverse strings through other loops
c. draw one transverse string through other loops so that . . .
d. it is wrapped around former index loop
e. it is drawn through former index loop
f. it is drawn through at right and wrapped around at left
g. steps 4–7 of a Patch [61]
h. draw index loops through central diamond
i. retrieve side strings and katilluik
j. two ulnar transverse strings through other loops
k. two-loop version of Burbot pattern
l. draw left index loop through central lozenge
m. release thumb loops with transverse strings
n. transfer right thumb loop to left thumb
o. exchange index loops, proceed on left hand only

Chart 7

Opening A

a

[58] —— b —— c —— [60]

wrist-finger
opening

d

[71] —— e —— f —— [72]

mechanical
opening

g

[88] —— h —— i —— [93]

Sand flea [81]

[82] —— j —— k —— [83]

[86] ——— l ——— thumb-index opening ——— m ——— [87]

n { } o

p

[96] [97]

a. index loops to middle fingers, thumb loops to indices
b. right middle finger-left little finger string through index loops
c. left middle finger-right little finger string through index loops
d. steps 2–4 of the Frogs [71]
e. cross vertical loops once
f. cross vertical loops twice
g. steps 1–4 of Two Bear Brothers' Jealousy [88]
h. pick up sides of central diamond
i. pick up central string of diamond
j. transfer figure to left hand
k. transfer figure to both hands
l. draw left thumb-index string through right loop
m. draw left thumb and index strings through right loop
n. create ulnar half-twist in loop
o. create radial half-twist in loop
p. steps 3–4 of Not Passing Through [96]

Independent figures (not diagrammed):

[1] [15] [21] [38] [49] [64] [65]

[66] [67] [73] [74] [79] [80] [90]

[91] [95] [98] [99] [100] [101] [102]

figures of the Eskimo repertoire so as to better assess the nature of their relatedness.

The Core Eskimo Figures

Unlike the situation among North American Indians, comprehensive string figure collections have been made from nearly all Eskimo tribes. Thus, core figures are readily discernible as being those with the widest distribution. Figures of limited distribution are viewed as local "variants" or local "inventions." Mary-Rousselière recently tabulated the distribution of the 328 known Eskimo patterns, which comprise the 252 complete figures so far collected (Mary-Rousselière, 1969:136–46). Although a full-scale analysis of the distribution data was beyond the scope of his paper, a complete analysis of the distribution data he compiled is crucial to the development of a theory which pinpoints the origin of string figures in North America. Such an analysis is therefore attempted here.

Although it is foolish to base theories of cultural contact and migration solely on the distribution patterns of string figures, the converse is not necessarily so. In fact, any acceptable theory that attempts to trace the evolution and development of string figures in any given region must be consistent with archaeological, linguistic, and ethnological evidence that suggests previous cultural contact or migration of peoples within that region. Therefore, before analyzing Mary-Rousselière's data, it is appropriate to review aspects of Eskimo pre-history relevant to proper interpretation of the distribution data. Since both Paterson and Mary-Rousselière agree that Thule people occupying Alaskan coastal sites during the first millennium A.D. were familiar with today's most widespread Eskimo string figures, my discussion is limited to the development of this particular culture.

THE NORTHERN MARITIME OR THULE TRADITION, A.D. 100–1800

People of Thule culture are characterized as coast

dwellers possessing a high degree of skill in the open-water hunting of sea mammals which, at its peak, included whales (Dumond 1978:72). The earliest known sites at which Thule culture was being practiced occur on St. Lawrence Island in the Bering Strait, and on adjacent regions of the Siberian Coast. Artifacts have been dated at around A.D. 100. This phase of Thule culture, known as *Okvik* or *Old Bering Sea,* was developing at the same time that Ipiutak culture was thriving on the North Alaskan Coast and late-stage Norton was flourishing in the south. Okvik and Old Bering Sea tools are highly developed and indicate great skill in the hunting of seals, walruses, and whales (Dumond 1978:72). Tools as well as ivory and bone objects were heavily decorated during this period. In fact, the period from A.D. 100–500 represents a high point in all Eskimo art work (Dumond 1978:72).

A change in art style soon after this period is used to define the *Punuk* tradition. People of Punuk culture essentially occupied the same regions of the Bering Strait as did their predecessors. At about the same time that Punuk style was evolving in the Bering Strait, (A.D. 500–1000), a closely related tradition known as *Birnirk* was replacing the Ipiutak tradition along the North Alaskan coast (Dumond 1978:75). Although Birnirk people were coastal sea-mammal hunters, more advanced than people of the Ipiutak tradition, they were still not capable of hunting large whales (McGhee 1984:369). The Birnirk tradition apparently flourished between A.D. 500 and 900 (McGhee 1984:369), at which time *Thule proper* emerged in North Alaska. One may therefore refer to all traditions leading up to the emergence of Thule proper as *Proto-Thule* (Old Bering Sea, Okvik, Punuk, Birnirk).

It was during the Thule period proper (A.D. 1000–1800) that most elements of material culture viewed today as being typically "Eskimo" were developed and perfected. Thus, people of authentic Thule culture were organized into whaling crews who hunted on open waters in umiaks and kayaks. A plethora of specialized tools designed to deal with the difficulties of ocean hunting allowed Thule culture to prosper to

such an extent that a general population expansion soon followed. Expansion up the major streams and rivers of North and West Alaska created a more balanced lifestyle, with river-fishing and caribou-hunting supplementing sea products (Dumond 1978:76). As a result of their increased interest in open-water hunting, people of Thule tradition began to drift southward along the Bering Sea coast, reaching Nunivak Island no later than A.D. 1000, and crossing the Alaskan peninsula no later than A.D. 1100 (Dumond 1977: 133). Thule culture apparently spread all the way to Kodiak Island soon after this time, based on the appearance of thick, gravel-tempered pottery on the southern end of the island (Dumond 1977:139). This southerly migration is of particular relevance in the development of a theory linking the Kwakiutl string figure repertoire with the Eskimo repertoire, since both Paterson (1949:62) and Mary-Rousselière (1969:165) provide strong evidence that the string figures they collected among the Eskimos were being made in Alaska by Thule people sometime prior to A.D. 1000.

A major expansion eastward from North Alaska occurred sometime during the tenth or eleventh century A.D. This explosive eastward expansion carried many elements of Thule culture, including string figures, all the way to Greenland in the short time span of less than two hundred years. Although the exact reason for the expansion eastward remains unknown, scholars have argued that the general warming trend which occurred soon after A.D. 900 may have permitted whales to feed in the otherwise ice-packed regions of the Arctic Sea north of the Canadian mainland (McGhee 1984:370). The North Alaskan Thule, probably realizing that it would now be possible to hunt whales all summer long rather than only during the spring and fall migratory periods, began to expand eastward. This primary expansion across the Arctic Archipelago resulted in the colonization of Northern Greenland by the middle of the 11th century A.D. (Dumond 1977:141). This proposed primary expansion route, called *Thule expansion Phase 1* by McGhee, is shown in map 3. Both Paterson and Mary-Rousselière be-

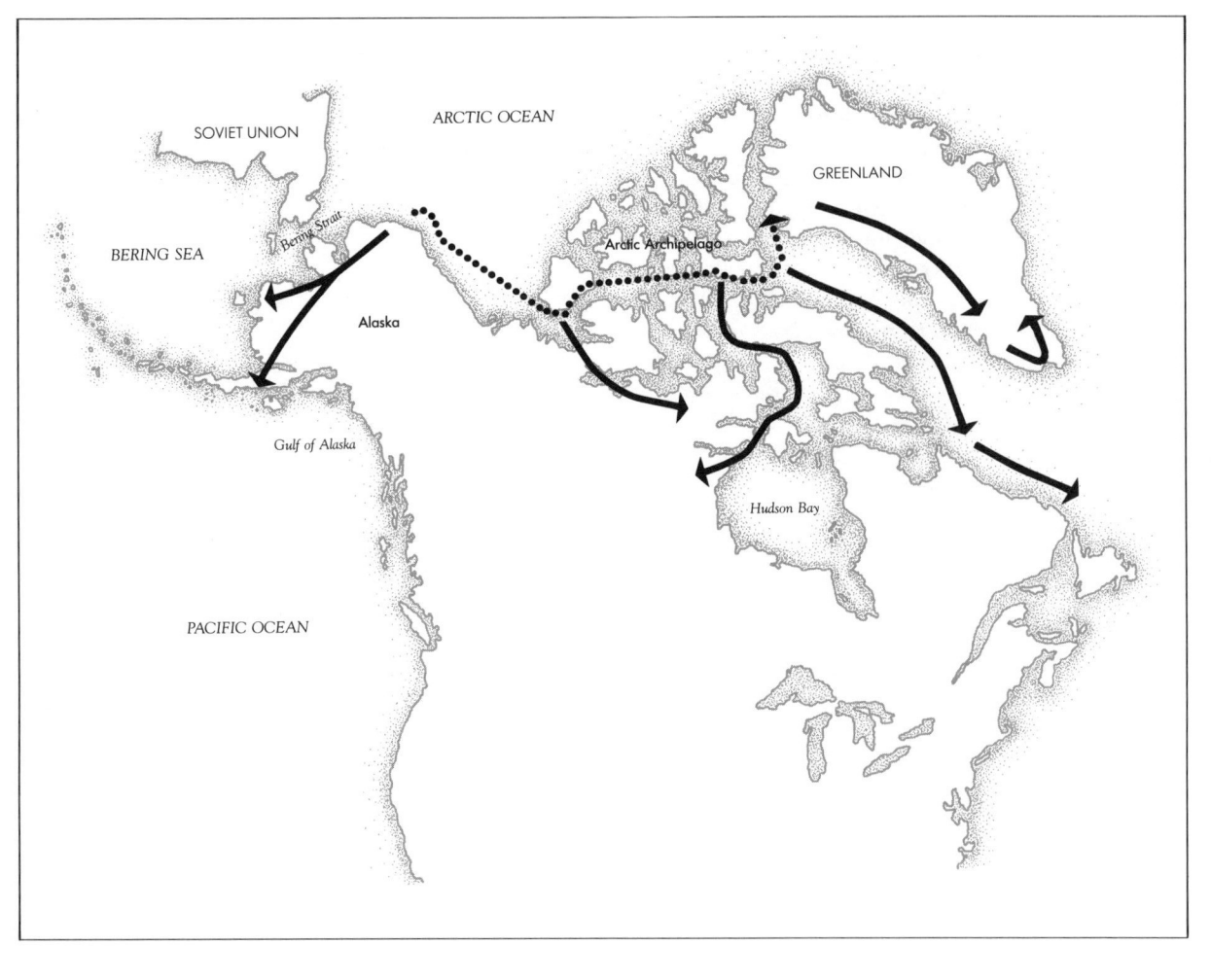

Map 3: Dotted line shows proposed migration route of Thule people during Thule Phase 1 expansion of the 10th–11th centuries A.D. Solid line shows proposed routes during Thule Phase 2 expansion of the 11th–15th centuries A.D. (adapted from McGhee 1984).

STRING FIGURE ORIGINS / 163

lieve that this is how the most widely known Eskimo string figures spread from Alaska to Greenland.

Soon after the Phase 1 expansion was complete, it appears that the climate once again began to deteriorate, resulting in the disappearance of whales from the high Arctic (Dumond 1977:145). The resilient Thule people, who had learned to exploit a variety of sea and mainland resources, were able to adapt by expanding southward to the northern shores of the Canadian mainland. This expansion away from the primary expansion route has been termed *Thule expansion Phase 2* (McGhee 1984:373). It was essentially complete by A.D. 1200–1300. The Phase 2 expansion was accomplished by several submigrations off the Phase 1 route, as shown in map 3. Occupants of the Amundsen Gulf region apparently expanded into the territories now occupied by the Mackenzie, Copper, and possibly the Netsilik Eskimos. Two other expansions which originated in the vicinity of Perry Channel near northern Greenland resulted in the colonization of areas now occupied by the Netsilik, Iglulik, Caribou, Baffinland, Quebec, and Labrador Eskimos. Apparently, string figures were being invented during the Phase 2 expansions, since many Eskimo figures have distribution patterns which coincide with these expansion routes. The previously described southerly expansion of Thule people in Alaska may also be considered as part of the Phase 2 expansion. By the fourteenth century, a similar southward expansion down the west coast of Greenland was complete, resulting in the displacement of early Norse settlers. By the fifteenth century, settlements in East Greenland were established. Thus, by the end of the fourteenth century, the Thule expansion was virtually over. This rather homogeneous culture would persist until Europeans encountered the Eskimo in the 1800s.

Interpretation of Eskimo String Figure Distribution Data

The above review of relevant aspects of Eskimo prehistory offers a context for my examination of the Eskimo string figure distribution data compiled by Mary-Rousselière. A detailed analysis suggests that five basic distribution patterns exist:

1. Figures known to nearly all Eskimo tribes, *including* those west of Central Alaska, (Siberian, Bering, and Nunivak Eskimos, plus the Chukchi).
2. Figures known to nearly all Eskimo tribes, but *absent* among the western tribes, (Siberian, Bering, and Nunivak Eskimos, plus the Chukchi).
3. Figures known to nearly all Eskimo tribes east of (but not including) North Alaska, (Mackenzie, Copper, etc.).
4. Figures confined in their distribution to broad Arctic subregions, defined as follows:
 a. Western Eskimo subregion: territories occupied by Siberian and Alaskan tribes. Occasionally the Mackenzie Eskimos fall within this category.
 b. Central Eskimo subregion: territories occupied by the Mackenzie, Copper, and Netsilik tribes. Occasionally the North Alaskan and Iglulik tribes fall within this category.
 c. Eastern Eskimo subregion: territories occupied by the Iglulik, Baffinland, Greenland, Labrador, and Quebec Eskimos. Occasionally the Netsilik Eskimos fall within this category.
5. Figures confined in their distribution to one tribe or several adjacent tribes.

The five major string figure distribution patterns defined above correlate precisely with the proposed distribution patterns of the various Thule and Proto-Thule people shortly before, during, and after their great expansion of the tenth century A.D. The five major string figure distribution patterns can therefore be renamed in terms of the cultures which most likely practiced them:

1. Figures known to nearly all tribes, including the westernmost tribes, seem to be artifacts of

Proto-Thule culture, or possibly even cultures ancestral to Proto-Thule. The distribution pattern suggests that these figures are the oldest Eskimo figures, developed before the great expansion of the tenth century. These figures are therefore the *core* figures of the repertoire.

2. Figures known to nearly all Eskimo tribes except those west of Central Alaska seem to be artifacts of the Thule culture proper. These figures were apparently developed by Thule people of North Alaska just prior to the great expansion, and are therefore called *pre-expansion figures*. These figures would later spread eastward to Greenland with the Thule Phase 1 expansion, and most would later spread southward with the Thule Phase 2 expansions.

3. Figures known to all tribes east of Alaska seem to be artifacts of Thule Phase 1 people. These figures were probably developed somewhere in the western reaches of the Arctic Archipelago soon after the eastward expansion began, and subsequently spread to Greenland. Most would later spread southward with the Phase 2 expansions.

4. Figures confined in their distribution to specific subregions of the Arctic seem to be remnants of various Thule Phase 2 people. These figures were apparently developed by people occupying specific subsections of the Phase 1 expansion route who later expanded southward. Figures developed in the vicinity of North Alaska would eventually spread to all parts of Alaska and perhaps Siberia (Phase 2a). Figures developed by the Thule Phase 1 people who occupied the western Arctic Archipelago would eventually spread to the present-day Mackenzie and Copper territories as the Phase 2 expansion progressed (Phase 2b). Figures developed by the Thule Phase 1 people who occupied Ellesmere Island or North Greenland would eventually spread to the present-day Netsilik, Iglulik, East and West Greenland, Baffinland, Quebec, and Labrador territories (Phase 2c).

5. Figures confined in their distribution to one or two tribes within a specific subregion were most likely developed by Thule Phase 2 people sometime after their expansion was complete, perhaps even in historic times. These figures are referred to as *regional variants*. Unfortunately, it is oftentimes impossible to distinguish a Thule Phase 2 figure from a regional variant based solely on its distribution pattern, since not all collections used in the analysis are comprehensive. Therefore, in order to simplify presentation of the data, regional variants will be placed in the appropriate Thule Phase 2 category (2a, 2b, or 2c) and treated as such until it can be clearly demonstrated that they are truly absent from other locations within a subregion.

Table 2 classifies the 252 Eskimo string figures tabulated by Mary-Rousselière as being either Proto-Thule, pre-expansion, Thule Phase 1, or Thule Phase 2a, 2b, or 2c in origin. Figures composed of several patterns (string figure series) are classified based on the overall distribution of the entire figure, even though some of the individual patterns may not have been recorded at every location within the subgroup. The numbering system of Paterson is retained in order to preserve a sense of continuity in the literature. Figures not reported by Paterson are given the number assigned by Mary-Rousselière or others.

The majority of figures are readily assigned to one of the four distribution categories defined above. This is especially true of figures in the Thule Phase 1 and 2 categories, since collections from these regions are believed to be comprehensive. However, collections from the western regions, especially those made among the Chukchi and Siberian Eskimos, are known to be incomplete. Occasionally this lack of data has interfered with the assignment of a figure as being either Proto-Thule or pre-expansion in origin. Therefore, in determining whether a figure is best classified as Proto-Thule or pre-expansion, rigid criteria are adopted. For a figure to be classified as Proto-Thule, the figure must appear in two or more of the

Table 2. Eskimo String Figure Distribution Analysis*

Figure designation	Classification	Related Kwakiutl figure	Nature of relation
P1	Proto	[48]	(ID, ID)
P2	Proto	[7a]	(ID, UN)
P3	Proto	-	-
P4a	Proto	[65a]	(ID, ID)
P4bc	2c	-	-
P4e	2a	-	-
P5	Proto	[59]	(ID, ID)
P6	Proto	[69d]	(ID, UN)
P7	Proto/Pre	[7a]	(ID, UN)
P8	Proto/Pre	[52]	(ID, UN)
P9	Pre	[3,6b, 78,79]	(ID, UN)
P10–P12	I	-	-
P13	2a	[74b]	(ID, ID)
P14	I	-	-
P15	Proto	[51c]	(ID, ID)
P16	Proto/Pre	-	-
P17	Proto	[1a], [69c,98]	(ID, ID), (ID, UN)
P18	Proto/Pre	-	-
P19	Proto/Pre	[80]	(ID, ID)
P20a	Proto	step 15 of [50]	(ID, ID)

*Proposed classification of the 252 Eskimo string figures tabulated by Mary-Rousselière (1969:136–46). Figures are classified as being relics of either Proto-Thule culture (Proto), Pre-expansion Thule culture (Pre), Thule Phase I expansion culture (I), or Thule Phase 2 expansion culture (2a, 2b, 2c). In cases where the distribution data are inconclusive, a slashed entry is used to indicate the two most probable classifications. Numbers prefixed by a P refer to Eskimo figures tabulated by Paterson (1949). Numbers or letters prefixed by a J refer to Eskimo figures described by Jenness (1924). Numbers prefixed by an MR refer to Eskimo figures described by Mary-Rousselière (1969). Numbers in brackets refer to Kwakiutl figures (this volume). The abbreviation "ID, ID" is used to indicate that the Kwakiutl and Eskimo patterns are identical (or nearly identical) in final pattern and method of construction. "ID, UN" indicates that the two figures are identical (or nearly identical) in final pattern but unrelated in method of construction. "SIM, SIM" indicates that the two figures are similar only in final pattern and method of construction.

Table 2—continued

Figure designation	Classification	Related Kwakiutl figure	Nature of relation
P20bc	Proto/ (2a + 2c)	-	-
P20def	Proto/2a	-	-
P21	Pre	[7b]	(ID, UN)
P22–P23	Pre	-	-
P24	I	-	-
P25	I/2c	-	-
P26–P27	I	-	-
P28	2c	-	-
P29	Proto	-	-
P30	Proto/ (I + 2a)	[82]	(SIM, SIM)
P31	Proto	-	-
P32	I	-	-
P33	Proto/Pre	-	-
P34	Proto/Pre	[86,87]	(ID, ID)
P35a	Proto/Pre	[13]	(ID, ID)
P35ce	2c	-	-
J LXXXIX	2a	[24]	(ID, UN)
P36	Proto/ (2a + 2c)	-	-
P37	Pre/I	-	-
P38	Proto/ (2a + 2c)	-	-
P39	Proto/Pre	-	-
P40	Proto/ (2a + 2c)	-	-
P41	Proto/Pre	-	-
P42	Proto/Pre	[67]	(ID, ID)
P43	Proto/Pre	-	-
P44	Proto	-	-
P45	Pre	[75,76]	(ID, UN)
P46	Proto/Pre	-	-
P47	Pre	[61]	(ID, ID)
P48	Pre	[23, 24]	(ID, UN)
P49 + J XCVIIAD	Pre	[75,76]	(SIM, SIM)
P50	Pre	-	-
P51	Pre	[62]	(ID, ID)
P52a	2c	-	-
P52b	Pre	[49]	(ID, UN)
P52c	2a	step 7 of [50]	(ID, ID)
P53	Pre	-	-
P54–P55	I	-	-
P56	2a	-	-

Table 2—*continued*

Figure designation	Classification	Related Kwakiutl figure	Nature of relation
P57	Pre	-	-
P58	Pre/ (2a + 2c)	-	-
P59	Pre/ (2b + 2c)	[65b]	(ID, UN)
P60–P61	Pre/ (2a + 2c)		
P62	Proto/ (2a + 2c)	-	-
P63–P67	Pre/ (2a + 2c)	-	-
P68	Proto/Pre	[10]	(ID, ID)
P69	2a	-	-
P70	2a	[21]	(SIM, SIM)
P71	Pre	[74b]	(ID, UN)
P72	2b	-	-
P73	Proto/ (2a + 2c)	-	-
P74	I/2c	-	-
P75–P83	I	-	-
P84	2a + 2b	[12]	(ID, ID)
P85	2a	-	-
P86–P88	2b	-	-
P89	2a	[59]	(ID, UN)
P90	2a + 2b +2c	-	-
P91	2a	-	-
P92–P93	2b	-	-
P94	I	-	-
P95	2a + 2b	-	-
P96	2a	-	-
P97	I	-	-
P98	2a	-	-
P99	2a	[30]	(ID, ID)
P100	2a	[73]	(ID, ID)
P101a	2a	[33]	(ID, ID)
P101b	2a	[92]	(ID, ID)
P102–P104	2a	-	-
P105	2a	step 4 of [51]	(ID, ID)
P106	2a	[39,41,42]	(SIM, SIM)
P107	2a	-	-
P108–P109	2c	-	-
P110	2c	[18b,19b]	(SIM, SIM)
P111–P133	2c	-	-

Table 2—*continued*

Figure designation	Classification	Related Kwakiutl figure	Nature of relation
P135–P139	2c	-	-
P142–P143	2c	-	-
P151	2c	[4]	(ID, UN)
P154–P155	2c	-	-
P156	2c	[18a,19a]	(SIM, SIM)
P157	2c	-	-
P159–P160	2c	-	-
P161	2b	[90]	(SIM, SIM)
P164–P170	2b	-	-
P171	2b	[70]	(ID, ID)
P172–P176	2b	-	-
P178–P185	2b	-	-
P186–P191	2a	-	-
P192	2a	step 5 of [52]	(ID, UN)
P193–P199	2a	-	-
P200	2a	-	-
P201	Proto/ (2a + 2c)	-	-
P202	Proto/ (2a + 2c)	[60]	(ID, UN)
P203	2a	[73]	(SIM, SIM)
P205	2a	[51d]	(ID, ID)
P207–P210	2a	-	-
P212	2a	-	-
P213	2a	[86,87]	(ID, UN)
P214	2a	[71,72]	(SIM, SIM)
P215–P216	2a	-	-
P217	2b	-	-
J LXVII	2b	-	-
J CXX	2b	-	-
J CXLI	2a	-	-
J CLIII	2a	-	-
J CLIV	2a + 2b	-	-
J XXXIV	2a + 2b	-	-
MR 3bis	2c	-	-
MR 2	2c	-	-
MR 4	2c	-	-
MR 5	2c	-	-
MR 8	2c	-	-
MR 13	2c	-	-
MR 14bis	2c	-	-
MR 15a	2c	-	-
MR 16–MR 17	2c	-	-
MR 17'	2c	-	-

Table 2—continued

Figure designation	Classification	Related Kwakiutl figure	Nature of relation
MR 20	2c	-	-
MR 29	2c	-	-
MR 30	2c	-	-
MR 38	2c	-	-
MR 51–MR 51'	2c	-	-
MR 55–MR 55'	2c	-	-
MR 58	2c	-	-
MR 61'	2c	-	-
MR 64	2c	-	-
MR 66bis	2c	-	-
MR 72	2c	-	-
MR 84	2c	-	-
MR 90	2c	-	-
MR 95	2c	-	-
MR 101	2c	-	-
MR IX	2c	-	-
MR XXI	2c	-	-
MR XXVI	2c	-	-
Rasmussen 21	2b	-	-
Birket-Smith 105c	2c	-	-
Lantis 15	2a	-	-
Jayne 806–807	2a	-	-
Jayne 810	2a	-	-
Jayne 819	2a	-	-
Jayne 821	2a	-	-
K. Haddon 8a	2a	step 6 of [51]	(ID, ID)
K. Haddon 8b	2a	[51b]	(ID, ID)

four western collections, (Chukchi, Siberia, Bering, Nunivak), in addition to nearly all collections from Alaska and the East. Figures appearing in only one of the four western collections may very well be Proto-Thule figures, but cannot be classified as such, given the incomplete nature of the data base. These figures are therefore designated as *Proto/pre-expansion figures*.

In reality, however, the lack of comprehensive data for the western regions may not be limiting. When Jenness examined the Chukchi figures sent to him on cards by Captain Bernard, he included in his monograph only those figures that he recognized as also occurring among the collections he had made among the Alaskan, Mackenzie, and West Copper Eskimos (Jenness 1924:9B). Therefore, it is quite likely that Jenness selectively retained the Proto-Thule figures and discarded the figures of Thule Phase 2a origin. A collection from St. Lawrence Island in the Bering Strait, where string figures still flourish (T. Johnston, personal communication) would be of great assistance in this matter.

After adopting the rigid criteria explained above, twelve figures emerge from the analysis as Proto-Thule figures (table 3), that is, figures developed well before the great expansion of the tenth century and therefore known to nearly all Eskimo tribes. Fourteen figures match the distribution pattern established for a pre-expansion figure, being known in North Alaska and to the east (table 3). An additional fourteen figures remain which, unfortunately, cannot be classified with certainty as being Proto-Thule or pre-expansion. These figures occur only once to the west of Central Alaska.

An educated guess as to which of these fourteen are true Proto-Thule figures might draw on the exact location of the single western occurrence. If the figure occurs among the Siberian, Nunivak Eskimos, or the Chukchi, chances are greater that the figure is actually Proto-Thule in origin. On the other hand, a single occurrence among the Bering Eskimos could easily be explained as an artifact of diffusion from the adjacent North Alaska region. Using these criteria, seven of the fourteen unclassified figures would move into the Proto-Thule category (P16, P18, P19, P34, P68, P41, P46). Because such a classification is extremely tenuous, it is not employed in formulating any of the theories that attempt to explain the Kwakiutl-Eskimo parallels.

Only twenty-one figures emerge as probable Thule Phase 1 expansion figures. According to the classification scheme adopted above, these figures were probably developed just north of the Mackenzie region soon after the eastward expansion was underway. Two figures for which data is incomplete remain unclassified (P25, P30).

Table 3. Summary of Eskimo String Figure Classification*

Proto-Thule: 12 figures
 Paterson 1, 2, 3, 4a, 5, 6, 15, 17, 20a, 29, 31a, 44
Proto-Thule/Pre-Expansion: 14 figures
 Paterson 7, 8, 16, 18, 19, 33, 34, 35a, 39, 41a, 42, 43, 46,
 68
Pre-Expansion Thule: 14 figures
 Paterson 9, 21, 22, 23, 45, 47, 48, 49, 50, 51, 52b, 53, 57,
 71
Thule Expansion Phase I: 21 figures
 Paterson 10, 11, 12, 14, 24, 26, 27, 32, 54, 55, 75–83, 94,
 97
Thule Expansion Phase 2a: 57 figures
 Paterson 4e, 13, 52c, 56, 69, 70, 85, 89, 91, 96, 98–107,
 186–200, 203, 205, 207–210, 212–216
 Jenness LXXXIX, CXLI, CLIII
 Lantis 15
 Jayne 806, 807, 810, 819, 821
 K. Haddon 8a, 8b
Thule Expansion Phase 2b: 32 figures
 Paterson 72, 86, 87, 88, 92, 93, 161, 164–176, 178–185,
 217
 Jenness LXVII, CXX
 Rasmussen 21
Thule Expansion Phase 2c: 76 figures
 Paterson 4bc, 28, 35ce, 52a, 108–133, 135–139, 142,
 143, 151, 154–157, 159, 160
 Mary-Rousselière 3bis, 2, 4, 5, 8, 13, 14bis, 15a, 16, 17,
 17', 20, 29, 30, 38, 51, 51', 55, 55', 58, 61', 64, 66bis,
 72, 84, 90, 95, 101, IX, XXI, XXVI
 Birket-Smith 105c
Unclassifiable due to insufficient data: 27 figures
 Total number of figures analyzed: 253
 Total number of figures classified: 226

*Numbers are those assigned to each string figure by the indicated author. Figures classified as Proto-Thule represent the oldest figures in the Eskimo repertoire, based on their widespread distribution. Pre-expansion figures represent those figures developed in Alaska sometime before the Thule expansion of the tenth century A.D. Figures in the Proto-Thule/Pre-expansion category will eventually be assigned as being either Proto-Thule or Pre-expansion, once comprehensive collections from the Bering Strait region become available. Thule Phase I and 2 figures represent those figures developed either during or after the tenth-century expansion.

Thule expansion Phase 2 figures (figures developed regionally after the Phase 1 expansion was complete) constitute the bulk of all known Eskimo string figures. Fifty-seven satisfy the criteria for a Phase 2a or *western variant* figure; thirty-two are of the Phase 2b or *central variant* type; seventy-six belong to the Phase 2c or *eastern variant* category. Twenty-four figures remain unclassified. Sixteen of the twenty-four unclassified figures occur in the western and eastern Arctic regions but are missing from the central region. Prior to Mary-Rousselière's work among the Netsilik, this distribution pattern was characteristic of many figures (see Paterson 1949:51). This led Paterson (1949:54) to conclude erroneously that the Central Eskimos descended from inland intruders who displaced coastal Thule people from the region sometime after the Phase 2 expansion was complete. But as a result of Mary-Rousselière's comprehensive Netsilik and Iglulik Eskimo collections, we now know that many of these figures are indeed present among the Central Eskimos. This may very well be true of the sixteen residual figures found here, since Jenness's West Copper Eskimo collection is probably not comprehensive.

In summary, the distribution analysis of the 252 Eskimo figures tabulated by Mary-Rousselière reveals that only 5 percent of the figures are likely *core* figures; that is, figures popular enough to have survived for over a thousand years. Many of the techniques used in creating the entire Eskimo repertoire will undoubtedly be found as components of core figures. The core figures themselves are quite interesting with respect to their level of complexity. If the practice of making string figures had arisen spontaneously among Proto-Thule people, one would expect the core figures of the collection to be relatively simple in pattern and construction. Rather, one finds that the core Eskimo figures are among the most complex of the repertoire. This implies that the core figures are far older than Thule culture itself, and indeed represent the outcome of long-term familiarity with the gentle art of making string figures.

Comparison of Kwakiutl and Core Eskimo Figures

Based on which Eskimo figures are core figures and which are variants developed locally at a later date, it is now possible to examine the shared figures of the Kwakiutl and Eskimo repertoires in order to gain insight into likely dates and modes of transmission. The Kwakiutl figures that are related to Eskimo figures by virtue of identical, nearly identical, or similar final patterns are listed in table 2 alongside their corresponding Eskimo equivalents.

Several very interesting observations emerge from the comparison, which can be found in chart 8. The comparison reveals that eight of twelve, or 66 percent, of the Proto-Thule Eskimo figures are represented by analogous patterns in the Kwakiutl repertoire. Nine of fourteen, or 64 percent of the Thule Pre-Expansion figures are likewise represented. Of the fourteen Eskimo figures that could not be specifically classified as being Proto-Thule or pre-expansion, seven, or 50 percent, are represented in the Kwakiutl repertoire. Furthermore, if one examines the subset of Proto-Thule figures known on Nunivak Island, the most southern Alaskan location from which Eskimo figures have been collected, one finds that an astounding 86 percent (six of seven) are duplicated in the Kwakiutl repertoire. This observation is particularly interesting if one assumes that the figures found at Nunivak Island are representative of most Yupik-speaking Eskimos in general who occupy Southwest Alaska (i.e., the Alaskan peninsula and coastal regions along the Gulf of Alaska). These regions are directly adjacent to Northwest Coast territories, and are perhaps accessible by boat from the Northwest Coast.

There are no Thule Phase 1 figures, and very few Thule Phase 2b (central variant) or 2c (eastern variant) figures represented (two of thirty-two, and three of seventy-six, respectively). The number of Phase 2a (western variant) figures represented in the Kwakiutl repertoire is a bit higher at 21 percent (twelve of fifty-seven), but is still much lower than

Chart 8. Percentages of Proto-Thule, Pre-expansion, Thule Phase I and Thule Phase 2a, 2b, and 2c Eskimo figures represented in the Kwakiutl repertoire by figures with identical, nearly identical, or similar final patterns (methods of construction not necessarily the same).

the number of figures of Proto-Thule or pre-expansion origin. Of the twelve Phase 2a figures represented, eight are found primarily or exclusively among Eskimos of the Bering Strait region of Alaska. The low percentage of Thule Phase 2a figures and high percentage of Proto-Thule and pre-expansion Eskimo figures in the Kwakiutl repertoire strongly suggests that, if an actual transfer of figures via diffusion did occur, the transfer began sometime prior to A.D. 1000, that is, prior to the time when Alaskan local variants began to appear.

The notion of a common origin, however, offers a far more attractive explanation for the high percentage of Proto-Thule Eskimo figures in the Kwakiutl repertoire: namely, that the shared figures were developed by a single ancient, ancestral culture whose descendants include the Kwakiutl and Thule Eskimos. If the common-origin hypothesis is indeed valid, a large percentage of the Proto-Thule figures present in the Kwakiutl repertoire should possess methods of construction identical to those recorded among the Eskimos.

As previously discussed, cultural units sharing a large number of identical figures made by identical methods of construction (ID, ID) either share a common ancestor, or engage in social practices that

encourage direct, long-term social interaction and integration with neighboring units. Units sharing a large number of identical figures made by unrelated methods of construction (ID, UN) may have experienced intermittent social contact, so that only the visual image of the final pattern could be transmitted. Units sharing similar figures made by similar methods of construction (SIM, SIM) may have acquired figures through a diffusion mechanism by way of many intermediaries. A methods analysis comparing the shared Kwakiutl and Eskimo figures can be found in charts 9, 10, and 11.

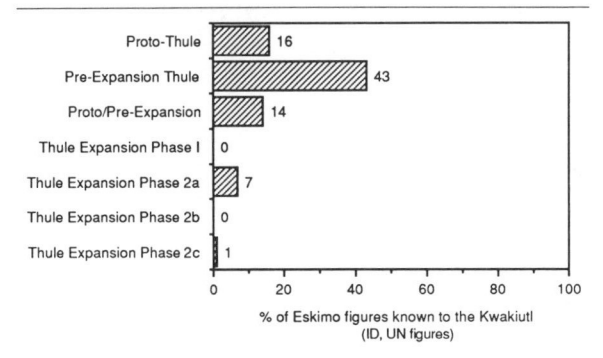

Chart 10. Percentages of Proto-Thule, Pre-expansion, Thule Phase I and Thule Phase 2a, 2b, and 2c Eskimo figures represented in the Kwakiutl repertoire by figures *identical* (or nearly identical) in final pattern but *unrelated* in method of construction (ID, UN figures).

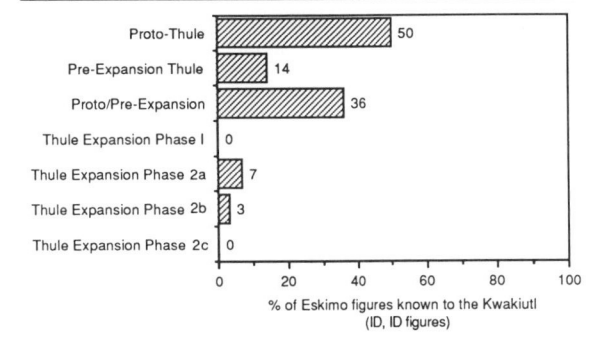

Chart 9. Percentages of Proto-Thule, Pre-expansion, Thule Phase I and Thule Phase 2a, 2b, and 2c Eskimo figures represented in the Kwakiutl repertoire by figures *identical* (or nearly identical) in final pattern *and* method of construction (ID, ID figures).

Chart 9 shows the percentages of Proto-Thule, pre-expansion, Thule Phase 1, and Thule Phase 2 Eskimo figures that the Kwakiutl make using identical or nearly identical methods. The analysis reveals that 50 percent of the Proto-Thule figures are made by the Kwakiutl using identical methods of construction, whereas only 14 percent of the pre-expansion figures fall into this category. Of the fourteen figures that could not be classified as being Proto-Thule or pre-expansion, 36 percent are made by the Kwakiutl in identical fashion. Only 7 percent of the Phase 2a (western variants) and 3 percent of the Phase 2b

(central variants) are formed by the Kwakiutl using the method previously recorded among the Eskimos.

Chart 10 shows the percentages of Proto-Thule, pre-expansion, Thule Phase 1, and Thule Phase 2 Eskimo figures that the Kwakiutl make using unrelated methods of construction. The large majority of these figures, 43 percent, are of the pre-expansion type. Only 16 percent of the Proto-Thule figures are made by the Kwakiutl using an unrelated method. Fourteen percent of the Proto/pre-expansion figures are also of this type. The number of Phase 2a (western variant) figures of this type is low at 9 percent.

Finally, chart 11 shows the percentages of Proto-Thule, pre-expansion, Thule Phase 1, and Thule Phase 2 Eskimo figures which are represented in the Kwakiutl repertoire by figures of similar final pattern and method of construction. There are no Proto-Thule or Proto/pre-expansion figures in this category. Only one of the fourteen pre-expansion figures are of this type. The majority of figures in this category are of the Phase 2a (western variant) type, with four out of fifty-seven meeting the criteria.

Thus, it seems unlikely that recent cultural diffusion or trade along the Northwest Coast is responsi-

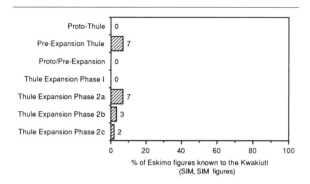

Chart 11. Percentages of Proto-Thule, Pre-expansion, Thule Phase I and Thule Phase 2a, 2b, and 2c Eskimo figures represented in the Kwakiutl repertoire by figures *similar* in final pattern *and* method of construction (SIM, SIM figures).

ble for the large percentage of Eskimo core figures in the Kwakiutl repertoire. Rather, the methods analysis presented above supports the notion that the Eskimo and Kwakiutl string figure repertoires may be "genetically" related products of cultural integration that took place either in North America (subsequent to occupation of their current territories), in Beringia (prior to settlement of the New World), or in Siberia (long before Northwest Coast Indians and Eskimos diverged).

Origin of Kwakiutl String Figures Not Found in Eskimo Repertoire

The above analysis has revealed that 46 of the 102 Kwakiutl figures collected by Averkieva are in some way related to figures collected among the Eskimos. One immediately wonders just how many of the remaining 56 figures are simply variant figures; figures with a method of construction based on one of the figures common to both the Kwakiutl and the Eskimos.

In order to address this question, I re-examined the "family tree" diagrams to determine how many of the previously defined Kwakiutl string figure families

contain an Eskimo-related figure. The results are presented in chart 12 where simplified versions of each family tree can be found. Eskimo-related figures are enclosed in boxes. The analysis reveals that sixteen of the twenty-two Kwakiutl string figure families previously defined contain one or more Eskimo-related figure. Of the twenty-one undiagrammed (independent) Kwakiutl figures, eleven are Eskimo-related. Thus, it appears that seventy of the 102 figures in the Kwakiutl repertoire are either Eskimo-related figures, or variations of such figures.

The origin of the remaining thirty-two figures remains obscure. Of the remaining thirty-two figures, twenty belong to one of six Kwakiutl families defined above (Canoe family, Sparrow family, Tree family, Sun, Moon, and Star family, Passing Through family, and Bear Brother family). Thus, it is quite conceivable that only six of the twenty figures were obtained from an outside source; the remaining fourteen could easily have been invented locally by varying the movements used in forming the six "core" figures. These six core figures may eventually prove to be widespread Native American figures, once other collections become available. The final twelve figures [15, 22, 34, 38, 64, 66, 91, 95, 99, 100, 101, 102], in addition to being unrelated to Eskimo figures, are also unrelated to any other figure in the Kwakiutl repertoire (independents). These figures are therefore either Northwest Coast inventions or unpublished Native American figures. In support of this hypothesis, [15] and [38] (as well as [26], [30], [80], [83], [94], and [98]) have already been observed among other Indian tribes outside the Northwest Coast cultural unit (T. Storer, personal communication). Kwakiutl figures [22], [34], and [102] have been observed among other Northwest Coast tribes. Kwakiutl figure [91] is known in Hawaii, and Kwakiutl figure [95] can be found throughout the South Pacific. Finally, Kwakiutl figures [64], [66], [99], [100], and [101] are all simple enough in concept and design to be classified as local inventions.

In summary, virtually all of the string figures in

Chart 12. Simplified renditions of the Kwakiutl string figure "family tree" diagrams. Bracketed numbers [] refer to specific figures in Averkieva's Kwakiutl collection. Figures that are *identical* (or nearly identical) in final pattern *and* method of construction to previously recorded Eskimo figures are enclosed in triple-frame boxes (ID, ID figures). Kwakiutl figures that are *similar* in final pattern *and* method of construction to previously recorded Eskimo figures are enclosed in double-frame boxes (*SIM, SIM figures*). *Kwakiutl figures that are identical* (or nearly identical) in final pattern but *unrelated* in method of construction to previously recorded Eskimo figures are enclosed in single-frame boxes (ID, UN figures).

Chart 12—continued

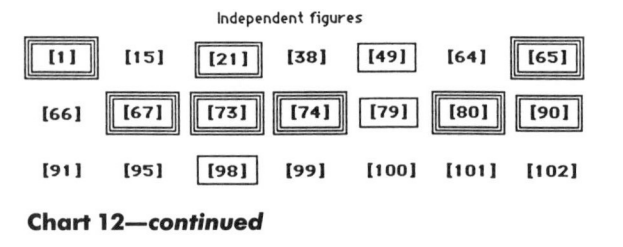

Chart 12—continued

the Kwakiutl repertoire can be connected in some way with figures known elsewhere in North America. Their total lack of resemblance to figures known outside the continent affirms the belief that the practice of making string figures is a *learned* skill: the creation of a new figure from scratch is not a common occurrence.

Implications of the Shared Kwakiutl-Eskimo String Figures

The comparative study presented herein suggests that most of the Kwakiutl string figures collected by

Averkieva are related, either directly or indirectly, to Eskimo figures. Those Kwakiutl figures directly related to Eskimo figures (i.e., with identical or nearly identical patterns and methods of construction) are predominantly core figures of the Eskimo repertoire. The construction analysis presented above indicates that these figures might also be core figures of the Kwakiutl repertoire. It is also noteworthy that the Eskimo core figures most familiar to the Kwakiutl are primarily those made by the Yupik-speaking Eskimos (Nunivak, Bering, and Siberian tribes). Finally, those Kwakiutl figures indirectly related to Eskimo figures (i.e., with identical or nearly identical patterns formed by unrelated methods of construction) tend to be figures developed (or acquired) by Eskimos of Thule culture just prior to their expansion eastward, circa A.D. 1000.

From a nondiffusionist point of view, the directly related Kwakiutl-Eskimo figures described herein strongly suggest that the two cultural units share a common ancestor. Turner has recently presented dental evidence in support of this contention (see below). If Turner's hypothesis is correct, the directly related Kwakiutl-Eskimo figures are at least 8,000 years old. On the other hand, a diffusionist would argue that the identical core figures present in both repertoires stem from long-term contact between the two cultural units. This argument is particularly attractive when presented in conjunction with ethnographic accounts describing a long-established social practice indulged in by all inhabitants of the Northwest Coast—the practice of capturing slaves from distant villages. Such a practice, in effect, would almost guarantee cultural integration.

But regardless of how one explains the presence of core Eskimo figures in the Kwakiutl repertoire, the fact remains that indirectly related versions of many Alaskan Thule pre-expansion figures are also present. If one accepts Mary-Rousselière's notion that "ID, UN" figures with restricted distributions are not necessarily the product of independent invention, but that such figures represent attempts at duplicating vaguely familiar figures, then one must conclude that at some point during the last 1,500 years,

Eskimos and Northwest Coast Indians were interacting under conditions intimate enough to permit exposure to new patterns, but not necessarily intimate enough to permit memorization of the accompanying construction methods. One can envision brief trade encounters as being of this nature.

Given that trade networks linking all inhabitants of the North American Pacific Coast have existed for at least 2,000 years, it is not unreasonable to propose that imitations of various pre-expansion Thule patterns entered the Kwakiutl repertoire (or vice versa) as a consequence of such encounters. Recent studies of common ancestry, slavery, and trade among prehistoric inhabitants of the Northwest Coast enable us to examine the role each of these may have played in the evolution of the Kwakiutl and Eskimo string figure repertoires.

Directly Related Kwakiutl-Eskimo String Figures: Common Ancestry as a Possible Source

The strongest archaeological evidence for a common Eskimo-Northwest Coast Indian ancestor comes from Turner's innovative and highly publicized study of over 9,000 dental remains from prehistoric crania (Turner 1985, 1986, 1988, 1989; Greenberg, Turner, and Zegura, 1986). Based on similarities in tooth morphology, Turner proposes that all Native Americans descend from a single ancestral population, called *Sinodonts,* inhabiting North China approximately 20,000 years ago (Greenberg, Turner, and Zegura 1986:485). Archaeologically speaking, these early Sinodonts are equated with bearers of the North Chinese Microlithic Tradition (Turner 1985:49). Expansion northward into Northeast Asia subsequently divided the early Sinodonts into two and possibly three distinct cultural units.

This cultural division and subsequent independent evolution was largely an artifact of local geography: those Sinodonts occupying the Amur River basin and Okhotsk coast of Siberia developed extensive fishing and sea-mammal hunting skills. Approximately 15,000 years ago, this population began to expand along the southern coast of Beringia (Turner 1989:94–95). This culture again diverged around 4,000 years before present (B.P.) to produce two genetically and culturally distinct populations; the Aleuts and the Eskimos.

The Sinodonts who occupied the Lena River basin in Northeast Siberia became large game (mammoth) hunters (Turner 1985:43). According to Turner, this population expanded along the northern plains of Beringia at about the same time the ancestral Aleut-Eskimos were occupying the southern coast—approximately 12,000 years B.P. By 10,000 years B.P., these big game hunters, or *Paleo-Indians,* had reached the southern tip of Chile, having expanded at a rate of about ten miles per year (Turner 1989:94). Turner proposes that this group is ancestral to most post-Clovis North and South American Indians.

Turner and others do not believe, however, that the Paleo-Indians are ancestral to the Greater Northwest Coast Indians. Turner's dental evidence suggests that the Greater Northwest Coast Indians descended from a hybrid population that developed in Siberia as a result of admixture between the Lena and Amur River basin populations described above (Turner 1985:32). This hybrid population, a culture adapted to forest/forest-steppe/river habitats, subsisted on fish and small animals such as caribou, horse, and bison (Turner 1985:54). Turner suggests that this population expanded into North America via the Beringian interior several thousands of years after the ancestral Aleut-Eskimo and Paleo-Indian populations had colonized North America. By approximately 8,000 years B.P., these small game hunters and fishers were occupying the Pacific Northwest Coast. Turner associates these people with the *Denali* or *Paleo-Arctic* microblade tradition. This microblade tradition is an archaeological tool assemblage found, among other places, along the entire Pacific Northwest Coast as far north as Kachemak Bay and Kodiak Island off the Alaskan peninsula, and as far south as the Puget Sound region of Washington state

(Dumond 1978:79). It must be noted, however, that opponents of Turner's "three-migration" theory claim that the Paleo-Indian / Aleut-Eskimo hybrid population ancestral to Paleo-Arctic people actually formed in Alaska rather than Siberia, and at a much later date, therefore requiring only two migrations to explain the peopling of North and South America (E. Szathmary, in Greenberg, Turner, and Zegura 1986:490). Others argue that multiple influxes would have been needed to account for the genetic differences known to exist among Native Americans, especially those occupying the Northwest Coast, where thirty separate mitochondrial DNA lineages have recently been identified (Dew, et al. 1990). Future advances in the emerging field of molecular archaeology (Pääbo, Higuchi, and Wilson 1989) may someday resolve the dispute.

Does the distribution pattern of New World string figures support Turner's hypothesis? In my opinion, the answer is yes. First, there is very little overlap between the Eskimo and post-Clovis Indian string figure repertoires. This supports Turner's hypothesis that at least two distinct waves of migration were responsible for the peopling of America. It also suggests that the two respective string figure repertoires were largely developed after the Amur basin/Lena basin Sinodont split, which occurred somewhere between 20,000 and 15,000 years B.P. Turner's notion that Paleo-Indians are descended from Lena basin inhabitants of the late Pleistocene also seems supported by string figure evidence. Several simple figures collected among the Dolgan people who currently occupy Siberian territory between the Yenesai and Lena Rivers are clearly of the post-Clovis Indian rather than Eskimo type (Popov 1946:61). Finally, the extensive comparative study presented herein supports Turner's hypothesis that Greater Northwest Coast Indians are descended from a hybrid population derived from ancestral Eskimos and Paleo-Indians: the Kwakiutl repertoire contains both Eskimo and post-Clovis Indian figures. It is also quite likely that the ratio of Eskimo to post-Clovis Indian figures in the Kwakiutl repertoire will approach unity as more American Indian figures are collected, in further support of Turner's hypothesis.

Given the large percentage of Eskimo core figures made by the Kwakiutl using the same method, it seems quite valid to propose that the Paleo-Arctic population ancestral to the Kwakiutl carried these core figures with them after separating from ancestral Paleo-Indians and Aleut-Eskimos, either in Alaska or perhaps even in Siberia. (Note, however, that the large number of Yupik Eskimo core figures in the Kwakiutl repertoire supports the Alaskan alternative.) This suggests that the core Eskimo figures (and some of the core Kwakiutl figures) may be over 8,000 years old, far older than the age of 1,000 years proposed by Paterson and Mary-Rousselière. Additional string figure collections from Siberia may some day clarify this point.

Directly Related Kwakiutl-Eskimo String Figures: Slavery as a Possible Source

Traditionally, two mechanisms bring people of differing cultural practices into contact—war and trade. At first glance, one might dismiss war as a viable means of string figure transmission, given war's brief and hostile nature. But for centuries, the taking of slaves as prisoners of war contributed significantly to the economic prosperity of Northwest Coast culture (Averkieva 1941).

Slaves were acquired by raiding neighboring villages along the coast. According to Woodcock (1977:17), "such prisoners were not absorbed into the victorious tribe by adoption, as happened among the Plains Indians, but became the absolute property of their captors and could be used or sold or killed or liberated as their owners wished." At the time of European contact, 20–25 percent of Kwakiutl society was composed of slaves (Kirk 1978:45). Although slaves lived with their owners, they were given the most undesirable sleeping quarters in the house, often exposed to drafts and rain (Kirk 1986:39). Kirk comments on the function of slaves in Northwest Coast society (Kirk 1986:45):

Early written accounts and traditions recalled by elders mention slaves as labourers who fetched wood and water, rocked the cradles of crying babies, paddled canoes, laid and tended fires. While in their prime, slave men helped build houses, canoes, fish weirs, drying racks and dead-falls. Women slaves cleaned fish and readied them for smoking or sun drying. They provided the labour absolutely essential to process winter supplies, for getting enough food seldom was a serious problem; preserving it was. Slaves served as a basic part of the economic foundation on which Northwest Coast culture was built.

Could slaves have been responsible for the spread of string figures up and down the Pacific Coast? Many believe that a great number of cultural traits were spread via this route (Woodcock 1977:198):

> Even the institution of slavery—as in the ancient world—was a channel of contact between peoples, for the slave often brought with him some technique that was a little better than that used in his master's house, and the slave who was ransomed often took some similar gift home to his own people. Even war played its part in the diffusion of the culture.

Slaves acquired in distant locations were the most desirable (Kirk 1986:44–45):

> Chiefs usually quickly traded slaves to a distant area, thus eliminating easy rescue or escape. What price they got fluctuated according to the reputation of individual captives and the overall supply-demand situation. There are accounts of 43 m (140 feet) of strung dentalia shells, 10 sea otter skins, or 100 or more woolen blankets being exchanged for a healthy slave.

Some tribes traveled great distances in pursuit of slaves (Woodcock 1977:152–53):

> [Haida canoes] were substantial enough to cross in relatively calm weather the considerable stretches of unsheltered water between the Queen Charlottes and the mainland channels, and would often travel down to Victoria for trading or make the eight-hundred-mile journey to Puget Sound for slave raiding. One of the Tlingit tribes, after their village had been bombarded by an American warship and their chief killed, actually made a revenge voyage in a Haida canoe down to Washington Territory, as it then was, killed and beheaded the local customs officer at Port Townsend in

compensation for the death of their kinsman, and then set out for home.

Clearly, the ability to obtain slaves from rather distant locations was present. But just how old is slavery on the Northwest Coast? Apparently, the practice of slavery is as old as Northwest Coast culture itself: Boas recorded fifty-seven different myths among the Kwakiutl which describe the functions and rights of slaves (Boas 1935a:58–59). Was slavery in practice during the time when the Proto-Thule figures might have been transmitted? The answer appears to be yes. Slavery has probably been in practice since at least the beginning of the Christian era. Archaeological evidence suggests that many features of Northwest Coast culture, such as emphasis on personal wealth, social status, and ceremonialism, were well established by this time (Dumond 1978:79).

Slavery may have contributed significantly to the spread of string figures up and down the coast, since the taking of slaves was an act of forced migration. In addition, the slave-owners themselves gained the luxury of leisure time, another factor conducive to the development of an extensive string figure repertoire. The arts in general, often a product of leisure time, flourished during the first half of the first millennium A.D. (Woodcock 1977:40).

Did Northwest Coast Indians raid Eskimo villages in search of slaves in prehistoric times? One can never know for sure, but it is known that in historic times, the Chugach Eskimos of Prince William Sound were subject to raids by the Eyak, Tlingit, and even by other Eskimos, such as the Koniag (Birket-Smith and de Laguna 1938:147). The Aleuts were likewise prey to the Tlingit (Averkieva 1941[1966]:82). And unlike most other Alaskan Eskimos, the Pacific Eskimos practiced slavery themselves, which is one of the many indicators of Northwest Coast influence in this region (Oswalt 1967:246). One must keep in mind, however, that little is known about the Paleo-Arctic people who occupied Tlingit territory prior to the arrival of this tribe from the interior around A.D. 1000.

In summary, the ethnographic literature suggests

that a diffusion mechanism in the form of slavery might be responsible for the direct incorporation of Eskimo string figures into the Kwakiutl repertoire, possibly as early as 2,000 years ago. Unlike Turner's theory of common ancestry, the slave-trade theory better explains the high percentage of Yupik vs. Inupik-Inupiaq Eskimo figures in the Kwakiutl repertoire, since slave raids into Eskimo territory appear to have been restricted to the Alaskan peninsula.

Indirectly Related Kwakiutl-Eskimo String Figures: Trade as a Possible Source

Trade may also have contributed to the spread of string figures up and down the Northwest Coast in prehistoric times. According to Woodcock (1977:198):

> Trade, extending southward down the whole coast and inland up all the great river routes, not only linked the Coast peoples with each other but also sustained relations between them and peoples outside the area, such as the Eskimos and Aleuts to the north, the Athapaskan and Interior Salish peoples to the east, and the Chinook to the south; techniques and ideas as well as material commodities passed along the trade routes. The Coast peoples seem to have known more about each other and about the world immediately surrounding them than early ethnologists were inclined to assume.

The evidence for trade consists of archaeological artifacts not native to the Northwest Coast (Woodcock 1977:39):

> The elaborate trading networks that existed up and down the Pacific Coast two millennia ago are suggested by the materials not native to the Fraser Delta region that have been discovered in the Marpole sites, the most impressive of them being native copper, used for personal ornaments (and at the time of first contact with the Europeans still being traded down the coast from the Copper River in Alaska), clear obsidian blades from the Oregon interior, and dentalium shells fished off the west coast of Vancouver Island. Orna-

ments of copper, shell, and worked stone were buried in a few of the graves dug on the lee side of the village middens, and this—along with the fact that some skulls were already being deformed in a manner that later became habitual among the Salish—suggests that a social hierarchy already existed on the Coast two thousand years ago. Hoards of material wealth, like the cache of more than twenty thousand shale beads discovered at Marpole, indicate that large quantities of non-utilitarian property were accumulated by the people of this ancient riparian society, perhaps for trading, but perhaps also for giving away at feasts resembling the potlatch of historical times.

The reference to copper trade is particularly interesting here, since the ore can only be found in one location on the Pacific Coast, the Copper River of southern Alaska. The Copper River emerges from the Chugach Mountains. In historic times, it roughly defined the boundaries between Pacific Eskimo (Chugach, Koniag) and northernmost Northwest Coast Indian tribes (Eyak, Tlingit). Copper was highly sought after by the Kwakiutl for use in personal ornamentation. In historic times, ornamental copper shields known as "coppers" were symbols of great wealth. Their value increased with each exchange (Boas 1966:81–83). When Europeans first arrived on Vancouver Island in the late 1700s, one of the first items requested in trade by the Indians was copper; clearly, the Indians were already familiar with its value (Woodcock 1977:97; Kirk 1986:203).

Regional mythologies suggest that ancestral Kwakiutls either visited the Copper River themselves or were in close contact with others who did. As previously described, the supernatural being *Q!ō'mogwa*, also called Coppermaker, lives in the North (or West) beyond or under the ocean; the Kwakiutl do not distinguish between the two (Boas 1935a:128). His country is reached by passing under the mountains (possibly a reference to the Chugach Mountains). The entire belief is embodied in a Kwakiutl string figure, Paddling under Coppermaker [21]. The Kwakiutl also say that *Q!ō'mogwa* is a source of dances and other supernatural gifts (Boas 1935a:130). This may refer to the fact that, in addition to material possessions, commodities such

as rituals and customs (and perhaps string figures) were also traded. According to Woodcock (1977:19):

> The spread of rites up and down the Coast was a manifestation of the constant intercourse that went on among these peoples in spite of their linguistic differences. . . . Such trading intercourse furthered the exchange—often by hard barter—of immaterial commodities like dances, rituals, and art forms.

Clearly, the trade networks introduced far more than material goods into Kwakiutl society, and continued to do so throughout the age of European contact. But if certain Eskimo string figures were indeed acquired by the Kwakiutl through trade, why then does the Kwakiutl repertoire lack figures resembling the more recently invented Alaskan Eskimo figures (i.e., the Thule Phase 2a or western variant figures)? Northern trade routes appear to have been active long before the time these figures appeared in Alaska (sometime after A.D. 1000). According to Kirk (1986:165), trade probably began among Northwest Coast tribes as early as 1500 B.C. Archaeological artifacts afford concrete evidence that trade routes extended northward to Alaska by at least A.D. 450: the previously described artifacts uncovered at sites in the Fraser River Delta region belong to the Marpole culture, which flourished between 400 B.C. and A.D. 450 (Woodcock 1977:38–39). Indian-Eskimo trade networks were apparently quite extensive. Recent archaeological digs at Cape Alava, a Makah village buried by a mudslide around A.D. 1579, uncovered over 45,000 items of local manufacture and intertribal trading. Among the finds were iron knives of non-European origin (Woodcock 1977:98):

> Iron knives and chisels had reached the village in small quantities at least two hundred and possibly four hundred years before the arrival of the first European traders. The iron discovered there bore no resemblance to that being made at that period in the only three possible European countries—Britain, Spain, and Russia. It was nearer to early mediaeval Japanese iron, and this accords with the observation of more than one of the early Spanish and British explorers, that the 'rough knives with coarse wooden hafts' . . . were of unfamiliar manufacture. . . . It seems that the knives must have been traded from some Asian source, carried over the Bering Strait by the Eskimos who inhabited both its shores, and found their way through the Aleuts to the northern Tlingit; once at Yakutat Bay, they would enter the North Pacific coastal trading area and would find their way down the Coast in the chain that circulated products as far apart in their origin as the copper of Alaska, the abalone shell of northern California and the obsidian blades found in the interior plateaus of British Columbia and Oregon.

Why then did the introduction of Alaskan Eskimo string figures apparently stop soon after A.D. 1000? The explanation of this anomaly may lie with the arrival of the Tlingits and other Athabaskans who descended the river valleys from the interior soon after A.D. 1000, displacing or absorbing previous inhabitants of the Alaskan panhandle. The introduction of such "middlemen" into the lucrative northern trade route may have effectively severed direct Wakashan-Eskimo relations.

But even prior to Tlingit intervention, the question remains: Were string figures likely to be shared during trade encounters with Eskimos? Oswalt's remarks (1967:133) on Eskimo trading in Alaska pertain here: "Visiting a trading center provided an opportunity to obtain exotic products, but in addition, it was an occasion to renew friendships, *to entertain, and to be entertained*" (italics added). Since both cultures are known to have engaged in string figure contests (Averkieva, p. 3, above; and Glassford 1976:279), there is no reason to believe that this sort of entertainment would be discouraged during trade encounters.

One must also question whether trade encounters were of sufficient length and frequency to allow the *faithful* transmission of the figure (complete with method of construction). According to Oswalt, Alaskan Eskimo trade encounters lasted for "days or even weeks" (Oswalt 1967:133). If one accepts Mary-Rousselière's theory that the faithful transmission of a figure requires repeated exposure over long periods of time, then a two-weeks' visit hardly seems sufficient, unless specific trade partners were repeatedly

sought out, as they were in northern Alaska (Spencer 1977:76). But given the brief nature of a single trade encounter, it is much more likely that the visual image of the string figure pattern alone was transmitted without the kinetic image (i.e., the method of construction). This would explain the origin of shared Kwakiutl-Eskimo figures which are nearly identical in pattern but are made by unrelated methods.

Conclusion

One of the most intriguing questions yet to be answered about American string figures concerns their ultimate origin and antiquity. Did the practice of making string figures arise spontaneously among scattered prehistoric populations of the Old and New World? Or was the practice developed by a single ancient culture ancestral to all present-day American string figure makers? Currently, the practice of making string figures appears to be most highly developed among descendants of early Mongoloid populations, defined by Turner as *Sundadonts* and *Sinodonts* (Turner 1989:90). It is interesting to note that the Mongoloid subdivisions suggested by Turner based on differences in dental morphology are consistent with differences in Mongoloid string figure design: Sundadonts (original inhabitants of Southeast Asia, Indonesia, and most of Oceania) typically construct abstract geometric string figure patterns characterized by intricate, weblike arrays of diamonds. On the other hand, Sinodonts (original inhabitants of China, Japan, Siberia, and the entire New World) are much more inclined to construct complex, asymmetric patterns, patterns that often resemble actual objects or features of the maker's environment. If the perfection of string figure making was indeed a Mongoloid innovation, then one can estimate that the art of string figure making is at least 20,000 years old, based on Turner's Sundadont / Sinodont separation date (Turner 1989:91). Large-scale comparative studies similar to those undertaken

in the present volume may someday confirm this hypothesis.

But before such global studies can proceed with confidence, patterns and techniques characteristic of more restricted geographical regions need to be clearly defined. Averkieva's Kwakiutl collection represents a major step forward in the characterization of North American string figures. The Kwakiutl collection unifies two string figure "schools" that apparently diverged long ago; the American Indian school and the Eskimo school. Figures and techniques from both schools are present in the Kwakiutl repertoire. In exploring possible mechanisms by which the hybrid repertoire may have evolved, I noted three alternative explanations for the observed similarities; shared figures as a direct result of a common Eskimo–Northwest Coast Indian ancestor, shared figures as a direct result of the cultural integration incurred by slaving customs, and shared figures as an indirect result of the trade networks linking distant tribes. In reality, all three mechanisms are likely to be partly responsible for the repertoire similarities recorded herein. But regardless of how Eskimo figures entered the Kwakiutl repertoire (or vice versa), I would propose that the distribution of string figure patterns in North America is clinal in nature rather than clustered or disjointed: indeed, Averkieva's data suggests a "genetic" relationship between all North American string figures. Once additional Native American string figure collections become available, it should be possible to classify specific patterns and techniques as being typically "American." But until such collections surface, the origin of string figures in North America must remain a tantalizing mystery.

Appendix C. Analogous Figures
An Illustrated Cross Index

Many of the Kwakiutl string figures described in this volume are nearly identical or similar to figures collected from other parts of the globe, especially the Arctic regions. Since many of the original publications which illustrate the nearly identical and similar figures are now difficult to obtain, reproductions of these figures have been adapted from the source documents and are presented here in reduced form.

Cross Index of Illustrated Figures

Paterson 9 = The Bear [3, 6b, 78, 79]

Paterson 2, 7 = An Elk [7a]

Paterson 21a = Two Little Elks Lying [7b]

Paterson 60 = A Canoe [16]

Paterson 156 = TsɛlatsɛlatsoᵋE [18a]

Paterson 110 = Ġā'galbalaᵋEmɫ [18b]

Paterson 70; Maude (Nauru) 46 = Paddling under Coppermaker [21]

Paterson 98 = Wrinkled Face in the House [22a]

Roth 263f; Shishido & Noguchi 23 = A Toad [23]

Paterson 48c; Jenness 89, fig. 134 = A Kick in the Back [24]

Paterson 87 = The "Sparrow" series [27] (technique only)

Mary-Rousselière 15a = The Sparrow [27a]

Jayne, fig. 77; Maude & Maude 115 = A Snake [31]

Jayne, fig. 826 = Another Deer [33]

Paterson 106a; Jayne fig. 153 = A Butterfly [39]; Laughing in the House [41]; The Spider's Web [42]

McIlwraith VII = A Butterfly [39]

Jayne, fig. 810 = continuation of *Sisiutl* [48]

Jenness LXXVI, fig. 105; Jayne, fig. 515 = Nā'ᵋnakoma [49]

Paterson 20a = A Grave of a Child [50], step 15

Paterson 8 = Two Bears [52]

Maude (Solomon) 62 = A Toad and a Man ahead of It [56]

Paterson 56 = To Hang Oneself by the Neck [58]

K. Haddon, 2a, 2b = Members of the Patch family [61, 62, 63]

Paterson 59 = Two Killerwhales [65b]

Paterson 214 = The Frogs [71]; The Frog [72]

Paterson 203; Dickey 20a, 16 = Two Dogs [73a]

Dickey 20b = Two Dogs Running Away from Each Other [73b]

Jenness 97B = The Goose [75a]; The Bear [75b]

Paterson 45 = The Goose [75a]

Paterson 45a = The Bear [75b]

Paterson 19b = A Halibut [80b]

Tessmann VI; Jenness 46; Hornell, fig. 3 = A Sand Flea [81]

Paterson 30a, 30b, 30c; Mary-Rousselière 83 = The Killerwhale [82]

Jayne, fig. 563; Paterson 185 = A Salmon Trap [86] (technique only)

Paterson 161 = Digging Clams [90]

Dickey 95 = Digging Clams [91]

Chart 13. Illustrations of string figures collected from other parts of the world which are similar or nearly identical to figures collected among the Kwakiutl (see "Analysis" of each figure's construction method for detailed descriptions and bibliographic citations). For illustrations of figures that are truly identical to figures collected among the Kwakiutl, see the corresponding Kwakiutl string figure illustration.

Paterson 87

Jenness LXXVI fig. 105

Paterson 20a

Mary-Rousselière 15a

Jayne fig. 515

Paterson 8

Jayne fig. 826

Maude (Solomon) 62

Paterson 56

McIlwraith VII

K. Haddon 2a

Paterson 59

Jayne fig. 810

K. Haddon 2b

Chart 13—*continued*

Chart 13—continued

Paterson 161

Paterson 196

Paterson 185

Paterson 45a

Paterson 45

Jenness 97B

Paterson 30c

Dickey 16

Paterson 30a

Dickey 20b

Jenness 46

Tessmann VI

Dickey 20a

Paterson 203

Paterson 214

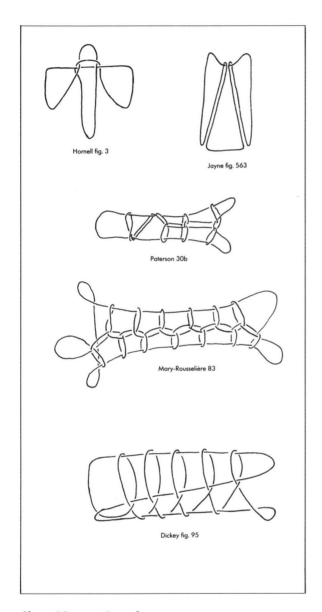

Hornell fig. 3

Jayne fig. 563

Paterson 30b

Mary-Rousselière 83

Dickey fig. 95

Chart 13—*continued*

BIBLIOGRAPHY

Those works dealing specifically with string figures are indicated below in the following manner. A single asterisk (*) denotes source documents describing the string figures of a specific region. All source documents consulted in preparing the string figure distribution data are included, regardless of whether they contain Kwakiutl-like figures. A dagger (†) denotes popular string figure literature presenting figures extracted from various scholarly source documents and intended for the general reader. A double dagger (‡) denotes other informative string figure documents cited in this text, most of which contain no string figure descriptions per se. Many of the citations below are taken from Thomas F. Storer's comprehensive string figure bibliography (Storer 1984). In multi-subject works, only those pages describing string figures are cited.

An International String Figure Society dedicated to the collection, preservation, and study of string figures was founded in 1978 in Tokyo, Japan. The society issues an annual bulletin.

†Abraham, A. J. (1988) *String Figures*. Edited by Keith Irvine. Algonac, Michigan: Reference Publications.

‡Amir-Moéz, A. R. (1965) *Mathematics and String Figures*. Ann Arbor: Edwards Brothers.

*Andersen, J. C. (1927) "Maori String Figures." Board of Maori Ethnological Research, Wellington. *Memoir* 2:171.

†Ariki, T. (1981) *Ayatori Nyumon*. Osaka: Hoiku-sha.

*Ashley, C. W. (1944) "The Ashley Book of Knots." *Mariner's Museum Publication* 13:405–24. Garden City: Doubleday, Doran.

Averkieva, J. P. (1941) *Slavery among the Indians of North America*. Moscow: USSR Academy of Sciences (in Russian). English translation (1957, revised 1966) by G. R. Elliot. Victoria, B.C.: Victoria College.

†Ball, W. W. Rouse (1971) *Fun with String Figures*. New York: Dover (Reprint of *An Introduction to String Figures*, 1920, 1921, 1929; and *String Figures and Other Monographs*, 1960).

*Barrett, S. A., and E. W. Gifford (1933) "Miwok Material Culture." *Public Museum of Milwaukee Bulletin* 2(4):270, 358–63.

*Barton, F. R. (1908) "Children's Games in British New Guinea." *Journal of the Royal Anthropological Institute* 38:263–64; plate 26.

*Beaglehole, P., and H. C. Maude (1989) *String Figures from Pukapuka*. Canberra: Homa Press.

*Beart, C. (1955) "Jeux et Jouets de l'Ouest Africain." *Mémoires de l'Institut Français d'Afrique Noire* 42(1):398–412.

*Biedermann-Wiens, A. (1980) "A Malaysian Fisherman and Two Women Grinding Corn." *String Figures Association Bulletin* 4:8–12.

*Birket-Smith, K. (1924) "Ethnology of the Egedesminde District." *Meddelelser om Grønland* 66:399–400.

*Birket-Smith, K. (1929) *Report of the Fifth Thule Expedition, 1921–1924* 5(1):276–81; 5(2):120, 204–5, 291, 375–76. Copenhagen: Gyldendal.

*Birket-Smith, K. (1930) "Contributions to Chipewyan Ethnology." *Report of the Fifth Thule Expedition, 1921–1924* 6(3):72. Copenhagen: Gyldendal.

‡Birket-Smith, K., and F. de Laguna (1938) *The Eyak Indians of the Copper River Delta (Alaska)*. Copenhagen: Levin and Munksgaard. P. 239.

*Blixen, O. (1979) "Figuras de Hilo tradicionales de la Isla de Pascua." *MOANA: Estudios de Anthropologia Oceania* 2(1).

*Boas, F. (1888a) "The Central Eskimo." Bureau of Ethnology, Washington, D.C., *Annual Report* 6:161–62.

*Boas, F. (1888b) "The Game of Cat's Cradle." *International Archiv für Ethnographie* 1:229–30.

‡Boas, F. (1888c) "Das Fadenspiel." *Mittheilungen der Anthropolische Gesellschaft in Wien* 18 (N.S. 8):85.

Boas, F. (1895) *Indianische Sagen von der Nord-Pacifischen Küste Amerikas*. Berlin.

Boas, F. (1897) *Social Organization and Secret Societies of the Kwakiutl Indians*. United States National Museum, Annual Report for 1895.

Boas, F. (1902) "Kwakiutl Texts." Publications of the Jesup North Pacific Expedition 3. *Memoirs of the American Museum of Natural History* 5:1–3. Leiden: E. J. Brill.

Boas, F. (1908) "Kwakiutl Texts." 2nd series. Publications of the Jesup North Pacific Expedition 10(1). *Memoirs of the American Museum of Natural History* 14(1). Leiden: E. J. Brill.

Boas, F. (1909) "The Kwakiutl of Vancouver Island." *Memoirs of the American Museum of Natural History* 5(2):301–522. (Reprint edition, New York: AMS Press, 1975).

Boas, F. (1910) *Kwakiutl Tales*. Columbia University Contributions to Anthropology 2. New York: Columbia University Press.

Boas, F. (1935a) *Kwakiutl Culture as Reflected in Mythology*. Memoirs of the American Folklore Society 28.

Boas, F. (1935b) *Kwakiutl Tales, New Series*. Columbia University Contributions to Anthropology 26. New York: Columbia University Press.

Boas, F. (1966) *Kwakiutl Ethnography*. Edited by H. Codere. Chicago: University of Chicago Press.

*Boegershausen, P. G. (1915–1916) "Fadenspiele in Matupit, Neupommern." *Anthropos* 10–11:908–12

*Bogoras, W. (1904) "The Chukchee." Publications of the Jesup North Pacific Expedition 7. *Memoirs of the American Museum of Natural History* 11:275–76, 287. (New York: Johnson Reprint, 1966)

*Brewster, P. G. (1953) "Some String Figures and Tricks from the United States." *Rivista di Etnografia* 7(1/4):1–12

*Brewster, P. G. (1954) "Fadenspiele aus dem Mittleren Western der Vereinigten Staaten von Amerika." *Osterreichische Zeitschrift für Volkskunde*, N.S. 8(1–2):23–32

*Brewster, P. G., and G. Tarsouli (1951) "A String Figure Series from Greece." *Epeteris ton Laographikon Archeion* 13:101–25.

*Buck, P. H. (Te Rangi Hiroa) (1930) "Samoan Material Culture." *B. P. Bishop Museum Bulletin* 75:557–63.

*Burrows, E. G. (1937) "Ethnology of Uvea." *B. P. Bishop Museum Bulletin* 145:158–61.

*Campbell, R. (1971) *La Herencia Musical de Rapanui*. Santiago: Litografia Stanley. Pp. 413–42.

*Centner, T. H. (1962?) "L'Enfant Africain et ses Jeux." Centre d'étude des problèmes sociaux indigènes. *Memoir* 17:383–90.

*Compton, R. H. (1919) "String Figures from New Caledonia and the Loyalty Islands." *Journal of the Royal Anthropological Institute* 49:204–36.

Codere, H. (1956) "Kwakiutl." In *Perspectives in American Indian Culture Change*. Edited by E. H. Spicer. Inter-University Summer Research Seminar, University of New Mexico. Chicago: University of Chicago Press. Pp. 431–516.

*Culin, S. (1899) "Hawaiian Games." *American Anthropologist* N.S. 1(2):222–23.

*Culin, S. (1907) "Games of North American Indians." Bureau of Ethnology, Washington, D.C., *Annual Report* 24:761–79. (Reprint edition, New York: AMS Press, 1973).

*Cunnington, W. A. (1906) "String Figures and Tricks from Central Africa." *Journal of the Royal Anthropological Institute* 36:121–31.

*Cunnington, W. A. (1908) "String Tricks from Egypt." *Man* 8:149–50.

*Davidson, D. S. (1927) "Some String Figures of the Virginia Indians." *Indian Notes* 4(4):384–95

*Davidson, D. S. (1941) "Aboriginal Australian String Figures." *Proceedings of the American Philosophical Society* 84:763–901.

‡Dawkins, R. M. (1931) "Some Remarks on String Figures." *Annals of Archaeology and Anthropology* 18:39–49.

‡Day, C. L. (1967) *Quipus and Witches' Knots*. Lawrence: University of Kansas Press. Pp. 84, 87, 124–26.

‡de Laguna, F. (1972) "Under Mount Saint Elias: The History and Culture of the Yakutat Tlingit." *Smithsonian Contributions to Anthropology* 7(2):559–60.

*Devonshire, C. W. (1949) "Rarotongan String Figures." *Journal of the Polynesian Society* 58(3):112–23.

Dew, K., B. S. Frazier, R. H. Ward, and S. Pääbo (1990) "Mitochondrial Evolution and the Peopling of America." *American Journal of Physical Anthropology* 81(2):277.

*Dickey, L. A. (1928) "String Figures from Hawaii." *B. P. Bishop Museum Bulletin* 54 (New York: Kraus Reprint, 1985).

Dumond, D. E. (1977) *The Eskimos and Aleuts*. London: Thames and Hudson.

Dumond, D. E. (1978) "Alaska and the Northwest Coast." In *Ancient Native Americans*. Edited by J. D. Jennings. San Francisco: W. H. Freeman. Pp. 42–93.

*Earthy, E. D. (1953) *Valenga Women*. London: Oxford University Press. Pp. 95–101.

†Elffers, J., and M. Schuyt (1978) *Cat's Cradles and Other String Figures*. (Text: B. Westerveld). New York: Penguin.

*Emerson, J. S., and M. W. Beckwith (1924) "Hawaiian String Games." *Vassar College Folk-Lore Foundation Publication* 5:1–18.

*Emory, K. P., and H. C. Maude (1979) *String Figures of the Tuamotus*. Canberra: Homa Press.

*Eschlimann, P. H. (1911) "L'Enfant chez les Kuni." *Anthropos* 6:271–72.

*Evans-Pritchard, E. E. (1972) "Zande String Figures." *Folklore* (London) 83:225–39.

*Farabee, W. C. (1918) "The Central Arawaks." University of Pennsylvania, *University Museum Anthropological Publication* 9:123–31.

*Farabee, W. C. (1924) "The Central Caribs." University of Pennsylvania, *University Museum Anthropological Publication* 10:85–96.

*Firth, R., and H. C. Maude (1970) "Tikopia String Figures." Royal Anthropological Institute, *Occasional Paper* 29:1–63.

*Fischer, H. (1960) "Fadenspiele vom Unteren Watut, und Banir River (Ost-Neuguinea)." *Baessler-Archiv*, N.S. 8:171–214.

*Foster, G. M. (1941) "String Figure Divination." *American Anthropologist*, N.S. 43:126–27.

‡Frachtenberg, L. J. (1920) "Alsea Texts and Myths." *Bureau of American Ethnology Bulletin* 67:211.

‡Gardener, M. (1962) "Mathematical Games: The Ancient Lore of String Play." *Scientific American* 206(6):146–54.

‡Glassford, R. G. (1976) *Application of a Theory of Games to the Transitional Eskimo Culture*. New York: Arno Press. Pp. 277–79.

*Gordon, G. B. (1906) "Notes on the Western Eskimo." University of Pennsylvania, Free Museum of Science and Art, *Transactions of the Department of Archaeology* 2(1):87–97.

*Gray, J. (1903) "Some Scottish String Figures." *Man* 3:117–18.

Greenberg, J. H., C. G. Turner II, and S. L. Zegura (1986) "The Settlement of the Americas: A Comparison of the Linguistic, Dental, and Genetic Evidence." *Current Anthropology* 27(5):477–97

*Griaule, M. (1935) "Jeux et Divertissements Abyssins." Bibliotheque de l'Ecole de Hautes Etudes. *Sciences Religieuses* 49:181–83; plate 7.

*Griaule, M. (1938) "Jeux Dogons." Institut d'Ethnologie de l'Université de Paris, *Travaux et Mémoires* 32:71–83.

*Griffith, C. L. T. (1925) "Gold Coast String Games." *Journal of the Royal Anthropological Institute* 55:271–302.

*Griffith, C. L. T., and K. Haddon (1914) "Some Brahmanic String Figures." *Man* 14:92–97.

†Gryski, C. (1984) *Cat's Cradles, Owl's Eyes*. New York: Morrow.

†Gryski, C. (1985) *Many Stars and More String Games*. New York: Morrow.

†Gryski, C. (1988) *Super String Games*. New York: Morrow.

*Haddon, A. C. (1903) "A Few American String Figures and Tricks." *American Anthropologist* N.S. 5(2):213–23.

*Haddon, A. C. (1906) "String Figures from South Africa." *Journal of the Royal Anthropological Institute* 36:142–49.

*Haddon, A. C. (1912) "String Figures and Tricks." *Reports of the Cambridge Anthropological Expedition to the Torres Straits* 4:320–41. London: Cambridge University Press.

†Haddon, K. (1912) *Cat's Cradles from Many Lands*. New York: Longmans, Green (Reprint edition, West Orange: Saifer, 1983).

*Haddon, K. (1918) "Some Australian String Figures." *Proceedings of the Royal Society of Victoria* N.S. 30(2):121–36.

†Haddon, K. (1930) *Artists in String*. London: Methuen (Reprint edition, New York: AMS Press, 1979).

†Haddon, K. (1942) *String Games for Beginners*. 2nd Edition. Cambridge: Heffer.

*Haddon, K., and H. A. Treleaven (1936) "Some Nigerian String Figures." *Nigerian Field* 5(1):31–38; 5(2):86–95.

*Hambruch, P. (1914) "Nauru." In *Ergebnisse der Südsee-Expedition (1908–1910)*. Edited by G. Thilenius. Hamburg: L. Friedrichsen. Vol. 2, part B(1):343–67.

*Handy, W. C. (1925) "String Figures from the Marquesas and Society Islands." *B. P. Bishop Museum Bulletin 18* (New York: Kraus Reprint, 1971).

*Hansen, K. (1974–75) "String Figures from West Greenland." *Folk* (Copenhagen) 16–17:213–26.

*Harbison, R., and R. Reichelt (1985) "Some String Figures from Papua New Guinea." *String Figures Association Bulletin* 11:18–27.

*Hassrick, R., and E. Carpenter (1944) "Rappahannock Games and Amusements." *Primitive Man* 17:36–37.

*Hathalmi, G. F. (1904) "Gyermekmüvészet es Gyermekjátékok." *Néprajzi Értesitö* 5:132–45.

*Held, G. J. (1957) *The Papuans of Waropen*. Translation series 2. The Hague: Martinus Nijhoff. Pp. 182, 362–68.

†Helfman, H. C., and E. Helfman (1965) *String on your Fingers*. New York: Morrow.

*Hingston, M. A. (1903) " 'The Candles' String Figure in Somerset." *Man* 3:147.

*Holmes, J. H. (1924) *In Primitive New Guinea*. London: Seeley, Service. Pp. 279–82, 286.

*Holtved, E. (1967) "Contributions to Polar Eskimo Ethnography." *Meddelelser om Grønland* 182(2):162–69.

‡Hornbostel, E. M. von, and M. A. Sherman (1989) "Kwakiutl String Figures: A Preface." *String Figures Association Bulletin* 16:25–48.

*Hornell, J. (1927) "String Figures from Fiji and Western Polynesia." *B. P. Bishop Museum Bulletin 39* (New York: Kraus Reprint, 1971).

*Hornell, J. (1930) "String Figures from Sierra Leone, Liberia, and Zanzibar." *Journal of the Royal Anthropological Institute* 60:81–114.

*Hornell, J. (1932) "String Figures from Gujarat and Kathiawar." *Memoirs of the Asiatic Society of Bengal* 11(4):147–64.

*Hornell, J. (1940) "String Figures from the Anglo-Egyptian Sudan." *Sudan Notes and Records* 13(1):99–122.

*Hrabalová, O., and P. G. Brewster (1957) "A Czechoslovak Cat's Cradle Series." *Ceskoslovenska Ethnografie* 5:176–83.

*James, H. C. (1959) "Cahuilla Cat's Cradle." *Desert Magazine* 22(8):26.

*Jättiläinen, P. (1962) *Antero Vipunen*. Helsinki: Porvoo. Pp. 370–75.

*Jayne, C. F. (1906) *String Figures*. New York: Charles Scribner's Sons.

*Jayne, C. F. (1962) *String Figures and How to Make Them*. (Reprint edition, 1906 book.) New York: Dover.

*Jenness, D. (1920) "Papuan Cat's Cradles." *Journal of the Royal Anthropological Institute* 50:299–326.

*Jenness, D. (1924) Eskimo String Figures. Report of the Canadian Arctic Expedition (1913–1918), Vol. 13, pt. B.

*Johnston, T. F. (1979) "Illeagosiik! Eskimo String Figure Games." *Music Educator's Journal* 65:54–61.

*Jochelson, W. (1933) "History, Ethnology and Anthropology of the Aleut." *Carnegie Institute of Washington Publication* 432:63–65.

*Junod, H. A. (1927) *The Life of a South African Tribe*. Vol. 1:175–76. London: Macmillan.

†Kalter, J. (1978) *String Figures*. New York: Drake.

†Kattentidt, I. (1936) *Fadenspiele aus aller Welt*. Ravensburg, Germany: O. Maier.

Kirk, R. (1986) *Tradition and Change on the Northwest Coast*. Seattle: University of Washington Press.

*Klutschak, H. W. (1881) *Als Eskimos unter den Eskimos*. Wien: A Hartleben. Pp. 136, 139.

*Kramer, A. (1932) "Truk." In *Ergebnisse der Südsee-Expedition (1908–1910)*. Edited by G. Thilenius. Hamburg: L. Friederichsen. Vol. 2, part B(5):288–95.

*Kraus, H. (1907) "Lufambo." *Globus* 92(14):221–22.

*Kroeber, A. L. (1899) "The Eskimo of Smith Sound." *American Museum of Natural History Bulletin* 12:298–300.

Kroeber, A. L. (1939) "Culture Element Distributions XI; Tribes Surveyed (and references therein)." University of California, *Anthropological Records* 1(7):435–40.

*Lagercranz, S. (1950) "Contribution to the Ethnography of Africa." *Studia Ethnographica Upsaliensia* 1:269–74.

*Landtmann, G. (1914) "Cat's Cradle of the Kiwai Papuans, British New-Guinea." *Anthropos* 9:221–32.

*Lantis, M. (1946) "Social Customs of the Nunivak Eskimo." *Transactions of the American Philosophical Society* 35(3):217–22.

*Leakey, M. D., and L. S. B. Leakey (1949) *Some String Figures from North-East Angola.* Lisbon: Museo do Dundo.

†Leeming, J. (1940) *Fun with String.* Philadelphia: J. B. Lippincott. Pp. 135–59.

*Lindblom, G. (1930) "String Figures in Africa." Riksmuseets Etnografiska Avdelning, *Smärre Meddelanden* 9:1–12.

*Lutz, F. E. (1912) "String Figures from the Patomana Indians of British Guiana." *Anthropological Papers of the American Museum of Natural History* 12(1):1–14 (Reprinted 1912). "String Figures from the Upper Potaro." *Timehri.* 3(2):117–27.

‡McCarthy, F. D. (1958) "String Figures of Australia." *Australian Museum Magazine* 12:279–83.

*McCarthy, F. D. (1960) "The String Figures of Yirrkalla." In *The American-Australian Expedition to Arnhem Land.* Vol. 2. Edited by C. P. Mountford. Melbourne: Melbourne University Press.

McGhee, R. (1984) "Thule Pre-History of Canada." In *Handbook of North American Indians (Arctic).* Vol. 5. Edited by W. C. Sturtevant. Washington, D.C.: Smithsonian Institution.

*McIlwraith, T. F. (1948) *The Bella Coola Indians.* Vol. 2. Toronto: University of Toronto Press. Pp. 384, 543–69.

*Macfarlan, A. A. (1958) *Book of American Indian Games.* New York: Association Press. Pp. 189–96.

*Malaurie, J. (1982) *The Last Kings of Thule.* London: Jonathan Cape. Pp. 42, 111, 115, 116, 159, 273, 467.

*Malinowski, B. (1929) *The Sexual Life of Savages in North-Western Melanesia* 2:398–402. New York: H. Liveright (Reprinted 1987). New York: Routledge, Chapman and Hall.

*Martinez-Crovetto, R. (1970) "Juegos de Hilo de los Aborigenes del Norte de Patagonia." *Etnobiologica* 14.

‡Mary-Rousselière, G. (1965) "Eskimo String Figures." *Eskimo* (Country, Inhabitants, Catholic Missions) 70:8–15. [English summary of later 1969 monograph.]

*Mary-Rousselière, G. (1969) "Les Jeux de Ficelle des Arviligjuarmiut." *Musées Nationaux du Canada Bulletin* 233.

*Mathiassen, T. (1928) "Material Culture of the Iglulik Eskimos." *Report of the Fifth Thule Expedition, 1921–1924* 6(1):222–27. Copenhagen: Gyldendal.

*Maude, H. C. (1971) "The String Figures of Nauru Island." Libraries Board of South Australia, *Occasional Papers in Asian and Pacific Studies* 2.

*Maude, H. C. (1978) *Solomon Island String Figures.* Canberra: Homa Press.

*Maude, H. C. (1981) "Two Birds, Birds' Eggs, and a Flock of Birds; from the Island of Uvea in the Loyalty Group." *String Figures Association Bulletin* 6:2–3.

*Maude, H. C. (1982) "Two Figures from New Caledonia." *String Figures Association Bulletin* 8:1–3.

*Maude, H. C. (1983) "Variation of Two Gilbertese Figures." *String Figures Association Bulletin* 9:5–7.

*Maude, H. C. (1984) *String Figures of New Caledonia and the Loyalty Islands.* Canberra: Homa Press.

*Maude, H. C. (1986) "String Figures from Tonga." *String Figures Association Bulletin* 13:7–21.

*Maude, H. C. (1987) "String Figures from Torres Strait." *String Figures Association Bulletin* 14:1–35.

*Maude, H. C., and G. Koch (1969) "Polynesier (Ellice-Inseln, Niutao) Fadenspiele." Institute für den Wissenschaftlichen Film, *Encyclopedia Cinematographica,* pp. 585–604.

*Maude, H. C., and H. E. Maude (1958) "String Figures from the Gilbert Islands." *Memoirs of the Polynesian Society* 13.

*Maude, H. C., and C. H. Wedgewood (1967) "String Figures of Northern New Guinea." *Oceania* 37:202–29.

*Métraux, A. (1930) "Etudes sur la Civilisation des Indiens Chiriguano." *Revista del Instituto de Etnologià de la Universidad Nacional de Tucumán* 1(3):473–76.

*Métraux, A. (1935) "Quelques Jeux de Ficelle l'Amerique du Sud." *Societé des Americanistes de Belgiques Bulletin* 17:67–81.

*Michelson, T. (1929) "Algonquian Indian Tribes of Oklahoma and Iowa." In *Smithsonian Institute Explorations and Fieldwork in 1928.* P. 184.

*Miller, L. G. (1945) "Earliest (?) Description of a String Figure." *American Anthropologist* N.S. 47:461–62.

*Mindt-Paturi, F. R. (1985) "Three String Tricks from the Wolof of Senegal." *String Figures Association Bulletin* 11:10–16

*Mountford, C. P. (1950) "String Figures of the Adnyamata Tribe." *Mankind* 4(5):183–89.

*Muller, W. (1917) "Yap." In *Ergebnisse der Südsee-Expedition (1908–1910)*. Edited by G. Thilenius. Hamburg: L. Friedrichsen. Vol. 2, part B(2):206–15.

*Natsubori, K. (1986) *Nippon No Ayatori*. Tokyo: Yukishobo.

*Nimuendaju, C. (1952) "The Tukuna." University of California, *Publications in American Archaeology and Ethnology* 45:72, 188–89.

*Noble, P. D. (1979) *String Figures of Papua New Guinea*. Boroko: Institute of Papua New Guinea Studies.

*Noble, P. D. (1980) "Echo (Imitation) from Southern Papua." *String Figures Association Bulletin* 5:2–5.

‡Noble, P. D. (1980) "String Games and Paper Equivalent Models." *String Figures Association Bulletin* 4:1–5.

†Noguchi, H. (1973) *Ayatori*. 2 vols. Tokyo: Kawade Shobo Shin-sha.

‡Noguchi, H. (1981) *Zukei-Asobi No Sekai*. Tokyo: Kodansha. Pp. 125–62.

*Noguchi, H. (1982) "String Figures in Japan, I." *String Figures Association Bulletin* 7:1–21.

*Noguchi, H. (1983) "String Figures in Japan, II." *String Figures Association Bulletin* 9:21–43.

*Noguchi, H. (1984) "String Figures in Japan, III." *String Figures Association Bulletin* 10:1–33.

*Noguchi, H. (1986) "String Figures in Japan, IV." *String Figures Association Bulletin* 13:22–43.

†Oorschot, A. van (1966) *Touwfiguren*. Amsterdam: G. J. A. Ruys.

Oswalt, W. H. (1967) *Alaskan Eskimos*. San Francisco: Chandler Publishing.

Pääbo, S., R. G. Higuchi, and A. C. Wilson (1989) "Ancient DNA and the Polymerase Chain Reaction: The Emerging Field of Molecular Archaeology." *Journal of Biological Chemistry* 264(17):9702–12.

*Parkinson, J. (1906) "Yoruba String Figures." *Journal of the Royal Anthropological Institute* 36:132–41.

‡Paterson, T. T. (1939) "Eskimo Cat's Cradles." *Geographical Magazine* 9:85–91.

*Paterson, T. T. (1949) "Eskimo String Figures and Their Origin." *Acta Arctica* 3:1–98.

†Paturi, F. (1988) *Schnur-figuren aus aller Welt*. Munich: Hugendubel.

*Pocock, W. I. (1906) "Cat's Cradle." *Folklore* 17(1):73–93.

*Pocock, W. I. (1906) "Some English String Tricks." *Folklore* 17(1):351–73.

*Pocock, W. I. (1907) "Supplementary Notes on Cat's Cradle and String Tricks." *Folklore* 18(3):325–29.

*Poncins, G. de (1941) *Kabloona*. New York: Reynal and Hitchcock. Pp. 322–23.

*Popov, A. A. (1946) "Dolgan Family Life" (in Russian). *Sovetskaia Etnografiia* 1946(4):61–62

*Rasmussen, K. (1932) Intellectual Culture of the Copper Eskimos. *Report of the Fifth Thule Expedition, 1921–1924* 9:271–88. Copenhagen: Gyldendal.

*Raymund, P. (1911) "Die Faden- und Abnehmspiele auf Palau." *Anthropos* 6(1):40–61.

*Rivers, W. H. R., and A. C. Haddon (1902) "A Method of Recording String Figures and Tricks." *Man* 2:146–53.

*Robinson, A. (1918) "Some Figures in String from the Makushis on the Ireng and Takutu Rivers." *Timehri* 3(5):140–52.

*Rogers, E. S. (1967) "The Material Culture of the Mistassini." *National Museum of Canada Bulletin* 218:120.

Rohner, R. P. (1969) *The Ethnography of Franz Boas: Letters and Diaries of Franz Boas Written on the Northwest Coast from 1886–1931*. Chicago: University of Chicago Press.

*Rosser, W. E., and J. Hornell (1932) "String Figures from British New Guinea." *Journal of the Royal Anthropological Institute* 62:39–50.

*Roth, W. E. (1902) "Games, Sports and Amusements." *North Queensland Ethnography* 4:10–11; plates 3–12.

*Roth, W. E. (1908) "Cratch-Cradle in British Guiana." *Revue des Etudes Ethnographique et Sociologiques* 4–5:193–99.

*Roth, W. E. (1924) "String Figures, Tricks, and Puzzles of the Guiana Indians." Washington, D.C., Bureau of American Ethnology, *Annual Report* 38:500–50.

*Roth, W. E. (1929) "Corrections and Addenda to 'String Figures, Tricks, and Puzzles of the Guiana Indians.' " Washington, D.C., Bureau of American Ethnology, *Bulletin* 91:92–93.

*Ryden, S. (1934) "South American String Figures." *GOTHIA (Meddelanden från Geografiska Föreningen i Göteborg)* 6:1–43.

*Saito, T. (1982) *Ayatori Itotori.* 3 vols. Tokyo: Hukuinkan.

*Sbrzesny, H. (1976) "Die Spiele der !Ko-Buschleute." *Monographien zur Humanethnologie, bd. 2.* München, Zurich: Piper. Pp. 95–102.

*Schebesta, P. (1941) "Die Bambuti-Pygmäen von Ituri." *Mémoires du Institut Royal Colonial Belge* 2:242–43; plates 69–86.

Scholarly Resources, Inc. (1972) *Guide to the Microfilm Collection of the Professional Papers of Franz Boas: A Project of Scholarly Resources, Inc., in Cooperation with the American Philosophical Society, by Permission of Miss Franziska Boas.* Wilmington, Delaware.

*Senft, B., and G. Senft (1986) "Ninikula Fadenspiele auf den Trobriand-Inseln, Papua, Neu Guinea." *Baessler-Archiv* N.S. 34:93–235.

†Sherman, M. A. (1991) "Rationally designed String Figures: Variations of the Kwakiutl Figure 'Two Trees'." *String Figures Association Bulletin* 17:29–106.

*Shishido, Y., and H. Noguchi (1987) "Some String Figures of Highland People in Papua New Guinea." *String Figures Association Bulletin* 14:38–69.

*Siliceo Pauer, P. (1920) "Cat's Cradle." *Journal of American Folklore* 83:85–86.

*Speck, F. G. (1935) *Naskapi: The Savage Hunters of the Labrador Peninsula.* Norman: University of Oklahoma Press. Pp. 194, 219–23.

*Spencer, B. (1928) *Wanderings in Wild Australia.* Vol. 2. London: Macmillan. Pp. 581–84.

Spencer, R. F. (1977) "The Arctic and Subarctic." In *The Native Americans.* 2d edition. Edited by R. F. Spencer, J. D. Jennings et al. New York: Harper and Row.

*Spier, L. (1930) *Klamath Ethnography.* Berkeley: University of California Press. Pp. 84–85.

*Stanley, G. A. V. (1926) "String Figures of the North Queensland Aborigines, Part 1." *Queensland Geographical Journal* 40–41:73–92.

*Starr, F. (1909) "Ethnographic Notes from the Congo Free State." *Proceedings of the Davenport Academy of Sciences* 12:135–36, 148–75; plate 12.

*Stokes, J. F. G., and M. A. Sherman, "String Figures from the Austral Islands." (Manuscript in preparation).

*Storer, T. (1964) "String Figures from Old Oraibe." (Unpublished manuscript, 9 pp.).

‡Storer, T. (1984) "String Figure Bibliography." *String Figures Association Bulletin* 12:1–66.

‡Storer, T. (1988) "String Figures." 2 vols. *String Figures Association Bulletin* 16:1–410. [A comprehensive mathematical analysis.]

*Teit, J. A. (1900) "The Thompson Indians of British Columbia." *Memoirs of the American Museum of Natural History: Anthropology* 2:281–82.

*Tenicheff, W. (1898) *L'Activite de l'Homme.* Paris: E. Cornely. Pp. 153–54.

*Tessmann, G. (1912) "Die Kinderspiele der Pangwe." *Baessler-Archiv* 1–2:271–78.

*Tessmann, G., E. M. von Hornbostel, and K. Haddon (1939) "Chama String Games (Peru)." *Journal of the Royal Anthropological Institute* 69:163–86.

*Tozzer, A. M. (1907) *A Comparative Study of the Mayas and the Lacandones: Report of the Fellow in American Archaeology (1902–1905).* New York: Macmillan. P. 76.

*Tracey, H. (1936–37) "String Figures (Madandi) found in Southern Rhodesia." *NADA* 14:78–88.

*Trapp, K. (1959) *Bantu-spiele.* Bonn: Rheinischen Friedrich-Wilhelms Universität. Pp. 96–104, 129.

Turner, C. G., II (1985) "The Dental Search for Native American Origins." In *Out of Asia: Peopling the Americas and the Pacific.* Edited by R. Kirk and E. Szathmary. Canberra: Journal of Pacific History.

Turner, C. G., II (1986) "Dentochronological Separation Estimates for Pacific Rim Populations." *Science* 232:1140–42.

Turner, C. G., II (1988) "Ancient Peoples of the North Pacific Rim." In *Crossroads of Continents: Cultures of Siberia and Alaska.* Edited by W. W. Fitzhugh and A. Crowell. Washington D. C.: Smithsonian Institution Press.

Turner, C. G., II (1989) "Teeth and Prehistory in Asia." *Scientific American* 260(2):88–96.

‡Tylor, E. B. (1879) "Remarks on the Geographical Distribution of Games." *Journal of the Royal Anthropological Institute* 9:26.

*Victor, P. E. (1940) "Jeux d'Enfants et d'Adultes chez les Eskimo d'Angmagssalik: Les Jeux de Ficelle." *Meddelelser om Grønland* 125.

‡Walker, J. (1985) "Cat's Cradle and Other Topologies Formed with a Two-meter Loop of Flexible String." *Scientific American* 252(5):138–43.

*Wedgewood, C. H., and I. Schapera (1931) "String Figures from Bechuanaland Protectorate." *Bantu Studies* 4:251–58.

Woodcock, G. (1977) *Peoples of the Coast: The Indians of the Pacific Northwest.* Bloomington: Indiana University Press.

†Wu, Tzu-yun (1975) *T'iao Hsien Yu Shi.* Hong Kong: Manri Press.

†Yuasa, S., and T. Ariki (1973) *Tanoshii Ayatori Asobi.* Nagoya: Reimei Shobo.

INDEX

Italicized page numbers denote cultural background material about the referent string figure. Bracketed numbers represent the number assigned by Averkieva to individual string figure patterns.